SCRIBES AND SOURCES

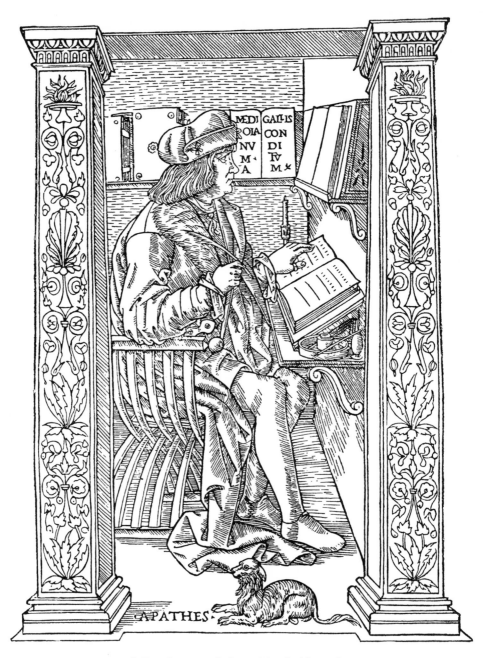

A Renaissance scholar writing in his study.
From Bernardo Corio *Historia . . . di Milano*, 1503.

SCRIBES and SOURCES

Handbook of the Chancery Hand
in the Sixteenth Century

*Texts from the Writing-Masters
selected, introduced and translated by*

A. S. OSLEY

*with an account of John de Beauchesne
by Berthold Wolpe*

DAVID R. GODINE · *Publisher*
Boston

First published in the United States of America in 1980 by
David R. Godine, Publisher Inc.,
306 Dartmouth Street,
Boston, Massachusetts 02116

Printed in Great Britain

L.C.C. NO. 79–88418
ISBN 0 87923 297 8

CONTENTS

* This chapter is contributed by Dr. Berthold Wolpe.

LIST OF ILLUSTRATIONS

NOTES

1. In addition to the illustrations listed above, there are reproductions of decorative motifs and of lettering taken from the work of the writing-masters concerned on pages 54, 86, 120, 125 and 159.

2. For typographical reasons, examples of individual letters, or groups of letters, integrated in the text have unfortunately had to be reduced.

TO THE MEMORY OF
DONALD TOYNBEE WORTHY
1916–1973

'And the treasures that the wise men of old have left behind
in their written books, I open and explore with my friends;
and if we light upon any good thing, we extract it, regarding
it as a great gain if we can be of help to each other.'
Xenophon, *Memorabilia* I, VI, 14

PREFACE

This book is about handwriting—a subject much neglected, badly taught, badly practised. Some people regard it at best with polite toleration. For the late Richard Crossman,[1] it was 'a useful method of taking notes or communicating and all I want for my children is that they are able to do it competently and clearly before they learn to type'. Others consider that it is already obsolete, superseded by the tape-recorder and the typewriter, oblivious to the fact that some change in the Earth's magnetism could wipe clean all the tapes in existence.

A little reflection shows that, for a long time to come, reports of the imminent death of handwriting will be premature. Cheques will undoubtedly continue to be made out and signed, labels displayed in shop windows, graffiti scribbled mysteriously on walls, and indiscretions entered in diaries. Only the most resolute will wish to take their typewriters on holiday in order to write the customary postcards to friends. Poets and composers will continue to jot down their sudden illuminations on the backs of envelopes. Members of committees who wish to pass a message to a colleague during a discussion will usually prefer to write a few words and hand them silently over the table rather than bang them out on a typewriter.

Even as a purely commercial proposition, handwriting has its advantages. Much of the preliminary work in a computer programme is more effectively performed if the material is marshalled with clarity and legibility by hand. Again, it is cheaper, often quicker, to write a memorandum long-hand and reproduce it by a copying machine than to dictate it. This has been recognised in many businesses and government agencies. When sufficient office workers can write decently, the Xerox will make the typewriter and typist obsolete.

Handwriting is everyman's craft. It requires neither high intelligence, nor wealth, nor physical strength. All that is needed is pen, ink, and paper; and a good model on which to base one's style. With this simple equipment, the gates of the inexhaustible treasure-house of the Western alphabet—perhaps the most far-reaching and attractive device of the human mind to appear in the interval that separates the inventions of the wheel and the printing-press—lie open.

Success in handwriting is closely related to the models that are taught. It so happens that a simple, elegant and practical model is readily available. This is italic script, evolved for twentieth-century use from the chancery hands of the fifteenth and sixteenth centuries, as seen in the manuals of writing-masters, such as Tagliente,

[1] *Diaries of a Cabinet Minister*, Vol. II, p. 568, London, 1976.

Vicentino (Arrighi), Palatino and Mercator, and others, whom we shall meet in this book.

These manuals, fallen into disuse for over three hundred years, began to exercise their magic again in England in the 1880s. William Morris owned four of them and experimented with the chancery hand. Manuscript books written by him were shown at the first exhibition of the Arts and Crafts Exhibition Society in 1888. During this same exhibition, Oscar Wilde reported a lecture given by Emery Walker on letterpress printing and illustration, in the course of which 'a photographic projection of a page of Arrighi was greeted with a spontaneous round of applause from the large and attentive audience'. Shortly after, Walker embarked on a never-completed project of designing a type-face based on Tagliente. In 1898 Monica, wife of the poet Robert Bridges, published *A New Handwriting for Teachers*, which recommended a model influenced by the chancery hand. Edward Johnston also showed, in his classic handbook *Writing & Illuminating, & Lettering* (1906), a few examples of chancery script from Italian manuscripts.

It is now just over half a century since a young Admiralty clerk named Alfred Fairbank, a disciple though not a pupil of Johnston, began to contemplate his handwriting. He had learned how to make illuminated manuscripts at evening classes and, although his job prevented him from practising his art except at weekends, he was rapidly becoming one of the foremost calligraphers of his time. He found his ordinary Civil Service handwriting pretty dull, and the incongruity of this writing, when compared with the formal beauty of his manuscripts, struck him forcibly. About 1922, he had noticed some sixteenth-century writing-books displayed at the Victoria and Albert Museum and had obtained a few photographs. He was impressed by the linking strokes of Tagliente's rather pointed style and by the more rounded models of the Spanish writer Lucas. He realised that both qualities could be amalgamated in a simple modern hand, which would meet all contemporary needs. He set to work devising exemplars and analysing methods of teaching them. He called his new handwriting 'italic'. In 1926, he offered notes to Robert Bridges on the principles of the design of his italic hand: these were published in facsimile in Tract No. XXVIII, *English Handwriting*, of the Society for Pure English. Then in 1932 came his *Handwriting Manual* with the associated writing-cards. The most comprehensive exposition of his system, however, is in the *Beacon Writing-Books* (1957–63).

Italic is now well-established as an effective solution to the problems of handwriting to-day. Many books have been written about it since the war. Concurrently a lively interest in the historic origins of the hand has grown up and, with it, a desire to know more about its methods and techniques. The writing-masters of the sixteenth century often included comments, or even essays of some length, on these subjects in their works. They are unfortunately not accessible to the average student partly because they are written in the Latin, or the Italian and

Spanish, of the Renaissance; and partly because the books themselves are extremely rare. There is, moreover, a tedious tradition that facsimiles and monographs in this field should be printed in small, bibliophile editions.

This book aims to admit a wider public to an insufficiently familiar facet of European culture by giving some description of the writing-masters and their works, together with an English translation of selected passages from their books. The descriptions[2] are intended wherever possible to play a quite subordinate role to the original texts, which should themselves tell the main story of the chancery hand in sixteenth-century Europe.

Every attempt has been made to keep the translations as accurate, clear and natural as is permitted by the subject matter, which is often technical, and the style of the authors, which is frequently clumsy or repetitive. It is evident that the writing-master's task of explaining his art to his readers was complicated by the absence of an accepted set of technical terms. As a result, although the general sense of a passage is for the most part plain enough, details are sometimes obscure: it would therefore be presumptuous to claim that the translations are totally devoid of inaccuracies. The texts, each of which is self-contained, have been chosen with the chancery hand—its development and decline—primarily in mind. They have not been abridged or digested. At first sight it may seem that there is some overlap in the material, but closer inspection will show that there are quite significant variations between the authors. Indeed a detailed comparison of the texts can be extraordinarily revealing.

The author hopes that this collection, which follows a more or less geographical and chronological sequence, will be found useful as a source-book for the historical study of handwriting and especially of the italic hand. It is not, of course, intended to be read through at a sitting, but rather to be used as a reference book, or perhaps dipped into at odd times.

Dr. Berthold Wolpe, R.D.I., has kindly contributed the chapter on Beauchesne. He has been carrying out research into the life and work of this writing-master for some years and plans to publish a book on him in due course.

ACKNOWLEDGEMENTS

The writer wishes to thank Mr. A. R. A. Croiset van Uchelen, the leading authority on Dutch writing-masters, for hospitality and a generous sharing of new information from his researches; to Thea Wheelwright for encouragement; and to Doris Busby for typing the manuscript. The illustration on page 172 is reproduced by courtesy of the Wing Foundation, Newberry Library, Chicago.

A. S. OSLEY

[2] Those of the Italian and Netherlands writing-masters unavoidably range over ground which I explored in *Mercator*, Faber & Faber, London, 1969, and *Luminario: An Introduction to Italian Writing-Books of the Sixteenth Century*, Miland Publishers, Nieuwkoop, 1972.

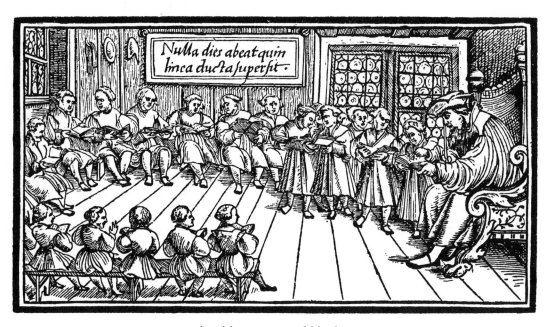

Nulla dies abeat quin
linea ducta superfit.

1. A writing-master and his class.
From Urban Wyss, *Libellus valde doctus*, Zürich, 1549.

CHAPTER ONE

The Background

At Florence, some time in the year 1480, the distinguished scribe Antonio Sinibaldi was filling in his tax return. He pleaded poverty. His copying work, he said, had slumped on account of the invention of printing, as a result of which he could hardly afford to clothe himself.[1] Many lesser scribes must also have felt the draught. The impact of the printed word on Europe was shattering in so many respects. Without it, the Reformation could hardly have come as rapidly. Ideas which had hitherto circulated in small coteries became common property. The texts of classical antiquity might now be studied by ever-increasing numbers. Religious controversy could be fanned by printed pamphlets cheaply produced. As Cardinal Wolsey wrote to Clement VII: 'Men begin to call in question the present faith and tenets of the Church; the laity read the Scriptures and pray in their vulgar tongue.' Knowledge of practical subjects such as medicine, navigation, economics, agriculture, engineering and mathematics was disseminated on an unprecedented scale. The actual amount of material to be read piled up prodigiously. Between 1440 and 1500, about 40,000 books were published: the total for the sixteenth century came to approximately 500,000. The irascible Luther grumbled 'The multitude of books is a great evil. There is no measure or limit to this form of writing.' Traditional curricula and methods of education also came under searching criticism.

Other forces were working in the same direction. The process, by which the European community of the Middle Ages faded away before the emerging forces of nationalism, was sharply accelerated. The apparatus of the modern state began to take shape. This gave rise to a vast increase in international diplomacy. Nationalism, moreover, strained the traditional authority of the Church. At the same time, exploration was changing the geographical perspective of European man, bringing trade and new wealth in its train; and this too induced questioning and doubts about many previously accepted ideas of the world. In short, the ferment of ideas which we conveniently cloak with such concepts as Humanism, the Reformation, the Renaissance and the New World, produced an explosion of activity—political, ecclesiastical, commercial and diplomatic.

Machinery had to be created to meet the new requirements. Historians agree that during the sixteenth century bureaucracy really began to flourish in Europe. The new offices had to be manned, and consequently a demand arose for secretaries who

[1] See Cecil H. Clough, 'A Signed MS. of Antonio Sinibaldi', *Journal of the Society for Italic Handwriting*, No. 78, Spring 1974, p. 6.

could speak more than one language, who could handle voluminous correspondence, who could write quickly and clearly when taking dictation, and who could draft documents at short notice. Such men could rise high in the State and Church even if of humble birth, although they might not all reach the eminence of a Cardinal Wolsey or Thomas Cromwell. Young men of good family could find satisfying careers in this line of business. But all these budding secretaries had to be trained, and the man who would play a leading role in this was the writing-master.

There had always been teachers of handwriting. Their status had never been very high. In antiquity such a person would frequently have been a slave. At the end of the fifteenth century and even more in the sixteenth, the writing-master—because of the social changes already sketched—rose in society. Ironically enough the printing press, which had depressed the status of the copyist of manuscripts, elevated that of the writing-master. A top-flight penman, if he were able to make his own blocks or to hire a capable engraver, could now publish his models, which might be used by other teachers not only in his own town but throughout the country. Printing also *preserved* a master's work for imitation, modification and (more probably) criticism by his successors. Thus a rather commonplace book (the *Thesauro de Scrittori* of Ugo da Carpi) was first published in 1525 and was still being used a quarter of a century later, after being reprinted at least eight times.

Even so, the exact status of the writing-master in sixteenth-century society is not easy to determine. Some of them (e.g. Sigismondo Fanti and Giovan Francesco Cresci) came of noble families. Others, like Amphiareo and Augustino da Siena, belonged to the Church but were not very far up in the hierarchy. In Spain, Andres Brun was advanced during his lifetime to a minor title in the aristocracy; Juan de Yciar and Francisco Lucas held appointments at the royal court, and so did Pierre Hamon in France. Giovannantonio Tagliente was a minor official in the Venetian civil service. Vicentino (Arrighi), his contemporary, had a varied career as a professional copyist, as a scriptor in the Vatican and as a master printer; this brought him into association with wealthy patrons and figures of distinction such as Machiavelli and Raphael, but always in a rather subordinate role. On the other hand, Giovambattista Palatino moved at ease on equal terms with the Roman upper crust of diplomats, literary men and church dignitaries. In Pedro Madariaga's book of 1587, *Libro subtilissimo*, we learn of a writing-master wealthy enough to have three cargo ships at sea. Madariaga, moreover, developed at length the thesis that handwriting was important to Spanish society and was an appropriate, if not essential, accomplishment for the hidalgo who, at that time, like many since, regarded it with contempt.[2] The world was, however, changing, and even the young aristocrat could no longer stand aside if he wished to do his king and country some service.

[2] Cf. George Eliot, *Middlemarch*, Ch. LVI: 'At that time the opinion existed that it was beneath a gentleman to write legibly, or with a hand in the least suitable to a clerk.' The action of the novel takes place in the 1830s.

We read, too, of the master Rocco Gieronomi, who in 1603 dedicated his manual to the Duke of Savoy; in return, the Duke not only rewarded him with a golden necklace worth 125 scudi but placed it over the master's shoulders with his own hands, 'an honour so great that I do not know what more a man with any human feelings could desire'.[3] The picture is an uneven one, but it is safe to assume that, in general, the status of the writing-master improved as the century went on, and that the improvement was maintained in the seventeenth century. Perhaps it would not be too fanciful to think of the writing-master as occupying a similar place, and performing a similar function, to that of a computer systems analyst or programmer to-day.

What kind of handwriting did these new writing masters teach? The earliest books seem to a newcomer to be a complete jumble of styles. Commercial and ecclesiastical hands, Roman inscriptional capitals geometrically constructed, alphabets of scroll-work, monograms, even Arabic and Hebrew alphabets, all jostle for the available space. Many of the models would have been useful to illuminators, copyists, goldsmiths, jewellers, etc., and some were intended simply as displays of virtuosity. But closer inspection shows that, outside Germany, it is normally the italic or chancery script that has pride of place. When, as we shall see later from the translated texts, the writing-master gave directions for handwriting, he concentrated his teaching almost exclusively on this style, leaving the student to pick up the remainder for himself. As the century progressed, and the manuals responded more and more to the actual needs of the day, the garden of styles was weeded. Eventually the writing-masters came down to two main scripts, an everyday cursive and a roman, with perhaps some formal lettering. Virtuosity showed itself rather in the twists and flourishes added (often in exquisitely bad taste) to the letters, in ornate borders and in pictures of ships, animals, vegetation, human figures, etc., each alleged to have been drawn by the master in a single stroke of the pen. 'Flourishing', as it was known, came to be regarded as a touchstone of skill, though some writing-masters considered it a confidence-trick played on a gullible public.

The origins of the italic or chancery hand go back to the Carolingian times. Charlemagne, though himself illiterate for much of his life, encouraged the monasteries to make fine copies of sacred and classical texts. Under his influence, a clear upright letter, not unlike our traditional lower-case roman type, was developed and widely used for a time. But as the Dark Ages got darker, this clear letter was gradually superseded by the gothic script. With the revival of learning in Italy in the fourteenth century, literary men and scholars, such as Petrarch and Boccaccio, sought out the forgotten texts of classical antiquity and copied what they found. They were entranced by the clarity of Carolingian manuscripts and adopted them as models for their own copying.

[3] A. M. Spelta, *Saggia Pazzia, Dilettevole Pazzia*, Padua, 1607, Ch. XIV.

Now any upright hand if written quickly and regularly will acquire a cursive quality; the round letters like 'o' tend to become oval, the writing slopes somewhat to the right, and, to assist speed, letters are joined together where convenient. When the revived Carolingian script was written with the appropriate instrument—a square-edged pen held at about 45 degrees—and subjected to these pressures, a neat, rapid hand, known as the humanistic cursive, evolved. It was of course so called because it was the style much used by the Humanists, especially for marginal notes and emendations. The hand was adapted for both formal and informal uses.

Certain conventions emerged, for example, that the height of the basic letters like *a*, *e*, *i*, *o*, and *n*, should be about five pen-widths, that the long strokes (up or down) used in letters like *b*, *d*, *g*, *h*, *q*, should be equal to the height of *a*, that the distance between letters should be the width of either the white space between the legs of an *n* or of the two legs combined (which was much the same), that the distance between words should be such that a letter *n* or *o* could be inserted between them, that capital letters should be upright and not quite so high as *b* or *d*, that certain letters should, or should not, be joined. The elementary mathematics involved was frequently known as 'geometry'; and this is normally what is meant when the masters claim that they are teaching handwriting according to geometry. This system was, so to speak, canonised when the papal chanceries adopted it, particularly for the copying of briefs, about the middle of the fifteenth century. It then became variously known as the chancery cursive (*cancellaresca corsiva*), the Italian hand, or the italic hand.

It is not to be supposed that all Renaissance handwriting was italic. Far from it. The great mass of commercial and personal correspondence continued to be conducted in one or other of the legal, mercantile or secretary hands derived from gothic script. The chancery cursive was a quality hand for the princes of the Church, the diplomats and the scholars. It was always associated with its classical origins, being regarded as the proper dress for material written in Latin, as both Erasmus and Mercator insisted. It was also felt to be appropriate for vernacular languages based on Latin, i.e. Italian and Spanish. So long as Latin remained the language of science, the chancery hand was often used in such contexts, e.g. the maps and scientific instruments of Mercator in the Netherlands and the manuscripts of Copernicus in Poland. For the most part, however, the chancery hand was not widely taught in Germany or Switzerland.[4] It had a somewhat greater vogue in France and England. Queen Elizabeth, for example, could write well in italic, as could her favourite astrologer John Dee. Most of the writing-masters who advocated the chancery hand, however, were Italian or Spanish.

[4] The two masters who did so, however, are Caspar Neff of Cologne (see p. 215 below) and Urban Wyss. The latter's *Libellus valde doctus* (Zürich, 1549) contains a selection of italic models. But they are heavy and coarse, and rely heavily on Mercator's *Literarum Latinarum* of 1540. Lest it be thought that Wyss has been too summarily excluded from consideration, we have reproduced an illustration from his book on p. 16.

The writing-books began to appear when the chancery hand was fully mature. They are the culmination, not the beginning of a tradition. One might, however, have expected them to have come earlier in the history of the printed book. After all, the first italic *type* was designed and cut in 1500, but the first writing-book with italic models was not published until over twenty years later. The reason is almost certainly a technical one. The models in the books were reproduced from wooden blocks, and the immensely skilled art of cutting cursive script so faithfully that, when printed, it would retain the freedom and naturalness of handwriting, had yet to be learned. The chancery hand was extraordinarily difficult to cut. The first printed writing-book, the *Theorica et Pratica* of Sigismondo Fanti (1514), while containing examples of large letters, actually leaves blank spaces for the chancery models. The success of a writing-book turned on the skill of the engraver, though writing-masters rarely acknowledged the debt, preferring to complain that the printed book could never capture the excellence of their own hands. A Spanish master, Juan de la Cuesta, deliberately showed only two or three examples of writing models in his book, arguing that the engraver, not the master, would receive all the credit. Probably the real reason was that he could not find or afford a good engraver.[5]

Another technical change occurred around 1560. Owing to improvements in the rolling-mill, copper plates suitable for the engraving of handwritten scripts were more easily to be had. Although good formal italic continued to be embodied in this new process of reproduction, e.g. on maps, frontispieces and book illustrations, the effect on handwriting was on the whole bad. Many writing-masters now aimed to capture with the pen the effects of the engraver's burin; exaggerated flourishes and excessive contrasts of thick and thin lines presented an irresistible temptation. The pen itself became narrower and softer and was held in a different way. These changes do not form part of our survey, except insofar as they hastened the demise of the classic chancery hand (already being criticised by a new generation as 'slow and angular') and opened the way to the copperplate style.

It may be helpful to round off this brief survey by explaining some of the terms found in the writing-books. The absence of an accepted nomenclature was a stumbling-block for most masters. If technical terms had existed, a great deal of long-winded and obscure explanation might have been avoided. Only Mercator, in whom a trained scientific mind was linked to the hand of a skilled craftsman, really overcame the obstacles.[6] Briefly, the writing-masters thought of writing as falling within groups of four imaginary parallel lines. Juan de la Cuesta even left the lines in his models. The usual practice was either to place a sheet, ruled in ink with parallel lines, under the writing paper so that it showed through (the so-called 'false rule') or to mark the top sheet with blind lines. The latter was done either with a lead stylus, the two points of a pair of dividers or a fork with two or more prongs; in Spain it was the custom to set guitar strings in a smooth block of wood and to rub the paper over

[5] See p. 173 below. [6] See p. 190 *et seq.* below.

the projecting parallel wires. The master often ruled the lines for the whole class, which could consist of up to 30 boys.

The inner pair of lines were the 'lines of writing'; the part of the letter which was written between them, e.g. the bowl of *b* and the whole of *a* or *c*, was called 'the body'. Outer lines marked the boundaries of the long downward strokes, which either came down from above ('ascenders') as with *b* and *d*, or went below ('descenders') as with *g* and *q*. The vertical[7] strokes of such letters as *m* and *n* were called the 'legs'. Special terms were also required, and variously invented, for the diagonal strokes that begin and finish letters like *i* or *n*. Sometimes they were called 'beginning'- or 'finishing'-strokes. The most convenient, though not entirely accurate, term in English is probably 'serif'. Letters with ascenders, e.g. *b*, *d*, *f*, were usually begun at the top with an in-and-out movement which thickened the tip slightly: this was sometimes referred to as the 'head' of the letter. Conversely, the curved end of a descender was named the 'tail'.

No special terminology was developed for the capital letters. Here, by common consent, the discipline imposed by the conventions which regulated the writing of minuscules was relaxed in favour of personal expression. Writing masters usually took this opportunity to display their individual skill, verve and invention. Thus we find a pleasing contrast between the regularity of the text and the freedom of the capital letters. The price was that writing masters could not, perhaps would not, give detailed rules for the construction of majuscules. They did not go further than to recommend the use of bold, confident strokes and a careful adherence to the models provided in their books.

To conclude: if on occasion, particularly when discussing Tagliente, Vicentino and Palatino, I appear to pass summary judgements, this is because I have striven to make my commentaries on the writing-masters as concise as possible, in order to allow sufficient space and prominence for their texts and, at the same time, to keep the book within reasonable compass. Any reader who wishes to explore further will find more detailed accounts of my views, with supporting evidence, in my *Luminario: An Introduction to the Italian Writing-Books of the 16th and 17th Centuries*, Miland Publishers, Nieuwkoop, Holland, 1972.

[7] Here, and elsewhere when convenient, I have used the term 'vertical' a little loosely to embrace both the true perpendicular and the slight off-perpendicular lines of the sloping italic hand.

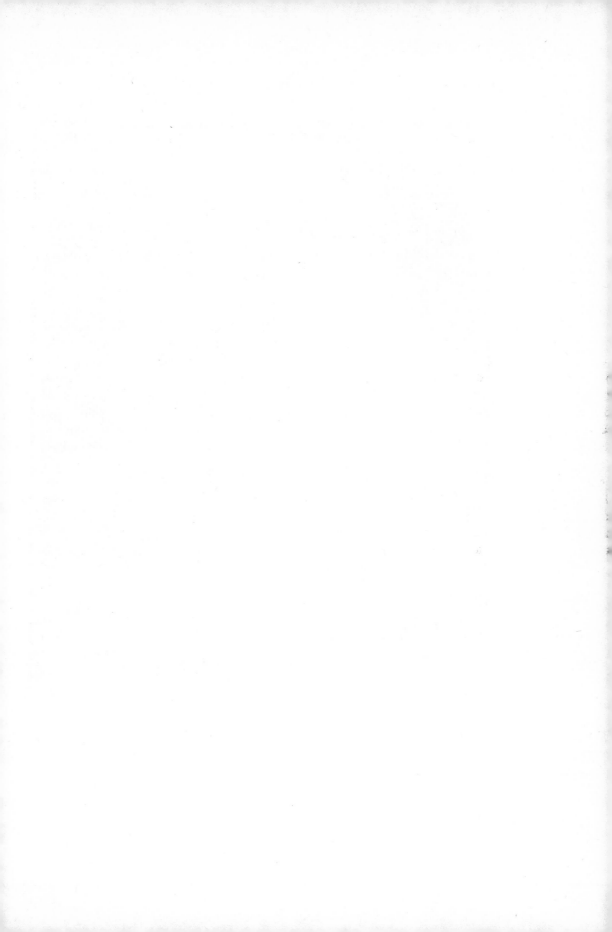

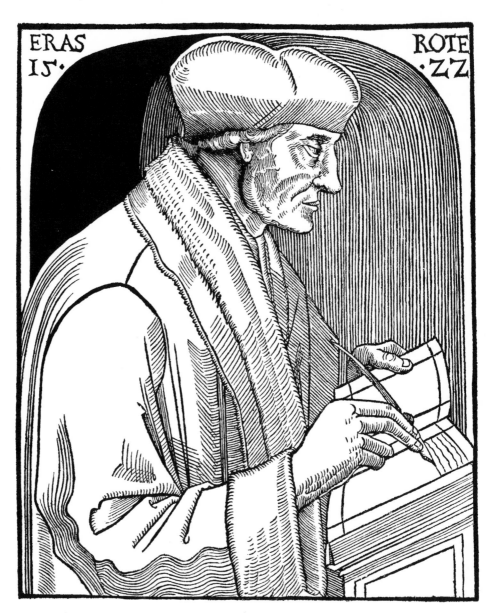

2. Portrait of Erasmus.
From an anonymous woodcut, Basel, 1522.

CHAPTER TWO

Humanists on Handwriting: Erasmus and Vives

I

ERASMUS

Before we come to the writing-masters, it will be instructive to consider three texts which show handwriting in a wider social setting. They are by Desiderius Erasmus (1466–1536) and Juan Vives (1492–1540) respectively. These two men, with Guillaume Budé (1468–1540), are usually considered to be the outstanding figures of Renaissance Humanism. This is not, however, the place to discuss that movement in any detail. Suffice it to say that Erasmus and Vives were scholars of European stature, distinguished for their learning, the breadth and variety of their ideas, their hatred of intolerance, bigotry and violence, and their belief in the ultimate rationality of man. Both advocated that children should receive a more enlightened style of education than the dry scholastic system inherited from the Middle Ages and that schoolmasters, instead of beating knowledge into their pupils, should apply reason and understanding. These ideas, which were shared with other Humanists of the time, such as Colet, More and Ascham, can be traced back to Quintilian, the Roman teacher of public speaking who flourished in the second half of the first century A.D.

Let us pause for a brief glance at the kind of educational theory advocated by Quintilian, since it formed a vital part of sixteenth-century thought.[1] We catch the note immediately from such passages as the following: 'Learning for the young child should be a form of play. Ask him questions, praise him, let him rejoice from time to time that he has done well. If he refuses to learn, teach another child instead so as to make him jealous. Let him occasionally compete with other boys, and let him think that he has succeeded more often than not.' Or in this metaphor, often revived

[1] The passages which follow will be found in the first book of Quintilian, *Institutio Oratoria*. 'Every educator of the Revival, whether man of theory or man of practice, whether on Italian or Teutonic soil, Aeneas Sylvius or Patrizi, Agricola, Erasmus, Melanchthon, or Elyot, steeped himself in the text and in the spirit of this treatise.' W. H. Woodward, *Studies in Education . . . 1400–1600*, Cambridge, 1924.

by Renaissance educators: 'Just as jars with narrow mouths reject liquids if one tries to pour too much in at once but are easily filled if the liquid is admitted gradually, or even drop by drop, so it is necessary to pay regard to how much a child's mind can assimilate; for things that are beyond his grasp will not enter his mind, because it has not opened out sufficiently to take them in.'

Quintilian suggests that, when the child is learning to write, he should 'first of all learn the individual letter-shapes. For this purpose, it is a good idea to give him ivory letters to play with. As soon as he begins to recognise the letters, it will be helpful to have them engraved as accurately as possible on a smooth piece of board so that his stylus-pen can be guided along the grooves. He will thus not make the mistakes that you get with a wax tablet, since the pen is confined between the sides of the letters and unable to wander from its proper course. By tracing these fixed outlines with increasing speed and frequency, he will strengthen his fingers and he will not need to be helped by having the teacher's hand placed over his own.

'The art of writing well and rapidly is not an irrelevant matter, although it is apt to be neglected by persons of quality. Writing plays a fundamental part in education. It is only with this that real, well grounded progress can be made. If handwriting is slow, it holds up the train of our thoughts; if ill-formed and confused, it cannot be deciphered, and this leads to another chore—dictating to a secretary. So it will at all times and in all places be a source of pleasure not to have neglected handwriting, but most of all when writing personal letters to friends.'

Again: 'Pupils should love their teachers no less than their studies; they should look upon them as the parents not of their bodies but of their minds. This attitude of respect will contribute much to the progress of their work; for, with its assistance, they will gladly listen to their teachers, will believe what they are told, and will strive to imitate them. They will come to school with cheerful alacrity. They will not resent correction and will be gladdened by praise. And they will study hard so as to win the affection of their teacher.' No Blackboard Jungle here!

We can see these concepts at work in the two immediately following texts, each of which is written in the form of a dialogue, a device for discussing ideas that goes back to Plato; the language used is Latin. The first comes from a dialogue, in the March 1522 Basel edition of the constantly revised *Colloquia Familiaria* of Erasmus, in which he imagines a short conversation between two schoolboys, the elder of whom is helping a friend with his writing. Slight though it is, it makes a suitable curtain-raiser for our collection because it may be the earliest printed passage about handwriting in schools.

Erasmus treated the subject with greater care in a work on the correct pronunciation of Greek and Latin (*De recta Graeci et Latini sermonis pronunciatione*), published in Basel in 1528 and dedicated to the Emperor Maximilian. As this second text reflects the author's considered views, we have not hesitated to give the translation the title 'Erasmus on Handwriting'. Spelling, pronunciation and

handwriting formed an interrelated group of subjects, and a schoolmaster was expected to teach them all. Thus it is natural to find a full treatment of handwriting in such a book.

Erasmus introduces us to some contemporary themes—the ruin of handwriting when students are obliged to take down so many notes, the cult of illegibility by people who ought to know better, the impairment of personal communication that results from dependence on secretaries. He considers that boys should be taught at an early age to write quickly and well. Correct handwriting leads to rapid handwriting. The models to be preferred are those of Italy, not those of Germany and France. Like Mercator twelve years later, he believed that, both in handwriting and in printing, the gothic styles were inappropriate for texts written in Latin. The points to be looked for in good handwriting are the shaping of letters, the way they are joined, their linear arrangement, and their proportion (i.e. mathematical relationship). These canons of excellence will be encountered more than once in our survey.

The dialogue also touches on teaching aids then in common use, some of which have already been mentioned and will come to notice again: tablets inscribed with letters and words, which the pupil follows by placing a stylus in the grooves; exemplars inserted for tracing under the writing-sheet; letters scored with a stylus on a piece of paper, which the student runs over with pen and ink; alphabets written in a light-coloured ink, which the boy then covers with black ink; and line-rulers made by fixing parallel wires on a block. Erasmus also refers to the experiments which his friend Dürer, who (like other misguided spirits of the age) searched for formulae by which Roman inscriptional capitals could be mechanically constructed on geometrical principles with compasses and straight-edge and who published his findings in the *Underweysung der Messung mit dem Zirckel und Richtscheyt*. Dürer, by the way, had drawn Erasmus' hand in 1523. The drawing, which has often been reproduced, gives a very clear impression of how the humanist held his pen.

Although he was not a professional writing-master, Erasmus provides us with a convenient account in popular terms of current ideas about the teaching of handwriting.

CORNELIUS
HELPS ANDREAS TO WRITE

CORNELIUS: You certainly write well, but your paper leaks. The paper is a bit damp and lets the ink through.

ANDREAS: Please get this pen ready for me.

CORNELIUS: I don't have my pen-knife with me.

ANDREAS: Here is one.

CORNELIUS: Goodness, how blunt it is!

ANDREAS: Here, take my whetstone.

CORNELIUS (*trimming the quill*): Do you like to write with a rather hard or a soft nib?

ANDREAS: Trim it as you would for your hand.

CORNELIUS: I write with a somewhat softer point.

ANDREAS: Please write the letters of the alphabet down for me in order.

CORNELIUS: Greek or Latin?

ANDREAS: The Latin letters first. Then I'll try to copy them.

CORNELIUS: Give me some paper.

ANDREAS: There you are.

CORNELIUS: But my ink is too thin; it has been watered down too often.

ANDREAS: While my piece of rag has dried out completely.[2]

CORNELIUS: Well, blow your nose in it or, if you prefer, piss on it.

ANDREAS: I'd sooner borrow some ink from some-one.

CORNELIUS (*sententiously*): It's better to have it at home rather than to ask for a loan.

ANDREAS: Yes, for what is a scholar without his pen and ink?

CORNELIUS: Like a soldier without his shield and spear.

ANDREAS: I wish my fingers were more nimble. I really cannot write fast enough to take down the words of the master when he dictates.

CORNELIUS: Your first aim must be to write well; *then* to write quickly. Well-written is quick enough.

ANDREAS: Fine, but sing that song 'Well-written is quick enough' to the master as he dictates.

From the dialogue 'Euntes in ludum' in Erasmus, *Colloquia Familiaria*, Basel, 1522.

[2] A piece of cloth was used as a stopper for the ink-horn to prevent spillage. Usually it would soak up some ink and, if the ink-horn ran dry, a few drops of ink might be squeezed from the cloth. A secretary, carrying his ink-horn and stopper, is shown on the cartouche of a map of Venice in Braun and Hogenberg, *Civitates orbis terrarum*, 1573.

ERASMUS
ON HANDWRITING

An extract translated from his Latin dialogue
De recta Graeci et Latini sermonis pronunciatione

The characters in the dialogue are Ursus (Bear) and Leo (Lion).

URSUS: But please explain why, Leo, you are so concerned that your lion-cub should be able to read easily and to write with some skill.

LEO: Because I see that this too is something to which Fabius attached special importance and because it is possible to learn both simultaneously. One helps the other along. For bad handwriting is attended by the same drawbacks as incorrect pronunciation. Write out a speech of Cicero's in Gothic script, and you will say it is outlandish and barbarous. It either loses its elegance when so written, or the reader completely rejects it or is utterly worn out. The consequence is that you neither instruct your reader because he cannot understand you, nor please him because he finds it hard to read, nor convince him because he is exhausted with fatigue. And you know how irritable some people are, especially if you are writing to them when they are busy or on a subject that is in itself rather disagreeable to the reader. Who can listen for long to a stuttering speaker, whose discourse you scarcely follow? On the other hand, you would hardly believe how much your material can be set off to advantage by elegant, clear and legible writing when the Latin words are represented in the Latin script.

In former times pupils at school had to take down so much long-hand that boys wrote rapidly but with difficulty, constantly on the look-out for symbols and for abbreviations to save time. Nowadays the art of printing has led to the situation that some scholars do not write down anything at all! For, if they decide to commit any of their lucubrations to paper, they write so beautifully that they themselves cannot read what they have written and require a secretary to read it and decipher what they cannot decipher themselves.

Furthermore, in their correspondence many of them follow the example of princes and invoke the assistance of secretaries. But how do they manage with confidential letters, which even kings have to deal with from time to time? Not to mention how much a hand that is recognized contributes either to confidence or pleasure as the case may be. It is significant that the apostle Paul penned his letter to the Galatians entirely in his own hand. And who would not respect a king who dispatches a letter that he himself has written? How warmly we respond whenever we receive from friends or scholars letters written in their own hands! We feel as if we were listening to them and seeing them face to face.

To be brief: a letter that is a product of someone else's fingers hardly deserves the name. For secretaries import a great deal of their own. If you dictate verbatim, then it is goodbye to your privacy; and so you disguise some things and suppress others in order to avoid having an unwanted confidant. Hence, quite apart from the problem of the genuineness of the text, no open conversation with a friend is possible here. It is very easy to forge a signature but very difficult to forge a complete letter. A man's handwriting, like his voice, has a special, individual quality.

URSUS: I confess that what you say is remarkable, and very true as well.

LEO: Do you suppose that it doesn't matter whether a man communicates his thoughts to you with his own lips or entrusts them to an intermediary?

URSUS: In my opinion it matters a great deal.

LEO: Your agent may lie, omit things and report his instructions differently from the way in which he received them: finally, even if he reports everything in good faith, he still cannot reproduce the force of a glance, an expression, a look or a voice.

URSUS: You've convinced me that it is very important for a boy to learn at an early stage to write as well as possible, not only for the weighty reasons that you have urged but also because a boy who has learned to write properly writes with greater ease and freedom. For an elegant script is like a fine picture; it has a pleasure of its own which engages the author of a letter while he is composing it no less than the recipient when he is studying it. And both these sayings are very true, namely that correct writing leads us to rapid writing, and that it isn't by writing a lot that we come to write well.

LEO: So it remains for us to examine by what methods a boy can learn to write both quickly and well.

URSUS: This problem has been worrying me for some time now. I should like one or two of my many bear-cubs brought up in such a way that they can be taken for children of human parentage!

LEO: Then tell me if you have any ideas.

URSUS: I've none of my own but, if you like, I will disclose to you what I have learned from others, such as it is, and on condition that you in turn do not hold back any better ideas of your own.

LEO: I promise.

URSUS: I recently attended a dinner of schoolmasters — I believe that more than a dozen of them were there. You could say that it was not only a good but a full house. It was there that they discussed matters of this kind.

LEO: And was there much agreement among them?

URSUS: To the extent that I would have regarded it as a success if this assembly had broken up without bloodshed! I never saw a hotter argument on so unexciting a subject. A long dispute went on about how many parts of speech there are, some increasing them from eight to fifteen, and others reducing them to five, and others to a single pair. In most struggles, however bitter they are, nightfall usually puts an

end to the fighting; but these people argued strenuously from early evening to dawn. I do not remember it all, though I will, if you wish, tell you as much as I recall.

LEO: You would give me much pleasure.

URSUS: I will begin from the wrong end. For speaking comes first, then reading and thirdly writing, which I will deal with first.

LEO: It doesn't matter at all.

URSUS: They said that we should take special care to put before the pupil right from the start the most perfect possible model for him to reproduce. There is no reason why it should not be easy for him to copy it. For common scribes with their curves, joins, tails and similar frivolous strokes, in which they revel out of a kind of pride, make writing more difficult without any compensating advantage whatever. For surely you see how in bygone times the gothic hand was harder to learn than the Latin and how nowadays the French and German hands more difficult than the Italian.

LEO: But the Greeks achieved a cursive style, at least in their minuscules.

URSUS: They succeeded in this as in everything else. But I wish that they had not attempted it; I would much prefer the script not to be disfigured with a mass of marks of abbreviation.

LEO: But even the ancient Romans used marks of this kind. The grammarian Probus has actually left a book on the subject.

URSUS: Agreed; they used them, however, only in a few expressions for numbers, weights, measures and for other things which occur repeatedly in our speech. And even this compression has caused scholars to waste a lot of time. For since shorthand-writers are prone to error, abbreviations of this kind cannot easily be restored. The same thing happens with mathematicians who use basic letter-forms to describe the proofs of their propositions.

LEO: Do go ahead.

URSUS: Well, first the individual shapes of the elements of the letters, minuscules and majuscules, are to be copied.

LEO: Some, in teaching the basic elements, affect an outmoded antiquity, drawn, so to speak, from the Twelve Tables or something even older.

URSUS: These people behave as ridiculously as those who delight in using obsolete words as though they were talking to primitive aborigines or the mother of Evander.

LEO: Yet, if you go back to the Assyrians and Phoenicians and to Cadmus, you will find that neither the shapes nor the sounds are the same. And there are people who affect a peculiar script of their own, writing Latin in such a way that it might well look like Greek to an unpractised eye.

URSUS: The people you describe should be scorned, not imitated, unless you like authors such as Apuleius and Sidonius or, to quote a more recent example, Baptista Pius, who, although there are generally accepted, splendid, and appropriate words to

hand, prefer to speak a private language with neologisms that they have impudently invented as if nothing in common usage can have any distinction.

LEO: But what sort of models for handwriting do you particularly commend?

URSUS: The most perfect example of majuscules is on coins struck at the time of Augustus and in the immediately succeeding centuries, especially in Italy: in the provinces the craftsmen owing to lack of experience fell short. For minuscules, Italy everywhere provides the models, except that we should select those that are simplest and do not differ too markedly from the majuscules. So much, then, for the recommended ancient models.

LEO: On what is the elegance of letters primarily based?

URSUS: On four things: their shape, the way they are joined, their linear arrangement, and their proportion.

LEO: Is it enough merely to show the pupil the finished form of the letter?

URSUS: No. It will help him if you both show him how the elements are formed and also indicate to him how one element is related to another.

LEO: Please tell me more clearly what you are advocating.

URSUS: Leo, it would take me too long to discuss each detail, so I'll give you an example from which you will be able to deduce the remainder.

LEO: I'm listening!

URSUS: The majuscule Alpha is made with the same shape in both Greek and Latin. Its left stroke is a little narrower, being formed with the edge of the pen and coming down from the top of the base of the letter: the right-hand stroke is broader and is constructed with the full width of the pen. So, too, with the bar across the middle, which is added apparently to distinguish this letter from the Greek Lambda (Λ). When matters are explained to him in this way, a boy will find it easier to copy than if you just show him the finished shape of the letter.

LEO: You are absolutely right.

URSUS: The minuscule Alpha is written in various ways but the simplest is to draw an oval *o*, with the upper curve projecting a little to the right like a hunchback; and then, starting from the top, with your pen bending round nicely in a curve, add a smooth semi-circle that turns up a little at the bottom. Again, if you want to make the minuscule *b*, first draw a straight stroke descending from above the line, then join to it a semi-circle like a *c* backwards. If you leave a gap at the bottom, the letter will become the aspirate *h*. And if you join a broken line to this same down-stroke, the result will be a *k*. Furthermore, if you let this down-stroke project below the line of writing and add a reversed *c* on the right-hand side, the letter will be a *p*; and if you add a *c* on the left, it will become *g*. But if you leave the downstroke sticking up above the line without adding anything, it will be *l*, the only difference from capital *I* being a slight curve at the bottom.

LEO: Enough. I now have a sample from which I can deduce the rest.

URSUS: That leaves various other symbols, for example, accents, the number of

which is greater for the minuscules in Greek. Then the abbreviation marks, which have more to do with ease of reading than with correct writing. But simplicity is the keynote in the first stages.

After these points have been mastered, there follow the joins; for it is important to know which letter should be linked to another. Some of them cannot bear to be joined, others enjoy being close together, and others embrace one another tightly. For example, *p* and *o* shrink from contact; *f*, *g* and *t* and perhaps some others like to be regularly tied to certain letters just as a vile crime always brings disgrace with it. But not even these can be linked indiscriminately to any other. In making their minuscules, the Greeks used great freedom, running some of them together in a row. The same thing has been tried with the majuscules, though only sparingly by the Greeks, except for the designation of numerals as, for example, when they want to indicate the number 50, they enclose a small Delta with a Pi. Many Romans have attempted it without success. So it will help a budding scribe to see the various forms not only as written but in the process of being written.

LEO: I am pleased to have your advice on these points, however trifling they may be.

URSUS: Next they discussed the linear arrangement, by which the words should run between parallel lines so that the writing is not scattered about like the Sybil's leaves and the letters, to quote a joke of Plautus, do not 'clamber over each other'. Nothing is uglier than this unevenness.

LEO: Yet this is just how my wife writes!

URSUS: A great deal of the art depends on correct proportion. This is founded partly upon the elements of the letter-shapes, partly upon the ascenders and descenders, and partly upon the spacing.

LEO: I don't quite follow.

URSUS: Then I'll give you an example of what I mean. The majuscule A is constructed from three lines. Therefore, in the interests of symmetry, the cross-bar should be equidistant from top and bottom. Again, some idea must be given of the distance between the foot of the left-hand down-stroke and that of the right. Imagine an equilateral triangle, take away the base, shorten it a little, move it up to the centre, and you have the letter A.

LEO: I understand.

URSUS: Again, take B. To a perpendicular line, like a column, are joined two curved lines, which resemble bellies, but with unequal swelling; if a proper symmetry is lacking here, then the letter is defective.

LEO: Quite so.

URSUS: The same principle applies to ascenders and to descenders (*l*, for instance, has an ascender and *p* a descender); they ascend or descend the same distance as the height of the main writing-line. The letter *c*, for example, fills the space of the line of writing, but when you add a down-stroke to it to form a *q*, that

stroke should be double the height or a little more. Here I am not covering the whole of the art but simply citing an example.

LEO: It is sufficient for me.

URSUS: Now let us consider two sorts of spacing. One divides line from line; the other, the letter from letter. I will, if you like, add a third category, that which divides words, phrases, clauses, and sentences from each other, together with the appropriate punctuation marks. Just as the principle of symmetry, when properly applied, makes a great improvement in the appearance of script, so you would hardly credit how much good punctuation contributes to the understanding of a passage; so much so that a certain scholar said rather wittily that punctuation was a 'kind of commentary on the text'. It is useful, therefore, that a boy should quickly familiarise himself with this feature also, and that the habit should become second nature so that, even when his mind is on something else, he should, as he writes, attend to the punctuation marks as much as to the letters themselves.

LEO: I have heard that the ancients did not separate their words by spaces but ran on the lines in an unbroken chain.

URSUS: I agree. The Hebrews never used to add vowel signs to their letters nor, I believe, the Greeks the accents to theirs. But we are so mean nowadays that if anything better is discovered by men in more recent times, we are reluctant to accept it. Care in these matters has the advantage that a text when correctly ordered with vowel signs, punctuation and spacing is less susceptible to corruption.

LEO: But it seems clear the ancients used vowel marks.

URSUS: How do you deduce that?

LEO: Because of the story they tell of Cadmus being the first to import the art of writing from the Phoenicians. The matter is symbolised in the fable which depicts him sowing the teeth of a dead snake in the ground; from this seed there suddenly leapt up two lines of men, armed with helmets and spears, who destroyed themselves by dealing each other mortal wounds. But I wonder what this fable has to do with letters.

URSUS: I will tell you, if it will not bore you.

LEO: I should like you to very much, if it is not putting you to great trouble.

URSUS: Have you ever looked at a snake's mouth?

LEO: No, and I don't wish to either.

URSUS: But I mean a dead snake.

LEO: Not even a dead one!

URSUS: A more timid lion than you, Leo, has never been known. Anyway, if you do look at one and you count the upper and lower teeth, you will find that they are equal in their number to the letters introduced by Cadmus.

LEO: How many?

URSUS: Sixteen, unless I am mistaken. At first the letters are at peace, being set in the alphabetical order in which they were born; then they are scattered, sown,

multiplied in number and, when marshalled in various ways, come alive, burst into activity, fight. And, if you do not believe this, look at the destruction which men of letters inflict on each other today.

LEO: What you say is truer than truth.

URSUS: What is handwriting but silent speech, similar to the conversation which dumb people carry on by signs and nods?

LEO: That is precisely what it is.

URSUS: And the sons of the grammarians state that the Latin word for speech (*sermo*) comes from the word for sowing (*serendo*). Here you have the allegorical meaning of Cadmus the Sower. Now I will remove a scruple that I fancy may be bothering you. You imagine that the signs which mark the accents and breathings are symbolised by the armed men's spears and helmets.

LEO: Your guess is right.

URSUS: It is rather the ascenders of the letters that look like these objects; if you examine the matter more closely, you will see there not only lancers and light-armed troops but also mailed soldiers equipped with shields, swords and engines for hurling stones. The Hebrew letters present a better image of this sort of thing; some scholars reasonably believe that our letters and letter-shapes derive from them.

LEO: Believe me. I was all ears as you related this fable. But please deal with a further question: how should a boy get used to recognising the letters?

URSUS: I will speak about recognising the shapes of the letters in a moment. For we are proceeding, as was said, back to front. In order to depict each individual letter, an exemplar is the first requirement; then the way the lines are made should be demonstrated; and then the hand of the teacher should be placed over the pupil's, guiding and directing it. Fabius has described another aid to learning, i.e. that ivory tablets should be skilfully engraved, first with individual letters, then with syllables and words, and then with a few sentences. The boy should then accustom himself to moving a stylus in the grooves until—as the philosophers tell us—the action frequently repeated generates a habit. For we know that in some cases even blind people have readily acquired the ability to write with this method. By this means he will neither diverge from the straight line nor err in the harmonious proportion of his letters. In former days men wrote on wax tablets. But now that we use reed or quill pens and write on paper or vellum, another way of writing is required.

LEO: In antiquity they also wrote on leaves, blocks of wood, or pieces of linen, whiteleaded or prepared with some other thin surface.

URSUS: And today there are some who write with a bronze or silver stylus on plates smeared with dust. But first-class craftsmen will devise various means of assisting their pupil's efforts. One is to put the finished model under a piece of transparent vellum, on which the boy should move his pen, tracing the lines underneath. Another is for someone with experience in writing with a silver or with a bronze stylus to engrave blind letter-shapes on the paper; then the boy should follow

these same outlines with a reed or quill dipped in ink. The same purpose will be served by writing letters tinted to a light blue colour with vegetable dye, which the boy should cover with ink. The outlines of the letters written first will show him how far he has strayed from the model. Some employ blocks on which they glue threads or strings, and these leave an impression of straight lines when the paper is placed over them. This device does not contribute much to the appearance of the letter-shapes, but it is of great help in keeping the line of the writing straight and in preserving the harmony of the ascenders and descenders. This can be most easily achieved if each line of writing is marked out by four equidistant parallels, the body of the letters falling between the two middle ones; ascenders and descenders will be kept within due limits by the outer pair. It will be possible by the same means to separate the lines of writing by equal spaces. But, although it is helpful to train a boy with these aids, it will not be good for him to become dependent on them. When he has made some progress, he must, so to speak, get used to swimming without his cork belt and not permanently need to be guided by lines.

LEO: I reckon you've taught me enough about writing!

URSUS: Only one more point. Boys should be so taught this subject that they feel they are playing, not studying. For some masters teach writing with such severity that the pupils learn to hate letters before they can make them. It will, therefore, be useful to give them occasional training in drawing. Many are attracted spontaneously to this art because they delight to express what they recognise and to recognise what others have expressed. Just as trained musicians have a superior enunciation even when they are not singing, so a man whose fingers are trained to draw lines of every shape will construct letters with greater ease and felicity. But, if you want more refined and exact teaching about this, there is the book of Albrecht Dürer, written in German but with immense learning. In it he follows the ancient worthies of the art—the Macedonian Pamphilus, well schooled in all sides of literature as well as geometry and arithmetic (for he stated that the art of lettering is not complete without these disciplines) and also Apelles, who himself corresponded with his disciple Perseus about his art—and presents clearly many facts about the mysteries of drawing derived from mathematical principles, including several that are concerned with the basic elements of the letters, their construction and their proportions.

LEO: I have long known the name of Dürer, a painter of the front rank. Some call him 'the Apelles of our time'.

URSUS: I for my part believe that, if Apelles—open and sincere man that he was—were alive today, he'd concede the palm of victory to our friend Albrecht Dürer.

From Erasmus, *De recta Graeci et Latini sermonis pronunciatione.*

II

VIVES

Juan Vives was born at Valencia in 1492. A brilliant scholar, he studied at Paris, and in 1519 was appointed professor of humanities at Louvain, where he became friends with Erasmus. Another colleague was the Dutchman who in 1521 was elected as Pope Adrian VI, and may unwittingly have provided an impulse for the Vatican scribe Vicentino degli Arrighi to compose his celebrated treatise on handwriting, *La Operina*.[3] Vives' work was admired in England by Sir Thomas More and Cardinal Wolsey. It was probably by their interest that he was invited to lecture at Corpus Christi, Oxford. He left Louvain in 1523, just seven years before Mercator enrolled as a student in that university.

In England, he enjoyed the favour of the Court. Of his rooms near the Tower of London, he wrote: 'I have a narrow den for a sleeping-place, and in it no chair or table. Other people have their quarters around it: and there is so much noise going on all the time that it is impossible to settle one's mind to anything.' He supervised the education of the Princess Mary. He also acted as adviser to her mother, Catherine of Aragon (who, incidentally, herself wrote a very clear hand) when she was being pressed to give Henry VIII a divorce. This cost him his favoured position in the King's household, so that he felt it prudent to return to Bruges, where he spent the rest of his life. He died in 1540, the year in which the young Mercator brought out his manual of the italic hand.

Vives was a deeper thinker than Erasmus. He was an early student of the psychology of education. He argued that the senses are our first teacher. Each child therefore has his own vision, and the curriculum should be tailored to his needs. The true method of learning is not deductive (i.e. inferring particular instances from a general rule) but inductive (i.e. eliciting general rules from particular instances). The foundations of writing need to be laid while pupils are being taught to read; they should use notebooks since the act of writing fixes ideas in the mind. Children who don't want to learn should simply be sent home.

Vives was conscious of living in a time of transition. 'I see that a fundamental change is coming. In every nation, men are springing up with clear, fine, free intellects, impatient of servitude, determined to cast the yoke of tyranny from their necks. They are calling their fellow citizens to liberty.' It was, no doubt, this social awareness which directed his attention to the problems of poor relief and to reach conclusions that were well in advance of those of his contemporaries; he urged that the poor, the blind, the deaf should be assisted by properly co-ordinated charity, and should not be shrugged off by an indifferent society.

[3] See p. 72 below.

Among his educational works, which include an enlightened essay on the education of women, there is a set of dialogues (*Linguae Latinae Exercitatio*, 1538), written in simple Latin, for the use of boys. Each covers some aspect of school life. The ninth dialogue is concerned with handwriting. The characters are two Spanish boys, Manricus and Mendoza, who obviously belong to noble families, and a writing-master. The latter criticises the aristocrats for their contempt of good handwriting and argues that the ability to write well is a suitable and necessary accomplishment for the nobility. Later Spanish masters—Madariaga for example— developed this idea with some passion.[4]

Vives' writing-master then tells the boys about the tools of handwriting, how to cut the quill, prepare ink and select paper. He gives them models to copy and criticises the result—uneven letters, uneven pressure of the pen, ugly erasures, etc. At the end of it all, he has obviously inspired the boys, in spite of the high-born misgivings with which they started, with an enthusiasm for handwriting. This charming interlude, even if slightly idealised, vividly depicts the way in which a writing-master went about his business.

[4] See pp. 153–6 below.

TWO NOBLE SPANISH YOUTHS
LEARN TO WRITE

MANRICUS: Were you there today when he [*the writing-master*] gave a lecture on the advantages of handwriting?
MENDOZA: Where was it?
MANRICUS: In the lecture-room of Antonio de Nebrijo.[5]
MENDOZA: No, I wasn't. But do recount whatever you can remember.
MANRICUS: How can I? He said so much that I have forgotten pretty well all of it.
MENDOZA: Then you're just like those jars with a narrow neck, which Quintilian mentions. If you flood them with water they won't take it; but if you pour it in drop by drop, they accept it. But do you really recall nothing at all?
MANRICUS: Practically nothing. MENDOZA: Something at least?
MANRICUS: Only a trifle. MENDOZA: Well tell me about this 'trifle'.
MANRICUS: First he said how remarkable it was that such a variety of human sounds could be embraced by such a small number of letters; and then that absent friends could speak to each other with the help of letters. He added that, to the people of those islands[6] lately discovered by our kings, from which gold is imported, nothing seemed more astonishing than that men could reveal their thoughts by means of a little piece of paper, covered with black marks and sent from such a distant place. For they asked our people whether the paper knew how to speak. He said this and a lot of other things that I've forgotten.
MENDOZA: How long did he speak for?
MANRICUS: Two hours.
MENDOZA: You've committed to memory only this miserable fragment of such a long lecture?
MANRICUS: I *committed* the whole of it to my memory all right, but my memory refused to hang on to it.
MENDOZA: Then your memory is like the pitchers of the daughter of Danaus.[7]
MANRICUS: More like a sieve than a pitcher!
MENDOZA: Let's find someone who *did* remember what he said to you.
MANRICUS: Wait a bit: I am trying to recall something by thinking about it. Now I have it.
MENDOZA: But tell me: why didn't you take notes?
MANRICUS: I didn't have a pen with me. MENDOZA: Nor a notebook?
MANRICUS: No. MENDOZA: Well tell me what it is.

[5] Spanish Humanist.
[6] Mexico and Peru.
[7] The fifty daughters of Danaus were condemned to fill pitchers with holes in them.

MANRICUS: It's gone; you've driven it out of my mind with your beastly interruptions. MENDOZA: So soon?

MANRICUS: Ah, it's come back. He claimed, on the authority of some author or other, that nothing contributed so much to great learning as the ability to write quickly and clearly.

MENDOZA: Who is the author?

MANRICUS: I've often heard his name, but I have forgotten it.

MENDOZA: Like everything else! But our noblemen commonly do not follow this precept. They think it fine and proper for them not to know how to shape their letters properly. You would think that it was a lot of chickens scratching about; unless you know beforehand who the writer was, you'd never guess.

MANRICUS: And for this reason you can see how stupid, senseless and full of corrupt opinions these men are.

MENDOZA: But how can they be common if they are noble? Surely there is a great difference between the two qualities.

MANRICUS: Because a common man is not identified by his fine clothing and possessions, but by the life he leads and the soundness of his judgement.

MENDOZA: Shall we try to emancipate ourselves from this common ignorance? Let's take up this practice of good writing.

MANRICUS: Somehow I find it natural when writing to make twisted, unequal, and confused letters.

MENDOZA: This is a sign of your nobility! Train yourself; for practice will alter what you believe to be natural.

MANRICUS: But where does he [*the writing-master*] live?

MENDOZA: *You* are asking this of *me*? I never heard nor saw the man, while you yourself heard him. As far as I can see, you want all your food to be put in your mouth predigested!

MANRICUS: Now I remember. He said that he lived near the church of SS. Justus and Pastor.

MENDOZA: So he lives around here. Let's go.

MANRICUS (*Calling to a boy*): Hey, my lad, where is your master?

BOY: He's in that room there.

MANRICUS: What's he doing?

BOY: Teaching some of his pupils.

MANRICUS (*Loftily*): Please inform him that other pupils, who wish to be taught by him, are also standing at his door.

MASTER (*Appearing at door*): And who are these youths? What do they want?

BOY: They wish to meet you. MASTER: Let them come straight in to me.

MANRICUS AND MENDOZA: We wish you good health and prosperity, Sir.

MASTER: I too wish you good fortune in coming here. God preserve you. Now what is it? What do you want?

MANRICUS: To be taught by you the art that you profess, if you have both the time and the inclination.

MASTER: You must be well brought-up lads who speak with such courtesy and have such modest looks. Now you're blushing all over! But don't be bashful, my sons. This blush is a sign of virtue. What are your names?

MANRICUS: Manricus and Mendoza.

MASTER: The names in themselves are evidence of your noble upbringing and generous hearts. You will finally attain true nobility if you train your minds with those accomplishments which are particularly appropriate to your noble lineage. How much wiser you will be than the mass of the nobility, who hope that they will be held to be of higher birth the more ignorantly they write. But we should not be surprised, since this conviction has now seized and corrupted the nobility that nothing is more base and cheap than to know how to do something. So we see them signing letters composed by their secretaries with totally illegible signatures; nor would you know who sent the letter unless you were told by the bearer or you recognised your correspondent's seal.

MANRICUS: Mendoza and I were complaining about this just now.

MASTER: Did you come here properly armed for your task?

MANRICUS: No, Sir. We would be beaten by our tutors if we dared at our tender age even to look at arms, let alone touch them.

MASTER: Come now! I'm not talking about the bloodthirsty arms of the soldier but those of the writer, which we need now. Have you got your pen-case and quills?

MANRICUS: What is a pen-case? Is that what we call a 'calamarium'?[8]

MASTER: Precisely. In distant antiquity men used to write with a stylus. This was superseded by reeds, especially those from the river Nile. The Saracens, if you happen to have seen any of them, write with reeds from right to left, like almost all Eastern peoples; in Europe, we follow the Greeks and write in the opposite way, from left to right. MANRICUS: The Romans also did this.

MASTER: Yes, my son, the Romans too. But they were descended from the Greeks; once upon a time the early Romans wrote on pieces of parchment, from which writing could be erased, known as 'palimpsests'. At that time they wrote on one side only. Books written on both sides of the page were called 'opisthographi', as for example the play *Orestes*, mentioned by Juvenal,[9] which was, however, started but never completed. But more of this another time. Let us get back to the matter in hand. The quills with which we write are taken from geese or sometimes from chickens. Those you have are very handy. They have a stem which is of good length, and are clear and firm. Take away the little pieces of feather with your penknife and cut a length off the barrel. Then scrape off any rough edges: for they are better when smoothed.

[8] 'Calamarium' is a case for reed-pens, as opposed to quills.

[9] The reference is to his first *Satire*, lines 6 and 7.

MANRICUS: I never carry them with me unless they have been trimmed of feathers and are clear. But my tutor taught me to make them smooth by spitting on them and rubbing them on the inside of my coat or the thigh of my hose.

MASTER: Good advice!

MENDOZA: Now please teach us how to prepare our pens.

MASTER: First of all you divide the end with a cut so that it is split into two prongs. Then with a gradual movement of your penknife, make a cut at the extremity, which is called the nib. Shape its two little feet, or if you prefer to call them legs, in such a way that the right side on which the pen presses in the act of writing is just a fraction longer.[10] The difference should be almost imperceptible. If you wish to press your pen on the paper with greater firmness, hold it with three fingers: but if you want to write more quickly, hold it with two—the thumb and forefinger—as the Italians do. For the middle finger rather acts as a brake and restrains the hand from rushing forward more impetuously than it should.

MANRICUS (*To Mendoza*): Let us have the ink-well.

MENDOZA: Ahem. The ink-well dropped out of my ink-horn on the way here.

MASTER (*Calls to his servant*): Bring that ink-bottle. We will pour some ink from it into this lead ink-well.

MENDOZA: Without a stopper.

MASTER: Thus it will come away on the pen more freely and easily. For if cotton, silk, or linen is used for a stopper, when you dip your pen, a thread or bit of fluff always sticks to the nib. While you are removing this, the writing is being held up: or, if you don't remove it, you will make smudges rather than letters.

MENDOZA: I follow the advice of one of my friends and use a Maltese linen cloth or a piece of light, thin silk.

MASTER: Indeed that is better. But by far the best is simply to pour the ink into a fixed ink-well. For with portable ink, you must always have a stopper. Now, do you have some paper?

MENDOZA: This?

MASTER: It's too rough—the sort that slows up the pen so that it does not run without interruption: and this is bad for your work, since, while you are struggling against the roughness of the paper, many of the thoughts that you wanted to write down slip out of your mind. Leave this kind of large, thick, hard, rough paper to the book copyists. It is called 'book' paper because books intended to have a long life are made from it. Nor should you get for daily use that large-sized Augustan or imperial paper, which is called 'hieratic' because of its connection with religious matters such as you see in church books. No. Get yourself some correspondence paper—the best, which is very thin and firm, comes from Italy: or the common paper imported from France which you can buy anywhere for 8 cents a packet more or less. And, to

[10] First a slit is made in the bottom; then the tip is cut almost at right-angles, but not quite.

supplement your equipment, you should have one or two sheets of 'emporetic' paper, which we call blotting-paper.[11]

MENDOZA: What is the reason for its name? I have often wondered about it.

MASTER: The word 'emporetic' is derived from a Greek word meaning 'for wrapping goods up', and it is blotting-paper because it absorbs ink. If you use this, you won't need flour or sand, or plaster dust rubbed off from the walls. But the best course of all is to let the writing dry out. In this way it will be more durable. Blotting-paper will also serve to lay beneath your hand to prevent your writing page being marked with sweat or dirt.

MANRICUS: Please will you be good enough to write a model for us to copy.

MASTER: Well first I write an alphabet, then word-syllables, then complete words like this. (*Writes the following sentences.*) 'Disce puer quibus fias sapientior et proinde melior.' 'Voces sunt animorum signa inter praesentes, literae inter absentes.'[12] Now copy these and come back either at dinner time or tomorrow so that I can correct your writing.

MANRICUS: We will do so. Meanwhile we commend you to Christ.

MASTER: The same to you. (*They leave the master's house.*)

MENDOZA: Let us go to some quiet place where we can think about what we have learned from the master, without being interrupted and disturbed by our companions.

MANRICUS: Agreed! Let's do that.

MENDOZA: Here we are at the place we wanted. Let us sit on these stones.

MANRICUS: Yes, but away from the sun.

MENDOZA: Lend me half a sheet of paper. I'll give it back to you tomorrow.

MANRICUS: This piece is enough for you.

MENDOZA: There won't be room for six lines on that, especially of mine.

MANRICUS: Write on both sides and compress your lines. Why do you have to leave such huge spaces between them?

MENDOZA: Me? There's hardly any space between them. The letters are touching each other on both sides, particularly those with ascenders and descenders, like *b* and *p*. But what about you? And have you written two lines? How extremely elegant—except that they are not straight.

MANRICUS: Get on with your writing and shut up!

MENDOZA: I can't write at all with this pen and ink.

MANRICUS: Why?

MENDOZA: Can't you see that my ink is so thick that you would think it was mud. Please look how it sticks to the nib and does not flow down to enable me to make my letters.

[11] This passage derives from the Elder Pliny, *Historia Naturalis*, Book XIII, 76.

[12] 'Learn, my boy, by what means you become wiser and therefore better.' 'Words are the expression of the mind when people are face to face, as written letters are when they are absent.'

MANRICUS: We'll soon put that right. You trim back the nib with your penknife so that it will collect the ink nicely for writing, while I put a few drops of water in the ink-well to thin the ink.

MENDOZA: Better piss in it.[13]

MANRICUS: Oh no! The piss would make both the ink-well and your writing stink. Nor would you find it easy to wash away the smell afterwards from your stopper. The best thing to use is vinegar if you have it to hand. For this quickly thins down thick ink by its strength.

MENDOZA: True: but there is the risk that it will penetrate the paper with its acid.

MANRICUS: You need not be afraid of that. This paper more than any other prevents the ink from running away.

MENDOZA: The edges of this paper of yours are ragged, wrinkled and rough.

MANRICUS: Well make a straight margin with your shears. This is the neatest way. Or stop writing before you reach the rough edge. You always let the most trivial difficulties hold up progress. You immediately put aside anything that comes to your hand.

MENDOZA: Let us go back to the writing-master.

MANRICUS: D'you think it's time?

MENDOZA: I'm afraid the time may have passed. He usually has an early dinner.

MANRICUS: Let's go. (*They return to the master's house.*) You go in first since you have less feeling.

MENDOZA: No, you go because you have less shame.

MANRICUS: Watch out in case someone comes out from his house and finds us here joking and fooling around. Let us knock on the door even though it is open. It is more polite. (*Knock! knock!*)

BOY: Who's there? Come right in whoever you are.

MANRICUS: It is us. Where is the master?

BOY: In his room. (*They go in.*)

MANRICUS: Our best greetings, Sir.

MASTER: Welcome back.

MENDOZA: We have copied your model five or six times on the same sheet of paper and we have brought our work back for you to correct.

MASTER: Quite right. Let me see it. (*Looks.*) Now in future you must leave more space between your lines so that I have room to correct your mistakes. The letters

[13] Probably an echo from the passage in the *Colloquies* of Erasmus which is printed above (see p. 28). But was this simply a joke? In a book on writing materials *De Nieuwe Wel-Gestoffeerade Schryf-Winkel* by Gerrit Bom, Amsterdam, 1776, the author lists the ingredients of ink — gall-nuts, ferrous sulphate, gum arabic, alum, vinegar, soot, wine, water, and finally 'Piss prevents the ink from drying out'. This passage, which no doubt embodies traditional wisdom, was brought to my notice by Mr. A. R. A. Croiset van Uchelen.

here are very uneven. This is an ugly fault in handwriting. Look! see how much greater *n* is than *e*, and *o* and than the bowl of this *p*. All the bodies of the letters should be equal in height.

MENDOZA: Please, what do you mean by 'bodies'?

MASTER: The middle portions of the letters, without the ascenders and descenders if you have any; *b* and *l* have ascenders, and *p* and *q* descenders. Again, the legs that form part of *m* are of different lengths. The first is shorter than the middle one and has too much of a tail; and it is the same with the *a*. Nor is the pressure of your pen on the paper adequate. The ink hardly adheres and you cannot distinguish the details of the letter. Here you have tried to make one letter into another by scraping out parts of it with the point of your penknife and have only succeeded in disfiguring your writing. It would have been enough to have lightly crossed out the letter. Another thing: any excess letters at the end of a line should be carried over the beginning of the next line, provided that you do not split syllables which it is wrong to divide, according to the rules for writing Latin. It is recorded, however, that the Emperor Augustus neither divided his words nor transferred superfluous letters from the end of one line to the next, but would bring them round underneath.

MANRICUS: We shall be glad to follow his practice, since he was an Emperor.

MASTER (*ironically*): Quite right. And in what other ways will you try to prove that you are descended from him? Now do not join up all your letters nor separate each one. Some of them demand to be joined to each other because they have tails (such as *a*, *l*, and *u*) or because they have cross-bars (such as *f* and *t*). Others such as the rounded letters *p*, *o*, *b*, refuse to be joined. When you are writing, keep your head up. For if it is bent down and leaning over, humours collect in your forehead and eyes. This is the cause of many diseases and damages one's sight. Now take this other model and, God willing, copy it tomorrow:

Sed propera, nec te venturas differ in horas:
Qui non est hodie, cras minus aptus erit.

And this one:

Currant verba licet, manus est velocior illis;
Nondum lingua suum, dextra pergit opus.[14]

MENDOZA: Do you want us also to copy this correction?

MASTER: Yes, copy it, provided you write the rest of it properly.

MENDOZA: Meanwhile, Sir, we wish you farewell. (*Exeunt*.)

From Vives, *Linguae Latinae Exercitatio*, Dialogue 9.

[14] These two couplets are from Ovid. Their sense is 'But hasten and don't keep yourself back for some future hour: he who is not ready today will be less so tomorrow' and 'Although words may run, the hand is faster than they are. The right hand has finished its task while that of the tongue is still not completed'.

CAD ILLVSTRISSIMVM
Principem ALFONSVM estensem
Ferrariæ Ducem Mathematicę disci‑
plinæ Cultorem Feruentissimum
SIGISMVNDI De fan‑
tis Ferrariensis Professoris in
Artem Arithimeticę. Geo
metric. Astronomiæ: &
Scribendi. Prefatio.

MAGINAN,
do & piu uoltæ cũ
la Mente a lę cosæ
Del Microcesimo
mũdo considerãdo
MAGNANI,
MO ET EX‑
CELLENTE
DVCA Semper
Inuictissimo Q uã
to fu Alta e sublime Inuentione Ritrouare

3. From Sigismondo Fanti, *Theorica et Pratica*, Venice, 1514.

CHAPTER THREE

A Nobleman of Ferrara:
Sigismondo Fanti

It is frequently stated that the first printed writing-book is *La Operina* of 1522 by Vicentino (Arrighi). This is open to question on two counts; first, it is not absolutely beyond dispute that the book appeared in that year, and second, it was preceded by Johann Neudörffer the Elder's *Fundament* of 1519 and, even earlier, by Sigismondo Fanti's *Theorica et Pratica*, which was published in Venice in 1514.

Few facts are known of Sigismondo Fanti, yet quite clearly he lived a full, many-sided life. He belonged to the nobility of Ferrara. He was distinguished for his breadth of learning and sharpness of intellect. According to his contemporaries, he was a 'learned' architect (which probably means that he was expert in the theory of the subject and perhaps taught rather than built), a skilled astrologer, and an expert in the study of the geometrical basis of letters. This latter was a Renaissance fad that distracted many fine minds, including those of Leonardo da Vinci and Dürer;[1] as if, by straight-edge and compasses, the so-called 'divine proportion' of the ancients—even if it existed—could be discovered! Fanti seems to have been the Grand Old Man, to whom the younger generation of writing-masters in Venice looked up in the early years of the sixteenth century. Some words in his writing-book may indicate that he had travelled extensively in Italy, Spain and the Balkans.

Fanti was a prolific author. By 1514, according to a list printed at the front of the *Theorica et Pratica*, he had composed twenty-two works on various subjects—mathematics, astronomy, philosophy, games, and of course the art of handwriting and lettering. In 1516 he produced a handsome, well illustrated book on fortune-telling, *Il Triompho della Fortuna*. When we dip into this book, we see the less rational side of the Renaissance; it is the world of Nostradamus, John Dee, and Simon Forman.

This many-sided man must have left other traces of himself, which later and deeper research will surely bring to light. For the moment, he remains a shadowy and elusive figure. We approach him most nearly in his writing-book, which is the most substantial product of this kind, until we come to the Spanish masters more than half a century later. In this work, he reveals himself as a somewhat cantankerous fellow, a self-confessed élitist, and one for whom the rules of handwriting are

[1] See p. 27 above.

mysterious craft secrets to be handed down to the select few. He brings out the
occasional Latin tag with the air of a man dropping a pearl before swine. He seems to
bestride two worlds, combining the closed attitude of the mediaeval guildsman with
the wider educational views of the Humanist. His book was in fact intended to
benefit a wide public: employees of chanceries, secretaries, agents, merchants,
artisans, children, and copyists in the service of the Church, not to mention painters
and sculptors. Many of these people would have been hard put to it to plough right
through the book without the aid of a writing-master.

The *Theorica et Pratica* has the oblong format about 15 × 20 cm (depending on
the binder), in which all the earlier Italian writing-books were produced. It is divided
into four sections. Each of the last three is devoted to lettering rather than
handwriting—in particular, the geometric construction of the *rotunda* (round
gothic), *textura* (pointed gothic), and the Roman inscriptional capitals respectively.
The first part, a general introduction to handwriting and calligraphy, must be our
main concern; it staked out the ground for later writers, who occasionally repeat
some of its wording.

After a warning that the master should be paid his proper fee, Fanti urges the
student to select the style that he wishes to learn; this will affect his choice of paper.
The chancery hand, for example, requires thin, smooth, clean, well sized paper,
whereas a stouter paper is appropriate to the mercantile hand. Next, the question of
pounce (pumice): this was a fine powder, often of ground cuttlefish or gum-sandaric,
rubbed into the paper to make it smoother and less absorbent, so that the outlines of
the letters were sharper and therefore stood out more clearly. Later writing-masters
(especially Cresci and Scalzini[2]) were violently divided about its use. Some said that
it was unsuitable for cursive handwriting because it slowed up the pace of the writer;
others disputed this. Fanti says clearly that it should not be used.

He then gives instructions for ruling up the paper, with directions about how to
make a comb-shaped metal marker, with which several parallel lines could be ruled
at once. After recipes for various inks, he describes (and illustrates with a drawing)
the tools of handwriting—the penknife with a short, curved blade and comfortable
handle; quills that should be hard, round and slender, so as to hold the ink; straight
edge; shears and dividers.

He describes the cutting of a quill. It is first lightly scraped with the back of the
penknife to remove superfluous stuff; then you take it between the middle and third
fingers of the left hand, holding the end by your forefinger and thumb, and pointing
it to your chest. The tip rests on the ball of the thumb as you make an oblique,
curving cut towards you. At the top of the first cut, you make a second short curved
cut, which is equal in size to the diameter of the quill. The two cuts together should
have the shape of a step in a stairway. The nib is then squared off, its width being
regulated by the size of the letters to be written. Finally, the nib is divided equally by

² See pp. 258, 275–6 below.

a slit, whose length is about double that of the quill's width, and thinned down a trifle. Where very large letters are to be written, pens of metal or bone may be more suitable.

Fanti then mentions an important point. The trimming of the quill should be varied according to the kind of script envisaged. For example, the mercantile hand demands that the second cut shall be like an eagle's beak; the *rotunda* style, with its broad, heavy lines, does not need the point to be divided; whereas the Roman minuscule requires only a short division of the nib. Some remarks on pen-hold and writing posture follow. Then comes a long technical section, in which the lines produced by varying the pen-hold, and their employment as a basis for letters, are analysed on Euclidean principles. This leads into a detailed consideration of the chancery hand with only brief remarks on the mercantile hand and the capital letters: the precedent by which the early Italian writing-books throw the main emphasis on the italic script is thus established.

Fanti relates the basic letter-forms of the chancery italic to a quadrilateral, but he gives no dimensions for it. We can, however, deduce something from the rule which he gives for making the letter *a*. Here the top of the letter is made from a horizontal line which is half the height of *a*. The pen then goes down in a shallow arc before returning to its starting point. The typical flattened egg-shape of the italic body is thus produced. Because of the outward curve of the down-stroke just mentioned, the quadrilateral into which the letter would fall would be somewhat less than twice as high as wide.

These minutiae are rather critical because they determine the whole character of the script. If the letters fell into a quadrilateral of equal height and width, they would be tubby, non-italic, slower to write and awkward to join. On the other hand, if the quadrilateral is exactly twice as high as wide, the letter-forms tend to become too angular. Fanti well understood the risk of over-angularity, and he prescribes that letters with bowls such as *a* should be well rounded, as well as elongated. Unlike most of his successors, he does not suggest any basic strokes or patterns to be practised by the beginner. He goes straight through the alphabet letter by letter. The impact of his teaching is unfortunately blunted because, not being able to have the necessary wood-blocks cut to illustrate his alphabet, he had to leave blank spaces in the book. And so, just when we were expecting to see some evidence of the living man from his handwriting, the noble Sigismondo slips back into the shadows again.

The following extracts deal with his teaching of pen-hold, writing position, and the italic hand. The passage in which he deplores the difficulty of cutting cursive letters in wood should be noted: interesting, too, is Fanti's estimate of the time he allows for an ordinary person to become proficient in writing—sixty days.

PEN-HOLD AND POSTURE

Indeed it is absolutely essential that the trunk and limbs of the man who is writing should be carefully and gracefully accommodated to the pen and paper. You should first take the quill or reed with two fingers, i.e. the thumb and forefinger, which should be extended forward, not curved. The portion of the quill or reed that has been cut should be held down [*on the paper*] by means of the two fingers in which the pen is grasped. You should keep the remaining fingers lifted in their natural order, except the little one, which should always be placed and rest on whatever surface you are writing on. It acts as a support to the other fingers, which are ranged above it, one over the other. The middle finger always touches and remains below the forefinger to support it. Thus, with the two fingers which hold the pen and with the help of the others, you can write confidently and make short or long strokes as required, moving the joints of the forefinger and thumb when necessary; and with the forefinger and middle finger of the left hand spread apart, you should hold the paper and follow the pen along. But, while the paper should be held parallel to the chest of the writer, the elbows should be kept opposite each other, so that a line prolonged from one would pass along the other and would be contiguous with your chest. To the extent that the writer holds the paper askew or, as I would say, at an angle, he must keep his forearm at a corresponding angle. Furthermore, you must hold your head up and, above all, do not let your chest in any way touch the table at which you are writing, because this is an ugly posture and detrimental to your health.

Sigismondo Fanti *Theorica et Pratica*, Book I, Ch. XXXV.

HOW TO CONSTRUCT ITALIC LETTERS

Learn by heart this instruction too, as you have learned those in the past and will learn others in future, namely that the distance between one line and another in the chancery script should be four times the height of the letter (according to the size you intend to make); and the ascenders and descenders should be equal in length and should occupy three-quarters of the space between lines[3] more or less. Otherwise the writing would not look well, because there would be confusion between the ascenders and descenders of one line and those of the line above or below. You must see that the bodies of the letters also are of equal height, and that the long vertical lines and the bodies slope a little to the right,[4] because it is natural and more rapid to

[3] i.e. taking the ascenders and descenders together. For example, in the word 'hog', 'h' is two letter-heights (ascending), 'o' is one, and 'g' is two (descending), so that the word occupies three of the four letter-heights that separate two lines of writing. Fanti refers to the upper and lower limits of the ascenders and descenders as the 'three-quarter' points. This arrangement separates the ascenders and descenders of one line from another by half a letter-height.

[4] Fanti actually says 'to the left', thinking of the bottom of the letters, rather than the top.

write like this, as well as more elegant, as you can see from the illustration shown here, although it is crude and not very nicely done because it is impossible to set down and engrave on wood letters that are well constructed without any fault.[5] But study the theory with the model and, by means of my directions, you will be able by yourself to write letters of delicacy and grace.

Now we have to discuss the distance between one letter and another. This should be equal to the width of the black parts of the letter. For example, the space which falls between two *n*'s should be equivalent to the width which the two legs of that letter would occupy if placed side by side. Thus the distance between one word and another should be such that an *n* or *o* could fall between them. A little more or less will make no difference, but do not depart from my instructions because you would be committing an error. Do not forget to make sure that the letter is full. Its body should be slightly elongated, and it should have that spacing which I have mentioned. If you do this, you will make absolutely perfect chancery letters, from which you will also know something about the mercantile and *bastarda* styles.

My conclusion under this next head is that the chancery letter *a* is derived from a quadrilateral. You must first place the pen above the line at a height which seems to you appropriate to the size of the pen which you are using. Then move the pen to the left and parallel to the line. When the pen has moved to a distance of half the letter-height that you have selected, then descend forthwith to the line with a curving stroke, which should make a small bend, curving not too much but almost imperceptibly. When the pen has touched the line, then move it up in a straight line so that it joins the point from which you started the first stroke. Then bring the pen straight down to the line once again, and, turning back up again, give the letter a little of a certain movement which is called the 'dead line' (*linea morta*)[6] because it is almost invisible. It is with this line that the link is made with other letters. In this way you will have constructed a perfect chancery *a*. But take care that you do not lift the pen at all from the paper until you have completed the letter (unless it is *d, f, g, p, t, x*, etc.; with these you have to lift the pen if you are to make them well).

Concerning the letters *b, c, d, e, f, g, h, i*

The letter *b* begins with a knob of a certain size at the [*upper*] three-quarter point, and from it a vertical line is brought down to the writing-line. This vertical should have a slight slope. Then return with your pen up the same stroke to a point about half the body-height of the letter *a* and branch off immediately with a straight line to a height which is equivalent to that of the top of the body of letter *a*, and then come down again to the foot of the vertical that you have already written and make the join just above the writing-line, going round in a slight curve. Thus your *b* will be

[5] No illustration in text.
[6] This is, of course, the little diagonal tail or serif which finishes off the letter.

constructed. See, moreover, that you do not turn your pen in your fingers, and hold your arm as indicated in Chapters XXXVI and XXXVII above [*not reproduced here*].

The letter *c* is constructed and fashioned from an arc which is a little larger than a semi-circle. The pen should be placed at the same height as that of the letter *a*.

The letter *d* is derived from the body of *a*. Its long vertical is made like the letter *b* but passes through the first stroke which you made when beginning the body of *d* and goes straight down to the line, and has the 'dead line' behind it, like the tail of a lion when it is raised.

The letter *e* is based on the letter *c* and is made like it, except for its head, which goes from the upper part, where the letter started, to the middle of the body or preferably a little higher. You must make a straight line with the edge of the pen to the inner circumference of the body. It is necessary that this stroke should be without any curve at all.

The letter *f* is constructed like *b* so far as its beginning is concerned. It has the same vertical, except that this goes straight down without a break to the lower three-quarter point with its tail pointing in the opposite direction to its head. Then this vertical is cut with a cross-stroke at a height equivalent to that of the other letters with bodies that I have mentioned. This stroke should run parallel to the writing-line, and its length should not exceed that of the head-stroke with which the letter starts. Thus *f* is fashioned.

The letter *g*—I mean the roman G—is based on an arc rather greater than a semi-circle; but the chancery version (with which we are dealing) consists of an oval, whose height is the same as that of the other letters; now place your pen at the circumference of this oval body, just where it touches the writing-line, and proceed to make a descending stroke, which curves out just to the right a little further than the oval and finishes at the lower three-quarter point. You must write without altering the angle of your pen. Then you move to the left with an almost straight line which is parallel to the writing-line and exceeds the width of the upper oval on the left by as much as it does on the right. Then make a straight stroke with your pen to the neck of the *g* so as to touch it. When you have done this you will indubitably have produced the chancery *g*.

The letter *h* exactly resembles *b* except that the letter is not enclosed or shut entirely.

The letter *i* consists of a vertical stroke of a height equal to that of the bodies of other letters, but in front at the top on the left and below on the right opposite to it you must make 'dead lines'.[7]

[7] The *linea morta* already referred to: in this case, short diagonal starting and finishing strokes.

Concerning the letters k, l, m, n, o, p, q, r

The letter *k* is based on the vertical of *b* which descends to the writing-line. Then, with your pen raised a body-height from the base of this stroke, make a little oval like the head of *g* and from the corner [*where it meets the vertical*] make a straight line down to the writing-line, so that it is distant from the principal vertical by one letter-height.

The letter *l* is derived from the vertical of *b*, except that when you reach the writing-line, you write a [*diagonal*] straight line to the right. This is extended so that its length is half that of a body or is equal to it when the letter begins a word. But if it occurs in the middle of a word, you should follow the procedure that I have outlined for *a* and *d*, namely give it a 'dead line', and this will serve as a link to the letter that follows.

The letter *m* is constructed by starting with a 'dead line' at the requisite height. Then you come down vertically to the writing-line and go back up to the top with your pen. After this, without removing the pen from the paper, continue until you have made three sevens of the abacus [*i.e. the numeral 7*], one near the other according to the instructions in Chapter XLI.[8] The upper part of these 7's must form a continuous line parallel to the writing-line. The letter should begin and end with the 'dead line'. In this way you will have created the letter *m*.

The letter *n* consists of two legs of letter *m*, i.e. the two last on the right.

The letter *o* is formed from an oval of the height of the other letters that have bodies. It should also slope a little, just as I said in regard to previous letters.

The letter *p* derives exactly from a letter *d* placed upside down, except that, when writing *d*, you first make the body of an *a*, whereas, to write the letter *p*, you must make a vertical which goes below to the same distance as other descenders, i.e. to the lower three-quarter point.

The letter *q* is constructed exactly like *a*, except that the vertical should be prolonged to the lower three-quarter point; note that all descenders must have a tail turning to the left, i.e. in an opposite direction to the heads of the ascenders.

The letter *r* is constructed in exactly the same way as the *i*, except that the pen returns halfway up the vertical and then immediately branches out until it is equal in height to the top part of the *i*, forming an acute angle. It has a knob at the head. This stroke, which is made with the edge of the pen, should end at a point whose distance from the vertical is equal to half the latter's height.

[8] See p. 51 above.

Concerning the letters ſ, t, u, x, y, z, etc.

The long ſ is written exactly like f except that it does not have the cross-bar.

The letter t is formed like i, but you should make it a little longer than normal, i.e. higher, because it must, like f, have a cross-bar.

The letter u is constructed exactly like two i's joined together with a 'dead line'.

The letter x consists of two diagonal strokes crossing one another. The first diagonal, which begins on the left side, is made just like the tail of a capital Q, and the other is like the chancery long s, which I have already discussed; they intersect at an oblique angle.

The letter y begins in exactly the same way as r but the point of its 'beak' is connected to its lower extremity by a straight line prolonged below the writing-line and finished with a tail. It is also a Greek letter [Gamma] as you see in the illustration.[9]

The letter z[10] is constructed from two sevens of an abacus [i.e. one number 7 upon another] joined at opposite ends, except that the descender of the lower one is prolonged a little with a certain grace.

The ampersand is based on an antique q, that is to say, this: Q. Then place your pen at the point where you started the tail [i.e. where it joins the bowl] and then make a C underneath, bringing the line up around until it cuts the tail of the antique Q with its final portion.

[9] Illustration missing from original.
[10] Text has *linea* ('line'), apparently an error for *lettera* (letter). This letter described here is the double z with three, instead of two parallels.

The contraction ɔ is made from a *c* but you bring a line down which curves to the left. Its construction is similar to the nine of the abacus [*i.e. the numeral 9*].

The contraction ℞ consists of the letter *r*, to which you add a straight stroke which runs horizontally along the writing-line to the right and then curves back to the left, so that it cuts across itself as is clear in the example.[11]

Concluding note

Since there are some people who have never picked up a pen to write throughout their lives and are also at a disadvantage, both physically and mentally—like the common mob to which I have already referred—they must be made to use two lines to contain the bodies of their letters, both when they write individual letters and when they write complete lines, always beginning at the upper line and finishing at the lower. But if you proceed according to the instructions which I have already laid down, you will see such a man learn to write in thirty days. Then make him write on one line for fifteen days and without any lines for a further fifteen. By this method he will become a competent writer. *Quod est propositum.*

Theorica et Pratica, Book I, Ch. XL–XLII.

[11] Example missing from original. Here follow the gaps in the text which were left unfilled.

Egli e' manifesto Egregio lettore, che' le' lettere' C an=
cellaresche' sono de' uarie' sorti, si come' poi ueder
nelle scritte' tabelle', le' quali to scritto con mesura
e' arte', Et per satisfatione' de' cui apiti sse' una'
sorte', et cui un'altra, Io to scritto questa' altra'
uariatione' de' lettere la qual uolendo imparare'
osserua la regula del sottoscritto Alphabeto :

A a. b. c. d. e e. ff. g. h. i. k. l. m. n. o. p p.
.o. q. r. s. s. t. u. x. y. z. &.

Le' lettere' cancellaresche' sopranominate' se' fanno tonde'
longe' large' tratizzate e' non tratizzate ET per che' io
to scritto questa' uariacione' de' lettera' la qual im=
pareraj secundo li nostri precetti et opere

A a'a b. c. d. e e. f. g. h. i. k. l. m. n. o. p. g. r. s. s. t. u. x. y. z. &.

4. From Giovannantonio Tagliente, *Lo presente libro*, Venice, 1524.

CHAPTER FOUR

'I, Giovannantonio Tagliente, employed by the Most Serene Republic of Venice . . .'

Within a decade of the publication of Fanti's book, the problem of cutting wooden blocks from which cursive script could be accurately represented had been solved in Italy. At last the writing-master could meet the rising demand for printed models of handwriting. The credit must go to two outstanding engravers, Ugo da Carpi and Eustachio Celebrino. Of the former, who was the pioneer in Italy, we shall say more at a later stage. Celebrino was born in Udine about 1480 and graduated with a double doctorate in philosophy and medicine from the University of Padua. He abandoned his medical career to become an engraver, writer, and minor publisher. The latter part of his life was spent in Venice. He designed title-pages, composed bad verses, and produced short manuals for popular consumption—a little pamphlet on the mercantile script, a Turkish dictionary, a book on cosmetics, and a guide for those desiring to avoid the plague, perhaps a belated fruit of the medical studies of his youth. He is, however, best known for his collaboration with Giovannantonio Tagliente, whose famous writing-book *Lo presente libro* came out in 1524.

Tagliente was a professional writing-master employed by the Venetian Republic. He was born probably between 1465 and 1470. He first tried to get into the civil service in 1491. His letter of application, written in a careful yet vigorous italic hand, still survives:[1] in it he claims to be known throughout Italy but, his travels now finished, he wants to settle permanently in Venice and to become a professional instructor of handwriting to the Republic, teaching young secretaries and children of noble families. He failed in his first attempt, but received permission a few months later to take over a sinecure recently vacated by his uncle. So, after all, he was able to be a public servant and a writing-master. Like Celebrino, he was responsible for some little books of self-help. In association with his kinsman Hieronymo, he published a highly successful primer on arithmetic in 1515; in 1524, helped by his son Pietro, he brought out a reading book, *Libro Maestrevole*, which undertook to teach anyone to read in about a month; then a letter-writing manual, *Componimento*

[1] James Wardrop reproduced it in *The Script of Humanism*, Oxford University Press, 1963, as Plate 50.

di parlamenti; a collection of specimen love-letters with replies, *Il refugio di amanti*; a handbook of accountancy, *Luminario di arithmetica* (1525), the first book to distinguish between single- and double-entry book-keeping,[2] and an attractive collection of embroidery patterns, *Essempio di recammi* (1527).[3] He also found time to design an italic type based on his own handwriting and printed some of his books in it. Nothing is heard of him after 1527; perhaps he died in the typhus epidemic that hit Venice in 1528—the sharpest attack of plague there for fifty years in a city already stricken with famine and swamped with refugees.

Tagliente appears to have been impatient to get his writing manual before the Venetian public, possibly because he knew that a rival, Ludovico Vicentino degli Arrighi, was working on a similar project in Rome. At any rate, at least four editions appeared in rapid succession in 1524–5, in which the author made various changes, adding here, cutting there. The most important innovation is mentioned not in the manual but in a petition for a privilege to cover four of his works. There he says: 'I have invented, not without a good deal of labour and personal expense, a new way of printing every kind of letter that can be made by the living hand: not printing in the usual way, but by a new method never used before in Venice or in her territory.' This is obviously something quite new, and seems to refer to the cutting of wood-blocks for the reproduction of handwriting, in which Tagliente employed the services of Celebrino—although he allowed the latter's name to appear in only one of his editions. The partnership was evidently a brief one.

Lo presente libro is arranged so that the various models are shown as a collection first, no doubt with the intention of displaying the master's versatility and skill and of appealing to a wide public. The actual directions for handwriting appear at the end of the book.[4] They are printed in Tagliente's own calligraphic type, already mentioned. As in Fanti's book, the instructions are confined almost exclusively to the chancery italic style. The models themselves are rich in variety. Many of them could not have been of much assistance to young secretaries: but goldsmiths, jewellers, book-copyists, sign-writers and others would have used them. They include chancery alphabets, a selection of mercantile and gothic hands, Arabic, Hebrew and Chaldean scripts, Roman inscriptional capitals, large gothic and *rotunda* alphabets constructed 'geometrically' (and derived from Fanti), and so on. Some of the letters are shown white against a black background, apparently a speciality of Celebrino's. Contents vary between editions, but the chancery alphabets are common to all and always come first. The set starts with a simple model of italic, which in its proportions and clarity, is one of the finest in any writing-book. Then the master writes further versions of increasing elaboration and virtuosity (among them one that slopes

[2] It is actually in two parts: one addressed to the small shopkeeper, the other to the big merchant.

[3] At this time the Venetian textile industry was expanding at a phenomenal rate.

[4] They were expanded in the second 1524 edition. Since this version probably represents Tagliente's intention, it is used here.

headlong to the right and another that slopes 45 degrees backward), just as in music a composer may write an air with many variations, some of them grotesque. There is also a nice page of capital letters and another of abbreviations for use in addressing letters and petitions to superior persons.

Tagliente's instructions for handwriting are composed in verbose, sometimes clumsy, language, and their sequence is not particularly logical. They almost give an impression of having been dictated. Many echoes of Fanti's teaching can be detected. He starts by describing how to select and cut quills. Then he shows how to hold the pen, which should be kept steadily at an oblique angle, but we are not told exactly what this angle should be. Next we hear about paper; for the chancery italic, it should be thin, white and opaque, that made at Fabriano being (as it still is today) superior. And then there is some brief information about the tools of handwriting, an illustration of which is helpfully placed at the front of the manual.

From his long experience of teaching, Tagliente recognises that the chancery italic is a flexible instrument, which can be adapted to a variety of men and uses. The main point is to master the construction of the letters and then to practise the particular version which is required. Rather surprisingly, he says that one might become a competent writer in a few days, simply by copying a model. He states that the letters without ascenders and descenders should fall within a sloping oblong. He is not very precise about this. He uses the word *bislongo*, which could mean an oblong with one pair of sides twice as long as the other. But the actual models indicate a ratio which is nearer seven to twelve. After this, he shows how to make the basic building-blocks of italic—the slightly sloping ovoid bowl and the long ascender. A minor point to note is that he provides two ways of beginning an ascender; the first is by an in-and-out stroke that slightly thickens the line at the top, and the other by a downward diagonal stroke made with the edge of the pen. Then he takes the reader through the alphabet, letter by letter, explaining how each is constructed. The clarity of his instruction is, however, impaired by the fact that the illustrations, instead of being handwritten to demonstrate the sequence of strokes, consist of rows of letters in printing type, which serve little purpose. The reason that type was used was probably in order to get the book into print more quickly. Finally, there are instructions about the proportion of ascenders and descenders, and about how to join up the letters.

Tagliente's italic is essentially that of a practical, rather extrovert teacher, not of a cloistered copyist. The qualities he seeks are freedom and pattern, the distinguishing marks of all good cursive handwriting. He is in love with the bold flourish, the decorative touch, the dance of the pen. Some have criticised his swagger and exuberance; no one can deny his vitality.

TAGLIENTE'S
RULES FOR HANDWRITING

Now that I have written so many sorts of script, I must give you instruction about how to learn them.

Having resolved, kind Reader, to make a start in teaching you how to learn to write skilfully, correctly, and in proportion, I want first to set forth all the following instructions.

The pupil who aims to learn properly how to write one or more styles of script must understand five main rules: first, how to cut the quill; second, how to hold the pen in the hand; third, how to manipulate the pen, depending on the fashion in which the quill has been cut; the fourth is the size and nature of the letters, which you will learn as we go along.[5]

It is right that you should first learn to cut your quill, in accordance with the following method.

Take your quill and scrape it with the back of your penknife, and make a cut at the mid-point of the barrel (at your discretion) [*going out diagonally*] from the side which has the groove. Then, using your eye as a guide, allow the cut to be of reasonable length, but not too much—I mean as appropriate to a quill that is to write the chancery and mercantile styles. Take care that the cut is even on each side [*i.e. symmetrical*]. Now, with the quill resting on your thumbnail, pare down the end to a gradual bevel. With a vertical cut of your knife, cut the point back carefully more or less according to the thickness of the letter you intend to write. This cut should be at a slight angle. If you want to write rapidly, you must carefully shave down, with the blade of your knife, the four corners of the quadrilateral [*edge*] of your quill-nib. Then you must make a little [*vertical*] slit so that your pen shall move faster as you write. Note that the nib of a quill trimmed for the mercantile style should not be square, but round and rigid. The way to obtain this round effect is as follows. When you have trimmed your quill in the way described above, do not cut it at an angle but straight across. Do not scrape the point; but, cutting with your knife, gradually round the square edge of the nib so that you are left with a curved tip without any squareness at all. Then lightly smooth it round. This method of trimming will be very effective and durable, and you will be able to write quickly with it. So much for my teaching under this head.

A good quill should have five qualities. It should: (a) be large of its kind [*i.e. according to the species of bird from which it was taken*], (b) be hard, (c) be round, (d) be narrow, (e) be taken from the right wing, so that it does not bend in the wrong

[5] The fifth rule has dropped out; as later becomes clear, it is concerned with joining letters together.

direction when you hold it in your hand. Feathers taken from the wild goose are very good, but those of the domestic goose are much better than all the rest, especially if you want to write letters with their correct measure and proportion.

Many use the feather of the swan because of its size and hardness. I can say with assurance that it is excellent, particularly for the mercantile and chancery cursive styles. Let this suffice for your instruction.

My second topic deals with holding the pen correctly in your hand. You should keep it in one position, without turning it in your hand. Let your elbow[6] rest on the writing surface, as well as the tips of the two fingers—namely the little finger in company with the one next to it. The forearm should be raised so that it does not touch the writing surface: all three joints of the two fingers which hold the pen in the hand should also be lifted.

My third topic deals with knowing how to manipulate the pen. You must understand that one can write with the pen in three modes, and no more: first with the edge of the pen (*taglio*), second with the pen at an angle (*traverso*), and third with the full width of the pen (*corpo*).

My view is that you should not hold the pen by the edge, nor with the full width, but obliquely, i.e. so that the full width of the pen always remains at an angle.[7]

My fourth topic deals with the size and quality of the letters. I say that this topic is easy to understand; for all that is meant by the size and quality is that every letter of the alphabet should be of equal size, whether written individually or when joined together to form words or lines in proportion.

My fifth topic[8] deals with joining up letters and words. You should understand that this means that, when you have learned to make all the letters of the alphabet separately, you should know how to join one letter to another properly and to knit the letters into words, as you will see in due course.

Besides the five topics discussed above, I state as part of your instruction that, when you wish to write at a table, you should stand with your body erect and your head held moderately high—I mean neither very high nor very low. Hold the paper at right-angles to the plane of your body.

So as to instruct you fully in all you need to know about the art of handwriting, I now explain to you the virtues of the papers appropriate to the characteristics of the various kinds of script.

The chancery hand requires a very thin paper, of any kind you like. The paper should be smooth, white and well sized, because the most competent scribes always

[6] Tagliente says 'arm' but, as will be seen a few words later, the only part of the arm that touches the writing surface is the elbow.

[7] The pen can be held (1) with the edge of the nib at 90 degrees to the line of writing, which produces the *thinnest* downstroke, (2) or at 0 degrees, which makes the *thickest* vertical, (3) or at some intermediate diagonal, giving an oblique stroke between the thickest and the thinnest.

[8] The text erroneously has 'fourth'.

write with a delicate touch. The paper from Fabriano is superior to that from anywhere else.

The mercantile style really requires a strong, solid paper; similarly all the other kinds of bold, large scripts need thick, smooth, well sized paper in both the medium and royal sizes. This knowledge is essential for you in respect of every variety of letter.

It is obvious that no competent barber can ever shave a beard well without hurting[9] the man who is being shaved, unless he has a razor honed to a cutting edge. So note, discreet Reader, that if you want to write all the various kinds of letters and do not have the appropriate tools for the purpose, you will never be successful in the practice of the art. Therefore it is necessary for you to provide yourself with the tools which I have depicted here in this manual.[10] They are the following: quills, penknife, straight-edge, dividers, lead stylus, set-square, pounce (if you want to write with it), shears and good ink. All of these, or most of them, are indispensable to your learning.

I want you to understand that the chancery style admits different kinds of bodies, of long vertical strokes, of joins for letters and words—curved or straight, rounded or otherwise, flourished or not flourished—and variations of other sorts, such as I have been able to observe in the styles of writing which are employed in the chanceries of all the cities of Italy, one version being in normal use here and another there. But, to make a good start with my instructions, I will begin with those sorts which are the most in demand and are absolutely essential for everyone, i.e. those most in vogue at present in the various chanceries, especially that of the Most Serene Republic of Venice, where I have lived for many years and have held an official position by virtue of my craft. So we shall make a good start with these kinds of the chancery hand.

Although I could, for the purpose of teaching you how to write the above-mentioned varieties of script, merely tell you that you should first learn the [*separate letters of*] the alphabet and then complete lines of writing and that, by repeatedly practising my models with care, you could within a few days make yourself into a competent writer of that chancery style (or any style that you wish to learn), yet in order to make things clearer to you and to enable you to learn more rapidly, I will give you forthwith the rules of handwriting letter by letter, with secret methods that will enable you to master the subject. Then I will instruct you in joining up letters and every kind of word by means of the science of geometry. You will find that it is the easiest thing in the world to learn it all in a very few days. Now, with God's help, I will make a good start.

[9] The text reads 'noglia': this seems to be a misprint for 'doglia'.
[10] The illustration referred to here usually appears after the title-page.

Turning now to the first point in this part of my teaching: you should know that all the letters of the chancery alphabet are derived from the following oblong, as you will understand more clearly in due course.

The second instruction which I should like to give you is that you should know that, if you aim to learn the chancery style which we have mentioned above, you must first learn to write each letter of the alphabet between lines: then, when you know how to write them, you should dispense with the lines, because by now your hand has become fully trained. To make these letters of the alphabet, you should first learn the following body-shape, which is derived from a sloping oblong, as you see in the following example:

Coming to the next topic: you should know that you will be able, by employing as rapidly as possible this body-shape made in its correct proportion to the best of your ability with the guidance of geometry, to form the following three letters, which I write here as a model for you:

The foregoing letter *a* is constructed from the body-shape that I have written for you. First bring down a vertical stroke at a slight slope alongside the [*right side of the*] body in such a way that most of the latter is joined to it. At the foot of the down-stroke give a graceful little turn. This is called the 'finishing-stroke' because it finishes off the main stroke, as you can see in the following example, which has been prepared for your instruction:

The letter *b* is constructed from the oblong, but first you make a lively, vigorous long down-stroke, giving it a slight inclination as you did with *a*. This stroke should commence with a firm point that starts at an angle and resembles a [*word apparently omitted*], thus forming the beginning of the down-stroke. When you have completed the down-stroke,[11] then starting near the [*lower*] writing line, you retrace your steps up the vertical in such a way that you can form the body of an *a* in reverse and so your letter *b* will be made. But take care that its body remains somewhat open in the same way that you made *a*, as follows:

[11] The text is obscure and probably corrupt. Ugo da Carpi's *Thesauro de Scrittori* (1525), a contemporary anthology, which embodies most of Tagliente's directions for writing, has a slightly different, but hardly more satisfactory reading.

You should know that, by means of the same rule, you can make two different varieties of letter: in one, you should make all the long sloping ascenders and descenders so that they have a point or swelling at the tip, according to the rule for letter *b* which I have already taught you: in the other, the tips of the ascenders and descenders are made with the edge of the pen [*the narrow diagonal stroke*] as you see in the model below, which will explain it more clearly to you:

b d f h k l p g ſ

The letter *c* is constructed on the basis of the oblong in the same way as you made the body of *a*, but it is written in two strokes. First, you should write half the body of *a*. Then starting right at the tip of this, make a head which curves round in its path as if you were closing the letter *o*, in two strokes as you can see in the following example:

ccc ccc ccc cc cc cc cccc

For letter *d*, make the body exactly as you did with letter *a* and then add a long down-stroke as for *b*—this latter being finished off with the same diagonal stroke and having the same slope as letter *a*, as you can see in the following example:

dd dd dd dd dd dd

You should form the letter *e* in the same way as *c*, except that, when you are making the head like that of the letter *c*, you then go in to join your first stroke at its middle with a [*thin diagonal*] line made with the edge of the pen, as you can see in the following example:

e e e e e e e·e e

For letter *f*, start above the upper writing-line at a distance equal to the height of *a*, or any other letter of that height, and make a sloping down-stroke, as you did for the letters *b* and *d* (for all the long verticals and bodies should slope in the same way i.e. the slope of one should equal that of another); [then give it a thick point at the top[12]] and move the nib of the pen back to the point where you commenced the stroke and make the 'head' of the letter, going up to a height that seems right to you. Then divide this letter *f* as if you were making a cross, at a height above the lower writing-line equivalent to that of the other letters which consist of bodies, as you can see in the following example:

f f f f f f f f

[12] This phrase seems to be a more concise alternative version of the words that follow: Ugo da Carpi saw that something was wrong and omitted it.

The upper bowl of *g* is derived from the oblong, as was the case when you made the letter *c*, but it should be closed. Then start at the centre of the base of this bowl and make a line shaped like an egg [*i.e. an oval*] and see that this lower bowl is aligned with the upper one, as you can see in the following example:

You can also make another version of it in this way. Make the bowl so that it falls within the usual oblong and give it a sloping tail with the end turned up as you can see in the following example:

The letter *h* is constructed in the same way as you made the letter *b*, except that its main body is not closed up at the bottom, as you can see in the following example:

The letter *i* is similar to the vertical line of *a* and has the same slope and finishing stroke. When you begin it, you should start with a short, upward diagonal stroke known as the *presa* ['*starter*']. It is like the finishing-stroke at the foot of the letter *a*, but one faces the other, as you see in the following example:

The letter *k* is related to the letter *b*, with its slope and second stroke beginning at a height above the writing-line equal to that of other letters with rounded bodies, as you can see in the following example:

The letter *l* has a long down-stroke similar to that of the letter *b*, but at the foot where the line ends you add a little finishing-stroke, which is called the *lassata* ['*finisher*'], because it finishes off the letter, as you see in the following example:

The letter *m* is based on the letter *i*, but do not put a finishing stroke on the first two legs. Put it on the third leg, just as you did with the letter *i*. Similarly, start it with the same initial stroke as for the letter *i*, and now you will have the letter *m*, fashioned in the right way and with the right slope, and constructed with a single stroke of the pen, as you see in the following example:

The letter *n* derives from the last two legs of *m*; it has the same finishing stroke and slope, as you see in the following example:

n n n n n n n n

The letter *o* is based on the oblong. It has the same length and slope as the body of *c* but you must close it, as you see in the following example:

o o o o o o o o

The letter *p* is similar to the lower half of *f*; you make its body in a proportion that resembles [*the right*] half of the letter *o*, with the same length and slope, as you see in the following example:

p p p p p

The letter *q* is based on the letter *a*, its tail being made like that of the letter *f*, with the same slope, as you see in the following example:

g q g g g

The letter *r* is derived from the first leg of *n*; it has a head and slope, as you see in the following example:

r r r r r

The long *s* [*ſ*] is constructed in the same way as you made the letter *f*, with the exception of the cross-bar but with its slope, as you see in the following example:

ſ ſ ſ ſ ſ

The small *s* is, in the chancery style, based on the oblong; the round part underneath should be a little larger than the one above, as you see in the following example:

s s s s s

The letter *t* is constructed in a similar fashion to the letter *c*[13]; you should give it a cross-stroke with the edge of the pen as you did with the letter *f*. Note that the letter *t* should be a little higher than the other letters [*of its size*] and should have its appropriate slope, as you see in the following example:

t t t t t

The letter *x* is based on the oblong, as you see in the following example:

x x x

[13] This has dropped out of the text, as have the entries for *u* and *v* below.

The letter *y* is easy to construct as you see in the following example:

ɣ ɣ ɣ *ɣ* *ɣ*

The letter *z* is based on the oblong. It has its own starting- and finishing-strokes. You can also learn to make these two strokes of the [*alternative version of the*] letter *z* which are joined together as you see in the following example:

z z z z z z z z

The *ampersand* can be made in several strokes, but the better way is to write it in a single movement without lifting the pen from the paper. Be sure that the little bowl on top rests on the centre of the lower bowl, as you see in the following example:

& & & & & & & &

The abbreviation ꝫ is formed like a *g* except that its tail is curved round, as you see in the following example:

ꝯ

The abbreviation ꝶ is based on the letter *r*, but it has a second stroke, such as you see in the following example:

ꝶ

My dear Reader, now that I have equipped you with the means of learning easily and rapidly all the letters, one by one, of the alphabet of the noble and celebrated chancery script, with their rules and proportions founded on the science of geometry, all that remains is that, when you wish to construct a complete alphabet, you should do so in the following way. To deal with this new topic: you should know that all the bodies in the letters of the alphabet which have them—there are ten of them, i.e. *a, b, c, d, e, f, g, h, o, p, q*[14]—should have the same size, roundness and slope. I should also explain that all the ascenders and descenders should be of equal length, as you see in the following specimen of the chancery alphabet:

A b c d e f g h i k l m n o p g r ſs t u x y z z

Now that you have been furnished with the rules, principles, proportions and explanations, you must first copy the [*individual*] letters, aided by the eye of your understanding, and then learn the links which join letters into words in the various kinds of script that you wish to learn: and to practise and master them with the help of my models, using a quill or reed pen. Start with the letter *a*, writing it many, many times so that, by selecting from my models the style you wish to learn, you become expert in it, both in theory and in practice; and not only with this letter *a* but with all

[14] There are eleven here: the letter *f* seems to have been included by mistake.

the others, one by one; after this you should begin to join up letters and connect them into complete words according to the science of geometry. So, with God's help, make a start as follows.

As an introduction to the rules for joining letters and linking them into words, we must first understand how they apply to one word — let us say, for example, the word 'magnifico'. Proceed as follows. First make an *m* with its finishing-stroke. Lift your hand [*i.e. pen*] and make an *a* next to the *m* (thus giving us '*ma*'). Starting from the finishing-stroke of *a*, make the upper bowl of the letter *g*. After you have completed *g*, pick up the opening-stroke of *n* from the bowl of *g* and make the letter *n*. Without lifting the pen from the paper, continue the finishing-stroke of *n* and make the letter *i* (this gives us '*magni*'). Next write the letter *f* and next to it the letter *i* in one movement (this gives us '*magnifi*'). Similarly continue the finishing stroke of *i* and write the first circular element of *c*, then add to *c* its head-piece. Next make the letter *o* beside *c* (and this gives us '*magnifico*'). See that the distance between the letters always equals the space between the legs of *n*, joining and linking all the letters above and below as far as you can without lifting your hand, never stopping unless you have to, until you have completed the word. After applying this system of rules for joining and linking in the single case of this word '*magnifico*', you will be able to write any word. I should explain to you that the distance between one word and the next should equal the space occupied by a letter *m*. Now I say to you that this word '*magnifico*' looks well, as you can see from the following example:

magnifico magnifico magnifico,

Having learned the rules for joining together the letters of a single word (i.e. '*magnifico*'), you can, by means of the same rules, connect up any word that you wish and know how to write. Above all, if you keep before you as models the displays of chancery letters, both flourished and unflourished, which I have written out for you, and constantly practise them, you will make yourself a proficient writer.

You can make every style of letter in large and small sizes as you prefer, now that you have been given the rules for writing them perfectly. Furthermore, kind reader, I should inform you that the distance between your lines of writing should be such as to admit four letter-bodies, one on top of the other — either more or less at your discretion: for this rule is not very important.

You will also need to know how long the ascenders and descenders should be between one line and another. I answer by telling you that they should ascend or descend in such a way that they occupy half the distance between the lines. If you prefer, you can allow them to take up two-thirds of the distance.

Pupils who wish to learn the mercantile script should observe the rules for learning all the letters of the alphabet one by one until they know how to form them with lively, vigorous strokes. Note that this script should be upright, round, full and

stocky in the body, as you can see from the various kinds of mercantile script which I have written as models for you.[15]

I should explain to you that as a result of the instruction which I have given you in the above-mentioned scripts, you will be able, by applying the same rules, to master all the other scripts that I have written as models for you. First learn all the letters of their alphabets in the order that I have taken them; then similarly the joins and links, the sizes appropriate to the various styles, whether flourished or unflourished, upright or sloping. Always keep the scripts before you as models, and, if you follow all these precepts, you will reach a very high standard of proficiency.

The majuscules of the *antiqua*, *formata*, *moderna* and *francesca* styles[16] are also based on a square and circle. They have various sorts of lines, some straight and some crossed in different ways, as you can see in the models. These also enable you to see their theoretical basis and dimensions, drawn in proportion in a square or in a circle, or ruled with a straight-edge or constructed with dividers. By the science of geometry you can see, too, all the other relevant particulars and attributes. Anyone who wishes to learn them, will, by practising them intelligently one by one, readily discover the essence of their perfection and their correct dimensions by means of dividers, using the models which indicate the true road to success. After you have learned geometrically their correct theoretical construction, with the dimensions already mentioned, you can easily make them in practice. For practice backed by theory is generally approved.

I, Giovanniantonio Tagliente, employed by the Most Serene Republic of Venice as an official instructor in this art of handwriting, have with all due care shown you how to make the various styles of letter and have attempted to relate everything that is necessary; and now I come to the end. If, as a consequence of a defect of mine or of a slip of my pen, someone of unusual ability discovers some mistakes, I pray that he will charge them to my account, while attributing any fame or honour, which the present work may enjoy, to the Supreme Dispenser of Divine Grace, and that He shall grant you all a long life here on Earth and endow you with joy and happiness in the life to come.

From Giovannantonio Tagliente, *Lo presente libro* (2nd expanded edition of 1524).

[15] Shown elsewhere in the manual.

[16] *Antiqua* is the roman letter (like the upper and lower case of ordinary printing type); *formata* and *moderna* are varieties of round, Italian gothic, usually known as *rotunda*; *francesca* is the gothic black letter.

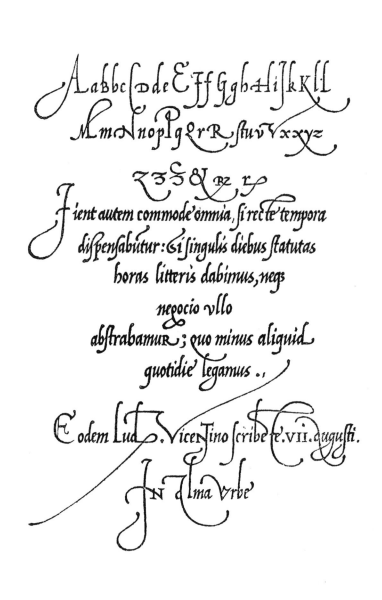

5. From Ludovico Vicentino degli Arrighi, *La Operina*, Rome, about 1522–4.

CHAPTER FIVE

A Vatican Scriptor:
Ludovico Vicentino degli Arrighi

On 15 August 1514 the painter Raphael wrote to his friend Marco Calvo to acknowledge the receipt of an exquisitely written manuscript. The man who delivered the work to Raphael was in fact its calligrapher. Raphael had undertaken to provide illustrations and to design a title-page. Unfortunately, the project came to nothing and the manuscript, which contained the treatise of the Roman architect Vitruvius, has not survived. The calligrapher, one of the most accomplished copyists of the day, was Ludovico Vicentino degli Arrighi.[1] It is the current custom to refer to him by his family name of Arrighi, but contemporaries knew him as Vicentino, and this is what we call him in this book.

Ludovico Vicentino was born towards the end of the fifteenth century at the small village of Corneto, about fifteen miles from Vicenza. Although nothing is known of his boyhood, his later activities show that he had been trained in calligraphy, typography and book design. Venice would be the natural place where a young man in that region could receive a thorough grounding in such arts. If he did, in fact, study in Venice, he might well have been a pupil of Tagliente's. He may have fled south in 1509 when the French and German troops of the League of Cambrai fought a sharp campaign against the Venetians in Northern Italy. It is not, however, until 1510 that anything certain is known about him. In that year, he was concerned with the publication of a popular travel-book, *Itinerario de Varthema Bolognese nello Egypto*. In the succeeding years, he specialised as a book-copyist, and became a complete master of the formal chancery hand. A typical example, a manuscript of Aristotle's *Ethics*, can be seen in the library of the University of Amsterdam — page after page written with ease, regularity and grace. His commissions brought him in touch with such people as Raphael, Machiavelli, Cardinal Giulio de' Medici, Vittoria Colonna and Lorenzo de' Medici. Later, he obtained a position as a copier of briefs in the chancery of the Pope. Here he would continue to write a chancery hand, still rather formal, but somewhat nearer to handwriting than the book hand.

[1] See Cecil H. Clough. 'Ludovico degli Arrighi and Raphael', *Journal of the Society for Italic Handwriting*, No. 79, Summer 1974, p. 14.

When the old Pope died at the end of 1521, an austere Dutch cardinal was elected to the Holy See. During his short pontificate, Adrian VI attempted to prune the luxuriant and corrupt bureaucracy at the Vatican. Ludovico Vicentino probably lost his post as a result. About this time, he composed a writing-manual. Furthermore, under the patronage of Georgio Trissino, whom he had known in earlier days in Vicenza, he was able to realise a long-cherished ambition to make and print fine books. He had access to a press of his own; he designed one, probably two, type-faces, and between 1523 and 1524 brought out some twenty-seven titles. Then, perhaps because he was on more distant terms with his patron, he went to work at Venice for several months. On his return to Rome in 1526 he resumed printing, designed another type, and brought out ten further books. In one of his last productions, a topography of ancient Rome *Antiquae urbis Romae cum regionibus simulachrum*, he appeared in a new role as map-letterer. The author of the book, incidentally, was the Calvo mentioned above, and the engravings in it were based on drawings made earlier by Raphael.

On 6 May 1527 troops of the Emperor Charles V broke into Rome. They pillaged the city with appalling ferocity for eight days. Four thousand citizens were killed without distinction of age, sex or rank. Among them, almost certainly, was Ludovico Vicentino.

Before we look at Vicentino's writing manual, it is only fair to mention the engraver, without whom the book might not have seen the light of day. This was Ugo da Carpi, who was born between 1479 and 1481. Like Sigismondo Fanti, he came of a noble family. After dissipating his inheritance, he took up painting. Vasari tells us a little about him. Once he painted a picture with his fingers, not with a brush. It must have been tolerably good, because it was hung in St. Peter's with an inscription recording how it had been painted. Michelangelo, however, when he saw it said 'He ought to have used a brush and made a better job of it.' Ugo da Carpi was the first Italian artist to perfect (if not invent) chiaroscuro engraving, by which designs were reproduced with a series of blocks of different colours or in differing tones of the same colour. If his painting left something to be desired, he was in the first rank of block-cutters. As we have seen, he was interested in new techniques; and it is not surprising that he attacked, and largely solved, the problem of engraving pages of cursive handwriting. This can perhaps be inferred from the privilege which he obtained from the Venetian government in 1516 to protect both his current work as well as 'the engraving of things not hitherto done or imagined by other men'. In 1525 he published his own writing-book, a pastiche of blocks copied from Tagliente and Vicentino.

As we have seen, Vicentino composed his writing manual during the last weeks of his employment in the Vatican or soon afterwards. It must have been about this time that he joined forces with Ugo da Carpi. The partnership was stormy and short-lived. The manual, surely conceived as a single book, came out in two parts under the

title *La Operina* and (a year later) *Il modo de Temperare le Penne*, or *How to cut your quills*. I have suggested elsewhere that *La Operina* was put out at Rome in some haste in an attempt to anticipate the publication of Tagliente's book.[2] The collaboration with Ugo da Carpi finished abruptly when the first part was almost completed. The second part was published in Venice, where Vicentino employed as his engraver Celebrino, who had either quarrelled with Tagliente, or had been induced to leave him. *La Operina* bears the date 1522 and *Il Modo* 1523.[3] No doubt this was the programme that Vicentino set for himself, and one that would have enabled him to 'scoop' Tagliente. One of the blocks, however, in *Il Modo* is dated 9 February 1525 and was written in Venice. Since no other example is known of a post-dated block in any Italian writing-book, it can fairly be assumed that *Il Modo* did not appear before 1525 and *La Operina*, therefore, not before 1524. This dating explains more clearly the race that was going on to produce the first fully engraved set of chancery models.

Vicentino tells us that his friends had pressed him to write out models of the chancery hand which could be used for teaching. He was willing to do so, but he could not provide enough material to meet all the demand for it. Accordingly he 'struggled to devise this new invention of letters and to print them'. Once again we hear of an innovation, and once again the reference seems to be to the successful solution of the problem of cutting of blocks from which handwriting could be printed. But Vicentino never gave any of the credit to Ugo da Carpi. There is, in fact, a copy of *La Operina* in the Harvard University Library in which the engraver's name has been obliterated under a solid black cartouche apparently designed by his rival Celebrino.

The *Operina* is the first manual in which the directions for handwriting are set out in a hand-written script.

Vicentino defines two basic strokes: a broad, straight horizontal (*tratto piano e grosso*) and a narrow diagonal (*tratto acuto e sottile*). These, however, are merely the lines that *start* the letters; e.g. *a* begins with a horizontal at the top, and *i* with the diagonal serif. He groups the letters of the alphabet according to the first stroke used to make them. He then establishes the two main elements on which the italic alphabet is built: the ovoid body and the vertical, slightly sloping ascenders and descenders. He says rather vaguely that the body 'is made from the horizontal stroke', but does not describe how it is done; the pupil simply has to copy from the example. The essential curved line is thus introduced almost surreptitiously. The vertical strokes which go to form such letters as *b*, *d*, *h* are also begun with the horizontal movement. In order to be sure that the ink will flow properly, the initial top-stroke first moves forward (i.e. from left to right) and the pen is brought back over the same path (right to left) before the descent. The slight thickening produced

[2] See *Luminario*, Miland Publishers, Nieuwkoop, 1972, p. 35 *et seq.*

[3] These dates, as Vicentino most clearly states, are those of the composition or drafting of the text. He is careful not to record the date of *printing*.

by the doubling of the stroke, sometimes called the 'head' by the writing-masters, was felt to be attractive; the debased taste of a later generation was to distend it into a round blob.[4]

Vicentino prescribes that his chancery letters should fall within an oblong. He does not state the proportion, but it is a little less than two units of height to one of breadth, though his tall willowy ascenders cause the letters to appear somewhat more narrow. To his eye, the italic hand 'needs to be based on an ellipse rather than a circle; you will find that it will turn out to be circular if you shape it within a square and not an oblong'. Here, as elsewhere, the final test for him is the human eye; he never mentions the fashionable word 'geometry'.

After some further instructions about the proportions of the long strokes, and the number of strokes required by the various letters, and about their joining, we come to the question of slope. Vicentino recommends that letters other than the capitals should incline to the right. He is not very precise about it, but his models indicate an angle of 5–7 degrees. (To digress for a moment: slope is an essential of all cursive handwriting. When we write more rapidly, slope tends to increase. Unless it is curbed, however, the letters will sprawl and tend to break down. Illegibility follows. If we have learned to write from a model with only a slight slope, we stand a better chance of remaining legible when we have to write fast. This fundamental point was instinctively realised by the early teachers of italic. Many teachers today are not sufficiently careful about it.)

The *Operina* continues with rules about spacing, and ends with some information about capitals, abbreviations, forms of address, and a number of short pieces to copy. It is curious that the book does not discuss the instruments of writing nor the crucial question of how to hold the pen.

The opening pages of the second book, *Il modo de Temperare le Penne*, are set in a type designed by the author himself. Type may have been used to save time. These pages contain detailed and clear instructions on how to cut quills; and several later writers based their instructions on this passage. The text is illustrated by two full-page drawings of the penknife and quill, which make the whole business much clearer: a translation will be found below. Most of the book, though one would not have guessed so from the title, is, like Tagliente's, made up of a variety of scripts— mercantile and legal hands, roman and gothic alphabets, alphabets of scrolls or lace-work, etc. Some have the letters white on a black background, an arrangement much favoured by Celebrino, who engraved this part of the work.

Vicentino's italic hand as reproduced in the *Operina* reflects the discipline of the copyist. It is cooler and more deliberate than that of Tagliente. The latter's models encourage the student to take a few chances, the former's to play safe. Vicentino has a kind of feminine refinement and delicacy, Tagliente a coarser, masculine vitality.

[4] It may be recalled that Tagliente suggested an alternative way of starting the ascenders: see p. 64

HOW TO WRITE THE ITALIC HAND

Anyone who wishes to learn how to write the cursive, or chancery, hand should observe the following rules. First, you should learn to make these two strokes, i.e. ⁻ ⁄, with which all the chancery letters begin. One of the two strokes is horizontal and broad; the other is sloping (*diagonal*) and narrow, as you can see shown here:

Well, it is with this first horizontal, broad stroke (i.e. ⁻ ⁻ ⁻) that, starting in the reverse direction [*left to right*] and coming back along the same path, you begin all the following letters: ⁻*abcdfghklogsſx xyz* . The remaining letters of the alphabet begin with the second sloping, narrow stroke, going up the diagonal with the edge of the pen and coming down vertically in the following fashion:

ıeeimnprtuÿ

From the first broad, horizontal stroke you should make a body[5] of this shape *ı⁻ıı* . Five letters—*a*, *d*, *c*, *g* and *q*—are derived from it. In these letters, all the bodies which rest on the line on which you are writing, should be made so that they fall within an oblong quadrilateral, not a square, as follows, i.e.

I want you to understand that, besides the five letters *a*, *c*, *d*, *g*, and *q*[6] which I have written above, almost all the other letters too should be made to fall within this oblong ∷ and not a square ▫ for, to my eye, the cursive, or chancery, letter needs to be based on an ellipse rather than a circle. You will find that it will turn out to be circular if you shape it inside a square, and not an oblong.

To progress further through the alphabet, you should learn to make this line: *ſ* starting it with the first broad, horizontal stroke ⁻*ſſ*. The following letters are derived from it:

To ensure that they have their correct shape, you should make the extreme tip a trifle thicker than the rest of the line. You can easily produce this thickness by beginning the first stroke in the reverse direction [*left to right*] and then returning along the same path:

[5] *Corpo*: the main part of the letter, which is bounded by the two writing-lines.
[6] Note the slight change in order, which is perhaps evidence of haste.

When you have learned the letters written above (all of which begin with that first broad, horizontal stroke that I have mentioned to you), then you proceed to those letters which should start with the second sloping, narrow stroke, as you can readily understand for yourself by following this little treatise of mine.

Anyway, the letters that begin with the second sloping, narrow stroke are those written below, i.e.: *ꞁ t e e' i j m n p r*

t u

All of these should be of equal height, except that *p* and *t* should be a fraction higher than the bodies of the other letters, as I shall demonstrate to you in the following example: *apatmtumpnoturpqrsſumputinatmpi*

This extra height given to *p* (I mean of its vertical line, not its bowl) is more pleasing to my eye. In the case of *t*, it is done to distinguish the letter from *c*.

Since we have two kinds of *s*, *sſ* as you see, and since I have already given instructions to you about the long one, it remains to speak about the short one. You should make it so that the lower curve is larger than the upper, as you see shown here: *s s s* . So begin with the first broad, horizontal stroke which I told you about, then come back along the same path, curving down in such a way that a recognisable *s* is formed.

I have still to deal with *x*, *y* and *z*. Of these three, the *x* and *y* begin in practically the same way, i.e. with *ꞁꞁ* . This first stroke is bisected by a diagonal to form an *x*. Its width in front should not exceed the height of an *a*. So far as height is concerned [*i.e. between the writing-lines*], you follow the same principle with *y* in this way:

xayaxayaxayaxy

Try to make your *z* with the strokes that are shown below:

ꝛ 7 ꝝ ꝝ ꝣ
ꞩ ꝝ ꝣ
ȣ

Now that you have mastered the [*individual letters of the*] alphabet, take care that, when you are joining the letters together, all the long ascenders are of equal height, as with *b*, *d*, *h*, *k*, *l*. The extreme tip should be sloping, curved, and a little full like the beginning of *c* [*or*] *l*. Similarly, the descenders should be of equal length: *ſgpgſxyſſ*. The bodies of all the letters should be equal both above and below in the manner shown here:[7]

A abcdemſngmbiklmnopqrsſtuſtumvxyꝛ

[7] i.e. of the same height, the upper part of each body touching the upper writing-line, and the lower part the bottom line.

Some of the letters of the alphabet are constructed in one stroke without lifting the pen from the paper, and others in two. I therefore thought it relevant to tell which are made with one stroke and which with two. Those made with one stroke are written below, i.e.:

abcgh ill mnogrsfuyz

The remaining letters of the alphabet are made in two strokes:

d e e'fkpt x &

You should further understand, Reader, that as regards the small letters [*minuscules*] of the alphabet, some can be joined to an immediately following letter, and others cannot. Those that can be joined to a succeeding letter are the following:

acdfiklm
n fs t u

Of these, *a, d, i, k, l, m, n, u* may be joined to every succeeding letter, but *c, f, f, s, t* can only be joined with some. The remaining letters of the alphabet, i.e.:

be'eg hopgrxyz

must never be joined to the letter that follows. Nevertheless, I leave it to you to decide whether to join or not, provided that you keep your letters even.

Now follows an exemplar of the letters that can be joined with any succeeding letter in this way, i.e.:

aa ab ac ad ae'af ag ah ai ak al am an
ao ap aq ar as af at au axc ay az

You can do the same with *d, i, k, l, m, n, u*. The ligatures for *c, f, s, f, t* are as follows:

cz, fa ff fi fm fn fo fr fu fy,
st st
ff ff ff ft, ta te' ti tm tn to tg tr tt tu
tx ty

No succeeding letter should ever be joined with the remaining letters of the alphabet, which are

be'g h opg rxy z3

In order to write with greater facility, see that all the characters[8] —or letters, if you prefer to call them so—slope forward in this way:

Virtus omnibus rebus anteit profecto :~

[8] Strange how the word 'characters' is dragged in at this point for the first time; but the whole passage shows traces of haste.

But I don't want you to tilt them quite as much as that! I wrote the example in the way that I have, in order to show you more clearly the manner in which the letters should slope.

Take note, kind Reader, that although I have told you that all the characters should slope forward, I mean you to understand that this applies only to the minuscules: I want you to write your majuscules so that they always stand upright, making them with confident, well defined strokes without any shakiness in them. Otherwise they will, in my opinion, be completely devoid of elegance.

Make sure that the distance between the lines of the material that you write in this chancery hand is neither too large nor too small but medium; that the distance between one word and another is equivalent to the width of an *n*, and that, when you join one letter to another, the distance between them equals that of the width of the white space between the legs of *n*. Since, however, it is practically impossible to observe this rule, try to submit yourself to the judgement of your eye and satisfy that. If you do, even the best pair of dividers will forgive you.[9]

I believe that I have given you sufficient instruction in the method I employ to write the chancery alphabet, insofar as the minuscules are concerned. Now it remains for me to give you the appropriate instruction for writing the majuscules. All of these letters should begin with [*one or other of*] the two strokes which I mentioned when dealing with the minuscules, i.e. the one being broad and horizontal and the other diagonal and narrow in the following fashion: -/-/-/-

It should not be a great effort for you to learn all the majuscules once you have trained your hand well with the minuscules, especially since I have already told you that the two basic strokes which make the small letters are also those of the large, as you will come to understand for yourself in the progress of your writing. I will say no more than that you should try to learn to shape the majuscules as you will find here in the example which I have written for you.

[Here follows a model for capital letters: the rest of *La Operina* consists mainly of a supplement of examples for writing practice. There is, however, a short closing passage consisting of seven lines of rhymed doggerel, in which the author apologises to the reader for any errors in his work.]

From Ludovico Vicentino, *La Operina*.

[9] This somewhat ironic remark is the only allusion to 'geometry' and the mechanical construction of letters in the manual.

HOW TO CUT YOUR QUILLS

Last year, studious Reader, I wrote for you a short book on learning to write the chancery hand, which, in my opinion, takes first place [*among the styles of writing*]. But I do not think that I shall have satisfied your needs fully unless in addition I show you how to prepare your quill—an essential part of the business of handwriting. So with this second little book of mine (in which, as you see, I have also included various other kinds of scripts that will be of use to many readers) I have decided to describe for you, in the clearest and most concise manner of which I am capable, how you should cut your quill.

It would take too long if I were to attempt to set out for you all the rules for the various kinds of script which you will find in this manual. Nevertheless, if you have the desire to learn them, keep these examples before you and try to copy them as best you can: for if you follow them faithfully, they will assist you to master, if not completely, at least for the most part, the style that attracts you most. Go ahead then and train yourself, having every hope of success, since nothing is difficult for anyone who really wants to master an art.

Just as a man who wishes to learn to play a musical instrument must also know how to tune it, because many contingencies may occur, so for many reasons the student who aims to learn handwriting must know how to cut quills. Therefore I, who intend as far as I can to teach the art of handwriting in this little book of mine,[10] was unwilling to omit this topic. A quill, then, should be chosen which is round, clear and hard, and is not too large. A goose-quill is usually the best. Similarly choose a penknife of good steel with a sharp edge. The blade should be straight and narrow and not hollowed (as you see in my illustration here); a knife which is round, broad and hollowed does not permit the hand to control it properly.

Having selected your quill and penknife, first look at the end of the quill which points towards the bird's body. This has a groove which runs down to join the end of a round barrel. From this portion [*i.e. the barrel*] cut off about an inch or so from where it starts (that is to say just above the part that was planted in the wing); by this means you can remove the marrow of the feather. You can readily do this with the piece of the feather that you have cut off. I say that the cut should be made away from the groove[11] because normally feathers are not straight, but curve towards the part that I have mentioned, though some curve to the right. Therefore you must be careful here that [*when you hold it*] the quill curves a little towards the fork formed by the thumb and index finger.

When you have done this, you should pare down the quill with two cuts, one on each side, a little above the place from where your first cut begins, in such a way that

[10] An indication that *Il Modo* was originally planned as an integral part of *La Operina*.

[11] The groove runs down the *underside* of the feather. The barrel is cut diagonally starting from this underside and moving towards the outer side.

the pen goes down to its point shaped like a ploughshare or like the beak of a sparrow-hawk. All that part of the quill which lies below the first cut we call the 'ploughshare'. Both sides of the 'ploughshare' should be cut symmetrically, as you see in the illustration—I mean that the cut on the inner edge should not slope more than the outer edge. Now take the quill and place the 'ploughshare' so that its inner surface rests on your thumbnail; then starting on the back of the quill and cutting down at an angle towards the point (the length of the cut being equal to half that of the side of the blade or a little less), trim your quill with the penknife to a sharp bevel if you want to write with thin strokes, or to a thicker bevel for broader strokes.

In addition it is necessary, at the end of this sloping cut, i.e. at the very tip of the quill that has been trimmed, to cut a tiny piece off at right angles and not on a bevel. For if the whole point were bevelled, it would be too fragile, so that the letters it would make would probably be too runny: but if you cut them in this way, your quills will always write excellently. Anyone, however, who wishes the ink to flow more freely, because he has a light touch, can with the tip of his knife divide the point of the 'ploughshare' into two equal parts, starting the division a trifle above the bevel. This will meet his needs. Let this suffice for cutting quills, which I have illustrated below to make it more clear to you.

From Ludovico Vicentino, *Il modo di Temperare le Penne.*

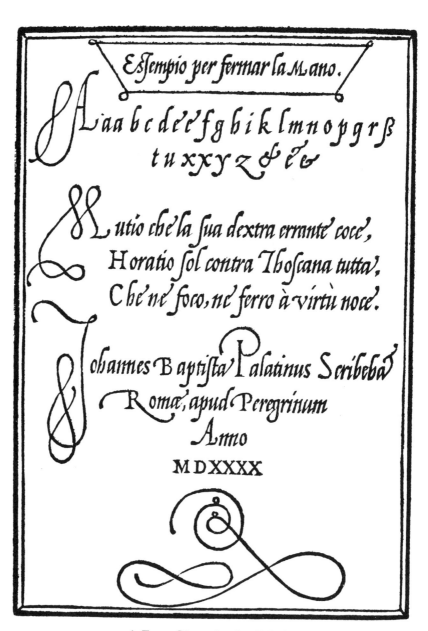

Essempio per fermar la Mano.

A aa bc de e f g h i k l m n o p q r ß
t u x y z & ᴇᴇ

Lutio che'la sua dextra errante coce,
Horatio sol contra Thoscana tutta,
Che ne'foco, ne'ferro à virtù noce.

Johannes Baptista Palatinus Scribeba
Roma, apud Peregrinum
Anno
MDXXXX

6. From Giovambattista Palatino,
Libro nuovo d'imparare a scrivere, Rome, 1540.

CHAPTER SIX

Giovambattista Palatino: the Man about Town

Giovannantonio Tagliente, the practical teacher and publisher; Ludovico Vicentino degli Arrighi, the scrupulous copyist and printer; and now Giovambattista Palatino, the cultured intellectual, writer and man about town, the first writing-master to leave a portrait of himself—curly hair, copious beard, large watchful eyes, prominent nose and a wart on the right cheek. He was born at Rossano in Calabria about 1515 and obviously received a good education. In early manhood he moved to Rome, where his talents quickly brought him recognition. By 1538 he had obtained Roman citizenship, of which he was extremely proud, for he never ceases to remind us of it. He had an appointment as a notary. He also worked as a graphic designer. The inscription which can be seen on the arch of Pius IV at the Porta del Popolo was executed to his design; and, like Vicentino before him, he was responsible for lettering maps in a book of Roman topography—in this case the 1533 edition of *Urbis Romanae topographia* by G. B. Marlianus.

Much of his early life revolved round a select circle of diplomats, churchmen, scholars and men of letters who started a dining club (as we would probably term it today), which they called the Academy of the Sdegnati. Palatino was a regular and popular member and, no doubt because of his skill with the pen, acted as Secretary to the Academy. He wrote occasional verse, played chess and made love. He seems to have been amorous by nature and appropriately designed for himself an emblem which shows a moth fluttering around a candle, a symbol of hopeless passion. It is likely that he was homosexual.[1]

Yet the bright promise of his life was not entirely fulfilled. As the Counter-Reformation gained momentum, life at Rome became less carefree. There was bitterness in the air. The chancery italic hand, too, was now going out of fashion, and under attack from the younger generation, especially from a forthright new man from Northern Italy, G. F. Cresci. Palatino engaged in controversy with Cresci but had to retire, licking his wounds. His disillusionment was intensified by his failing to

[1] The British Library has a manuscript of his hand which contains a set of ardent verses to an unknown male *Il bel Gigliante* (MS. Add. 25454). The 'fig' passage in D. Atanagi's letter of 17 August 1544 in *Lettere Facete* (1565) could carry homosexual undertones. Even the line of Petrarch which surrounds Palatino's emblem could be given a secret meaning.

find a backer who would subsidise the publication of a large collection of over 200 pages of calligraphy, including yet another elaborate geometrical construction of Roman imperial capitals, a dedicatory sonnet addressed to Henry IV of France, and a variety of grotesque letters, with which he hoped to astonish the world. He had been engaged on the work for over thirty years.[2] He died some time after 1575, probably at Naples.

Palatino first issued his writing-manual in Rome in 1540 (the same year in which Mercator published *his* at Louvain) under the title *Libro nuovo d'imparare a scrivere*. In an enlarged version in 1545, he added fifteen further blocks. A revised version, which is entitled *Compendio del gran volume*, came out in 1566: this contains a controversial preface, directed against Cresci though not specifically naming him, and will be discussed later. Palatino, who was very conscious of his own versatility, believed that a writing-master should not confine himself to one or two practical styles but be 'universal in the art'. He therefore offers the most ambitious selection of exemplars that has so far been placed before the public. Its oblong quarto format and general arrangement follow the pattern set by his predecessors. Pride of place is given to the chancery italic hand, which 'more than any other deserves to be called cursive'. But there are new features — a separate section on the *cancellaresca formata*, a script which corresponds to the italic letters in printing type; an essay on cryptography, the inclusion of which makes it clear that the book is intended to be read by secretaries in the diplomatic service; full-page groups of monograms; a rebus on a love-sonnet, possibly composed by Palatino; and specimens of Hebrew, Greek, Chaldean, Saracen and other exotic alphabets. The book is rounded off with a section on the instruments of writing. The engraving throughout is of a high quality. We do not know who the engraver was.

Palatino's discourse on the chancery italic is, like Vicentino's, entirely hand-written. His hand is more disciplined than that of Tagliente and bolder, more assertive than that of Vicentino. The script is highly compressed. A greater contrast is made between the thick and thin strokes. The very facility of Palatino's pen gives the writing a somewhat mechanical gloss.

The instructions for writing begin with the vital question of pen-hold, so surprisingly omitted by Vicentino. Palatino defines three basic strokes — the horizontal (*testa*), the vertical (*traverso*) and the narrow diagonal (*taglio*). He calculates mathematically in a way that would have pleased Sigismondo Fanti, but would have been beyond Tagliente and Vicentino, the precise relationship between the thicknesses of the three lines. As a means of studying them, he suggests the use of a very broad pen to magnify them. He states that the bodies of the italic letters should fall not only within an oblong but one which is twice as high as wide. This apparently slight change from the proportions found in Tagliente and Vicentino is of

[2] This manuscript is preserved in the Kunstbibliothek at Berlin (MS OS.5280).

fundamental significance. Its effect is to narrow the letters and make them more angular. This was the core of the criticism which was starting to be thrown at the chancery hand. Palatino senses the trap, and tries to evade it by saying that the rule is not an easy one and does not have to be invariably followed. He also draws attention, a little later on, to the need for the round letters to have their 'proper roundness'.

Palatino then takes the reader sequentially through the alphabet, indicating the construction of each letter. His rules are clear, and the construction of each letter is illustrated by examples from his own hand. Further instructions deal with the length of ascenders and descenders, which should be equal in height to the small letters; the number of strokes to use; the joining of letters; the distance between letters, words and lines. The script should slope forward a little, because one can write faster in this way; backward-sloping letters are ugly and slow. No directions are given for making capital letters—all the writing-masters treated this aspect of handwriting somewhat cursorily. This part of the book concludes with the usual forms of address and a page of exercises to strengthen the hand.

The self-contained section on writing-tools, which is placed later in the manual, is the best account of these matters to be found in a sixteenth-century writing-book. Palatino has included it 'to satisfy the needs of young people and beginners', it being impossible to practise any craft without knowing about its essential tools. He is not put off because some of his material is bound to be obvious to many readers. In fact, his practical talk about simple things, derived from his everyday experience, is a welcome change from speculation about the theoretical proportions of the alphabet. For example, the ink-stand should have a broad base so that it won't be easily upset; quills must be kept clean because old ink interrupts the flow of fresh ink; the thimble you wear to protect your thumb when cutting the quill should be black so that the white barrel of the feather will show up against it. A standard recipe for making ink is also provided; this has been tried in modern times and found entirely satisfactory.[3] One point was disputed a few years later. This was Palatino's practice of leaving quills with the nib covered in water to prevent their drying out and thus making scratchy letters when used again. Cresci deplored it. He loathed a damp, mushy nib and preferred a harder tip.[4]

Palatino winds up the section with some advice about teaching. In order to train the hand, a light metal stylus, with its tip trimmed square like a quill, and a block of hard wood or copper, on which the letters have been engraved, should be prepared. The pupil then moves the stylus in the grooves until he is thoroughly familiar with the feel of the letters. As we have already seen, this is a teaching aid proposed by Quintilian and endorsed by Erasmus. The pupil should then write on paper scored in groups of four parallel lines, the two middle ones containing the body of the letters

[3] e.g. by Col. Crosland: see *The Calligrapher's Handbook*, ed. C. M. Lamb, London, 1968, p. 68.
[4] See p. 121 below. It is necessary, however, to remember that Cresci used a narrower pen, which would collapse more easily if softened.

and the outer ones marking the limits of ascenders and descenders. Gradually the two outer lines are discarded; and then only a single line is permitted, until the pupil is ready to write with no line at all. Another device is to rule a sheet with black lines, which will show through when the writing sheet is placed in position above it.[5]

The passages which we have selected for translation are the directions for writing the chancery italic hand and the section on the instruments of writing. The reader will observe in the former a note of self-justification and criticism of rival teachers, which, starting here with Palatino, became more strident with some later masters.

[5] The 'falsa riga'.

DIRECTIONS FOR WRITING
THE CHANCERY ITALIC HAND

If you wish to learn this excellent art of writing correctly in whatever style, you must first know how to hold the pen properly in your hand. Without this knowledge, it is impossible to attain to the full mastery of handwriting. Therefore, take note that you must hold the pen with your first two fingers [*i.e. index and thumb*], supporting them on the third. For if you hold it in any other way, your strokes will be shaky and not firm.

Besides this, the pen must be held securely in the hand, with your arm resting on the table. The pen should not be turned in the act of writing, but must be held steady at an angle. It is from the correct position of the pen, when held in this way, that the three natural strokes are derived.

Mathematicians would describe the first stroke as a 'five-fold measure', since its width is five times that of the thin diagonal stroke [*taglio*]: I shall call it the horizontal head-stroke [*testa*]. It is made with the body of the pen as follows: ⁻ʳ. They would describe the second stroke as 'in a five-to-four relationship' to the head-stroke, because its width is four-fifths of the first stroke; I shall call it the oblique down-stroke [*traverso*], because it is made with the pen at an angle as follows: *ıſ* . I am amazed that all previous writers dealing with the methods and theory of handwriting have not mentioned this second stroke, which is undoubtedly just as essential as the others. Although every letter—as they state[6]—begins with either the head-stroke or the thin diagonal, it is this second stroke that gives the letters fullness and completeness; and nobody can doubt that the completion of a thing is as worthy of respect and as essential as the starting of it, or even more so. It can plainly be seen how necessary this second stroke is and that not a single letter can be written without it, and consequently that those who have overlooked it are lacking in comprehension and their teaching is defective. If you study the matter carefully, you will find this second stroke in all the letters of the alphabet, descending vertically in the way that is natural to it. There are only four letters which contain it in its oblique form [*i.e. going down diagonally*]; they are *s x y z*, as you can see by trying it out with your pen in accordance with my method as described above.

The third stroke would be described by mathematicians as in 'four-fold relationship' with the downstroke, because its width is one quarter of that of the latter. I shall call it the narrow diagonal [*taglio*] because it is made with the edge of the pen, in the following shape: *ıʒ˙* .

So we have the horizontal ⁻ʳ , the vertical *ıı* , and the narrow diagonal *ıı* .

Some may argue that the proportions and measurements of the foregoing strokes

[6] Palatino is criticising Vicentino, but he himself omits to mention that some down-strokes are straight and others curved.

are false, or rather imaginary, and are not derived from practical geometry, because it is impossible to measure such small objects with accuracy. I therefore want to divulge to you the method I have discovered by which I have clearly seen that the matter is as I say it is. Now, to come down to brass tacks and to see the above-mentioned proportions by practical demonstration, you can take a very broad pen like those which are used for writing gothic letters[7] and write chancery letters instead with it. In this way, you will—because of the large size of the letters—be able to measure them easily and find by practical test the basis of these proportions.

Chancery letters which have a body need to be half as wide as they are high, so that they make a double square: for, if you make them within a square, they will—so far as the proportions of their bodies are concerned—belong to the mercantile, not the chancery, script. This proportion can be obtained by drawing a parallel, I mean two straight lines separated from each other by a distance fixed by the judgement of the eye (depending on the size of the letter that you want) as follows:

Then divide them up by vertical strokes which are separated from each other by half the distance between the parallels as follows:

In this way your letter will have its correct proportions:

But I don't say that it is necessary to observe these proportions each time that you must write because that would be such a difficult and tedious business. I resolved, however, to set out this proportion, like the others which I have mentioned, for the benefit of those who wish to master every aspect of this art, both in theory and in practice.

Detailed rules[8]

To make the letter *a*, you should begin with a horizontal head-stroke ˉ and, with a light stroke back, go down with your pen, making the vertical *ɾ*. Then, with a diagonal, move up to join the horizontal *ɾ* and then come down again with another vertical *ɑ*. Finish with a short [*upward*] diagonal *ɑ*. This stroke serves to join and link one letter with another. Give the letter its proper roundness and elegance, as you see in these examples: ˉɾɾɑɑ ɑ ɑ ɑ ɑ ɑɹ.

Begin the letter *b* in the same way with a horizontal ˆ , curving round into the vertical .ſ.: go back up again with a short diagonal ſ and curving round again make a second vertical *ƅ*. Then, when you have closed the bowl, the letter *b* will be seen to have been made as follows: ˈſſƅƅ ƅ ƅ ƅ ƅ ƅ ƅ ℬ.

The letter *c* begins with the horizontal ˆ curving round into the vertical *ɾ* . Finish it off with a diagonal flick as you lift the pen: ɾɾɛ ɛ ɛ ɛ ɛ ɛ ɛ ɛ ɛ ɛ ɛ.

[7] i.e. the *lettera formata*. [8] For individual letters.

The *d* is derived from *a* but add to it the long vertical of *b* as follows:[9]

rrodddddfd d

The *e* comes from *c*. The thin diagonal stroke which closes it should not (as some say) come down through the middle of the body but a little higher, as you see:

rrreddcdddcdd

The *f* begins with the vertical ¯ and then descends with the vertical *f*, which should be completed with a curve *f*. In my opinion, the height of the letter should be two and two-thirds of the standard body-height.[10] Its cross-bar should be made at a point which is two body-heights above its tail, so that the distance from the cross-bar to the top of the letter is two-thirds of a body-height. Some authorities, however, would have a full body-height between the cross-bar and the top.

TfffffffF

The *g* is derived from *a* and should be two body-heights in length, the lower bowl being somewhat broader than the upper. Do not be surprised that the lower bowl looks longer than the upper. It seems like that because it is wider, as you see:

rrrgggg g

The letter *h* is made exactly like *b*, except that its bowl should not be closed. When lifting the pen [*as you finish the letter*], let it pause for a moment, so that the letter is completed with a slightly thicker line: *ffhbbbbbbb*.

The *i* begins with the narrow diagonal stroke of the pen and runs down with the vertical *i*. It finishes with the diagonal as the pen is lifted in the following way:

iiviiyiiiiy

The letter *k* is composed of the long vertical of *b* and should have its rounded part at the middle of that vertical: *ffkkkkkk*.

The *l* is similarly composed of the long vertical of *b* and finishes with a little diagonal flick as with the letter *i*: *fffffffffff*.

The *m* and *n* begin with the diagonal ⁄ and then go down with the vertical *n*, a short diagonal being left at the foot of the letter. But take note that the connecting line from leg to leg commences above the middle of the first vertical, and so with the other legs as you see: *irnnmmm.irnnnnmm*.

The letter *o* is formed like *c* and is closed with a somewhat curved stroke .

coojojoo o

The *p* begins with the diagonal ⁄ and then goes down with the vertical *p* and should have a curve at the tail *p* and its body is constructed like that of *b*. Note that the down-stroke begins a little higher than the body because, in this way, it appears to have more elegance, as you see here: *ffppapppp*.

[9] Note how in this, as in other examples, Palatino superimposes or juxtaposes letters to indicate their relationship. [10] i.e. the x-height.

The *q* is derived entirely from the *a*, but you add to it the vertical of *p* in the following fashion: ⌐ℓℓℊ ℊ ℊ ℊ ℊ ℊ ℊ ℊ.

The *r* is constructed like *n*, but ends with the horizontal as follows:

⌐ℓℓ r r r r r r r ℓ r

The long *∫* is formed in exactly the same way as *f* but without the cross-bar:

⌐∫∫∫∫∫∫∫∫∫

The small *s*, in my opinion, begins with the horizontal ⌐ and curves away with an oblique down-stroke ⸲. The curve underneath should be somewhat greater than that above: ⌐ ⸲ s s s s s s

The letter *t* begins with the diagonal ⁄ and goes down with the vertical ℓ, to which you must give an up-turn at the bottom, as with *c*; then you cross it with a line at a point equal to the height of the other letters. The stroke, with which it begins, should be somewhat higher than the cross-stroke in order to differentiate it from the *c*, as you see: ⌐ℓℓ t t t ott t tt t t.

The letter *u* is made like the *n*, except that it should be closed at the bottom thus:

⌐ℓ v u u u uu u u u u

The *x* begins with the horizontal ⌐ and descends with an oblique down-stroke ⸌, curving as you see: ⸌. Then add to it a cross-stroke, which also begins with the horizontal stroke but goes down in a way diametrically opposed to the first stroke:

⌐ ⸌ ⸌ x x x x ,x x ,x

The *y* begins and goes down like [*the first stroke of*] *x* without the curved tail; then you add to it a leg as follows: ⌐ ⸌ r r y y y y y y.

The *z* is constructed from the horizontal ⌐ and a diagonal ,z, to which you add a turn at the bottom by means of a sloping down-stroke ℨ.

It can be made in many ways: ⌐ ⁊ z ℨ ℨ ℨ ℨ z ℨ.

The ampersand *&* is of little value, as the following variants are more commonly used: &⸍ ℰ⸍ *a*. . Still, if you want to write it, take note that the lower, larger bowl should be equal to the bodies of the other letters and that the little round part at the top should be half, or less than that, of the one below. It is all made with one single stroke of the pen as you see here: ℰ ℰ ℰ ℰ ℰℒ mℰℓ ℰ ℰℒℒ

The contractions .*ɟ*. and ⸍ℓℒ are now no longer in use; anyhow, they are constructed as follows: ⌐ℓℊℊℊ. ⸍ ℒ ℒℒℒℒℒℒℒℒ.ℒℒ.

General rules

The height of all the long down-strokes[11] should be twice that of the body of the letter: they should be equal in length whether they go above or below the line, as you see: ▭bb dd ff mn ff pp qq ℰℓ▭

The letters that are made in one stroke—I mean with a single movement of the pen—are the following: *a b c g b i k l mn o g r ∫ s u z ℰℓ ɟ*.

[11] i.e. ascenders or descenders.

All the following are made with two strokes: *defkptxyzßo·*

As regards the joining of one letter to another—since other authorities have written about it at great length and really in a very confused manner—I will give you this concise general rule: all the letters which end in a little diagonal or a flick of the pen, such as *acdeilmnu* are joined to the immediately succeeding letters, as you see: *ambmemdme fmgmbmn kmlmnom pmgmp*

So far as writing goes, the *f* and the *t* may be joined to all letters that have no long vertical down-stroke,

though in actual speech they are never accompanied by any of the above-mentioned letters that finish below the line.

The distance separating one letter from another should be equivalent to the space between the two legs of *n*:

The distance separating one word from another should be such that a letter *o* could be inserted between them as follows:

The distance separating one line from another should, in correct theory, equal the space of two body-heights, as you see:

Note that the chancery letter should lean a little forward as follows:

because, in this way, it can be written more quickly: moreover, if it slopes in the opposite direction, it is ugly and slow to write, thus:

The chancery majuscules are all derived from the same three basic strokes as the minuscules. But because there are no fixed rules for them, they are made according to the judgement of the eye. Note that the strokes should be lively and confident with no shakiness, as you see here:

CONCERNING
THE TOOLS OF HANDWRITING

It is not (as perhaps some might think) unnecessary or inappropriate to have included an illustration in my book to portray all the tools that a good scribe must have. For I think that everyone will agree that it is virtually impossible to practise any craft to full perfection without the appropriate essential tools; and even if these are familiar to some people, this is no reason why I should omit them, since throughout this work I aim —as I am sure that anybody who writes a book in any profession does —to teach and help those who lack knowledge: and I do not believe that the people who have knowledge should take offence or that I should be criticised for it. So, dealing briefly with each tool, I shall say the few words that are required to satisfy the needs of young people and beginners.

The *ink-stand* can be of any kind or of any material —it makes little difference. But ink-stands made of wood always tend to cause the ink to dry up; the best ones are of lead, because they keep the ink fresh and black. As to size, they should not be large or small. They should have a wide base to prevent their being upset every time you take some ink. The vessel that contains the ink should have a mouth of the same diameter as that of its bottom; it should not be very high. On account of the dust which spoils ink, it should be kept covered up with a scrap of silk or woollen cloth.

Take care not to use cotton, for it gets caught on the quill, and wears out and decays too quickly.

Ink should be nice and black: it should neither run too freely, nor be too thick because it has too much gum in it. It can be thinned or thickened according to individual need. Thus if it runs too much —and this makes your letters ragged —you should add some gum-arabic. And if it is too thick, so that it does not run smoothly, either because it contains too much gum or because it has been standing too long, then add a little filtered, boiled water, until you see that all is well. You should put the ink in the ink-stand, taking care not to shake it up, as many do, in order that it should be without impurity or sediment. Above all, you must not let it get stale. Those whose aim is to write well generally mix their own ink, for they make it to suit their personal taste. They make up a little at a time so that it is always fresh; this is no problem. And so, although the way to make ink is very well-known, I do not consider it superfluous to set it down here.

To make ink, take three ounces of galls, which should be small, solid, and wrinkled, and crush them coarsely. Steep them in half a flask of wine or, better still, of rain-water and allow them to soak in the sun for a day or two. Then take two ounces of copperas[12] or Roman nitre of a good, rich colour and finely crushed. Stir the galls with a stick of fig-wood and add them in, leaving the mixture in the sun for a further

[12] Ferrous sulphate.

day or two. Now, stirring the mixture up again, add an ounce of gum-arabic, which should be clear, lustrous, and well-ground. Leave for a whole day. To make it nice and bright, add a few pieces of pomegranate peel and bring to the boil over a very slow fire; then strain it and keep it covered up in a glass or a lead container; and it will be perfect.

Quills for writing the chancery hand should be from the domestic goose; they should be hard and clear, and small rather than large, because thus they can be used with greater ease and speed. It does not matter from which wing they are taken, though some writers draw a great distinction here; they can be broken off or bent back above the barrel to make them straight so that they do not twist when held in the hand: this is a serious impediment to rapid and even writing.

Quills should be kept clean of any ink which remains after writing, because old ink interferes with the flow of fresh ink. They should invariably be kept in a vessel with just enough water to cover the part which has been cut to form the nib. A quill must never be allowed to dry out, because this makes your letters ragged and feeble, and it is extremely difficult to write with such quills. You should be careful not to rub quills with a cloth or put them under hot ashes, as many do, to make them round.

Later on, I will tell you how to cut them.

The *knife* for cutting quills should be of good steel, properly tempered and well whetted and keenly sharpened. The handle must be rather sturdy and square so that it does not twist about in your hand when you are using it. It should be three times as long as the blade, though it can be more or less, depending on the length of the blade, provided that it is comfortable and can be firmly held. The blade should be rigid and not hollowed. It should curve a little forward as you see in the illustration. The back should be square, not round, with somewhat sharp edges so that you can scrape the quill. Do not use it to cut paper or hard substances that blunt the edge, but keep it exclusively for the job of cutting your quills.

The *thimble* is worn on your thumb when you cut quills, though it is not indispensable. Yet it is of great assistance to anyone who wears it while performing this operation. It should be black, so that the white colour of the quill shows up against it and you can see what you are cutting.

Pounce is employed when you want to write well and distinctly, but it must be used sparingly, as too much of it will stop the ink from flowing. If you are in a place where it is not available, or if, for some other reason, you want to make it yourself, place a quantity of egg-shells, cleaned of the inside skin, to dry in an oven and make powder of them. Put two parts of this powder with one of finely crushed incense and mix well. This mixture will be excellent and far better than any that you can buy. When your writing is finished and dry, and you wish, because of the smell, to remove from the paper the pounce which you have put on it, rub it with a bit of bread. This will remove it as completely as if you had not put it on in the first place.

The *hare's foot* is employed solely to spread pounce lightly and evenly. You should

keep a piece of paper over the sheet on which you are writing in order to prevent your arm from picking up the pounce on it and thereby spoiling the sheet.

The *lamp*, with its hood, serves to concentrate the light so that it is more intense and bright without injuring the eyes. The flame should be of oil, not of tallow or wax, because it is steady and pure, and does not need to be trimmed so often.

The *dividers*, the *square*, the *straight-edge*, the *ruler* of single and double lines, the *tweezers* for holding the sheet of false lines that show through on to the writing-sheet, enable you to write straight and in the correct proportion, and to develop a steady hand, as I explained in the beginning.

Of the *shears*, *thread*, *sealing-wax*, etc., nothing need be said as they are familiar to anyone who uses them.

The *mirror* is employed to protect the eyes and to ease them when you are working for long periods.[13] A glass one is better than a steel one.

The *stylus* which you see on the ink-stand in the illustration is often used by people when they are writing carefully, to steady the paper in front of the pen, so that the air does not get under it and cause it to flutter.

Concerning the Cutting of Quills

Some authors have devoted so many words to this business of cutting quills, that you would think that they had some great secret to reveal; they have even gone to the extent of writing special books about it. In my view, the longer they have taken— perhaps to pad out their works—the more confused and less well understood they are.[14] Since I do not know that there is such a vast mass of material which demands the consumption of so much paper, I will state the matter very briefly—not to show that I have anything different to say from what they have already said, for it is substantially the same, nor to blame anyone, as this is certainly not my purpose or intention—but simply so as not to confuse, and waste the time of, those that wish to learn, whom I am striving to help as much as my abilities permit.

When, then, you want to cut a quill, take care to select one of the type mentioned above, as shown in the illustration of the tools of writing, and scrape away the fatty tissue on top with the back of the knife. Make the first cut on the same side as the rib, or channel, of the quill to whatever length you think fit. Then with two further cuts give it an elegant and pleasing shape after the fashion of a sparrow-hawk's beak, just as you see in the foregoing illustration. See that the 'ploughshare', as we call that upper part which is made by two cuts, as already explained, is equal on both sides. Next, placing it on the nail of the thumb on which, if you wish, you can wear a thimble as stated above, cut the point according to the size of letter that you want, first thinning it down a little. Remember that, for writing the chancery hand, it

[13] Presumably the scribe turned away from the direct light of his lamp and used the mirror to reflect a patch of even light on to the paper on which he was writing. [14] He is attacking Vicentino.

should be cut at a slight angle, i.e. the right side of the nib, when it rests on the thumb-nail as I said, should be a trifle shorter than the left side. The other varieties of small scripts do not demand this treatment. Make a little slit in the nib with the point of your knife and lightly scrape the sides with the back of the blade to prevent their having ragged edges and picking up bits of cotton. If you keep it clean in the way that I stated earlier and adjust it when necessary, you will be able to write excellently with it.

The Method and Instructions to be followed by all those who are starting to learn Handwriting

To write well proportioned letters and to train the hand, it is my opinion that it would be a good thing to adopt a method mentioned by Quintilian, which I have put into practice with a number of my pupils and have found extremely suitable; for those who have used it have developed a fine, firm, and steady hand. My method is as follows.

First, you must have a tablet of hard wood or copper, in which are cut, or rather hollowed out, all the letters of the alphabet, made in their correct proportions with their basic elements, a little on the large side. Then take a stylus of tin, about the size of a small goose-quill, not hollow but completely solid so as to give it weight and to leave your hand light and rapid when you stop using it. Cut this stylus to the 'ploughshare' shape as for a quill, though it is not necessary to slit the nib. Make your beginner move the end of the stylus repeatedly in the letters which have been hollowed out, starting each letter at the appropriate point, and continuing just as one does when writing with a pen. He should practise in this way until he is certain that he can make the movements confidently without assistance. Then he begins to write on paper between four equidistant parallel lines marked with the tin stylus or a penknife so as not to show black. The middle pair of lines encloses the main body of the letter; the top one is for the ascenders and the bottom one for the descenders, as I said in the beginning when I gave the rules and the proportions for letters. The pupil can use these four lines for a few days until he has fully mastered, both in his mind and with his hand, the correct proportion and basis of all the letters. After he has done this, he should accustom himself to writing with only the middle pair of lines for a few days. Then he should write on one alone, until his hand is firm and confident.

It is also the practice to write on a blank sheet which rests upon another sheet, ruled with black lines that show or come through on the upper sheet. The sheet with the black lines is called by some the 'false rule' or 'show-through'. If you write over this, you will strengthen your hand perfectly until you will be able, without any aid of lines, to write well and very confidently.

I would recommend that, when the novice starts to use a pen, he should employ one that has been trimmed away so that it is flexible, with a good slit which gives an ample flow of ink, and the need to press down on the pen because it is moving laboriously and with difficulty—which would make for a heavy hand—is thus obviated.

Above all, the learner should accustom himself from the beginning to write in proportion and according to rule. This he can do without a master by availing himself of the models and instructions that I have given at the beginning of my manual. But I would always be in favour of his learning from a master from the outset because, as Cicero says, no art can be properly learned from the written word without a teacher. There is a lot more that I could say, but I will not set it down here. I will reserve it for another work, no less useful than this one, which, if it please God, I shall publish in a few months for the public's benefit and the satisfaction of connoisseurs.

From Giovambattista Palatino, *Libro nuovo d'imparare a scrivere.*

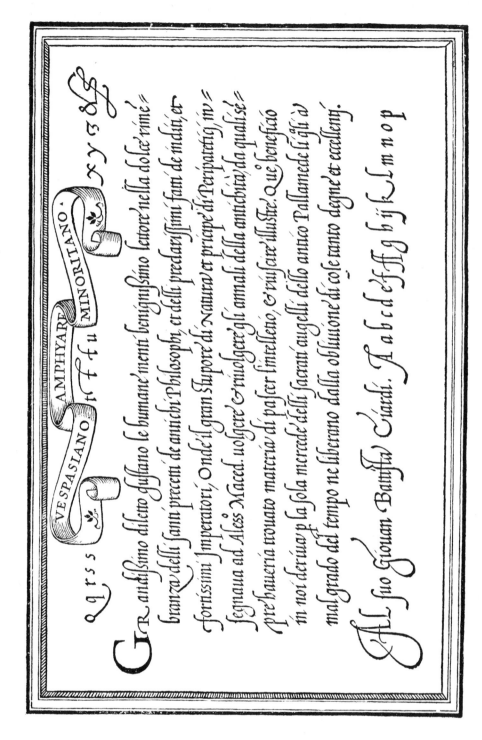

7. From Vespasiano Amphiareo, *Un novo modo d'insegnar a scrivere*, Venice, 1548.

CHAPTER SEVEN

Two Priests:
Amphiareo and Augustino da Siena

I

AMPHIAREO

Vespasiano Amphiareo was born about 1501 at Ferrara, where he was educated, and died about 1563, probably in Venice. He belonged, like Sigismondo Fanti and Ugo da Carpi, to a noble family. He entered the Church, becoming a member of the Franciscan minor order. From some hints in his writing-book, we can gather that at one time he travelled about Italy, spending some years in Florence. Most of his life, however, was spent as a public writing-master in Venice. As a young man, he could well have taken lessons from Tagliente; certainly he would have been familiar with his work.

In 1548, he published his book of models under the title *Un novo modo d'insegnar a scrivere* (called *Opera di Frate Vespasiano* in later editions). It is a handsome production, partly because of its format—the oblong quarto of earlier writers but arranged like a landscape album—and partly because of the clarity of its engravings. The contents are laid out in the familiar pattern in which everyday hands are followed by more exotic alphabets. The latter include, for the first time in an Italian writing-book,[1] a set of capitals derived from tree-trunks; another is of heavy gothic initials, hung with grotesque masks and providing a scaffolding on which naked cherubs, monkeys, storks and dogs engage in various activities; and a third displays rather hairy letters in black strapwork. The German influence is very strong here and reminds us that Venice was a terminus of the much-used trade-route to the great commercial centres of Augsburg and Nürnberg. The book ends with a type-set section, which provides directions for cutting quills (drastically abridged from Vicentino) and a recipe for making a clear, black ink that would not fade.

In his second edition, Amphiareo added further short sections about the preparation of azure, gold and vermilion for illuminating. His gilding required fine

[1] Similar designs can be found in Palatino's Berlin MS, the composition of which began about 1540.

gold powder, which involved the meticulous grinding of gold leaf. The good friar knew what hard work this was. 'Don't make this rod for your back,' he says. 'Get a painter's lad who can grind well, and leave it to him.' He shrewdly adds: 'But stand around to see that he does not spoil or steal the gold.' In his recipes, he has a delightful way of measuring time: 'Stir for as long as it takes to say a Miserere' or 'Grind for half an Ave Maria'.

Although Amphiareo's book unfortunately contains no instructions or reflections on handwriting, it is important because it tacitly betrays the unease about the future of the italic hand in Italy, which Cresci was to voice so harshly a few years later. In the first place, the chancery models shown in the book are slightly less compressed than those of Palatino. The letters with bowls or bodies such as *a*, *g* and *o* are a trifle more rounded and the two-to-one proportion consecrated by Palatino is not quite observed. The differences are subtle but sufficient to show that Amphiareo felt that there was a risk of the hand being too tight and angular. A more significant development, however, can be seen in the first few blocks of the manual. These are devoted to Friar Vespasiano's own invention.

It arose, as the book's introduction tells us, like this. For many years he had been meditating a hand that would be suitable both for chancery officials and merchants. He had noticed while teaching in Florence that they commonly used there a mercantile script, which was slow, and difficult to write and to learn. He therefore devised a synthesis of the mercantile and italic hands, in which different elements were blended 'like a mystic body'. This Friar's Bastard, as he calls it, being slightly elongated and graceful, would in his view meet the needs of chancery work; at the same time, being rapid and cursive, it would be of service to the commercial world. What Amphiareo did in effect was to graft a few mercantile letters and joins on to his chancery italic. The bastard, however, although it attracted some interest from later Spanish writing-masters, was never legitimised by popular adoption, though the book was reprinted from time to time for the rest of the century. It is doubtful whether it could have been written more quickly than either of its parents, since it was the product of arbitrary modification, not of natural evolution. Still, it showed that change was in the air.

The half-dozen or so pages of italic models which come after the experimental script are worthy to stand beside those of Tagliente and Vicentino. Although they are formal, even statuesque, they accurately reproduce the letter shapes of the true chancery hand. They are in keeping with the book as a whole, which echoes the tranquillity of the cloister rather than the bustle of the market-place.

HOW TO CUT QUILLS

I could make a long story out of this; but heed these few words, which I shall write down here for your instruction. To begin with, you must know that quills should be round and clear. When you have made the first cut of the quill, you should make the second and third so that the end looks like the beak of a sparrow-hawk. Then, placing it on your nail, cut the nib to a bevel. If you thin it down a little, it will write more smoothly. Above all, pay attention to what I tell you now about the correct manner of holding the pen in your hand. You should know that, when you are writing, the pen should point to your right shoulder, but see that the pen is cut from a quill taken from the bird's right wing, as this leads to better writing. When the quill comes from the left wing, it will point in the opposite direction, but let your hand grasp it in such a way that, if it were straight, it would point to the tip of your shoulder; for it is not always possible to have quills taken from the right wing. Do not expect to master the cutting of your quill immediately, since this is learned day by day just as you gradually learn to write.

RECIPE FOR MAKING INK
that will neither go mouldy
nor leave a sediment in the bottom of
the ink-pot

Of all the places where I have been, I have come across only a few where people know how to make good ink; in my opinion, this knowledge is an essential part of our daily life. Therefore, in order that you shall have the perfect recipe, I am publishing it, so that your writing will not fade in the way that you can observe happening in many manuscripts, choir-books and legal documents, in which the letters after a short time can hardly be seen and are illegible; it is with the aim of putting an end to this state of affairs that I am making public the following piece of knowledge.

Take thirty ounces of white wine, the strongest that you can find. For a strong wine extracts the vital essence of gall more effectively than water. Put into this wine three ounces of Istrian galls, which should be small and wrinkled and broken, not ground, because if you grind them, within a few days the ink will become as thick as mashed beans. Let the galls soak in the wine for twelve days or so, two days more or less do not matter. On the twelfth and final day do not stir, but sieve the wine through a piece of thickish linen, so that it is clear. Throw the rest away, as it is no good for anything. Now add to this wine twelve ounces of copperas[2] and see that it is

[2] Ferrous sulphate.

good, because the blackness of the ink depends on the copperas. When you have mixed in the copperas, stir the ink for as long as it takes to say a 'Miserere'. Then add an ounce of gum-arabic, which is clear and cracks like glass—this is the true gum-arabic. Let the gum-arabic first soak for a day in white wine until it has the consistency of turpentine. You will then have a most excellent ink; but note that good ink will not be at its best and blackest, unless it has been stored for fifteen to twenty days.

 This is all that is required to make a superb ink.

<div align="right">From Vespasiano Amphiareo, Un novo modo d'insegnar a scrivere.</div>

II

AUGUSTINO DA SIENA

No doubt because of its excessive rarity, the writing-manual of Don Augustino is not well known; yet it deserves more attention than it has received. The author was a Carthusian monk from Siena. No details of his life are known. He was a close friend of Mattheo Pagano, who is well known among cartographers as a Venetian map-publisher. When Don Augustino failed to find a printer for his models of the *littera formata*, the formal round gothic hand which was written with a broad pen and used for choir-books and missals,[3] Pagano ('dear to me as a brother') encouraged him to publish (about 1565) the collection of chancery italic and mercantile models, which formed his book *Opera . . . nella quale si insegna a scrivere*. Many, if not all, of the models were written in the Charterhouse of Bologna.

The *Opera* is an oblong quarto. Each of its blocks is surrounded by a broad wood-cut border of symbolic design, of which there are four main varieties. The text-area is often invaded by little drawings of flowers, or more often birds, and sometimes bits of pattern, similar to the specimens contained in Tagliente's book of embroidery samples. One block, for example, shows two cuts of a bird darting at an insect in a way that is reminiscent of a Thomas Bewick engraving. These decorations, although they are no doubt a reflection of Baroque taste and may be compared to the more elaborate confections which Clément Perret[4] was at this very time designing for his own writing-book, give the pages an innocent charm. They were probably intended for the diversion of younger pupils.

In the introduction, the Reverend Father says that he has published his work so that 'gentlemen and young men of good family can adorn themselves with a worthy and noble accomplishment that sets a man off perfectly, while those who, because of their parentage do not occupy so high a position in society and those of lowly birth can, with the aid of my *Opera*, improve themselves and not envy those who have been born and brought up in better circumstances (materially at least); they can walk with their heads high, proud to realise that, without this accomplishment, even men of superior quality cannot ennoble themselves or appear in the ranks of the noble.' We can appreciate that these are not idle words by considering how, through secretarial skills, a butcher's son, Thomas Wolsey, rose to be the most powerful man in England.

Augustino's manual is divided into three parts; the first is a treatise on the chancery hand, the second is devoted to the mercantile hand, and the third is a collection of mainly German scripts. The German influence is an interesting one; we noticed it earlier in Amphiareo. But the most unusual feature is the extended treatment of the mercantile hand, which was rapidly becoming obsolete, although it

[3] This is the same as the *rotunda*. [4] See pp.218–20 below.

must still have been widely used in Venice. On the other hand, Augustino drops most of the exotic alphabets that the earlier masters liked to show.

It can be seen from his opening section on the chancery hand that Don Augustino had studied the teaching of several masters. He gives his italic the compressed, acute proportions of Palatino; at the same time, he introduces vigorous, even extravagant, flourishes that derive from Tagliente. His link to Amphiareo is patent and undeniable; not only does he include an example of the bastard chancery-mercantile (criticising it, incidentally, with asperity[5]), but, at the end of his book, he prints verbatim Amphiareo's sections on quill-cutting and making black ink. His division of letters into groups, according to the line with which they begin, is probably based on Vicentino.

Augustino's main contribution to theory, which he records at the outset and repeats later, is to postulate four basic strokes for making letters: the horizontal or head-stroke (*testa*), the curved down-stroke or body-stroke (*corpo*), the narrow diagonal (*virgula*) and the vertical (*asta*). He has, in effect, taken the three strokes of Palatino and supplied a missing element—the curved down-stroke. He then explains that the chancery letter is related to an oblong consisting of two squares (one above the other), and not one. Again, he is echoing Palatino. He goes on to group the letters according to whether they begin with a horizontal or with a diagonal stroke, and explains their construction. After this, he deals with the relationship between the long letters—those with ascenders and descenders—and the rest. He adopts Palatino's method of starting off the pupil with four guide-lines for his writing, then removing the two outer ones, and finally leaving only one. Having dealt with the individual letters, he shows how words are built up and gives rules about joining and spacing letters and words. He ends with some brief comments on capital letters, which he states are not subject to rigid rules but can be made in various ways, always provided that lively, confident strokes are employed—another echo from Vicentino. The manual tells us nothing about paper, pen-hold, or the instruments of writing.

With hindsight, one can see that the *Opera*, although it went into three editions, was—in Italy at least—an anachronism, the last twitch of the nerve. Both the styles of handwriting with which the book is largely occupied (the chancery italic and the mercantile) were seriously threatened, and eventually overwhelmed, by changes in fashion and technique. As so often, underlying movements were invisible to those apparently best placed to notice them. It is especially ironic that Don Augustino, in teaching the chancery italic hand, should have followed Palatino's double-square or two-to-one proportion, which resulted in the narrow, angular version that was attracting criticism. We shall, however, say more about the crisis of the classic chancery hand in the next chapter.

[5] The wording of the example runs: 'He who neglects proportion in handwriting bastardises his reason and falls into a crude method of writing, thereby arriving at a bastard letter, whose only distinctive feature consists of crude strokes lacking in proportion.'

A DISCOURSE
ON THE CHANCERY HAND

If you want, kind and gentle readers, to learn the chancery hand, there can be no doubt that you must observe the following instructions; among them I shall mention some general and some particular rules about the construction of the chancery alphabet that will command universal approval.

Let us begin then with the four natural pen-strokes with which every chancery letter, minuscule and majuscule alike, is constructed. They are the following: the horizontal head-stroke [*testa*] ‑ , the curved down-stroke or body-stroke [*corpo*] ι , the narrow diagonal [*virgula*] ⁄ and the vertical down-stroke [*asta*] ı . All the above-mentioned strokes play some part in all the letters of the chancery alphabet, though of course in different ways—sometimes they are upright and sometimes sloping, as you can see by studying the alphabets of chancery letters written below:

in which the model shows you the whole alphabet in sequence.

From the point of view of geometry, the true chancery letter is based on two squares, not one, if you wish to write it and shape it correctly.

The chancery alphabet in its correct proportion:

Of the ten letters which have long ascenders or descenders, there are seven which, as you see, are made with body-strokes also:[7]

b.d.g.b.k.p.g.

The remaining letters in the alphabetical sequence x.y.z.&.g.ʃↄ. have their body-strokes or verticals at an angle to the natural descending strokes.

The following letters consist entirely of their bodies, none of them being accompanied by a long ascender or descender: a.c.e.o.s.

[6] This model would be more correctly placed at the end of the next sentence.

[7] The other three are *f*, *l* and long *ʃ*, which consist of little more than vertical lines.

Furthermore, the following letters ɪ.m.n.r.t u consist of short vertical lines but remain within the body-height; they are therefore grouped with the letters which are made with curved strokes.

Concerning the beginning and finishing of the letters of the alphabet

The following letters begin with the horizontal head-stroke: ⌐abcdefghklogſs

In particular, the letters acdegſ begin with the head-stroke and end with the 'dead line'[8] which is made with the edge of the pen. The following letters b bbogſsſſ ſʒ ßſʒ. finish with the same stroke as they started, i.e. a horizontal. The letter *k* begins with a horizontal head-stroke and finishes with an oblique stroke. The letter *p* starts with a short diagonal and ends with a horizontal. The letter *r* begins with a diagonal and finishes with a horizontal.

The letter *ſ* starts with a horizontal head-stroke; the letter *t* begins with a diagonal. Both are completed with a cross-bar. The following four letters begin and end with a short diagonal : i. m. n. u. The final letters of the alphabet which follow x. y. z. & g. ʃɔ. are begun with the horizontal and for the most part end in an oblique direction. You should note that, as a general rule, the letters of the alphabet can start only in one of two modes or strokes, i.e. the horizontal head-stroke ⌐ or the short diagonal ∕.

Model of the letters which begin with the horizontal: ā bcdefghk ſ ŏ gʒſxʒyʒ ʒ&g.
Model of the letters which start with the short diagonal:

 ⌐ɪ ∕m ∕n∕p∕r∕t ∕u∕ʃɔ

The characters written with a single stroke of the pen are the following:

 a b cgb iſm n o g rſsuxʒg.

Those written in two strokes are the following:

 ſ cf k p ɪx cy & cʒ.

In general, all the letters made with round strokes are either self-contained or are accompanied by a long vertical stroke.

They should all be constructed to the same size and proportion as follows:

 ⌐abrdcgbimnopx⌐

Similarly the verticals which extend above and below the letter-bodies should be regularly constructed to the same height or depth, with the exception of those of *f* and long *ſ*. These fall short of the height of the others by one quarter, as you see in this illustration:

 a bcdefghik ſmnopq rſstuxy

[8] The diagonal serif that finishes off the letter. It will be recalled that Sigismondo Fanti also used the expressions 'dead line' for this purpose. See p. 51 above.

Concerning the letter a, *which embodies the four natural pen-strokes in its construction*

The chancery letter *a* embodies in its construction four strokes as follows: the horizontal head-stroke ‑, the curved down-stroke *ı*, the narrow diagonal ⁄., and the vertical *ı·*. It is made as follows from these four natural strokes ‑ *ıı a*. All the letters of the alphabet can be made from them in the same way; some demand two, others three, and others four for their construction, as you will see when you come to shape them.

Illustration of the four chancery strokes: *compo ꝗ·Aſtꝛꝺ·*

Now I must tell you that none of these four strokes that I have mentioned serves any purpose in isolation; each simply contributes to the construction of the letters of the alphabets. When, therefore, you want to make any letter you need, you must first start with the horizontal head-stroke or short diagonal, which are the beginning of all the letters, and marry to these two (according to the letter you intend to make) the other strokes—the curved down-stroke and the vertical—and thus, with the assistance of one or the other, you will be able to fashion every letter of the chancery alphabet.

Detailed rules of construction

If you wish then to come to the actual practice of this excellent art of writing in the chancery style, you must first make a start, prudent Reader, with four equidistant parallel lines as shown here: *con chiara proſpettiua'uedi.*

These are marked with a lead stylus; their purpose is to regulate the proportions of the letter-bodies and the long ascenders and descenders. When you have thus learned every letter in detail, you should then write between two guide-lines, simply to give the dimensions of the letter bodies: *exemplo*
After you have practised this for several days, you should begin to write on one line only to acquire steadiness of hand.

Vmını coſedeınn.

By learning in this way from the outset with the correct rules and proportions, you can thereafter, without ruling any lines on the paper, write fluently by yourself and make confident flourishes; by always availing yourself of my models, both minuscule and majuscule, and observing the present rules and proportions you will find within a short time, I promise you, that you have completely mastered the art.

If you aim at a complete knowledge of how to write this chancery hand, whether formally or informally, make sure that the letters slope towards your left hand[9]

[9] In English we would normally say 'to the right' because we think of the top moving *forward*, whereas Augustino sees the bottom as moving *backward*. Sigismondo Fanti also described the sloping of writing in this way.

because you can write and form your letters more readily and more rapidly, as you can clearly see in the alphabet which I have prepared for you here:

Models of the alphabet to train the hand:

Now follows a model of the letters that are made in one stroke and those in two:

All the letters which are not marked with a point above them are made in one stroke as you see in the model above.

When, then, you have thoroughly learned the individual letters, you must, in order to build up a complete word, know how to set one letter alongside another and how to connect them up in the way that the following rules prescribe.

Model of a word: *Augustinus*

Take note that when you are writing, whether formally or informally, not to make more than two or three letters with a single pen-stroke, if you want to succeed in the chancery hand.

Model for letters:

Some general rules now follow. The first general rule which you should know is that all the letters which begin or end with a diagonal serif can, and should, be joined with the preceding and succeeding letters, as you see in the example:

But those that end in a cross-bar, such as *f* and *t*, are joined by the cross-stroke to the succeeding letters, as you see:

The following letters *b . g . b . o . p . g* do not themselves make a join but they may be joined by other letters. The following characters *x y z* cannot be correctly attached to other letters.

Furthermore, commit to memory the following brief rules: namely, you should know that the distance between one line of writing and another is thus—two double squares or two heights of the letter *a*.

You can see from the following example which I have set down here the true dimensions of the chancery ascenders and descenders which should be employed in the chancery hand:

The space which should separate one letter from another should be equivalent to the white space between the legs of a well-shaped *n*, as is carefully shown in the following example:

The interval or spacing between one word and another can be seen in the following measurement .II. or is rather the full width of the letter *u*, as the example written here illustrates:

These foregoing rules should be applied according to the judgement of the eye and not always by actual measurement, because it would be tiresome to measure every letter as you write. Let it suffice now that you know the rules and theories of the

chancery hand, and, by grasping the meaning of this art, you will quickly find that you are master of it.

The following majuscules, which are only lightly ornamented with flourishes, are for use in the body of the text. They are not made as large as those which are written at the opening of a passage, for this would be neither appropriate nor desirable.

Small chancery majuscules:

The following are the flourishes which are used for decoration in the chancery hand:

Concerning the large chancery majuscules

As to the majuscules, I should tell you that they are all derived from the four basic chancery strokes on which the minuscules are based. They always begin with one of these three strokes ⌐⌐ // ‖ . The head-stroke is horizontal and broad: the diagonal is slanting and narrow; and the vertical is broad and straight. Now I say that these majuscules do not have any rigid rules governing their construction, because they are written in various sizes and fashions according to the way in which the quill is cut. They can be formed with a variety of strokes, and they are more rapidly made by eye than by any other method. They should always have lively confident strokes, not spoiled by shakiness or any other fault, if you want to construct them properly. I will

conclude by simply saying that I urge you with good will to learn these letters in their perfection, copying the models of them which you see written here:

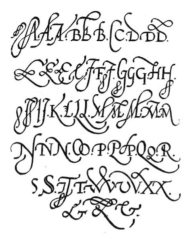

From Augustino Da Siena, *Opera . . . nella quale si insegna a scrivere.*

Gran differenza è da l'huomo, che si presume huomo senza sapere, da gli animali senza ragione, che sono senza comparatione più utili gli animali per lauorare la terra, che gli ignoranti per seruir la republica, Un semplice bue da il cuoio per calzare, la carne per mangiare, le forze per arare, La innocente pecora da la lana per uestire, e il latte per cibare, Ma l'huomo ignorante à niuno gioua, nuoce à tutti, offende Iddio et mangia il pane de Virtuosi.

Ioannes Franciscus Crescius Mediol=
Lanen. Nome Scalseb.

8. From Giovan Francesco Cresci, *Essemplare di piu sorti lettere*, Rome, 1560.

CHAPTER EIGHT

A Conservative Revolutionary: Giovan Francesco Cresci

The most passionate and radical critic of handwriting in the sixteenth century was undoubtedly Giovan Francesco Cresci. He was born in Milan of well-to-do parents, probably around 1534–5. The family fortunes changed for the worse, however, and about 1552 his father Bartholomeo, who had been procurator and agent to Cardinals Salviati and Cibò, brought him to Rome, where he spent most of his life. He liked, nevertheless, to describe himself as 'a gentleman of Milan' and occasionally introduced a Lombardic word into his writings.

He had been interested in handwriting and calligraphy from boyhood, and in 1556 he obtained an appointment as scriptor or copyist in the Vatican library with a salary of ten gold scudi a month. He must have been good at his job, since within four years he was given an additional appointment in the Sistine Chapel, where he copied missals, service-books and choir-books. During this period, he designed an elaborate alphabet of grotesque capitals, spending two years on the work, which so pleased Cardinal Salviati that he gave him 180 scudi to have it engraved. He had an interest in a printing-press, and he confesses that, given the opportunity, he would have tried his hand at designing type.

In 1570, he had to leave Rome to look after his aged father, who had returned to Milan. When he later came back, for some reason he did not take up his former place in the Vatican; it is likely (to judge from his writings) that he had been a difficult colleague, whose departure was not altogether unwelcome. He was by now so famous as a result of his books that we can reasonably assume that he had no difficulty in supporting himself as a writing-master. He died, according to his son, who arranged the posthumous publication of one of his books, 'in advanced old age'; perhaps, then, in the early years of the seventeenth century.

Cresci was the author of three writing-books[1] and two solid works of controversy.[2]

[1] *Essemplare*, Rome, 1560; *Il Perfetto Scrittore*, Rome, 1570; *Il Perfetto Cancelleresco Corsivo*, Rome, 1579. There is a fourth book attributed to Cresci, *Il Quarto Libro*, Rome, 1596. This is, however, a collection of models written by him in 1579–80 (by-products of his third book) and put together by a Cistercian monk, Silvio Valesi, who states that they had come into his possession after being lost for ten years. It could be inferred that Cresci was dead by then. Alternatively, he may have returned to Milan to spend his last years with his son.

[2] *Avertimenti*, Venice, 1579; *L'Idea . . . dello scrivere*, Milan, 1622 (posthumous).

All these contain passages of great interest and importance for the history of handwriting. We learn, for example, of his views on the physical problems of handwriting, a subject on which much research is required even today. Handwriting, he states, demands not only imagination but a steady, flexible, naturally gifted hand (which he justly says left-handers do not ordinarily possess), a good memory for the numerous rules that must be observed, and perfect vision. In the absence of the latter, it is better to be short-sighted than long-sighted[3] but sight should not be so short that the writer seems to be using his nose rather than his pen. Strong, heady wines are also a danger. They soon weaken the muscles of the hand and make it shaky; they impair the vision and undermine the secretary's skill. Heredity also plays a part. Parents accustomed to eat, drink and sleep too much tend to have children who are unteachable and senseless, and have poor sight. The offspring of poor parents living on a subsistence diet of millet and buckwheat bread with garlic, onions and water will also lack the constitution to become proficient in the art of writing.

Cresci waxes eloquent about the high calling of a secretary. Those 'to whom the burden of so honourable an office is entrusted' must not only be loyal, agreeable, discreet and industrious, but have command of several languages. Furthermore, they must be familiar with current affairs and be able to express themselves well. A vital part of their equipment is the mastery of the various styles of handwriting. A letter written in a faulty hand is bad for the reputation of the secretary, however cleverly he has drafted the text. A badly written letter is distasteful to the recipient; whereas, when a man opens an elegantly written letter, he is favourably disposed to accept the argument in it.

There is a curious schizophrenia about Cresci, which perhaps reflects the loss of direction of the times in which he lived. On the one hand, he looks back to the traditional scripts, especially the Roman inscriptional capitals, which he had studied intensively on Trajan's column and used as the basis for his own beautiful version, and the roman and italic book-hands, written deliberately with old-time craftsmanship. These were the scripts at which he excelled in his copying work at the Vatican. Here he was right at the centre of the Counter-Reformation, essentially a movement of turning back the clock. On the other hand, Cresci was responsive to the increasing demands of the political and commercial worlds. He could see, as we do today, that the pace of business was accelerating and that secretaries were under unprecedented pressure. He shared the gathering doubts as to whether the chancery italic and conventional mercantile hands were adequate for their purpose.

After deep reflection, he published his conclusions in the foreword to his manual, *Essemplare* (1560). They play on two basic themes, the new chancery cursive and the construction of Roman inscriptional capitals. The latter is worth studying by anyone

[3] An interesting point: perhaps the most notable instance of a long-sighted secretary was Samuel Pepys, whose vision greatly deteriorated in later life. Scribes who specialised in miniature writing, such as Scalzini (see p. 243 below), may have been able to do so because they were exceptionally near-sighted.

interested in lettering; Cresci throws out all the claims of 'geometry' and reinstates the judgement of the eye. As regards the former, Cresci claims that his is the modern, genuine chancery hand. The old-fashioned chancery italic (i.e. that of Tagliente, Vicentino and Palatino) is lethargic and slow, the reason being that the letters are too narrow and pointed, which makes it difficult to join one with another. The italic pen is too broad and square, and is held at too much of an angle. Finally, the letters do not slope enough. In a few words, directed at the right places with the skill of a professional who has thought about the fundamentals of his art, he demolishes a system.

It follows that he himself recommends a narrower pen, held only at a slight angle; adopts a slope of 10–15 degrees rather than 5–8 degrees; opens up and rounds the letters, as Amphiareo did to some extent before him; and uses more joins. He also employs, in the interests of speed, some non-italic letter forms e.g. an unclosed *o* made in one stroke *o* ; an *h* with the long vertical abbreviated *ʂ* ; a mercantile *r* *ɀ* ; a broken-backed *d* *∂* ; an *l* resting on a horizontal base, not finished off with a diagonal flick *ℓ* . The serifs which terminate such letters as *i, m, n,* and *h,* come up with a slight curve, not an angle. The heads of the letters with ascenders, such as *b, d,* and *h,* are no longer made with a short horizontal stroke or with an in-and-out movement which produces a slight thickening, but are formed by a circular movement that results in a blob or knob. The physical effect of these changes was that rotating movements of the hand tended to displace the reciprocal motions required for the chancery italic. At the same time, the writer now stood further back from the table, and manipulated his narrow pen (which required thinner ink) with more wrist movement. Instead of letting the pen do the work, as with the earlier italic, the writer had to have both a light touch (the ink now being more runny) and a steady but flexible hand. From now on the obsession of Italian writing-masters is transferred from constructing the alphabet by geometry to acquiring this brand of manual agility.

It is to be noted that the use of a narrower pen coincided with the spread of the copperplate process in Italy in the 1550s.[4] Writing-books would soon be reproduced no longer from wood-blocks but from engraved plates. As the pen becomes more like the engraver's burin, we find the writing models are decorated with loops and conceits until the italic element in the chancery style is submerged in the full flood of the copperplate hand. Here too, we notice a typical conflict in Cresci's mind. In the *Essemplare* he apologises because the blocks at the press were cut in wood, and thus detracted from the neatness and clarity of his originals. Yet he continued to use the traditional process. He makes an illuminating comment about it in a later work.[5] The wood-block process is, he says, *more faithful* because the wood-cutter removes the superfluous wood, leaving the master's writing on the block, whereas the copperplate

[4] See p. 21 above.
[5] *L'Idea ... dello scrivere.*

engraver, as he traces over the writing with his burin, destroys the original which he is copying and loses the subtle gradation of the lines.

One last point about the *Essemplare*: Cresci criticised the wide variety of scripts displayed by previous writers, many of whose products (e.g. the mirror-writing of Palatino and the tree-trunk alphabets of Amphiareo) were in his opinion absolutely useless. He severely restricted the inventory to the basic traditional book-hands and inscriptional capitals, and to his chancery cursive. Like Tagliente, however, he expected the secretary to know several versions of the latter in various sizes, ranging from those suitable for formal documents to looser (and it must be confessed) less legible models for general correspondence.

The revolution in handwriting—for that is what it was—represented by the *Essemplare* was not solely Cresci's work. He was putting into words a mounting dissatisfaction. His contribution was to pick up the problem, analyse it coldly, and to broadcast his solution in trenchant, vigorous language. His book had a decisive effect: after its publication only one manual dealing with the chancery italic, that of Augustino da Siena,[6] appeared in Italy.

The traditionalists knew who the enemy was. Palatino was rash enough to take up the challenge. He printed a counter-manifesto in the 1566 edition of his manual, which he now called *Compendio del gran volume*. Names are not specified. But no one could have had any doubt that it was aimed at Cresci, for the opening sentence cleverly parodies the rather pompous invocation of Cresci's dedication. Palatino despises his adversary as a mere 'scrivener and copyist'—a clear reference to Cresci's employment in the Vatican. He laughs at Cresci's meagre selection of book-hands, which look as though they were carefully painted rather than written and are far from true geometry. 'No variety of script rightly deserves to be called "cursive" simply because it makes the hand of the writer more swift and fluent, since any kind of letter, if written by a naturally gifted hand properly trained and practised in the art of writing, can, though inaccurately, be called "current" or "cursive" . . . but the only style which, beyond all others, can and should have this name is the genuine, natural letter of the Roman chancery, as taught by me.' He criticises the introduction of new letters into the chancery script; even though they may be faster to write, they form a mixture of styles which 'one might call the "common bastard" hand.' Some of the innovations are less offensive than others. In any event, this bastard hand is clearly the offspring of 'principles and rules both general and particular, set out by *me*'. He then does an extraordinary thing in order to prove this. He has all the italic section of his book re-written in a sloped Cresci-style script. In spite of the brave words in his preface, Palatino clearly saw that the day of the chancery italic was over and rather pathetically jumped on the bandwagon.[7] Victory to G. F. Cresci!

[6] See previous Chapter.
[7] Palatino's Berlin MS, which spans a period of about 1540–75, shows how decisively he renounced his version of the classic chancery hand for a less angular Cresci-type style.

In his next book, *Il Perfetto Scrittore* (1570), Cresci reaffirmed his devotion to a limited canon of scripts. In one of the similes of which he was so fond, he compares his styles to a company of soldiers, well armed and ready for combat, whereas those of Palatino resemble a mob of peasants who, as they come back from a day's reaping in the fields, shoulder their sticks like arms to make a show.

Cresci also tells us something of his teaching procedure. The paper should be ruled so that the young pupil can concentrate on learning the letter-shapes without worrying whether his lines of writing are straight. Each pupil should receive a daily lesson with individual attention, his progress being graded according to ability. The syllabus must revolve around five principal subjects which are repeatedly practised—the letter-shapes of the minuscules, capitals, joins, abbreviations, and cutting the quill. Much emphasis is laid on learning the correct letter-forms. When the pupil has a particular difficulty the master puts his left hand over the other's right and guides it so that the pupil experiences the letter kinaesthetically. Cresci did not, as later masters did, claim to teach proficiency in a few days. He believed in deep, systematic grounding, spread over a period of six months.[8] *Il Perfetto Scrittore*, one of the most sumptuous of writing-books, gives a further selection of the new chancery cursive models: it is significant that the most informal go further in the direction of illegibility-through-speed than in the earlier manual. The book is remarkable not only for the elaborate alphabet that earned the 200 scudi already mentioned but for two marvellous sets of large Roman capitals, white on grey and black backgrounds respectively. The latter are the finest to be found in any writing-book of the time.

With Cresci, the chancery italic system of handwriting reached a crossroads. One signpost pointed to a model with softer, rounder and ultimately more practical outlines, which at the same time preserved the essential principles. This was the direction that the Spanish writing-masters and the authors of the modern revival of italic handwriting would take. The other pointed to a sprawling sloping hand, in which legibility was unhesitatingly sacrificed to speed. This was the path along which Cresci (somewhat tentatively) and most of Europe marched. The Friar's Bastard proposed by Amphiareo was the grafting of a few alien strokes on a script, leaving the main mechanism unchanged. It therefore led to nothing. Cresci's bastard (as Palatino called it) was a quite different animal. For Cresci, who saw handwriting as an integrated system of interlocking movements, provoked an irreversible biological mutation in the chancery hand. As we shall see later, he in his turn was attacked by younger men for not going far enough. Thus the revolution devours its own children.

[8] Cresci, to judge from insinuations of opponents, which he does not deny, was himself a slow writer.

THE ATTRIBUTES OF A SECRETARY

Wishing to assist men of worth, particularly students of the art of handwriting, to the best of my ability, I have always striven in their interest, without sparing any effort, to enable them to see not only my words but my actual examples by having my work printed. (I leave each man to form what opinion he will about them.) Thus I published my first book of examples, *Essemplare*, followed by the second, *Il Perfetto Scrittore*, which contain all sorts of different scripts. Notwithstanding this, I have now decided to send to the press this further book, *Il Perfetto Cancellaresco Corsivo appartenente a Secretarij*, especially to meet the needs of those who find this cursive style more attractive than any other, both because it is generally the best known and also because of the dignity and excellence of the office in which it is employed; for it is specially suited to the requirements of the chancery.

This office of course has always been greatly respected in the world, particularly at courts, and is still so to-day. As we all know, it is the duty of those, to whom so honourable a charge has been entrusted, not only to be loyal, agreeable, discreet, industrious, fluent in several languages, conversant with the world of knowledge, and capable of explaining their own ideas, but also to possess an abundant stock of the styles of handwriting, and above all the capacity to write a fine chancery hand, by which (with credit to themselves) they are able to explain their thoughts. The ability to write well is as necessary as any other part of a secretary's equipment; for it is not a good thing, when he is writing a letter or other document, intended to be delivered to and read by a king, an emperor, or other great prince, that, though perfect in other respects, it should be defective and faulty in respect of the handwriting, because he has written it in a hand which is indistinct, shaky, uneven and ill-formed.

When this occurs, it not only seems to be an offence to the personage to whom such a deformed hand has been written, but also greatly detracts from the dignity of the gentleman who has sent the letter and obscures the reputation, knowledge and drafting skill of his secretary. As soon as a letter covered in bad writing is opened, it produces a sort of distaste in the recipient who looks at it; and the ideas and opinions it contains, because they have lost impetus and fall from the lips of the reader languid and imperfect, fail to impress. Instead of enlisting the goodwill of the reader, it rather earns his disapproval. This will not happen to a skilled secretary who matches the solemnity and sweetness of the literary style with the workmanship of a fine hand. The moment the letter is opened and reveals the arrangement, beauty and distinction of the writing, the mind of the man who looks at it is attracted by it, and it fills him with eagerness to read it; and as he reads it with extraordinary contentment, his understanding swiftly grasps the meaning and substance of everything which is discussed in it. The reader, being put in an indulgent frame of mind by the beauty of the script, and by the ease and elegance with which the letter has been composed, is readily disposed to agree with its contents.

In my opinion, you can compare a secretary who does not know how to write, even if he is thoroughly competent in other respects, to a very erudite orator with abundant knowledge of all the requirements of public speaking, who mounts a high platform to deliver an oration in the presence of many princes. The audience is all agog to hear him; he loosens his tongue to speak, and then he is heard stammering so uncouthly that he can get nothing out of his mouth except incomplete speech, which disgusts and upsets everyone who is listening to him. The secretary who combines a fine hand with good drafting can be compared to those superb goldsmiths who set precious jewels in bright gold, thereby enhancing their value and beauty at the same time.

In short, there is as wide a difference between a secretary who knows how to write well and another who does not, as there is between two good painters, one of whom works only in chalk, leaving his paintings cold and lifeless, and the other who, by the expert application of colour, renders his pictures lively and full of spirit. But just as different colours are needed in painting, and different kinds of outlines to shape a figure well according to the diversity of its parts, so anyone wishing to learn the handwriting appropriate to a secretary—which may be likened to a figure which contains within itself several parts (so to speak), even if they do not require different pigments (being always written with the same ink, though even here there are variations)—nonetheless must have different brushes and different outlines. The 'different brushes' are the quills that are trimmed in one fashion or another according to the variety of script to be written, and 'different outlines' are when the script is small or large, flourished or unflourished, elongated or round. These differences are found in varying degrees in the chancery cursive. The perfect Secretary (I mean 'perfect' so far as the art of writing is concerned) must be instructed in all of them, because every day he will have to copy different documents—privileges, edicts, laws, and above all, correspondence for despatch. These will sometimes vary in length, will be addressed to people of higher or lower degree than the writer, and will differ in their degree of familiarity. Now it is not right that one should have to use the same script for privileges as is employed in ordinary correspondence. And, even in correspondence, it is no more necessary to cling always to the same script, for reasons that will be stated in due course. I have accordingly included several styles of writing so that the secretary can avail himself of them according to his need and judgement, deploying this or that one to the appropriate place where it will give the best result. I have done this for the additional reason that men's hands do not all possess the same natural constitution; it happens that one is suited to writing with or without flourishes, while another man who has less of a gift for the profession of writing will succeed at only one kind of chancery style—one without flourishes, as this is easier. Moreover men have different inclinations and, as the proverb says, one likes bread and another likes cake. Thus one man will prefer a style which another man will not find to his taste. After

considering these points, I have therefore decided to embellish this book of mine with several sorts of chancery cursive, which have shapes, flourishes and joins newly invented and put into practice by me, and which, in my opinion, are better, more graceful, more beautiful and more useful for cursive writing. Any secretary who correctly and intelligently masters either all or some of them will be honoured by his fellow men, not only for his learning, knowledge, the dignity of his office and his other excellent qualities, but also because his handwriting is prized by all the great princes. Nor will he be placed in the situation in which secretaries of some repute often find themselves, namely that, because they do not know how to write properly, they have to entrust their master's secrets to men who take no care with them and may reveal them at any time.[9]

From Giovan Francesco Cresci, *Il Perfetto Cancellaresco Corsivo.*

[9] As the sad fate of Montano proved: see p. 156 below.

HOW A MASTER
SHOULD TEACH HIS PUPILS

First of all, the master should instruct the pupil how to hold the pen properly in his hand and remind him frequently of the *correct* position, because it is often forgotten; and since not everyone has a hand naturally disposed to holding a pen gracefully because of various physical defects, which in some cases are impossible to repair, he should at least show him a pen-hold that would enable him to make good strokes; after that, he can grip the pen as he wishes. He should also suggest to him that he holds some implement in his left hand which will assist him to keep the paper steady so that it does not move about when he writes; this is very important.

The master should teach the pupil how to keep his ink-horn charged with ink, to see that the ink runs smoothly, and always to keep by him four quills already cut because, when one pen has been used to write for a time, its point becomes wet and softened with ink; for this reason all pens gradually tend to thicken. By changing pens, one or the other can be drying out; this is also recommended because, if you want to retrim a pen which has become saturated, you must remove all the part previously cut, because it is too soft, and in this way a quill will be used up after being cut four or five times. Someone may argue that my advice here differs widely from that of others who have so far written on the subject and who completely oppose the idea that the pen should be at all dry,[10] advocating that quills should be kept in a jar with a little water sufficient to cover only the nib so that they become soft and humid instead of dry, and this makes writing more easy. My answer is that this rule is all right for those whose experience of writing is limited, who do not know how to keep their ink-horn charged with good, thin ink, and who do not know how to cut a quill properly; these people with their rounder and soft-pointed nibs are doubtless able to turn them to whatever use is needed in their professions. But as for wishing to lay down as a rule, for those who want to learn how to write *well*, that the nib should not in any way be dry (because, as they say, this makes the writing ragged and faint and it is most difficult to write thus), I consider that the man who first invented this rule, and those who have hitherto followed it, have shown that they possess little knowledge and even less experience of writing: for I contend that a dry pen that is well cut, when used with fresh, thin ink, is not only the easiest to write with but also produces blacker, clearer letters; this clarity can never be obtained so well from a wet, soft-pointed quill.

Another rule which these same masters give to their pupils is also to be avoided, i.e. their wanting the nib to have a longer slit than normal because this, they claim, accustoms the pupil to write with a light touch.[11] This is an extremely grave error. If

[10] Palatino is meant: see p. 93 above. [11] Palatino again.

it is difficult for a *master* (and it is) to shape his letters well with a pen that has an unusually long slit, how much more difficult will it be for a *pupil* to make sound letter-forms when the cut of his quill operates against it? These rules are pointless because, with the passage of time and frequent reminders from the master to the pupil, this defect of a heavy hand *can* gradually be eliminated.

The master should rule the paper for his pupils with a fork so that the lines come in pairs. For this purpose the fork should have fine, smooth tips since, if the tips are rough, the paper gets damaged when ruled, with the result that the lines absorb the ink and spread it out so that it is impossible to write well. Ruling the paper serves to make the pupil pay attention to the correct shape and construction of letters more than to help him write in a straight line. It also has a further aim, namely that the beginner's concentration should not be divided between keeping his lines straight and attending to the correct shape and construction of the letters that he is learning. He should stand with his head held high and keep his chest well away from the writing-table, but, first of all, he must be set to practise making good letter-forms. The remainder should be taught stage by stage according to the ability of the pupil; and thus he will, in due time, come to put everything elegantly into practice.

The good teacher should give a daily lesson to each of his pupils, which should be of medium length, not too long and not too short, but adapted to each according to his abilities. And when his pupil is unable to make an individual letter properly, he should not only repeat orally the construction and shape which that letter should have, but he should write it with his own hand several times in the presence of the pupil. If he is unable by this means to induce the pupil to avoid his error, the master should adopt the following device. With his left hand he should take hold of the right hand of the pupil who is standing by him and receiving the lesson, and make him shape the letter which he does not know how to form; the reason is that the pupil, by feeling the movement of the master's hand, comes to appreciate more readily the details, the subtle points, and the essential shape that this letter, which he is trying to learn, should have. This method is more effective than any other kind of demonstration or instruction which can be employed, not only with beginners, but also with those who have made some progress in the art of writing.

Furthermore, the master should not, in his course of lessons, depart from the following syllabus. He should repeatedly go over the letter-shapes of the alphabet, either in whole or in part, with his pupils; and at another time he should do the same with the joins, and similarly with the capitals, the abbreviations and the cutting of quills. He should vary these lessons from day to day and, by concentrating on one of them for several days (according to the capacity of the pupil), he will thereby keep the pupil firmly within the correct limits and enable him to acquire more experience and manual control in a far shorter time than anyone could possibly do by following his own bent. He should, however, not make the pupil dispense with ruled paper until he has strengthened his hand in all the lessons that I have mentioned. After thus

training him for about six months, or a little more or less as necessary, he can set him to write with false lines and gradually get into the habit of writing straight and evenly without any lines, the time required being determined by the good sense of the person who is being taught. Anyone, however, who is without a master, and finds that he lacks the ability to write in a straight line, should always write with false lines.

The models which the master should write at the top of a little book for his pupils to learn as they progress are the following: two alphabets of minuscules, an alphabet of capitals, all the necessary joins, the abbreviations, six examples of different proverbs or sayings. These can amount to a total of twenty exemplars, all of which are normally written in the presence of the pupil; it does not, however, matter greatly because, if the pupil is being taught by the methods that I have described, they can be shown to him with greater effect, particularly those features of which he is ignorant; these he cannot learn or understand so well merely by seeing the exemplar being written.[12]

Those who desire to learn to write well will be able with these directions to follow the methods and teaching which an industrious master should use in instructing a pupil to enable him to acquire a hand that will confidently write a fine, cursive script. I have always pursued these methods and I still use them with all those who come to me to be taught. At the same time, my pupils will be disabused of the calumnies of certain slanderous writing-instructors who say that, when I teach, I never let myself be seen writing by anyone, whereas they consider—such is their ignorance—that the principal part of good teaching is that the master should allow the pupil to see him writing just one exemplar every day with no other material. This is their practice. Having already stated above that this practice is of little benefit to a beginner, since he receives no instruction in the rules and directions which matter most and which, in this business, a teacher is expected to know how to demonstrate, it remains for me to say no more than that their talk might have some tincture of truth if *I* possessed the defects and the ugly appearance which *they* display in their writing: for, on account of the poor constitution of their fingers, they hold the pen in such a distorted fashion that, when they write, they reveal to anyone who is watching them letters which are ragged, uneven, and shaky, and lines so twisted that their pupils cannot possible derive any profit from them. If they had any sense at all, it would be their duty not only to run away and hide themselves because of these faults and never let themselves be seen in the act of writing, but also to stop boasting that they have taught to others an art of which, in point of truth, they have never been able to master properly by reason of these defects. They remind me here of second-rate grammatical purists and pedants, who are accustomed to claim naïvely that many doctors of law have emerged from their schools: neither these claims nor the other

[12] Here Cresci distinguishes between masters who teach by writing out models in the presence of the pupil, who is then left to learn by copying what he has seen, and his own system of correcting each pupil's mistakes by intensive personal tuition.

crazy things they utter are surprising, as the immoderate envy which they display, combined with the bitterness of realising their poverty in the art of writing, makes them go around broadcasting slanders in a matter about which it would have been more to their credit to remain silent. Consequently, to their confusion, it usually turns out that the works of men who are the object of envy shine out all the more brightly and excite contempt for their critics, since wise readers do not believe their words but judge them on a comparison of their deeds.

Those who wish to scale the summit of perfect writing with the aid of the examples and discussions contained in this book of mine will be able to discover the kinds of script which they should practise particularly, copying them with the greatest care and patience; for these are really the fountain-head of those styles that demand more skill and judgement for their correct construction than all the other styles of any other country in the world. They deserve to be practised and written to the highest possible degree of perfection because they train the hand to copy any sort of letter, whether it is Greek, Hebrew, Chaldean or any other style you wish; in fact, a writer trained in my system of writing will be able to teach himself all those other styles that I have mentioned and will write them better and more clearly, whenever he has to copy them, than the natives of the countries concerned. This measure of success will not attend the many people who, by reason of various defects, cannot attain to that experience and perfection of lettering which I have discussed above. Compelled to rely on their own efforts, they will practise this art as best they can to make a living. But what is so bad is that, among these people, there are some who, impelled by their ambition to be held in greater repute than those who could give them a lesson or two, have cunningly tried to fill many of their scrap-books[13] with so many kinds of useless and futile scripts that, with their assistance, they have persuaded ignorant men to believe that the more varieties of letters a writer shows that he can make, the more he proves his excellence. So in this lunatic fashion (concealing their lack of knowledge), they have by this method deceived the man in the street, who nowadays, when he wants to praise someone as a superb writer, tends to say that so-and-so (whom he names) knows how to write five or six hundred kinds of script!

It has therefore been my intention not to fail to expose in my book this great deception of the public caused by the cunning of these men, by making it understood that writers of *that* kind, for the reasons that I have given above, are the ones who are inferior to others. And if it appears from their different varieties and vain inventions of letters that they give an indication of knowing also how to write those styles which I claim are the most important and display in my book, yet they only make them in the way that an artist does, in painting some fair landscape: when he wants to portray a figure in the background, he paints it in with a broad brush to obtain the proper effect; but if you look at it from near at hand, you will not discern anything—

[13] Possibly a reference to Palatino's unpublished Berlin manuscript.

nose, eyes, ears, or any limb—in proportion but you will merely catch an impression or outline of a figure. Similarly, in the present context, because the writers I mention are completely inexperienced in my kinds of letter, they can write them only in a weak, distorted fashion so that, when you look at them, you see neither regular construction, nor elegance, nor clarity, nor logic in them, and therefore, on account of their ill proportions, you must look at them from a distance as though they were vague impressions of my letters.

From Giovan Francesco Cresci, *Il Perfetto Scrittore*.

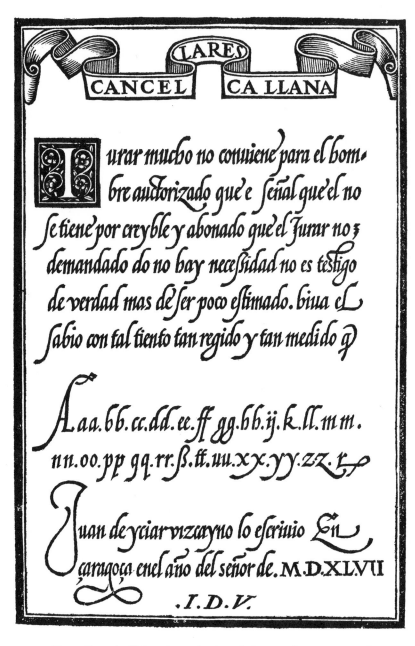

9. From Juan de Yciar, *Recopilación subtilissima*, Saragossa, 1548.

CHAPTER NINE

A Successful Partnership:
Juan de Yciar with Juan de Vingles

'Sancho asked: "Who is my secretary?" and one of those standing by answered: "I, sir, for I can read and write, and I'm a Basque." "With that last qualification," said Sancho, "you could well be secretary to the Emperor himself."' In this passage[1] Cervantes, writing at the beginning of the seventeenth century, was alluding to the traditional skill of the Basques as penmen in Spain. The Emperor Charles V, for example, had three Basque secretaries, and so did his son, Philip II of Spain. But of all the writers of his time, the Basque Juan de Yciar was held to be the foremost.

Little is known for certain about him. He was born about 1522 or 1523, the years in which Tagliente and Vicentino were preparing their writing-books, at Durango in Viscaya. He probably received a reasonable education; for in his work he refers to Plato and Quintilian as well as to Spanish humanists such as Vives and Alejo Vanegas. He must have realised at an early age that he was endowed with exceptional qualities as a scribe. He saw that, if he was to make a name for himself, he would have to leave his birthplace and settle in a larger town that would offer him greater opportunities of employment and improvement. He accordingly moved to Saragossa, then a considerable centre of culture and the cradle of Spanish printing. Here he earned a living as a teacher (perhaps in his own school) and as a copyist, particularly of choir- and service-books for church use. His speciality was the gothic *rotunda* style, written boldly with a broad pen and, as he himself says, superior to any that could be constructed by compasses. In the meantime, he was composing a manual of handwriting and calligraphy, and developing ideas about teaching methods, which we shall mention later. He studied the works of Tagliente, Vicentino and Palatino with care; this has led some writers to suppose that he travelled extensively in Italy to learn the chancery script, but there is no evidence at all of these hypothetical journeys.

Among his circle of friends in Saragossa were Miguel de Suelves, who was to help him with the publication of his books, the printers Esteban de Nagera, Bartolemé de Nagera, and Pedro Bernuz, and the French wood-engraver Juan de Vingles. In 1548, he brought out a writing-manual, of which he published a revised edition two years later. Like Tagliente before him, he was also the author of books on arithmetic and on the conduct of correspondence. His *Aritmetica Pratica* came out in 1549 and the

[1] *Don Quixote*, Part II, Ch. XLVII, J. M. Cohen's translation.

Nuevo Estillo D'Escrivir Cartas Mensageras in 1552. One authority states that he was summoned by King Philip II to teach handwriting to the odious and sadistic prince Don Carlos. He worked until he was fifty (i.e. about 1573) in Saragossa. He was then ordained as a priest and spent the rest of his life at Logroño. The date of his death is unknown.[2]

Yciar's fame rests on his writing-book. In this enterprise he was fortunate in having a master craftsman as his engraver. We have already seen in the case of Tagliente and of Vicentino how essential it was for a writing-master to obtain the services of an engraver who could make blocks which would retain some of the character and vitality of the original written models. The problem was just as acute in Spain. Yciar himself mentions 'the great difficulty of cutting wood in such a diversity of letters and the many years of work involved', and gives precisely this technical obstacle as the reason why no one had previously published a work on handwriting in his country, although many masters were competent enough to compose one. He describes how the script has to be written in reverse on blocks of hard wood and how the surplus wood is cut away so that the letters stand up in relief like printing type. Alternatively, they can be incised, in which event the letters will come out white on a black background. This tantalisingly brief glimpse of a crucial process leaves one in doubt whether the master himself wrote directly on the block; the implication is that he did (and it seems to be confirmed by a remark in a preface to the reader in the second edition),[3] though exceptional skill would be required to write spontaneously in reverse, even with the aid of a mirror. One would think a simpler method might be for the master to write his text on paper in the usual way and, while the ink was still wet, to turn the paper over and lightly press it on to a specially prepared (e.g. whitewashed) surface of the block.[4]

The engraver in question—Juan de Vingles (or, more probably, Jean de Vingle)—was a Frenchman. He was born in 1498, the son of a printer, at Lyon. He followed his father's trade and also practised the art of engraving. He came to work at Saragossa in the period 1547–50 and then returned to France. There is some evidence that he may have paid further visits to Spain. He occasionally 'signed' his work with a printing device of his father's—a sacred heart surmounted by a crown, to which he added his initials I.D.V. About a hundred of his blocks, comprising title-pages, decorative borders and book illustrations, are known.

The collaboration between Juan de Vingles and Juan de Yciar was a successful one, although the latter had not yet reached his twenty-fifth year, and his partner was twice as old. Yciar was ready to defer to the elder man not only because of his years, but because he had contributed towards the cost of printing and possibly also because his knowledge of press-work and design, in addition to that of engraving,

[2] Pedro Diaz Morante, Prologue to *Segunda parte del arte de escrivir*, Madrid, 1624.

[3] He refers to the Italian masters who signed each block 'despite the great effort it cost them in writing in reverse'. [4] Cresci implies that the script was written straight on the block: see p. 115 above.

facilitated production of his book. However that may be, the engraver was both permitted to introduce his personal device of the crowned heart, or his initials alone, into the blocks and (unprecedented distinction) to have his name recorded on the title-page.[5] Ironically, it was Yciar who was later criticised by his public for putting *his* own name on the blocks.

The fruit of the collaboration was called the *Recopilación subtilissima: intitulada orthographia pratica*, published at Saragossa in 1548. It aimed, according to the title-page, to teach 'how to write perfectly, both in practice and by geometrical theory, all the varieties of script used both in our Spain and abroad'. The book consists of wood-block reproductions interspersed with type-set passages, which are elegantly printed in a border of printer's flowers. Yciar describes himself as a copier of books: he thus had a technical background similar to that of Vicentino and Cresci, and we are not surprised therefore to see his careful and exact craftsmanship. To emphasise the point, the engraver has worked into the title-page a vignette of the author as he writes a formal alphabet in a book with one hand and holds a choir-book in the other. Then a full-page illustration depicts Yciar at the age of twenty-five—large eyes, full lips, strong nose and neatly trimmed beard, a grave, modest, but not unfriendly face, which may be a self-portrait.

The *Recopilación*, which means a 'compilation' or 'compendium', conforms to the pattern which had been set in the early Italian manuals; it shows a wide range of styles and alphabets, including several of the chancery italic, the book-hands (roman and italic), commercial hands, Roman capitals (for example, the set copied with one or two modifications from Dürer's alphabet[6]), the gothic script, the *rotunda*, elaborate capitals suitable for illumination, monograms and Greek and Hebrew alphabets. Some letters are constructed on 'geometrical' principles, i.e. with compasses and straight-edge. One's interest is excited by the large proportion of cuts printed white on black, and by the intricate and sumptuous decoration of many of them. Sometimes they make you feel that you are looking through a pattern-book for lace rather than a guide to lettering. This technique, which makes the alphabets static and formal, is not entirely suitable for the illustration of handwriting, and the more conventional black-on-white cuts are normally more effective for the purpose. It must, however, be admitted in this case that the engraver is more successful in preserving the delicacy of the lines on the black pages than on the white, where the black letters come out rather thick and stiff. It is interesting that the letters on the white pages show the rather pointed hand typical of Palatino, while those on the black pages show the slightly rounder style, which Amphiareo was simultaneously developing in Italy and was to be taken up subsequently by the Spanish masters.

[5] The engraver, to mark his partnership with Yciar, sometimes combines his device with the instruments of writing, the heart being grotesquely pierced by a penknife and a quill. On some blocks the initials I.D.V. are so clumsily placed that they seem to be an afterthought as though de Vingles, having obtained the concession after the blocks had been designed, added his initials wherever there was a suitable space. [6] See p. 27 above.

Though the book (like that of Mercator, which will be mentioned later) was the work of a young man, Yciar had clearly devoted much thought to it. His aim was to teach children as well as adults. His approach shows the influence of his fellow countryman Vives. He considers, for example, the problem of whether children should be taught reading and writing together. One school argued that reading should precede writing; another that the two should be taught together because the links between the two activities are so close that 'by teaching them both together one can in practice save almost half the time and labour spent in teaching them separately.' He sensibly concludes that it depends on the age of the child. A teacher who deals kindly with children will make more progress than one who is continuously severe with them, piling one task upon another as, for example, writing on top of reading. It is most important that a child should not hate his lessons. For a young child, it is better that reading should come first. With an older pupil, who was just starting, he would have no hesitation in putting both reading-book and pen in his hands. Elsewhere he suggests that children should be allowed to write on metal plates, because they can rub out mistakes with their fingers and are less inhibited in their writing; this idea is similar to that underlying the use of slate and chalk, which was often employed until quite recently in many British and American schools. Another teaching-aid mentioned is Quintilian's alphabet engraved in box-wood, the pupil moving a metal pen in the grooves until the letter-shapes and movements become second nature.[7] (This method is worth considering even today for the teaching of italic; the necessary apparatus, if suitably designed, could be made cheaply in coloured plastic.)

Yciar's instructions embrace a number of scripts. The fullest treatment, however, is reserved for the chancery italic hand. He calls it the 'cancellaresca' or the 'bastarda'; the latter became the accepted name in Spain. He says that this style is the one in commonest use in Spain and abroad. His teaching of the chancery hand is based on that of Palatino, the phraseology often being a straight translation from the Italian. Unfortunately he follows Tagliente's example of reproducing examples from printed type so that, with two small exceptions, the verbal descriptions are not supported by illustrations from Yciar's own pen. Occasionally one suspects that the master did not entirely understand the theoretical basis of his material. Thus he begins by saying that the italic letters without ascenders and descenders should fall in a rectangle with a height *rather less* than twice the width. This is a good practical rule. But when he comes to define this more clearly he adopts Palatino's formula of an exact two-to-one proportion, which gives a more angular letter.

For the most part Yciar has nothing new to say about the construction of italic letters, the instruments of writing, the making of ink, and the preparation of the quill. Nor would he have wished to claim originality: he is content to be the first

[7] Recommended by Erasmus and Palatino (see pp. 35 and 95 above), though Yciar probably took it from Vanegas, *Tractado de Orthographia*, Toledo 1531, from which he borrowed several other ideas.

Spaniard to have published this information for the benefit of his countrymen. He does, however, take up one point not mentioned by other writing-masters, namely that it is kinder to the eyes and less fatiguing if the writing-table is tilted towards the writer. He also deals with punctuation, a topic neglected by his predecessors in Italy. Writing, he says (as did Erasmus), is like talking to someone who isn't there. Just as when we talk, we pause according to the sense of the words, and this helps the listener to understand us, so we need to mark pauses in speech. Special signs have been devised for the purpose—the diastole, comma, colon, parenthesis, interrogation mark and the period stop. The space which follows the first five of these should be twice that of the space between letters, and after the period it should be even greater. When there is difficulty or doubt, the student should consult a good printed text: the practice employed by Aldus Manutius[8] is recommended. Here is another fascinating instance of the play between typography and handwriting. In the early days, the printer took over the conventions of the manuscript copyist; now we see the conventions of the printed book applied to the manuscript.

Yciar's writing-manual was an immediate success. It brought him to the notice of the King and led to a second edition in 1550. This was called the *Arte subtilissima*, the title by which Yciar's book is commonly known. It was dedicated to Philip II. Some consider the second to be the finer of the two editions, but this is a matter of opinion. It is the product of another printer, Pedro Bernuz. The texts are set in a muddle of different types, their order is not correct and some of the little vignettes are missing. The printer's flowers have been replaced by thick, engraved borders, which are not an improvement. These borders, together with the additional blocks, testify to Juan de Vingles' speed and industry. The fact that Yciar used a new printer and had all the texts completely reset leads one to suppose that he may have quarrelled with his former printer. Or possibly, he had learned that Philip II had shown interest in his work, and he wanted without loss of time to dedicate a splendid new edition to His Majesty, but found that he had to go to Pedro Bernuz to get the work done quickly.

Yciar's significance lies in his work as a pioneer in his own country. He not only digested and printed in a convenient form a lot of information about handwriting which was not readily available in Spain at the time, but (equally important) he was able to find and collaborate with a suitable engraver. Although Juan de Vingles is very strong in design and decoration, he is not in the top class when it comes to cutting blocks to reproduce cursive handwriting; but he, too, must have an honoured place in the history of Spanish culture. Yciar's book is obviously the product of a copyist and an illuminator; there is always a whiff of incense about it. His italic models are mainly formal or semi-formal in character. Only two of them show the true chancery cursive, and even these are rather immobile. But he will always command the admiration of lovers of the italic hand.

[8] Aldus first introduced italic type (or 'italics'). His reputation in Spain was high. The italic letter is called the *letra aldina* in some writing books.

HOW THE PEN
SHOULD BE HELD IN THE HAND[9]

Up to this point I have explained to you which tools are the most essential for a writer and the manner of preparing some of them; finally I have spoken of how quills should be cut. Now I ought to mention two other things: first, how to hold your pen in your hand and second, how to employ the pen according to the method in which it has been cut or trimmed. It is impossible to attain to a real mastery of writing without these two pieces of knowledge, and so no one should neglect them; for beginners are apt by this neglect to acquire such pernicious bad habits that, after wasting a lot of effort, they are unable to get out of them and they are left with such poor handwriting that some of them, not unreasonably, adopt the subterfuge of trying to conceal their deficiencies by pretending that they never had a chance to learn properly.

I must advise you, then, that according to the teaching of experience, about which everyone who has written on this subject agrees, the pen should be held with the first two fingers only, and should rest on the third. This is the rule for every piece of writing which is done unhurriedly and written correctly and in proportion, since the function of the third finger is simply to control the impetus of the other two fingers. But if anyone wants to speed up his hand, he should leave aside the third finger and make use of the first two only. Although this teaching may seem new here in Spain, abroad it is well known and employed at the Court of Rome, where the best writers in Europe are assembled. Luys Vives of Valencia writes to the same effect in one of his dialogues.[10] His actual words (translated from Latin) are as follows: 'If you wish to press your pen on the paper with greater firmness, hold it with three fingers. But if you want to write more quickly, hold it with two—the thumb and forefinger—as the Italians do. For the middle finger rather acts as a brake and restrains the hand from rushing forward more impetuously than it should.' As this does not differ in meaning from what I have said above, I do not turn it into Spanish.

So holding the pen with three fingers in the way that I have described, you must keep it firm in the hand without twisting or turning it between your fingers; it should always remain in the same position, with your arm resting on the table. Although we usually keep the table flat, we shall write with less fatigue if we tilt it slightly towards our body like a lectern or chorister's desk. This is also of benefit to the eyesight, which otherwise can be damaged if the head is held down.

The pen can be manipulated in one of three ways; either resting straight on the paper with the full width of the nib, or just with the edge,[11] or by holding it

[9] The extracts which follow are in their correct order, i.e. that of the first edition of 1548. The translation of Sir Evelyn Shuckburgh in the Oxford University Press edition of 1957 is based on the 1550 edition, in which certain sections are erroneously transposed. [10] See above on p. 42.
[11] i.e. with the pen held either at right-angles, or parallel, to the line of writing.

obliquely. The strokes produced by the last mode can be varied in thickness according to the degree of obliquity with which we slope the nib of the pen. Disregarding the first and second modes, we will deal simply with the third, i.e. operating the pen at an angle.

As this can be done to a greater or lesser degree, let us adopt the advice of Alonso Vanegas as given in his *Orthographia*, i.e. the position of the pen on the paper, when the latter is situated on the same axis as our body, should be somewhat tilted, as if the two tongues of the nib were placed on a die in such a way that the upper tongue points to the top right hand corner of the die and the lower to the bottom left-hand corner.[12] This is the correct way to hold the pen. Anyone who wants to deviate from it should realise that he is wandering from the true path of this noble art. No one should, however, be led to believe that, by using the pen in this position, we never write with the full width and body of the nib, or with the edge alone. This would be a serious mistake and quite foreign to my purpose, which is to teach you that we should not twist the pen between the fingers, with the result that, as we write, we sometimes use the full width of the nib, sometimes just the edge, and sometimes with a middle or some intermediate thickness; but the tongues of the nib are kept in the sloping position that we gave them on the die: from which, as Palatino says, we produce naturally [*i.e. automatically*] the three different strokes or lines that are so necessary, as we shall see later on. The first stroke or mode of writing, which is done with the full width of the pen-nib, is produced by drawing a line from left to right, thus :-. And the second (with the edge of the pen alone) is produced by drawing another line from the bottom left-hand corner of the page to the upper right-hand corner, or vice versa as follows: /. The third is produced by making another line from the top of the paper to the bottom as follows: I.

If anyone wishes to know the relative proportion of the thicknesses of these three sorts of line, he will find it in the beginning of Battista Palatino's treatise. As the author himself admits, it is a curiosity of no value, and therefore I did not want to waste time reporting it. And with this I conclude the section on how to manipulate and use the pen.

[12] More simply, at an angle of 45 degrees, since all the faces of dice are perfect squares, and the nib is placed on the diagonal. Yciar probably did not notice the mathematical inconsistency here. A pen held at exactly 45 degrees and writing vertical letters will make horizontal and vertical strokes of equal width. If the writing is sloped 5 degrees to the right, the ratio between horizontal and down-stroke will be 5 to 4.56, not Palatino's 5 to 4.

HOW TO COPY AND CONSTRUCT
THE VARIOUS LETTERS

Now that we have a clear, complete understanding of the last two sections, i.e. the method of holding the pen in the hand and of manipulating it while writing, I see no reason to defer any longer our discussion of how to copy and construct the various kinds of letters by the science of geometry. This discussion is the most important and the most fruitful of those contained in this manual; and at the same time, it is the most difficult because we lack the necessary technical language to describe what we are forced to put a name to, when we do not have the terms in our Spanish tongue; for example, there are the details relating to the starting, continuation and finishing of the letters. I shall have to explain them as best I can.

The elegance and splendour of letters, and their study in accordance with the science of geometry, consists (according to what reputable authors have said) of four elements, though to my mind the third is embodied in the fourth: that is to say, shaping, construction, order and proportion.[13] There is more hard work involved in shape than in the three other topics, since under this head you learn how to begin to write each letter and how to complete it; it cannot be left to the individual's caprice how to start and finish his letters, because this would generate a large variety of debased letter-forms. As there are so many different kinds of script, I consider it impossible to explain the order to be followed in making and writing them all; I have accordingly contented myself with imitating my predecessors who have written about this art. I have selected for our instruction the script, which of all the minuscules displays most beauty and finish, namely the true and genuine chancery style. In dealing with its alphabet, I shall say all that is necessary in regard to the first of the four topics that I suggested. I venture to promise that anyone who understands the mechanism and proportions of the chancery alphabet, will readily understand them in the other minuscules. Nevertheless, I shall not fail to touch on some of these, where and when I consider it appropriate, as I shall in the case of some of the large, formal letters, giving rules for writing them or, in their absence, referring the reader to those authors who have given them in their own works.

[13] Erasmus has this four-fold division: see p. 32 above.

ON THE CHANCERY HAND

The chancery letter, when given its correct construction and dimensions, should keep to the proportion and shape of a rectangle, the height of which is almost twice its width; for if it were based on a rectangle of equal sides (or a perfect square) it would, in its proportions, resemble the mercantile rather than the chancery hand. This can be understood by drawing two straight parallel lines (according to the size of the letter that we wish to make) in the following way:

The body of the chancery letter will be bounded by these lines so far as its height is concerned; its breadth, however (I mean of those letters which are constructed within the rectangle, such as the letter *a* and those related to it), will be equal to half the distance between these two lines, i.e. when they are divided by a third [*parallel*] as we show here:

Letters that do not exactly fill this rectangle, which is longer than a square, occupy an equivalent space. For example, the letter *r* does not fill the rectangle. Yet its height should occupy twice the space taken up by its arm and the broad point suspended aloft from it, this being the width of the letter. I do not mean that we must always observe this measurement in the chancery hand but that, once we have understood the ideal proportion, we can use it as a guide and keep it as far as possible, especially when we are starting to learn it.

To come now to the detailed description of the size and shape appropriate to each letter of the chancery alphabet, I tell you that it is necessary to recall those three different strokes or lines that I mentioned when I discussed how to handle the pen. The first and thickest of these is, as I said, made with the full breadth of the pen. The second, which is the thinnest and narrowest, is made with only the edge of the pen. While the third, which is not so wide as the first nor so narrow and thin as the second and is also made with the broad part of the pen, is not, however, of the same width. For the pen must be held at an oblique angle (in the way I described above) making a line like this. *///*., when drawn vertically down the paper. It is obvious that a line made thus cannot have the same width as that resulting from the first stroke, which is written from left to right as follows: ——— .

Having explained this, I now tell you that all the following letters *a b c d f g h k l o q s x y z* (and, according to Battista Palatino, the *e* too), start with the first, broadest stroke. All the remaining letters of the alphabet, viz. *i e m n p r t u*, begin with the second thin [*diagonal*] stroke, which is made with only the edge of the pen.

Now to demonstrate this with greater clarity by running systematically through the alphabet, we should note that the letter *a* begins with the first, or broad, stroke,

the top part of the letter being made with the broad edge of the pen and being written from left to right as follows: *r*. Then, without stopping, we turn back lightly to the point where we started and go down, using the third [*medium*] stroke for the length of the body of the letter as follows: *ι*. After that we go up with the second stroke—the [*diagonal*] one that is formed with the edge of the pen—so as to complete a triangular figure, which is this: *o*. Then, without a break, we come down again with the third [*medium*] stroke for the length of the letter, leaving at the end a little serif, made with the second [*diagonal*] stroke: the latter serves to tie and connect one letter with another, as can be seen from this example: *r.r.o.a.*

The letter *b* begins in a way similar to that of *a*. We start with Stroke One at a point high up on its ascender and then we turn back along the same path, as we did with the beginning of *a* and go down, using Stroke Three for the length of the letter, thus: *l*. After this, we go up with Stroke Two according to the height and body [i.e. width] of the letter as follows: *ト*. and finally turn round and down with Stroke Three; and we should complete the letter by closing it up with Stroke One drawn from right to left as follows: *l.ト.b.b.*

The letter *c* begins with Stroke One at its upper point as with *a*. We then make a down-stroke, using Stroke Three, and end with Stroke Two to make that little finishing serif which serves (as we saw in the instructions for *a*) as a link or tie with the next letter, as can be seen here: *r.c.c.*

The *d* is derived from that triangular shape which forms the first element of *a*, i.e. *a.o.* To this you should add the long vertical of *b* with the finishing serif and this, as you see, completes the formation of the letter, e.g. *a.d.*

The Italian authors differ about the construction of the *e*. Palatino says that it is based on *c* and that it is completed by closing its 'eye' with Stroke Two, written with an upward movement, as is usual when the letter is at the end of a word, or with a downward movement, when the letter is in the middle or at the beginning of a word thus *e.e.* Vicentino begins the *e* just where Palatino ends it, namely from that short stroke which closes its 'eye'. Palatino considers that this stroke should not cut the letter *e* at the middle of the body—as some authors have preferred—but a little above. Antonio Tagliente, abandoning both ways of cutting the *e* (which are in common use), tried to invent a third method, doing the same with almost all the other letters in order to appear to be contributing something of his own.

The *f* embodies the long vertical of the *b* and then descends below the writing line with a curve at the tail somewhat larger than that at the head, thus *affi.f.* Palatino's view was that the height of the *f* should be equivalent to two and two-thirds of the body-height. The cross-bar is placed at a point above the two body heights, leaving two-thirds of a body-height above it. Other writers consider, however, that the *f* should be prolonged for a full body-height above the cross-stroke. The total length of the letter would then be three body-heights, and not two and two-thirds as Palatino says.

The *g* is based on *a*. It contains two bowls, one of which is placed above the other.[14] The second [*i.e. the lower*] should be made wider than the first. For this reason, the lower bowl will have the appearance of being greater, though it is not in reality. For example: *ठ ठठठ*

The *h* has the shape of *b* except that it should be open at the bottom. Take note that, when you are on the point of completing the letter, you should stay your pen for a moment, so that you get a little thickness at the tip of the stroke thus: *h.h.*

The *i* begins with Stroke Two, continues with Stroke Three and finishes with the final serif made with Stroke Two. The pen should be lifted, as when we complete all the other letters that have ties, thus: *i.*

The *k* is derived from the long vertical of *b*. Its body begins at the centre point of this vertical. Its tail can either terminate on the same line as the vertical or go down beyond it with a sloping curve as in the case of the majuscule R thus: k.k.

The *l* begins in the same way as the long vertical of *b* and ends with the diagonal serif like *i* and other letters; thus: *l.ll.*

The *m* and *n* have the same beginning, i.e. with Stroke Two like *i*, but they should not have the finishing-serif until you get to the end of the last leg. Note further that the connecting-stroke between one leg and another should begin at a point more than halfway up the leg. For example: *i.r.n.m.*

The *o* is constructed like *c*, but it can be completed in two ways. The first is to close it in a single movement, not stopping at the end of the *c*, but carrying the stroke upwards until it joins the beginning of the letter. The second is done in two movements, viz. stopping at the end of the original *c*, you return to the starting-point at the top and then come down on the opposite side with a somewhat curved stroke to give the letter its correct roundness, until it joins the other end of the *c*. For example: *c.c.o.*

The *p* starts with the thin Stroke Two. Then you go down with Stroke Three, giving it a curved tail as we did with *f*. Its bowl is closed like that of *b*; note that the beginning of the down-stroke should project a little beyond the body, as it seems in this way to have more elegance. Example of this: *l.p.p.*

The letter *q* is made precisely like the *a*. Then you add the vertical stroke as with *p*. For example: *c.a.q.*

The *r* starts like *n* but it stops at the commencement of the second leg, being made in one stroke without lifting the pen. It is obvious that it should *not* have the finishing serif, as some believe. For example: *i.r.*

Long *ſ* has exactly the same shape as *f* except for the cross-bar. For example: *ſ.*

The round *s*, according to Palatino, should begin with Stroke One like *a*. You should make the middle curve with Stroke Three and finish the letter with Stroke One, written from right to left. The three curves are made in one movement without pen-lift. The lower curve must be a trifle larger than the upper. For example: *s.s.s.*

[14] The Spanish says 'Its length contains two bowls'.

The *t* starts like *i* and has its finishing serif, except that it should begin a little higher than the *i*, because its cross-bar has to be at the same height as the top of the *i* and, if the vertical were not extended, the letter's shape would be identical with that of *c*. For example: **tt.ita.**

The *u* is nothing but an *n* when the paper has been turned upside down. And the same thing happens with *q* and *b*, and with *d* and *p*, which have the same shape when the paper is turned round. The *u* should be closed at the bottom, unlike *n*. For example: **ı.u.**

The *x* should begin with Stroke One, descending diagonally from left to right as follows: **ı.** You should give it a little turn at the end. Now going back to the top, we start on the right-hand side with the same Stroke One and come down to the left at right angles to the first line as follows: **ı.x.** Others are accustomed to join two *c*'s together back to back, as follows: **ɔc.x.**

The *y* at its beginning, embodies the first element of *x* but without the turn at the end, thus: **ı.** Then a diagonal downstroke is added to it, as can be seen from the following example: **ı.v.y.**

Although the *z* can be constructed in various ways, they all begin identically, i.e. with Stroke One. We give it a slight downward curve at the beginning. Then we come down diagonally from right to left with Stroke Two until we reach the line on which the bodies of the other letters rest, thus: **ɀ.** Then we go back to the right with a Stroke Three at an angle. For example: **ɀ.ɀ.ʓ.**

The *ampersand* assumes several different shapes, although Palatino describes how to make only the one that I have set down here. All the other writers [*whose books*] I have seen omit this abbreviation, as well as all the other things that could be said about the construction of many other letters and abbreviations which are employed in the chancery hand. They leave this task to oral instruction, and to the good judgement and discretion of those who seek to teach themselves by copying out the shapes which are laid down as models in their treatises. I think that they are quite right to do this, since there are no fixed rules about how you should construct them and, even if there were, there is such a lack of terminology to explain them that the labour which the beginner would have to expend in mastering them would bear little fruit. For, in the space of time that he would give to learning the contents of one of those rules, he could learn orally from a master how to construct the letters covered by ten of them. So I too will bring to an end my detailed rules for writing and making this chancery alphabet. But first I will complete my explanation of the ampersand since I have started it. So I say that the lower bowl of the &, which is twice as big as the one above it, should rest on the lower line of writing. It is better made with a single stroke without pen-lift rather than with two, as is practised by some masters. The method of starting, continuing, and finishing off will be understood from the details set out in order in the example: *ʃ.ʊ.ℰ.&.*

You will gather from the above-mentioned letters that eighteen are written with a single stroke or movement without lifting the pen: they are the following: *a b c g h i k l m n o q r ſ u z &*[15] and also the *e* according to some authors. The others which follow are written with two strokes or movements, i.e. *d e f p t x y*. So much for the construction and initial discussion of the minuscules of the chancery alphabet. Note that the whole should lean forward a little; for in this way it looks more elegant and can be written more rapidly.

GUIDE TO
THE MAJUSCULE
OR CAPITAL LETTERS
OF THE CHANCERY ALPHABET

After the rules for the chancery minuscules, we should, if we are to try to proceed with our teaching in a logical order, now discuss how to construct the letters in the chancery alphabet which are known as majuscules or capitals, and give detailed instructions for each one of them in alphabetical sequence, as we did above. But since the number of those who have turned their hand to this noble practice of writing is so small, and since it is only a short time ago that they have tried to reduce it to an art, it is still a long way from reaching the height of perfection which many other arts, unworthily and to the perpetual disgrace of their inventors, have attained: for in some of these virtue is extinguished and in others vice is cultivated.[16] But, to return to the point, I declare that none of the authors who have come to my notice has so far given rules for the construction of these majuscules. Battista Palatino, the most recent writer, says that there is really no fixed rule other than that you should make them according to the judgement of your eye, copying the model alphabet which he has provided and taking pains to fashion the strokes lightly with a very steady hand; in this way they will come out elegant and neat. The same Palatino also advises that the majuscules or capitals, with which we are now dealing, are made with those same three strokes or writing modes as the minuscules, i.e. with the full breadth of the pen, or with just the edge of the pen, or in a way that is halfway between these two.

[15] Note the omission of small *s*.
[16] The last phrase is intended to show why some arts, which have received more attention and recognition than handwriting, are 'disgraceful'.

OF THE JOINING AND
CONNECTION OF THE LETTERS

Having said all there is to say under the first head, it remains for me to speak of the second—joining and linking one letter with another. Some letters are on such bad terms with each other that they absolutely refuse to join in any friendship or intercourse with others; for example, g, h, o, p, e, which never make peace with each other. (I am not framing a generalisation about every style: for this is not so in the formal script of church-books.) Other letters are affectionate and sociable by nature, and, so far as they can, they do not deny their intimacy to any other letter; such are all those that end with a diagonal serif c, d, e, l, m, n, t, u etc. Alejo Vanegas considers that in this case it is a good thing to copy the type cast by good printers, such as Aldus Manutius and others like him, who have developed the art of printing almost to perfection.[17] Battista Palatino lays down more concise rules. The first is that all letters that end with the diagonal serif (i.e. the following: a, c, d, i, k, l, m, n, t, u) can be joined or linked, by means of the little tail with which they finish, to any letter which can follow them. I say 'can follow' because in ordinary language every letter is not combined with every other letter.[18] Thus, there are some which, although they can in themselves join and are capable of being joined, are never in fact connected together because they can never occur in conjunction in ordinary speech. The general model for joining them is as follows: ab, ac, ad, af, ag, ah, ai, al, am, an, etc., and the same for the remainder.

The second rule is that f and t in themselves [i.e. in principle] can be joined with all those letters which have no ascenders, e.g. fa, fe, fg, fr, fm, fn, fu, etc.; ta, te, to, tm, etc. I say 'in themselves' for the same reason as in the first rule.

Concerning the Order
which certain Letters should preserve

Orderly arrangement is the third element which must be observed if your letters are to have grace and beauty. But if we say that it is derived from the regularity of the long ascenders and descenders that form part of certain letters, such as b, f, g, h, i,[19] k, l, p, q and long f (these project by a distance equal to that of the writing-lines [i.e. by the height of the small letters] sometimes above, sometimes below, and occasionally in both directions, as is obvious with f and long ſ), then I consider that this is robbing

[17] The Aldine italic type designed by Francesco Griffo contained a large number of ligatured letters, based on humanistic handwriting.

[18] i.e. certain combinations do not occur in the words as spelled.

[19] If this is correct, he presumably means long i = j.

proportion of something that legitimately belongs to it.[20] For to state that ascenders and descenders should not project from the writing lines for more than the space which separates these lines, is just another way of saying that there exists, between letters which have ascending and descending strokes and the distance between the writing lines, a constant proportion called 'equality' or, as Palatino rules for the upper projection of *f*, 'sescupla'.[21] Therefore let us say that order consists in assigning correct position to certain characters or letter-forms, which in practice are not allowed to occupy positions indiscriminately—for example, the letters that we call majuscules, versals or capitals, which are named after the individual position or place they hold in a piece of writing. To clarify the topic a little, I shall lay down some rules which, though not exhaustive in their coverage, nevertheless point the way sufficiently so that anyone can, without much difficulty, discover what is unsaid.

Let this be Rule One: that the majuscules or capitals, which are large letters, should always be put at the beginning of a sentence or word, and never in the middle or at the end. This rule might have been omitted except that one sees writers giving proof with their hands[22] of the negligence with which they regard it.

Rule Two is that no word should be written with a capital letter except at the beginning of a verse or sentence, and that a capital letter should be employed at the beginning of a book, chapter, letter, and other similar starting-points of that kind.

Rule Three is that all proper names and any words derived from them (as 'Roman' is derived from 'Roma', and 'Franciscan' from 'Francis') are written with a capital letter in whatever position they occur. The purpose of the rule is that readers should not think that they are names of a different derivation, and waste time trying to find what they mean, whereas if this practice is followed the meaning is clear.

There are some small letters which are commonly written with two alternative shapes without, however, affecting their function. This happens with the long and short *s*, there being no difference between them so far as the essential function and force of the letter are concerned. Others are of the opposite nature, in as much as one shape serves various functions, such as *z* which, in addition to its normal role, acts on some occasions as an *m*.[23] It is necessary to observe a certain order or *modus operandi* in regard to these similar letters; for professional writers have not been able to accept the alternative forms indiscriminately in every position. I shall mention three letters: *s* (long and short), *u* with *v*, and *z*. Any reader can see the point of the others, if he studies the work of good printers.

Of the three usual positions—beginning, middle or end of an expression or word—long *ſ* can only be written in the first two, never the last.

[20] The thought here is that one should not talk of the measurements of letters under the topic of *order* (which is concerned only with the relative position of individual letters) because this is encroaching on the topic of *proportion*.
[21] 'Equality' is one to one. 'Sescupla' means three to two; but Palatino says 'two-thirds'.
[22] i.e. in their writing. [23] In the gothic *rotunda* script.

Small, curved s is always put at the end of the word, not often in the middle, and hardly ever at the beginning. Many competent writers do not bother to follow this rule. This point at least is observed: when, as so often, double ss occurs in a word, they invariably write either a double long or a double short s, or a long one followed by a short one (ſs), but never a short one followed by a long one (sſ).

The u with the shape that looks like an n turned upside down always occupies the middle or end of a word. According to Aldus Manutius and other celebrated printers, it can go at the beginning: but others do not venture to give it this position, believing that it is an error to do so.

The alternative shape (v) which has a great similarity to the body of the Greek gamma (γ), if you take away everything except the body between the writing-lines, has attained such a position of privilege that, when it is invited to dine with the writer, it must be given a place at the head of the table, never in the middle or at the end.

It has another distinction that, when book-keepers have to enter the number five (in accordance with the accepted method of accounting), they are obliged to use this v, and never its companion. There are various ways of writing this letter, but not to the extent that they cease to look alike, e.g. V v.

z is not a true letter in its own right but an abbreviation of the letters s d. It can in this capacity be placed in any position in a word—the beginning, middle or end. But in older printing types, and even now in the black-letter script of church-books, it is often employed for m, though never for n, as some people are in the habit of incorrectly using it. You should note that the letter must never dare to assume this function except at the end of a word. And, to judge from the widespread murmurings of both printers and scribes, I believe that before long they will banish it from this last position, so far as its use as m is concerned.

Concerning the proportion
which should be observed when writing

The fourth and last element which we suggested in our discussion of letters and their elegance was the proportion which it is most important to observe in three main respects; namely the size and scale of the main bodies of the letters, of the long vertical strokes of the letters which have ascenders and descenders above and below the writing-line, and lastly of the spaces and intervals, of which there are four kinds, as we shall explain below.

As far as the first point is concerned, it is always essential with any kind of lettering—chancery, mercantile, large script or any other variety—to maintain proportion. This is what the mathematicians call 'equality', which consists, as they define it, in one quantity being equal to another. I mean that it should be maintained

in this way: that the body of one letter shall not be greater than that of any other letter but all should be of equal, matching size, in such a way that the lines of letters shall seem to run between two parallel lines, not counting (you will understand) the ascenders and descenders of the long letters, and also excluding the flourishes and loops which are customary in various sorts of script, particularly those called mercantile and other sorts of cursive hand. It is not necessary to speak of the capital letters, since it is certain that, because of their size, no one could confine them between the two imaginary lines of the minuscules, and consequently it is impossible to observe with these the proportion of 'equality'.

The second respect in which proportion is to be preserved is in the ascenders and descenders, above and below the line of writing, of letters with long vertical strokes such as *b*, *f*, *g*, and many others. They can be regulated by one general rule as follows. All the ascenders and descenders, of long letters, whether above or below the writing-line, must be of equal size, their length being measured as the sum of their body-height plus that of the band of writing.[24] For example, take the word '*planta*'. Here the descender of the *p* must equal the ascender of *l*, and each of the long strokes must not project (up or down) more than a body-height. From this you can deduce that, in any letter which projects on one side only of the writing-lines, the proportion of the total vertical stroke to the part which projects is two to one. I say 'which projects on one side only' because, if it projects both ways the proportion will not be two to one, but something quite different. An exception to this rule (according to Palatino) is the ascender of *f*; for, as I said when describing its construction, he did not wish this to be more than two-thirds of the body-height between the writing lines.

The third respect in which proportion plays a part is in the intervals or spaces that regularly occur in writing. I reckon that these are four in number. The *first* and most important is the distance between one line of writing and another, for which Palatino and others lay down the following rule. In accordance with correct proportion and sound geometry, the distance between paragraph and paragraph and between line and line (which is the same) should be two body-heights: the rule means that the distance between one line of writing and another is twice the width of each line of writing, depending on the height of the writing. It is right that I should tell you the argument on which the authors of the rule base it (they themselves have not stated it). I believe it to be as follows. It is a fact that, in the preceding rules, we have—in accordance with the views of Palatino and other authors whom we have followed—given the length of a body-height to the ascenders and descenders of the long letters. If the space between the lines of writing were less than the two body-heights prescribed by the rule, the descenders from the upper line of writing would be bound to bump into the ascenders from the line below, and you would end up with a tangle worse than a bramble. In order to avoid the ugly effect that would thus be produced,

[24] i.e. two body-heights.

it is essential to have at least as much space (defined according to the proportion of the ascenders and descenders) as the rule urges on us. But if we examine the matter carefully, many printers do not leave more than a body-height or a little more between lines. But we should not say that they are breaking the rule, since they are preserving its principle. We shall find that letters of their type-founts do not have ascenders longer than half the body-height of the script.

The *second* kind of spacing will be the distance which separates the letters of one word from another. Unless there is some equality and a certain proportion here, even if the letters are well shaped, the writing will be not only unsightly but also hard to read. Then it is necessary that the letters in each word should be connected with each other in such a way that their juxtaposition and design give rise to beauty in the lettering and clarity in reading, by indicating distinctly where each word begins and ends. For the most part the authors lay down the following rules about the spacing of individual letters, which will enhance the appearance of the writing.

The space between each letter should be equivalent to that of the distance between the legs of the *n*. And if someone objects that this still does not determine it, because the space in the middle of an *n* is not certain, since we have not mentioned the point so far, I reply that correct proportion of the white space between the legs of the *n* is that it should be as wide as the thickness of one of the legs.[25]

The *third* kind of spacing is the interval which should separate one word and another. Here again the relationship known as 'equality' is to be observed. For the individual words must be evenly separated, just as we said earlier about the lines of writing. You should, however, understand that this applies when there is no punctuation. (We will discuss the latter when we come to the fourth kind of spacing.) The rule then will be that the distance between words should equal twice the white space of an *n*, that is to say that the space between the words is double the space between letters. Palatino asserts that the distance between words should be such that a letter *o* can be inserted between them. Vicentino says that it should be an *n*. I see that in good printing the spaces left are hardly as much as my rule stipulates: the spacing both between letters and between words is smaller rather than greater. At any rate, all are agreed that the distance between one letter and another should be barely noticeable and that between words should be at least twice as much. The exact letter-space can be left to the discretion of a careful and competent writer.

By the *fourth* kind of spacing we mean the division between the sentences contained in the writing. Although here it is (as with the third kind of space) a question of word-division, it is done in a different way for a different purpose. Unless I am deceived, neither Palatino nor any other author has mentioned this fourth

[25] This makes a very narrow *n*: Fanti (see p. 51 above) implies that the white of the *n* should be equal to the combined width of two legs, the space between letters therefore being equal to the white space of one *n*.

spacing. Yet it is undoubtedly of great importance for a competent writer to know something about it, though a complete understanding of it is not essential in this profession.

To take the subject back almost to its roots, you should know that in our conversation and ordinary speech, we normally (as everyone is aware) make certain breaks and pauses. These serve to give the speaker a rest and to enable the listener to comprehend. Note that the pause is not made at will or to satisfy the speaker's fancy, but rather at a fixed point or position at the end of a complete sentence, or clause of a sentence. The amount of the speaker's pause or rest varies with the degree of completeness of the sentence. As writing is nothing else than a conversation or talk with an absent audience, it embodies the same pauses and breaks, indicated with various lines or points. For our purpose it suffices to know that the breaks and pauses in writing, which are marked at the end of sentences and also in certain other places, such as when a conjunction is omitted, are usually indicated by scribes and printers with certain points or lines which I set down here as an example : / , : () ? . The first of these symbols is called among grammarians *diastole*, the second *comma*, the third *colon*, the fourth *parentheses*, the fifth *interrogation-mark*, and the sixth *full stop* or *period*. Of course it is true that not every printer or scribe employs all these different symbols; for the most part, the second symbol (the comma) is used either as such or as a diastole, or as a colon with its two dots. However that may be, here we only need to know what space should be left in such places. For this purpose there is nothing better than to resort to the printers, on whom the duty and responsibility for correctly punctuating their material is mainly laid. If we follow them, our mistakes will, since there is no other rule, have a legitimate excuse. Since up to now the palm in the art of printing has, by general consent, been awarded to Aldus Manutius, I will follow him and state that the space to be left, when the first five symbols are inserted in the text, should be twice that which we have left between words where no punctuation mark intervenes. As for the last symbol, which we call the full stop (because it goes at the end of a sentence, which is a principal component of our speech, and is always followed by a capital letter or majuscule), I say that you should leave a space double that which we have given to the other five symbols—or at least a third more, as we find is the practice of Aldus Manutius.

The procedure to be followed
by those who are starting to learn to write

The correct procedure and method which the beginner should follow when he is starting to write, is to entrust himself to the care of some well known, industrious teacher, lest he should fall into any erroneous bad habits, as many do. Nevertheless it should not be regarded as superfluous for me (like other authors) to give some

suitable advice and instructions for him. Since not all of those, to whose notice the words which I have written here may come, will have the opportunity to learn from a teacher who is capable of giving them a good grounding, they will, in the absence of such a teacher, be compelled to have recourse to my rules. Furthermore, the majority of teachers either do not know the method to be followed or, if they know it, pretend that they do not and prolong the instruction of the unfortunate beginners in order to increase their earnings. I propose, in the interests of the public, to offer a practical remedy, advising all those whose ambition is to succeed in undertaking so profitable an accomplishment within a few days, not to spare the effort which they must encounter in learning the elements and to have the courage to request their teachers that, from now on, they should instruct them according to the system that I describe here. It has been tested and proven from time immemorial by many excellent men and owes its invention to Quintilian, a writer of great authority, from whom Battista Palatino admits that he took it.

I state then that the system to be followed when starting to write, if you wish to have a firm, light hand in a few days, is this. First take a small block of box-wood or well polished metal; and engrave on it all the letters of the alphabet as deeply as the thickness of a *real* [*a coin*]. These should be well designed and perfectly executed, rather on the large side, to enable the beginner to see distinctly the details which have to be noted. Next take a tin burin about the size of a goose-quill. It should be solid, so that it has some weight and requires a light hand for its use. The burin must be prepared and trimmed like a pen with a nib of the same shape, except that it is unnecessary to divide it as it would serve no purpose. The beginner, using this burin as if it were a pen, should begin by moving it in the grooves of the letters which have been cut in the block, exactly as though he were writing with ink on a piece of paper. But he must exercise particular care that he invariably begins, continues, and completes each letter as he goes, in accordance with the rules which we gave for this purpose when we discussed the construction of the letters. The beginner should persist in practising and continually moving in these grooves until he is confident and has learned how to move skilfully among them. Then, dispensing with the block, he now begins to write on ruled paper as follows. Equidistant parallel lines should be drawn in sets of four. The space between the lines of each group of four should be determined by the body-size of the letter. In order to avoid confusion, the lines should be of a different colour from the letters. The function of the centre pair of the four lines that I have mentioned is to regulate the height of the line of writing, and of the outer pair to determine the limits of the letters which have ascenders and descenders extending beyond the bodies of the other letters. Our beginner will operate within these four lines for a few days, until he has firmly impressed in his mind and his hand the dimensions, shape and basis by which each letter is constructed. Then the outer pair of the four lines can be removed, and he can proceed to write simply between the pair which delineate the height of the line of

writing. Some days later, one of the pair that remains can be removed, and he should venture to write with just that one line which marks the lower boundary of the line of writing. Finally, with the last line taken away, he should start to write on a blank sheet of paper, placing underneath it another sheet ruled with lines in black which can be seen shining through the blank sheet. This sheet that is ruled in black (which is commonly called a 'false rule') acts as a substitute for the line rule which we used at first. By continually practising his writing over it and getting used to it, he—the man who has done this—will train his hand to be steady and secure so completely that, without the aid of any lines, he will acquire a habit of writing smoothly, confidently, and well.

Palatino says (and I agree with him) that it helps the pupil to use initially a soft and open nib because the ink runs and flows more easily. For if it runs with difficulty, you have to press on the pen and this may give rise to a heavy and sluggish hand.

<div style="text-align: right;">From Juan de Yciar, Recopilación subtilíssima.</div>

Jamas falta al animoso pensamiento de abundancia, ni
miseria ni inconstancia al muy triste y perezoso. Madariaga.

Grifa de Francisco Lucas: año 1577.

IN principio erat verbum, & verbum erat
apud Deum, & Deus erat verbum. Hoc....

Redondilla liberal.

Esteuan de montaluo vez de

nombre de maria de montesinos biuda e de antz

Bastarda.

Señor que es el Hombre para que te acuerdes del. O el
hijo del hombre para que lo visites! que ha merecido el
hombre para que le diesses tu gracia. Señor de que

De punto al uso antiguo. F. L.

Sepan quantos esta carta de arrendamiento vie
ren como nos antonio martinez de montaluo

Antigua.

TE Deum laudamus: te Dominum
confitemur. Te æternum patrem omnis

Bastarda y Redondilla de Juan de la Cuesta. 1589.

E presentado ante los Jllustres señores

Al continuando y tomando las cuentas

Torío scrip.ᵗ Asensio sculp.ᵗ

10. Writing models by Pedro Madariaga, and other Spanish masters
as rendered by Torquato Torío de la Riva
in *Arte de Escribir*, Madrid, 1798.

CHAPTER TEN

A Philosopher of Handwriting:
Pedro Madariaga

Pedro Madariaga approaches the problems of handwriting instruction in Spain by a somewhat different route from that of his master Yciar. He starts by discussing the subject in a broader context as part of general education, and on a philosophic plane. Handwriting is elevated to a position that is rather above the traditional humane arts, such as grammar or geometry, and only slightly below the highest branches of knowledge, such as theology. These claims are elaborated in a series of arguments with the full apparatus of Renaissance classical scholarship. The practical side of handwriting, which comes later, receives less detailed attention and is rather disappointing.

Madariaga was a Basque, but we know very little about him. He was born at Arratia about 1537. His family was of some standing, because his father was one of a delegation which travelled to Valladolid to obtain the King's consent to renew a privilege protecting Basques against torture in judicial inquiries. Madariaga tells us that he was a pupil of Yciar and that he had travelled throughout Spain and Italy. He alleges that in Rome he found only one good teacher, and it is pleasant to think that this could well have been Cresci himself. There were, however, compensations; for he once saw an Italian woman 'who held a pen between the toes of her right foot and wrote with it, saying "With the grace of God, nothing is impossible"'. During his travels, he was so shocked by the absence of scientific method among writing-masters everywhere that he hastened to compose a compendium, which would contain everything that a self-respecting master should be able both to do himself and to impart to a pupil.

On his return, he began to propagate his ideas of handwriting, thereby stirring up some opposition among the writing-masters. In 1562 he expounded his new theories in a lecture-room at the University of Valencia, where, he would have us believe, he had five hundred pupils. He reduced what had normally (he says) taken six to eight years to learn to something which could be acquired in twenty days without a master. Valencia was apparently convinced of his claims, and he states that his system was accepted in Aragon and Castille. It is possible that, when he says this, he is hinting that his influence spread to Saragossa, where Yciar was teaching. In 1565 he published his ideas in a book *Libro Subtilissimo intitulado Honra de Escrivanos*, which

he dedicated to Philip II as a pioneering work of its kind. The title echoes that of Yciar's book of 1548, though whether in deference or irony is not entirely clear. Like Yciar he shows a portrait of himself. According to this, he was then twenty-eight years of age. Curiously enough the work was not reissued until 1777, when, if the writer of the preface is to be believed, it still had some value. After the publication of his book, Madariaga disappears from history.

The *Libro Subtilissimo* (to use its shorter title) is in three parts. The first is a high-flown defence of the importance and prestige of handwriting; the second contains an account of the author's system for teaching it; and the last is a self-contained treatise on spelling, punctuation and pronunciation, then known collectively as 'Ortho-graphy' and, with arithmetic, regarded as part of a writing-master's repertoire. The first and second parts are printed in an italic type and are cast in the dialogue form popularised by Vives and Erasmus. Indeed the whole work shows many signs of the influence of Vives. The dialogues (or extracts of them) were intended to be read, copied and learned by heart. Madariaga shared the Jesuits' belief that the mind of a child is like a piece of soft wax which can be fashioned in various ways. So care should be taken that its first impressions are sound, natural, simple, and capable of stimulating the understanding. Early impressions are so tenacious that they will defy the most strenuous efforts of the writing-master to eradicate them.

The following summarises some of the main ideas in the first part of the *Libro Subtilissimo*. Handwriting is a key to human understanding. How marvellous it is that an infinite variety of words in different languages can be built up from the alphabet! It is a 'superhuman artifice' that a universe of knowledge is recorded with twenty-three letters; their correct construction and arrangement in the right order are the business of the writing-master. The pen 'acts, so to speak, as a rapid wing to the understanding: if you decide to write a letter or compose something, this same pen, being set in motion, seems like a tail-wind to your mind, because it pours out on the paper the most profound thoughts which would not have occurred to you at the outset, nor would you have imagined them.' The pen is the principal tool for memorising knowledge, since the most reliable way to fix something in the memory is to write it out several times.

Penmanship can be considered as one of the liberal arts: without it none of the others could exist. It is therefore a fit accomplishment for a gentleman, even though it is customary for people of quality to despise writing and to content themselves with being able to scrawl a signature, all the rest being left to their secretaries. In antiquity, slaves and low-born people were not allowed to write or paint, whereas kings and generals like Pyrrhus and Julius Caesar wrote their own military memoirs. The wisest men have always been the best writers. Writing is more than a humane art; it was not invented by men, but divinely revealed, as passages in the Scriptures testify. It is the absolute ruler of the sciences; it is a rudder which guides the potential of the soul; it makes the poor rich and the ignorant wise; with its aid, the

low-born become gentlemen; and once it has befriended a man, it remains faithful to him to the day of his death. On this exalted note, Madariaga closes the first part of his book. Perhaps the real lesson to be drawn from all the rhetoric is that in Spain, as in Italy, the writing-master had become conscious of his worth to society and was seeking a place in the social hierarchy which would reflect it.

The set of dialogues which forms the second part of the *Libro Subtilissimo* brings us gently down to earth. Madariaga insists on the need for a systematic technique for teaching handwriting: mere diligence is not enough. At present each writer goes his own way; there is no more agreement between them than between doctors over a doubtful diagnosis. Often the same master will instruct his pupils in different ways, and even worse, teach the same pupil different methods. This problem has not been entirely solved in the twentieth century.

Madariaga begins to outline his own system. The first step is to rule lines. To learn how to write properly, one obviously needs to train the hand to be unhurried and well co-ordinated, so that all the letters will be even and all the lines of writing straight. Since a beginner's hand is not disciplined to this degree of control, he can concentrate more easily on his letters with the help of the lines. If the pupil still does not write straight, he should not be corrected for a few days, provided his letters are properly shaped. The use of pounce—a fine powder rubbed into the paper—must be avoided because it slows up the writing just as snow does on a path when you walk. (Nearly fifteen years later, the Italian masters Cresci and Scalzini were to be locked in battle on this same issue.[1]) Highly decorated capital letters are also to be shunned. Copyists of church-books may need to know how to write them; but they are a snare and a delusion for those who wish to learn good handwriting. Here Madariaga may be obliquely criticising Yciar, who was a professional copyist and showed many examples of embroidered capitals in his manual.

Having thus cleared some of the ground, Madariaga develops his system of the scalene triangle. He first explains how a pen, when held in the same position, will make strokes of different breadth according to the direction in which the pen is moved. The pupil has to learn three basic strokes: a broad diagonal drawn upwards from right to left (`) with the full width of the pen held at 45 degrees; a medium-width down-stroke (/); a narrow diagonal drawn upwards from left to right with the narrow edge of the pen (/). The strokes must be made in the order and direction stated. They are then combined in a scalene triangle (i.e. a triangle which is neither equilateral nor right-angled) like this *P* . From the three basic positions of the pen represented by this triangle, all the minuscule letters can be formed. Thus, when the rear portion of the triangle is removed, a *c* is left (*ſ*): the addition of a down-stroke produces *a* (*ɑ*); a prolongation of that down-stroke gives *q* (*ɋ*), and so on through the alphabet. No directions are given about the slope and proportions of the triangle. Rather surprisingly, the author claims that the strokes of his triangle can be applied

[1] See pp. 258, 275–6 below.

to any style of writing, including Greek and Hebrew. It will be seen that the upward thrust of the first stroke of the triangle accentuates the inherent tendency to spikiness of the classic chancery alphabet. Madariaga's system, although it was probably easy to learn and remember, is disappointingly mechanical and does not produce well shaped chancery letters. As the author says (without realising its implications) 'the demonstration is as clear as those of Euclid.'

After this, we learn that the ascenders and descenders should be equal in height to the body of the letters. The next stage is to write the individual letters as part of words. At this point, Madariaga produces (for the first time, I think, in a writing-manual) a hexameter verse containing all the letters of the Latin alphabet—*Gaza frequens libycum duxit Karthago triumphum*: unlike most modern alphabet sentences, it is concise, natural and plausible. The pupil is to copy this phrase repeatedly in a large, medium and small size, gradually dispensing with the ruled lines. A model of capital letters is then shown, but Madariaga does not lay down any instructions about making them. When the elements have been mastered, the pupil must practise with everyday material. If he is interested in the various chancery hands, he will get hold of letters sent from Rome, or from the King's secretaries at Court, or a book printed in a good italic type; for the round hand, he should try to obtain letters and documents from traders and merchants. He should then provide himself with two blocks of paper. He should fill one with copies of his material, written carefully and unhurriedly. With the second block, he should write the same material as quickly as possible.

The third and final section of the *Libro Subtilissimo* gives a full account of the punctuation and spelling of Spanish words, and is also a useful source for the pronunciation of the language in the sixteenth century.

Despite the length of his work (largely attributable to the dialogue form in which he has cast it), Madariaga omits many topics which other writing-masters regarded as vital to the art—the selection and preparation of the quill; the making of ink; writing posture and pen-hold; and the rules for joining letters. So far as practical instruction in handwriting is concerned, he is primarily interested in producing a set of rules which can be readily understood and quickly put into practice. The few examples contained in his book leave doubts about the depth of his understanding of italic letter-forms. Such a contrast to the deliberate, unhurried outlook of the master who taught him!

HANDWRITING: THE ACCOMPLISHMENT OF A GENTLEMAN

The speakers are Urquizu, Bernardo, Ibarra and Vives. Bernardo and Vives despise handwriting.

URQUIZU: Oh, what terrible writing there is in that letter of yours, Señor Bernardo! Have the chickens been scratching at this paper?

IBARRA: Are you going to send this letter to Court? You had better send a messenger in advance to advise the recipient; otherwise your signature will never be recognised.

URQUIZU: On the contrary, it is better that they should not contrive to read it, since this will serve them as an excuse for your not being granted what you are asking.

BERNARDO (*Loftily*): I always write through my secretary, but this particular business could not be entrusted to a third person.

IBARRA: Then, my dear sir, you could send it unsealed; for its secrecy will be unimpaired, as no one will be able to guess at your scribble, let alone read it.

VIVES: All we gentlemen think it a distinction to write badly: so Señor Bernardo isn't putting on airs.

BERNARDO: No, I'm not; my parents never bothered to teach me.

IBARRA: That seems to me no different from a man of my acquaintance who, although he was over sixty years of age, never knew the Credo nor his prayers, and always excused himself by saying that his parents never taught them to him.

URQUIZU: Then he was saying that he was a Christian through the negligence of his parents, just as you are a gentleman as a result of the negligence of yours!

VIVES: Gentlemen, here in Valencia we try to give ourselves a tincture of the liberal arts, and with that we are content.

URQUIZU: Don't you consider penmanship to be one of the liberal arts?

BERNARDO: I do not think so, and I wouldn't agree that it should be regarded as such, because, if it were a liberal art, I would not consider myself a gentleman, nor would I have been taken for one.

URQUIZU: Please tell me, since you are so wise and know the other liberal arts, how many there are and what they are.

BERNARDO: There are seven liberal arts; that is to say, Grammar, Dialectic, Rhetoric, Arithmetic, Geometry, Astronomy and Music.

IBARRA: Are there no more?

VIVES: There are, but Geometry includes Optics, Cosmography and Architecture.

IBARRA: Then do you not see that writing is embraced in what Señor Vives has

said? For Penmanship consists of two things: first, the size and proportions necessary for each letter to preserve its relative equality; by which I mean that *l* and *h* and *b* should not be taller than each other, and that *e* should not have a fuller body than *a*, and so with other letters. This is a part of Geometry. The second relates to the accuracy of writing, since a man who writes *c* for *s* or vice versa, cannot, in my opinion, be said to be a good penman, however elegant the shape of his letters, because the letters embody mental concepts and, if the pen does not preserve sufficient fidelity to write down those concepts with the appropriate spelling, then it is failing in its proper duty. It is therefore discredited, and is neither what it should be nor that which we hold in honour here. This aspect of Penmanship belongs to Grammar, because Orthography is one of the four principal parts of Grammar. Accordingly it is established by the clearest proofs that Penmanship forms part of two of the seven liberal arts that you mentioned.

URQUIZU: I cannot agree that there are no liberal arts other than those seven, since the arts are called liberal for one of two reasons; either because they enable us to advance towards the highest branches of knowledge such as Philosophy, Metaphysics and Theology: or they are called liberal because they are appropriate pursuits for a nobleman or gentleman. Thus Cicero describes them as the arts 'of the free-born man', which is practically the equivalent of saying 'of a nobleman'. Now if you take the first reason, tell me what accomplishment fits us better for all the sciences than Penmanship? You cannot name any of the others which equips us for Penmanship, whereas Penmanship equips us for them all, because no science can exist without it, as we proved in our first and second Dialogues. As for the second reason, are not fencing, swimming, and dancing the accomplishments of a nobleman?

IBARRA: This is true: thus Terence in his play *The Eunuch* brings in more liberal arts than those seven, since he describes many activities there, which he regards as liberal because they are worthy of noblemen and gentlemen. And Pliny tells us that, in the early days, slaves and people of low degree were not allowed to paint or write. It is recorded that King Pyrrhus was not only expert in the liberal and other sciences, but himself wrote books. The historians relate of Julius Caesar that, when he was not engaged in battles, he turned to writing and he thought so much of his own compositions that, when once in Alexandria in Egypt he had to jump in the sea and swim for his life, he carried with him his writings in one hand. So we see that, whatever king we invoke, they all believe the written word to be as precious as their life. Now which of the arts that anyone knows can be called liberal, or what nobility can there be, without Penmanship?

URQUIZU: Pliny the Elder says that painting is reckoned among the liberal arts, the reason being that it involves other sciences such as Perspective, and one could not be a good painter without knowing them. Then if painting is reckoned to be a liberal art because it relies on others, all the more reason why Penmanship should be

counted among the liberal arts, because all the others are connected to it; so that we can justly claim a place for Penmanship among the liberal arts.

IBARRA: How you weary us into admitting that it is a liberal art! Yet I do not know in truth whether you will get much thanks for honouring Penmanship in this way, since it is entitled to a *higher* position than the liberal arts; and it will always remain discontented, until you grant the approval it deserves.

VIVES: Tell us what you mean, Señor Ibarra.

IBARRA: I say that Penmanship should be given a place among the supreme accomplishments and inspired sciences close to holy Theology.

BERNARDO: Mind what you are saying!

URQUIZU: I can believe this, since the man who is asserting it is the one who is going to prove it.

IBARRA: The sciences which seem to me to be 'inspired' and 'supreme' are those that were not invented by mankind, but were revealed to us by God. Read in the seventh book of Pliny where he says that the 'pen is eternal'. That which is eternal does not originate in this world of ours. Look at the Apocalypse of St. John, and you will see that he relates that he saw in heaven a book written on both inside and outside. Reflect on Job who called the Lord himself a scribe. 'Do you not write, Lord' says Job, 'bitter things against me and seek to destroy me with the sins of my youth?'. Consider the twenty-fourth chapter of Exodus, and you will see how God called to Moses and gave him the Tablets of the Law written in his own hand; and St. John says in the fourteenth chapter of the Apocalypse that he saw one hundred and forty-four thousand beings who stood with the Lamb and had written on their foreheads the name of the Lamb and that of his Father; then consider whether those glorious writings do not have a solemn name in heaven. And St. John says in his eighth chapter that Christ wrote on earth. Because of all this, and for many other reasons and authorities which I omit for the sake of brevity, I take it as an ascertained truth that this accomplishment was not invented by humans, and on that account is to be more honoured than Grammar and all the liberal arts and humane sciences. Thus you will be lacking in courtesy if you do not give Penmanship its due by calling it a liberal art. It will be an honour for the highest accomplishments to take their place at its side as a mark of its worth and great excellence.

VIVES: Now I admit that Penmanship is not only not servile but is a divine and essential art, and is an appropriate employment for gentlemen.

URQUIZU: Have you never heard the tale of how a nobleman was ruined because he did not know how to write?

VIVES: I should like to hear it.

URQUIZU: When my father was a deputy of Vizcaya in the year of the Communities of Castille, he said that he was once obliged to proceed to Valladolid to beg the King's permission to renew a privilege that we held, by which no Basque should ever be put to the torture within any of His Majesty's realms and dominions;

and he used to relate that he saw a gentleman of Zamora, called Montano, beheaded as a traitor, although he had committed no treason.

VIVES: He must have been falsely accused, as sometimes occurs.

URQUIZU: No, it seems that, although he was a private gentleman, the King wished to make use of his services to subdue certain rebels and to write a despatch to him about the matter. He was instructed that he must not rely on anyone as secretary or messenger at all in that business, unless he were a relative, because the times were very dangerous. The poor gentleman, on the one hand, was overjoyed that, by the will of God, the King had found it necessary to employ his services; on the other hand, he did not know by what means he should safeguard the secrecy of the matter, as he could not send a reply in his own hand because his ability to write was limited to scrawling his signature. Eventually he obtained a scrivener to whom, with many gifts and even more promises, he entrusted the secret. But, as you might guess, the contents of the letter leaked out to the market-place and the whole town. As a result the Kingdom was in peril of being ruined, and the unfortunate gentleman suffered the same penalty as common criminals.

BERNARDO: Then I must agree that writing is more than a liberal art, and the higher our rank, the greater need we have of knowing how to write, because after all no one can be sure of what may happen to him.

From Pedro Madariaga, *Libro Subtilissimo*, Part I, Dialogue V.

THE SYSTEM OF THE SCALENE TRIANGLE

AYALA (*A pupil*): We have done nothing for two days except make triangles; we have brought you only these two, so that you, Sir, can see whether they are good.

ρρ

MASTER: You have done well; for the more time that you spend on this initial step, the less time you will waste on the letters. Next, you should note that, to start with, the letters of the alphabet should not be joined up, as is the custom in our schools. First comes the triangle and then the letter that follows in logical order; and when you have thoroughly learned this letter, then the next letter in the sequence that I will show you here—not the sequence of the alphabet. The triangles which you have made are exactly right. Now take away from that triangle (*he points*) the angle in front, which is the third one, and a perfect *c* is left, in the manner that you see; it does not need as much effort as the triangle, but rather less.

ſſſ

Now close the *c* with the second (*downward*) stroke of the triangle, giving the same slope as the triangle and the same length as you did for *c*, and you find you have a perfect *a*:

If you prolong this line of the *a*, the result will be a *q*:

By adding two sides of the triangle upside down to the *q*, you will see that you have a *g*:

In short, the *g* consists of two triangles.

Double the length of *c*, and you are left with an *l*:

Add an *l* to the *c*, and you have a *d*:

If you add to the *l* a reversed *c*, you have *h*:

Close up the *h* and you have *b*:

Turn the *b* upside down, and you have *p*:

Or you can finish it off with the third line of the triangle as follows:

If you close the eye of *c* with the third line, it becomes an *e*:

This letter should be made in one stroke.

By halving the length of *l*, we are left with an *i*, but, for the sake of elegance, we give it at the top a little serif made from the third line of the triangle:

If we take a pair of *i*'s and join them together, they become an *n*:

If you turn the *n* upside down, you have *u*:

If you join three *i*'s together, you have *m*:

The letter *r* is simply one leg of *n*, its hook being formed from the first and third lines of the triangle:

The letter *o* begins as the triangle does, though it is not completed with the third stroke, but is entirely round:

Long ʃ consists of *l*, to which is added a descender similar to the ascender of *l*, except that the descender should be a third longer than the ascender:

The letter *f* is made by crossing the second stroke in long *s*. The cross-bar can also be extended by a downward line:

The letter *s* is composed of the first two lines [*of the triangle*] and begins like a *c*; then continuing down the second line, it finishes with the first line—the one with which it started—leaving a curve below which is either equal to, or larger than, the one above:

The letter *x* is made with the same lines as *s*, but first you make half the letter as follows:

The curves are the same as we give to the lower part of long ʃ. The two ends should face each other on both sides:

The letter *z* is composed direct from the triangle. It contains the lower angle of the triangle twice by cutting through the middle as follows:

Then add another acute angle which makes a third in this way:

Finally, give it a little rounded curve, like this:

333

Or you can extend it to the right and add a curve as follows:

zz

The first arm of the letter *v* is a bent *i*, though somewhat larger, drawn from left to right as follows:

The other half is made rather like *p* with a rounded curve:

The letter *y* is made by slightly extending the curve of *v* in a similar way to the descender of *g*, but it must be restricted in such a way that, when the descender is extended below, it does not depart from the proportion of size of its body:

The letter *t* is merely an *i*, except that the upper tip is raised a little, so that it can be crossed like an *f*:

ttt

The letter *k* is formed by adding to an *l* the *z* which we described above:

kk

From Pedro Madariaga, *Libro Subtilissimo*, Part II, Dialogue V.

Gaza frequens libycum du-
xit kartago triumphum.

BASTARDO

O clementissimo y benignissimo Jesu enseñame, endereçame, y ayudame señor en todo. O muy dulcissimo Jesu quando tu visitares mi coraçon alegrarse han todas mis entrañas. Tu eres mi gloria y alegria de mi coraçon: tu eres mi esperança y mi refrigerio enel dia de mi tribulaciõ, y trabajo. Frã⁾ Lucas lo escreuia. Año M. D LXXVI.

11. From Francisco Lucas,
Instruccion muy provechosa para aprender a escrevir,
Toledo, 1577.

CHAPTER ELEVEN

Francisco Lucas:
Creator of the Spanish Bastarda

Francisco Lucas is commonly regarded as the most important Spanish writing-master of the sixteenth century. He was born in Seville, but the year of his birth is uncertain. All we can say is that he was a near-contemporary of Pedro Madariaga. For some years he taught in his native town and later moved to Madrid, where he opened a writing-school. In 1571, he published at Toledo his *Arte de Escrevir*.[1] He continued to work on his book and issued an enlarged edition in 1577 in Madrid. He now describes himself as a 'resident in the Royal Court'; it can be fairly inferred from a passage in the dedication that he had been appointed to teach Philip II's son Fernando. Perhaps his remark in the first edition that the quality of the teaching of handwriting in Spain was so poor because the nobles and gentry had little occasion to write had attracted some notice. The date of his death is unknown.

The *Arte de Escrevir* is composed in four parts, of which the first is devoted to the *letra bastarda*, the Spanish modified version of the chancery italic hand. Yciar had included a model of 'cancellaresca bastarda' in his manual. It has been suggested that he borrowed the name from Amphiareo, but this is unlikely as Yciar's model is dated 1547, and Amphiareo's book had not then been published. In any event, the latter applied the term to his combined chancery-mercantile script, whereas Yciar employed it in the sense of a modification to an existing model principally by abbreviating the ascenders and descenders to give a less angular effect. With Lucas, the name 'cancellaresca' becomes obsolete. He comments, rather acidly, that some people call the script 'chancery' in its simple form, and 'bastarda' in its cursive form. At any rate, he and the later writers in Spain speak only of the *bastarda*.

Unlike Yciar, Lucas does not aim for a profusion of styles but, following the trend of the age, reduces the number of styles to six; and only two of these are selected for general use. These are the *bastarda* already mentioned and the *redondilla*, a simplified, upright, round hand, derived from Spanish mercantile scripts, to which Lucas gave a special stamp. We are not concerned here with the *redondilla* but, in passing, we may say that Lucas's version was much prized in Spain, and its influence can be seen even to-day. He describes these two scripts as suitable 'to write all those things that demand speed and freedom'. They are letters which, in the absence of a

[1] This is how the book is commonly described. The short title of the first edition is *Instrucción muy provechosa para aprender a escrevir*.

pen, can be written with a reed or stalk. The pupil does not have to learn both, but can choose the one suited to his taste and need. The *bastarda* is appropriate to anyone of good standing, whether he holds an ecclesiastical or a secular office. It can—and here is further expert evidence in support of modern italic—be written rapidly, it looks nice, and it is the easiest to learn.

Lucas then goes on to talk about pen-hold, its faults and possible varieties. It is probably the fullest treatment of the subject in a sixteenth-century writing-book. The passage is reproduced below in translation. The recommended pen-hold is with the forefinger and thumb grasping the pen near to the point where the quill is cut. The pen rests on the middle finger. Only the little finger touches the paper. The third, fourth and little fingers should be in a line. Lucas suggests that, to help young pupils, these three fingers should be tied together in the early stages; all the movement is then concentrated in the forefinger and thumb. The body and the head should be kept upright. For a vertical script such as the *redondilla*, the paper is to be held straight, while, for a sloping script like the *bastarda*, it is tilted at the angle of the script.

His method of teaching is peculiar to the Spanish systems and will be found in Yciar, Madariaga and Brun (or for that matter Ximenes in 1789): this is to give the pupil at least three models, one large, one of intermediate size, and one of normal writing size. The purpose of the large letter is to enable the beginner to see the detailed construction of each letter. As he progresses, the size of his model is reduced and so is the number of ruled lines which he is allowed to guide him. The master is to pay special attention to any letter which gives difficulty. Lucas repeats this procedure in the final stages, when speed and fluency are to be developed. Models of the alphabet are supplemented first by material to be copied from well printed books, and then from manuscript letters and documents.

The qualities of handwriting for which Lucas is looking are clarity and harmony. Letter-forms are good 'when the breadth, height and thickness of the letters are so proportioned one to the other that nothing is confused, distorted or ugly; and each of the constituent parts is harmonious and well-calculated . . . and all the letters and their parts run in straight lines'. Anyone who wants to learn or teach must have a complete understanding of the elements of which the letters are constructed.

Now comes a most crucial passage, which was to have a fundamental effect on handwriting in Spain. It may be remembered that in 1540 Palatino had formalised the proportions of his italic hand by making the small letters fall within a slightly sloping quadrilateral, which was precisely twice as high as broad. Yciar took over this formula, though he was inconsistent in saying, almost immediately, that the height was to be 'a trifle less' than twice the width. It was this two-to-one proportion which confirmed critics of the chancery hand in their view that it was too sharp and angular. Lucas approaches the problem in this way. First he says that the height of the letters of the *bastarda* should be somewhat less than twice the width. He goes on to say that

the height of a letter should be five pen-widths and that the white space between such letters as *n* should be two pen-widths. If we take into account the fact that, because the pen is held at an angle of 45 degrees, the down-strokes are less than a full pen-width,[2] we shall find that the ratio of the height to the width is about 10 to 6.8, or for practical purposes three to two. It follows that, if this proportion is substituted for the old two to one, the letters are more rounded. At the same time the angle of the joins is also less abrupt and the joins themselves are shorter. The points of junction are less acute, and Lucas in fact smooths them off. The result is a handsome, legible letter, which was taught in Spain until at least the nineteenth century. We can see therefore that, when Fairbank adopted the *bastarda* of Lucas as the framework of modern italic, he was not turning the clock back to an antique style but continuing a living tradition.

How far was the Spanish solution to the problem of handwriting influenced by the craft of printing? Yciar, Madariaga and Lucas were all very conscious of a close relationship between handwriting and printing. Printers were now appealed to as arbiters in problems of punctuation, and passages from well printed books were recommended as copy for students of handwriting. This relationship was specially marked in Spain. For technical and economic reasons, printing types (as Yciar pointed out) tended to have somewhat shorter ascenders and descenders, and more open bodies. To eyes now conditioned by the printed word, Lucas's changes probably seemed a natural step.[3]

We have only to look at Lucas's models to see what a profound effect a small adjustment in proportion produced. As mentioned earlier, by the middle of the sixteenth century, a strong feeling had grown up in Italy and Spain that the classic chancery hand was in need of reform. In Italy, under the impetus of Cresci, the answer was to concentrate on speed and to allow the hand to degenerate. In Spain, thanks to the genius of Francisco Lucas and perhaps the conservative nature of Spanish society, the chancery italic script was preserved in its essentials. Strangely enough, although the instructions for handwriting contained in the *Arte de Escrevir* are extensive, even voluminous, they offer no precise advice about slope. He merely tells us to be neither too sloping nor too upright.

According to Lucas, the *bastarda* alphabet (as we must now call the italic of Spain) is constructed from six basic strokes: (a) a horizontal stroke about two pen-widths long or a little more, drawn from left to right; (b) the same drawn right to left (it is with these two strokes that the long ascenders of letters such as *b* and *d* begin); (c) a narrow diagonal; (d) a curving down-stroke; (e) a straight down-stroke; (f) a

[2] Suppose the pen-width to be two units. The height of the letter will therefore be ten units: and its width will be two pen-widths (or four units) of white space plus the width of two down-strokes. Simple geometry shows that, disregarding the slight slope of the letter, each down-stroke will be $\sqrt{2}$ (or 1.4) units, if the pen is held at 45 degrees. The total width of the letter is thus 6.8 units.

[3] Mercator had already worked out the same solution in 1540.

graceful curve made with an up-stroke turning to the right, which is used to begin *x*,
y, and *z*. He accepts that many will think this number of elements excessive,
especially if they have heard of writing-masters (such as Madariaga) who have
reduced the whole business to two or three strokes. He contends that they are all
necessary: indeed, in his first edition, he had tried to make do with four, but found
them insufficient. He then considers the alphabet letter by letter and describes in
detail the construction of each. Then he gives instructions about the way in which
letters should be joined. The general principle, which is a sound one, is that only
those letters should be connected, in which the join arises naturally from the
construction of the letter and does not distort its form. Then follow brief rules for
spacing letters and lines of writing, for making the capital letters, and for cutting the
quill. The section ends with a selection of models of handwriting.

 In the 1570 edition, the blocks were cut so that the letters appear white on a black
background. This sort of presentation was favoured also by Yciar and later by
Andres Brun. In 1577 Lucas added further blocks which reproduced his letters black
on white: some of these could justly be called bastard *bastarda*, for he has introduced
spurious joins, flourishes and even mercantile letters to satisfy the taste of his
contemporaries. Here we seem to detect the influence of Cresci.[4] The cutting is of a
high quality but the name of the craftsman is not known. It would be pleasant to
think that it was the writing-master Andres Brun, who was making similar models in
the style of Lucas for his own copy-books at this time. This is, however, just a
fanciful speculation. Like Vicentino and Cresci, Lucas was rather ungracious about
the work of the block-cutters, without whose skill his book would have been
incomplete. At the opening of the third section of his book he complains: 'The
cutting of blocks is so laborious and difficult, and there are so few persons who know
how to do it, that one is necessarily dissatisfied in some particular. Indeed, it is a pity
that they who write about the art of lettering cannot find anyone to cut their letters or
even to print them correctly. When a man has spent a lifetime composing a book and
he wants to get it published, he can hardly find a means of doing it, so that this causes
him more worry and anxiety than his original work; and then he has no alternative
but to accept what is offered.' One sees his point. Nevertheless, in spite of all the
difficulties, Lucas has left us italic models of extraordinary elegance and charm.

 The texts chosen for translation describe (1) the kinds of script in common use in
Spain in the second half of the sixteenth century, the palm being given to the
redondilla and, above all, to the *bastarda* scripts; (2) the problems of holding the pen;
(3) the fundamental change in the proportions of the chancery letter advocated by
Lucas; (4) Lucas's method of training the pupil to write with freedom and speed,
once the basic elements have been mastered. This is where many modern manuals
are sadly deficient; the transition from copying letters and words to writing clearly
and individually at speed is crucial.

[4] *Il Perfetto Scrittore* came out in 1570 and would hardly have been available for Lucas's first edition.

AN INVENTORY OF STYLES

The scripts which are, or may be, necessary for all those matters that in general comprise the business of writing nowadays are six in number — the *bastarda*, the *redondilla*, the formal book italic, the formal book roman, the Roman inscriptional capitals and the round gothic book-hand.[5] Of these six, the *bastarda* and *redondilla* meet almost all the needs of ordinary writing. The book italic and roman are for formal writing. The inscriptional capitals are for certain kinds of inscriptions, for the lettering that is placed over city gates and other buildings, for tombstones, for book-titles and other things of this kind. They can also be used as capital letters for the *bastarda*, the formal italic and formal roman styles and also in the *redondilla*, some in their ordinary shape and others differentiated by a number of carefully wrought flourishes. The round-hand, in its larger size, is used for service-books, notices, and other kinds of lettering; and, in its smaller size, for privileges and other documents of that kind, sometimes plain — as they call it — i.e. in its completely pure form, or sometimes with a serif at the end of certain letters, so that they can be written with greater ease.

Of the different styles mentioned above, the most necessary and indispensable are the *bastarda* and *redondilla*. They are so important that anyone who wants to know how to write cannot do without one or the other. The reason is that they possess the ease and convenience which enables one to write when and how one wishes; and they are the normal and universally accepted styles for writing anything that demands speed and freedom — and this is the aim and principal object of the practice of handwriting. It is not essential to learn them both, but simply the one which suits the learner's taste and need. Granted the fact that these two styles share these general characteristics, the one that can most conveniently serve the needs of people of almost any class is the *bastarda*. It is the script which suits every kind of person of rank, whether ecclesiastical or secular, and all those who practise writing and literature, with the exception of scribes and some merchants and certain others who prefer the *redondilla* — and even many of them use the *bastarda*. Certainly there are many grounds why it should be employed by everyone, since it is better both for the nobility and for ordinary people. It is the style preferred by those who use it and, moreover, the one which can be written more rapidly; at the same time, it is a good style and has the better appearance. Furthermore, it can be learned with somewhat less effort — at least to the point of writing it moderately well — which is the primary aim of a script. I do not deny that the others are individual styles of gentle invention, which serve marvellously the purposes that I have described. But I think that only three classes of person should learn them — writing-masters, in order to fulfil the obligations of their profession and not to be found wanting if someone asks for these

[5] i.e. the *rotunda*.

styles; those who use all or one of them in the course of their duties, or need one of them for some definite object; and other persons who are curious and have leisure, and who are often looking for something in which to employ their time.

From Francisco Lucas, *Arte de Escrevir*, Part I, Chapters I and II.

PROPORTIONS OF
THE LETRA BASTARDA

If the *letra bastarda* is to have its due proportion, its height must be somewhat less than twice its breadth, and this 'less' should be enough to be clearly seen. I mean to say that the letters which are made with two elements or lines, such as *a*, *n*, and *c* (but excluding *v* when it is used as an initial letter, and *m*, *x*, *y*, *z*, which are twice as wide as the other letters) should be somewhat less high than twice their width. But this reckoning and measurement excludes the serifs with which some letters begin or end, e.g. *m*, *a*, *u*, etc. Consequently the following letters have the proportion that I have mentioned: *a*, *b*, *c*, *d*, *e*, *g*, *h*, *n*, *o*, *p*, *q*, *r*, *s*, *u*. The *v* which is used at the beginning of sentences and *m*, *x*, *y*, *z*, are, as I have said, twice the width of the others; although *v* is actually a little less, the difference is negligible. The *f*, *i*, *l*, *ſ*, *t*, are letters which, as you see, are made mainly of single lines or curves, but their individual details can be seen in their design and method of construction.

Perhaps someone will say that, since the letters of the alphabet have these differences, they should all be reduced to the same proportion. The answer to that is that the letters from which the proportion and general appearance of the script are derived are those which lie between the space of the two writing-lines and are made of curved lines or elements in such a way that white space can be seen between their component parts, this space being of a consistent breadth, as in *n*, *o*, *p*, *q*, *y* and similar letters. Since these are the most numerous and the most important and are used more frequently, it is right that they should share the same proportion—a fact which is very obvious and can be readily understood: and this proportion and measure is the best and most correct that can be applied to this style. In order to comprehend readily how this proportion can be observed, whatever size of letter is being written and likewise whatever pen may be used to write a particular size of letter, the following rule is to be followed. The pen should be cut broad or narrow as required and then five pen-widths should be measured off (either up or down—it doesn't matter) and this will give the height of the letter to be written with that pen. Note that a little more or a little less (as with all the rules given in this book) is acceptable.

No one should think that everything is spoiled if the measure is slightly exceeded. After a few days of practice the size and thickness of any letter can be regulated on this scale without actual measurement. It must, however, be understood that, if the letter is to have its correct width, care should be taken that, in the white space which exists in each letter such as *n*, *o*, etc., the distance between the side-strokes should be equal to two pen-widths. By this means, each letter will be given its appropriate width, height and thickness.

From Francisco Lucas, *Arte de Escrevir*, Part I, Chapter VIII.

VARIETIES OF PEN-HOLD

Before I deal further with pen-hold, I will state briefly what holding the pen properly means, so as to disabuse those—and there are many of them—who have mistaken ideas about it. These people think it consists merely in making a show for the eye; or in holding the pen high or low; or in keeping ink-stains off their fingers; or in other similar matters. Nothing of the kind! For, in short, to hold the pen well consists in grasping it in the fingers (with the hand on the paper and the arm on the table) in such a way that it is possible to employ the full width of the nib without hindrance or obstruction, whether making up-strokes or down-strokes; and to shape the letters exactly as one would wish to have them. *This* is what holding the pen properly means, and it has nothing to do with the things I mentioned above. Therefore in order to grasp it correctly and to avoid any major faults in the pen-hold (because there are some, and they are such as might spoil or impede the success of any effort), I shall draw your attention to four mistakes which can be particularly damaging to anyone who embodies them in his pen-hold.

They are the following. First, when writing, to keep the hand too low to the right or too high to the left: secondly, to have the arm too near or too far from your body as you write; thirdly, to hold the pen so that it nestles in the centre, or thereabouts, of the space between the thumb and forefinger or is cradled in the second joint of the forefinger between the same fingers [*i.e. thumb and forefinger*]. The fourth fault is, when writing, to hold your fingers either too extended and straight or, on the contrary, too contracted. These mistakes are of such a kind that, as I have said, they can lead to so much trouble that a man who has picked some of them up will never be a competent writer, even though he spends his whole life in making the effort. No other defect in pen-hold will be able to cause much damage or to prevent anyone from writing well, given that in this, as in everything else, there is good and bad.

Now, regarding the sorts of pen-hold most commonly used, you should understand that holding the pen involves three factors. First, the fingers which are employed in grasping it; second, the fingers on which the hand rests and is

supported; and the third is the point where the pen rests. Each of the first two factors has three divisions and the third only one, though with a certain variation.

You should understand that the three divisions of the first factor are the following. One is holding the pen with the first three fingers (thumb, forefinger, middle finger), which is the one most commonly adopted. The next, which professional writers call 'over the finger', is grasping it with the first two fingers and pressing it against the middle finger, sometimes against the nail, sometimes rather higher against the joint.[6] The third is holding the pen in two fingers [*i.e. finger and thumb*], as the Italians do.

You should understand the three divisions of the second factor in the following fashion. One is keeping only the last [*i.e. little*] finger on the paper, the hand in the act of writing being supported by this one alone and the third finger being held between the little and middle fingers. The second is to keep both the last fingers [*i.e. third and little fingers*] on the paper so that the hand is supported by them; they can be either linked together or slightly apart. The third is to keep the little finger on the paper supporting the hand, with the third finger touching the little finger in such a way that it is neither in contact with the paper nor lying directly between the little and middle fingers, as in the first division of this factor, or to hold the third finger close to the middle finger without touching the little finger.

So far as the third factor —where the pen rests —is concerned, it is normally and of necessity in the forefinger at the second joint (looking along the fingers to the hand, it is the first which goes up from the hand). I said that there was a certain variation in this because there is no certainty in the distance which I have indicated. One man rests the pen on one part and another on another according to the fancy, habit or feeling of each. These are the commonest sorts of pen-hold.

From Francisco Lucas, *Arte de Escrevir*, Part I, Chapter III.

[6] In this position the middle finger is curved under the thumb and forefinger.

LEARNING TO WRITE
QUICKLY IN A SHORT TIME

I have been unable to find, and I have never heard, anything of substance about the question of whether there is any method or system for learning to write freely in a short time; it is, on the contrary, a matter which everyone simply attributes to practice without considering that there might be some means of cultivating it. Although, in fact, those who think in this way do not bother to give any reason for their views and, although practice *is* one of the most important ingredients in handwriting, nevertheless it ought to be possible to frame guidance and rules to make practice effective; for, if everything is to depend on practice, then it is most essential that the purpose of practising should be attained.

I confess that the opinion which I have heard most frequently on this subject is that one can succeed in writing with freedom by copying the simple, conventional script with no other method or special effort; and that, moreover, a person, even if he hardly knows how to write anything, will have a sound, free hand in a short time by practising an ordinary cursive script for a few days. Neither of these statements has any foundation, so that they cannot be regarded as in any way satisfactory. The road to freedom in handwriting does not lie in mechanically copying the everyday script without any method or special effort, although success may eventually come after a long time. It is quite absurd to suppose that anyone who has never learned a fair-sized script will be able to write an everyday cursive hand well and freely. If the people who think I say this had any conception of how difficult it is to write with correctness and freedom, they would appreciate that it is not solely a matter of practice, but at the same time requires much diligence and skill. So, bearing in mind the difficulty of this problem and how important it is in handwriting, I have tried many devices and made many experiments, both in my own case and that of others, with the result that I have discovered a method which, in my judgement, I believe to be correct; at least I can say that I have had striking results from it.

My method is the following. The first objective which must be attained if you are to succeed in this business is to write, at moderate speed with evenness and regularity, a plain version of the script which you want to write with freedom; for unless you can do this, everything else you do will be of little value. After this, you must write half of your daily stint of practice rather more quickly than usual. You should do this with moderate speed and not with frantic haste. The letters should be given about the normal number of joins (not more) without the addition of flourishes or turns. The only change from your previous practice will be that the script you will write for half your daily ration of exercise, as I have mentioned, should be *twice* the normal size and written somewhat more quickly. The rest of the daily practice should be devoted to the ordinary-sized letter.

When I feel that my pupil is acquiring some liveliness and his hand shows greater ease each time he sets himself to write, I first prepare for him a pair of copy-sheets of a script three times the normal size. This is to be copied even more rapidly, notwithstanding that his writing will be more broken and uneven. All he has to guard against is adding flourishes or using more joins than usual; if he takes this precaution, he cannot upset or disrupt his hand, and then he will carry out his exercises in the way that I have said.

It is also necessary at this stage to monitor those letters which cause him most trouble and which he finds more difficult to write quickly. He must practise those repeatedly until they match the rest. This is extremely important. Moreover, he must take pains that all is written with care and that everything should be the best possible of its kind, because it would not be good enough to copy the sheets with any other object in view.

A further point which needs to be watched is that the pupil should not write spasmodically or at uneven speed, but with a smooth finish and consistent appearance. When he feels that his hand has acquired dexterity and aptitude—for he must tread this path willy-nilly—he will then be able to confine himself to the normal-sized, ordinary script, practising intensively at a liberal pace, without changing anything else, so as to attain fluency in completing his letters. All he needs to do is to keep copying the two sheets of the large script to which I have referred, until his hand has become entirely flexible, and now and then some passages of normal script. At the beginning, it is a good idea to take most of what is to be written from well printed books, so as to learn to write different pieces from those to be found in copy-books, and then from some manuscript letters and documents so as to learn to take material in any kind of script without diverging from his own. He should also have some practice with a few modest flourishes, because this helps to give freedom to the hand, but he should take care that they are such as to need no pen-lift when they are written and to be made without interrupting the writing. In that event, they are of use. By following this road he will be able to write correctly, fluently and elegantly in a short time and do what, by any other method, would cost him double the time.

From Francisco Lucas, *Arte de Escrevir*, Part IV, Chapter IV.

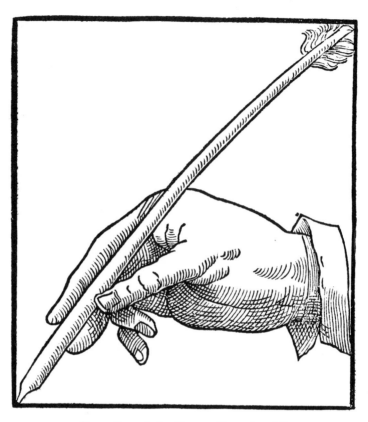

12. From Juan de La Cuesta, *Tratado y Libro*,
Alcalá 1589.

CHAPTER TWELVE

Juan de la Cuesta
of Alcalá

Although Francisco Lucas had evolved a long-term solution to the problem of the chancery hand, it is of some interest to glance briefly at an alternative proposed by another contemporary Spanish writing-master. Alas, as too often happens, we have only such information about him as can be extracted from his own work. Juan de la Cuesta was born at Valdenuño Fernandez, a tiny village in Guadalajara, about the middle of the sixteenth century. He must have left his native home while still young in order to seek his fortune in a city. We eventually find him running his own school in the South of Spain at Alcalá. Here, by his own account, he had a large number of pupils 'from the principal families not only in this district but from the Court and from the children of the chief servants and officials of His Majesty and from all the provinces of Spain'. These are large claims; part of his success may be attributed to the fact that Alcalá was a university town, to which many of the sort of persons he mentions would be naturally attracted. He obtained a privilege to publish a book in 1584 but, no doubt owing to the usual difficulties in finding a printer and engraver, it did not appear until 1589. Nothing further is known about Juan de la Cuesta.

His book *Tratado y Libro*, which was published at Alcalá with the customary dedication to Philip II, is directed primarily to the teaching of children. The text is type-set and is fairly copious; this was a regular feature of Spanish manuals from Madariaga and Lucas onwards. The treatise is divided into two parts, the first being concerned with pronunciation and spelling, and the second with handwriting. Since only a few examples of actual handwriting are shown, it is pretty certain that he could not find or afford an engraver sufficiently skilled in the art of transferring script to wood-blocks. The text, however, contains a number of diagrams, used chiefly to illustrate pen-hold.

He begins the section on handwriting with some advice about selecting and cutting quills. He discusses whether the nib should be cut square or at an angle, concluding that the former is sounder because the pen-point used now is so narrow and delicate that it would not stand up to rapid writing unless it were cut square. The three main strokes of the pen are the broad diagonal, made with the full width of the nib ('*quadro*'); the narrow diagonal, made with the edge of the nib ('*sesgo*'); and the intermediate vertical down-stroke ('*coluna*' or '*linea*'). All these are thought of as

falling within a perfect square, which means that the pen must be held at a constant angle of 45 degrees.

There is a passage, illustrated by several diagrams, on pen-hold. The quill rests in a cradle formed by the thumb and forefinger, with the middle finger tucked underneath. The hand is raised so that it is supported by the little finger.

Much of de la Cuesta's teaching revolves round his conception of the cursive hand. Although some attention is given to the *redondilla* style and the round gothic used in church-books, he always comes back to the cursive as the swift, all-purpose hand. 'It is,' he says, 'the style most commonly employed nowadays for business by the secretaries of the royal chancery and by other gentlemen, both ecclesiastical and secular, because, more than any other, it is rapid, extremely polished and elegant, and it is a script in which intelligent men can show their skill and understanding in the art of writing and display the good instruction that they received from their wise and experienced masters.'

He obviously disliked the way in which the chancery hand, in its new 'bastarda' incarnation, was being developed, and says that some people call it 'bastarda' because they have mixed in with it strokes and flourishes from the *redondilla* style with the object of speeding up the writing. But this bastard script is no faster than the legitimate cursive which, when correctly written with the appropriate letter-forms, is not only fast and fluent, but can be used for any sort of business.

He criticises his contemporaries for excessive decoration. 'Some writers introduce so many flourishes, ligatures and ornaments that their writing could more properly be termed a jumble; this is extraordinarily foolish.[1] For it is even more illegible than the old mercantile hand and, although they may gain speed . . . they at the same time render their writing hard to read, especially for old and elderly men as well as youngsters. It is the duty of us writers to pay particular regard to the satisfaction of wise and educated men of mature intelligence and understanding, who, just as such people in business and hard-pressed offices like to deal with plain and simple men, welcome handwriting in which the letters are plain, well shaped, readable, and simple, with no admixture of curls and flourishes. No person of common sense will deny what I am saying.'

But what is de la Cuesta's answer to the question? He looks back to the classic chancery cursive for his model. Strangely, he finds its best manifestation in printers' italic type ('*letra del grifo*'). Such letters may need a few small modifications, e.g. to the tail of *g*. Printed type, however, as Yciar had already pointed out, has—in the interests of economy—shorter ascenders and descenders than handwriting. De la Cuesta, therefore, instead of giving ascenders and descenders a length equal to the height of the body of the letters, reduces it by half. He also adopts Palatino's two-to-one proportion for the small letters like *a* and *n*: they are to be six pen-widths in

[1] Yciar, for example, at D v r of his 1550 edition has a chancery script defaced with non-italic flourishes and joins.

height (or certainly not less than five), and the space between the legs of *n* is to be equivalent to the width of two down-strokes.[2] So we end up with a slightly sloping, narrow letter, which looks even more cramped because of the mean ascenders and descenders. The master's readers may have wondered why, if italic type was so admirable, his book was printed in roman.

Furthermore, de la Cuesta was not entirely happy with the classic chancery hand. He felt that there were too many starting- and finishing-strokes and that this interfered with speed. His innovation is to remove the horizontal tips from ascenders and to cut out a number of in-and-out strokes used in letters such as *i*, *m*, and *n*, although he retained them in some cases 'where they impart grace and elegance without detracting from speed, which is our primary aim'. He does not go into any detail about the construction of individual characters except *a* and *b*. He says little more than that the broad diagonal starts *a*, *b*, *c*, *d*, *l* and *o*, finishes *r*, *y* and *z*, and is used for both starting and finishing *f*, long *f* and *s*; while the narrow diagonal starts *e*, *i*, *m*, *n*, *p*, *r*, *u*, *y*, and finishes *a*, *c*, *d*, *e*, *g*, *h*, *i*, *m*, *n*, *p*, *q*, *u*; and the down-stroke is used to start *t*.

The influence of the printer comes out in some of his other recommendations. Lines of writing should be of the same length and should range evenly down the page; 'for this is a great embellishment to writing'. Naturally this will involve breaking words, and a chapter is devoted to this subject. For capitals, one should again follow the usage of the printed word.

Juan de la Cuesta's solution was not a really successful one. He was to some extent swimming against the tide; it was Lucas who had set the course which handwriting would take for generations in Spain. One passage of his book, however, deserves to be reproduced in detail, because it throws some light on the organisation of school classes. The method recommended by Juan de la Cuesta anticipates that used in the elementary schools in the nineteenth century in England when compulsory education was getting into its stride. The essence of it is to make the more responsible pupils help the teacher to instruct the juniors who have not yet progressed so far. The passage is given below. One can, incidentally, deduce from it that a writing-master might have between forty and sixty boys at his school. The same master would generally teach reading, arithmetic, spelling etc. in addition to writing.

[2] This can be understood by using a calculation similar to that given in the note on p. 133 above. If the width of the pen is two units, the letter-height will be twelve and the width of the down-stroke about $\sqrt{2}$. The width of the letter, equivalent to four down-strokes, will be $4 \times \sqrt{2}$, i.e. about 5.6 units. The letter is thus six pen-widths high to just under three across, i.e. about two to one.

CLASSROOM ORGANISATION

It is the most effective means by which a teacher can successfully carry out his function. He should divide his pupils into three or four sections or classes. He should then select from them three or four pupils who have made the most progress in their studies and are ahead of the rest. To each of these three or four should be entrusted three or four teams or groups of boys in the school; their charge should consist of ten to twelve boys in all. These three or four prefects, being set over the others, can each depute three or four of the class who are more advanced in knowledge and can divide the whole section or class among them, giving to each of their seconds three or four boys of the class responsible for coaching them and watching them and understanding what they are doing. The prefect of each class should take special care with his three or four seconds to foster and attend to their progress, advising and guiding them, in the same way that they (the seconds) look after the remainder who are entrusted to them, teaching them and showing them whatever they see to be necessary—this to be done with much fraternal affection, as between friends and brothers.

The master should not give the prefects power or permission to punish or lay hands on their charges, but to guide them and urge them to behave sensibly when they see one who is misbehaving. The three or four seconds should inform their prefect that so-and-so is being slack in some respect or has some fault or defect. When the prefect has been so informed, he should take aside the boy who has been reported and tell him how he thinks he could do better, giving him two or three days in which to correct his fault in reading, writing, arithmetic, singing or scripture. If the boy does not improve, the prefect should go to the master and report his fault so that the master may remedy it in whatever way he chooses. The prefects and their seconds need do no more, for they have done their duty.

If they neglect their duty and do not report in the way that I have said, then whenever the master finds the ordinary pupils at fault he should give them the necessary punishment (which must always be moderate, as it is the most effective). But he should punish the prefects and seconds more sharply, because their naughtiness and carelessness is the greater; and if the master learns that they have concealed faults out of favouritism or bribery, he should mete out even severer punishment because this is a bad thing and has the seeds of wickedness in it. By this method, the master's pupils will make great progress; the prefects and seconds gain more because, in teaching the others, they keep on their toes and they instruct themselves with spirit and dash; their minds become supple and flexible and they make themselves masters of their subject. Thus it will be appreciated that the teacher in giving them this responsibility has done them a good service.

From Juan de la Cuesta, *Tratado y Libro.*

13. From Andres Brun,
Arte muy provechosa para apprendir de escrivir perfectamente,
Saragossa, 1583 and 1612 (reduced).

CHAPTER THIRTEEN

Andres Brun
and his Coloured Writing-sheets

The work of Andres Brun deserves to be better known. The reason for his obscurity is that no intact copies of his two books have survived, at least in public collections. The British Museum has a few leaves of one, while incomplete copies of the pair are bound haphazardly together in a volume preserved in the Kunstbibliothek at Berlin. Fortunately it is possible, from an analysis of the surviving material, to reconstruct the books almost in their entirety.[1]

Andres Brun de Borao, to give him his full name, was born in 1552. He spent most of his working life in Saragossa, where, as a young man he may well have met Yciar and would surely have known his work. Here he had his own school and was accepted as a professional writing-master. He was also an expert cutter of wood-blocks and, like Mercator, produced the wood-cut examples for his own books. Later in life he acquired the status of 'infançon', which made him a member of the minor nobility. These fragmentary glimpses of Brun's life encourage one to speculate about the real status of the writing-master and the degree of mobility existing in Spanish society. The evidence, however, is too scanty to enable a firm conclusion to be drawn. Brun at any rate does not seem to have made a great deal of money; for he speaks of the 'poverty of his old age'.

Brun's first book was published in 1583. It is in a larger format than any previous Spanish writing-book (25 × 19 cm) and the press-work is very handsome. The more spacious page enables big letters to be shown. Like his predecessors Madariaga and Lucas, Brun felt that it assisted the beginner to see the alphabet in a size that would clearly reveal the details of construction. There is an introduction to the reader, a page of instructions, ten (probably twelve in the original) sheets and a colophon. In the introduction, Brun extols the advantages of handwriting—it preserves the record of man's achievement throughout the ages, and it allows friends and relations to keep in touch, to console each other, and to share their thoughts. It is the cement of society, because without it kings could not govern, laws could not be written down nor could merchants engage in commerce. 'In short, I conclude that, if the Lord had not out of his generosity endowed us with this most useful gift, our life would differ

[1] Such an analysis can be found in Henry Thomas and Stanley Morison, *Andres Brun, Calligrapher of Saragossa*, Pegasus Press, Paris, 1929.

little from that of the brute animals. Plato says that the difference which divides us humans from the animals is that we have the power of speech and they do not. I, however, say that the difference is that we know how to *write* but they do not; by this means we are in a position to execute anything, however difficult it is.' This purple passage is most certainly inspired by Pedro Madariaga. But, continues Brun, there are many people who will not go to school or take lessons from a master, either because opportunity is lacking, or pride prevents them, or they are too old; he has therefore decided to publish a book, which will not only bring credit to his country but help those who otherwise would never learn to write.

When we turn to the sheets of examples, attention is immediately excited by the fact that they are set against a brick-red ground, the letters standing out in white. This is the first time that a coloured background is found in a sixteenth-century writing-book. Although the pages look well, we are faced with something more than an aesthetic innovation. Brun explains in his directions (printed in full below) that the pupil is intended to take a pen trimmed to the appropriate width and to fill in the white spaces by writing the letters in black ink, which would then be visible on the coloured ground.[2] The device reminds one of the set of letters engraved in wood, as recommended by Erasmus, Palatino and Yciar; but obviously Brun's method can be employed only at a later stage in the learner's development. Filling in the letters was a one-off operation demanding some skill. To make progress by this means, the pupil must have used up many sheets, and even when he had memorised the letter-shapes, he would still not have acquired their construction and the forward movement of the pen, which is necessary for fluent cursive writing. No guidance is given about how to join the letters, and hardly any ligatures are shown in the models.

The styles displayed comprise the chancery italic hand (*bastarda*), the round book-hand (*redonda*), and roman capitals and minuscules. The chancery and round-hands are modelled closely on those of Lucas, and Brun has engraved them with great skill. Two of the red sheets contain a further innovation, which one might have expected to see much earlier in the history of writing-books; at the top they have a large alphabet, one *bastarda* and one *redonda*, the remainder of the page being ruled so that the pupil can either copy the alphabets several times or use the rules as a guide which would show through when a blank sheet was placed over them.

Once the sheets had been used, whether to fill up the white letters or to copy the alphabet on ruled lines, they would normally be discarded. This is why so few of them have survived.

Brun continued to carve blocks, and in 1612 published an expanded version of his examples, giving them the title *Arte Muy Provechoso para Apprender de Escrivir perfectamente*, in the same large format. The whole book is printed in black. Many of

[2] Brun may well have adopted the idea from Vanegas, *Tractado de Orthographia*, Toledo, 1531, in which it was suggested, as a learning-aid, that coloured letters be prepared for pupils to cover with black ink: see also Erasmus, p. 36 above.

the blocks used in the earlier book reappear, but a variety of additional scripts, including roman capitals, gothic letters and a grotesque alphabet are shown. In his introduction (in which he tells us that he is sixty years of age) he commends the *bastarda* and the *redonda* scripts as the most handsome and the most serviceable for general purposes. Although the exemplars are not displayed against a coloured background, the same principle of learning is applied. The pupil has to get some thin paper and, after clipping this to one of the writing sheets, he is to trace one of the large alphabets in outline and then fill the letters in with black ink as before. When he has mastered the large white alphabet in this way, he then proceeds to the smaller black one which is written within four parallel lines.

A facsimile of Brun's books was published in 1929 with an introduction by Henry Thomas and Stanley Morison (see note on p. 179). Unfortunately even this is not easy to refer to, since, as with many of Morison's books in this field, it was printed in a small limited edition.

THE METHOD AND ORDER TO
BE OBSERVED TO LEARN
TO WRITE WELL

With the aid of the instructions which I set down here, one can learn to write well shaped letters in a few days without a master. The first thing to do is to have your quill, or quills, cut according to the size of the letter which you seek to learn. The second is to hold your pen somewhat at an angle with three fingers, and not with four as some do—and they write badly. I make a point of this, as it is a bad error. I am accustomed to teaching handwriting with large letters because they are more useful at the outset; and all the other masters who teach well-made letters follow the same practice. For this reason, I have made one alphabet in a large size, in which you have the beginnings, middle portions and endings of all the letters, and other models to be practised; these are in the two styles now in common use throughout our land of Spain: namely the *redonda* and the *bastarda*, so that any one can choose whichever he prefers. The background of the paper is coloured and the letter consists of that part of the paper which has been left white, with the idea that you should make each letter by covering the white space with ink. It is necessary to fill in the white part of the letter completely, without however making corrections; in completing the large alphabet, you will have the letters which are made in one stroke *a b c e g h i l m n o q r s ʃ u v y z*, and those which must be made in two—*d ʃ p t x*.[3] By practising on these sheets in the given order, you can learn to write and develop a nicely shaped letter. With this device the door will be shut on shame, the enemy of work, which makes many people hesitate to go to the writing-master's house to learn, since they pay greater regard to shame than to the acquisition of knowledge.

From Andres Brun, *Arte Muy Provechoso* (1583), Introduction.

[3] Brun includes two characters from the *rotunda* alphabet, not reproduced here.

LEARNING BY TRACING

First of all take some good, thin paper and test whether it can be seen through. Place it over my guide as you would with a false rule, and fix it with two clips at the sides, so that it cannot move in either direction. Then, after cutting your quill according to the size of your letter, write one or more outlines, following the guide, until you can shape the letters well, and fill in the black parts, taking care with the thin lines and white spaces of each letter. Hold your pen a little to the side [*at an angle*]. Note that for the large (white) alphabet the quill should be trimmed so that the inner part of the nib is a trifle shorter; for the smaller (black) letter, on the other hand, the outer part should be a little shorter; thus the pen will be well suited to make the letters. And in the same way the punctuation marks are made, which is a great advantage, as will be seen in the course of the work.

Hold the pen with two fingers and your thumb in such a way that the thumb is midway between the two fingers; the forefinger should be a finger's breadth from the tip of the pen, and the thumb a breadth and a half, rather more than less: the finger touching the thumb should be three breadths from the point of the pen. These two fingers and thumb should hold the pen close to the nail, but in such a way that its shaft is not hidden by the fingers. And of the other two fingers, the little one should move underneath, sliding over the paper. The remaining finger rests on the little finger and supports the thumb. This method of holding the pen will be found to be very useful both for cursive writing and for flourishing, and it makes the letters full. Note that the upper end of the pen should point to the top of the right shoulder. When you have mastered the large alphabet, pass to the smaller one with the four ruled lines and work at that. You will find the distance needed for the ascenders and descenders by tracing them. Then carry on copying the other material in the correct order, and you will attain your objective.

This book also contains all the other styles used in Spain, so that they can be practised.

From Andres Brun, *Arte Muy Provechoso* (1612).

Suprema mundi optima.

Doctissmo viro D. Abrahamo Ortelio,
Geographo Regio, longe amiciss: & di
lectißmo Gerardus Mercator in
Symbolum perpet

Duisburgi 5. Kal. Octob.
1575.

14. Gerardus Mercator: the man and his hand.
From the *Album Amicorum* of Ortelius,
MS. Pembroke 113, University Library, Cambridge.

CHAPTER FOURTEEN

Gerardus Mercator: Calligrapher and Cartographer

Of the men who wrote about the chancery hand in the sixteenth century, Mercator is the most approachable and sympathetic. This is partly because of the natural sweetness of his disposition, and partly because many particulars of his life were recorded in a biography by his friend Walter Ghim. His real name was Gerhard Cremer but, from his university days onward, he always used the Latin version of his name, Gerardus Mercator.

He was born early in the morning on Friday, 5 March 1512 at Rupelmonde in Flanders. He was brought up by his uncle, a priest, who sent him at his own expense to the school of the Brethren of the Common Life at 's Hertogenbosch (Bois-le-Duc). It was in fact the same school which Erasmus had attended nearly fifty years earlier, and was open to the sons of poor parents who were willing to be educated for the Church. Mercator was of course given a thorough training in Christian doctrine, which left a strong impression on him for the rest of his life; he was also well grounded in dialectic. The Brethren encouraged the copying of texts in their schools, and this may have stimulated Mercator's interest in good handwriting and lettering.

At the age of eighteen and a half, Mercator was entered in the University of Louvain, where he studied philosophy and the humanities, taking his Master's degree in 1532. It was a troubled period in his life. Louvain was intensely conservative and hostile to unorthodox speculation. Mercator, like many a young man, developed religious doubts, finding it impossible to reconcile the biblical account of the creation of the universe with the theories of Aristotle and other important authorities. He liked to get away from Louvain and used to go off by himself to Antwerp. At that time, Antwerp was one of the two principal centres in Europe where the best copper plates were to be had: it is therefore likely that Mercator learned the art of engraving there. In due course, the young man emerged from his difficulties with renewed faith and a determination to make his way in life. He threw himself into the study of mathematics and astronomy, often going without food and sleep. By the age of twenty-four he had not only mastered the techniques which would make him the leading cartographer of his day, but had become a superb engraver in wood, metal and glass, a fine calligrapher and one of the best scientific instrument makers in Europe. He married Barbara Schellekens in 1534 and lived happily with her for more than fifty years.

All Mercator's hard work was soon to bear fruit. Under the superintendence of Gemma Frisius, the master with whom he had studied so tenaciously, he helped to make globes (1535–6). These were the first globes on which italic lettering was prominently featured, and Mercator was responsible for this part of the enterprise. He then made his first experiments in cartography. His first map is of Palestine (1537); this was followed by a map of the world (1538) and a map of Flanders (about 1540). His treatise on italic script, which we shall discuss below, was published in Louvain in 1540.

Suddenly in 1544 a most unpleasant thing happened. He was arrested and imprisoned on a charge of heresy. Fortunately the authorities at Louvain supported him, so that he was released after a few months, but five of those concerned in this mysterious affair were executed. He resumed his work at Louvain. In 1552, he accepted an appointment as 'cosmographer' in the Court of the Duke of Cleve. So he moved to Duisburg, where he spent the rest of his life, no doubt finding the more liberal atmosphere at Cleve a pleasant change from the orthodoxy of Louvain. Among his first tasks was that of making a pair of portable globes for the Emperor Charles V; one 'was of purest crystal and one of wood. On the former, the planets and the more important constellations were engraved with a diamond and inlaid with shining gold; the latter, which was no bigger than the little ball with which boys play in a circle, depicted the world, in so far as its small size permitted, in exact detail.'

From his home in Duisburg, Mercator maintained an extensive and regular correspondence with scholars all over the world. His circle included the cartographic publishers Abraham Ortelius and Jodocus Hondius,[1] the eccentric English mathematician John Dee, Richard Hakluyt and Franz Hogenberg the engraver. During these years, he worked out his famous solution for representing the earth's sphere as a flat surface—the 'Mercator's Projection', which is still used today. He embodied this in his world map of 1589. The rest of his life was largely devoted to his great Atlas, which came out in parts, although he did not live to see the final printing. He never lost his taste for religious scholarship. He drew up a concordance of the Gospels and a commentary on the first part of St. Paul's Epistle to the Romans.

In Duisburg he was known as an honest citizen, and a good neighbour, who never crossed anyone's path and got on well with everybody. He was frugal without being inhospitable. He was never idle. He was blessed with good health, except that in old age he occasionally suffered from gout. His wife died in 1586, and he re-married shortly afterwards. In 1590, he had his first stroke. He recovered sufficiently to 'enjoy his usual calm sleep at night and to eat easily digested food or to refresh himself with a draught of wine or beer, but he was unable to recover the use of his left leg and arm, although his daughter-in-law diligently rubbed the limbs as necessary with excellent salves every day for an hour in the morning and evening.' A second stroke in 1594 proved fatal to the old man of 82.

[1] See p. 205 *et seq* below.

Even from this brief outline of his life, it can be seen that Mercator was a scholar and a scientist, not a writing-master. Yet he felt it useful to compose and publish the first manual in the Netherlands to be concerned with the italic style. The title *Literarum Latinarum, quas Italicas cursoriasque vocant, scribendarum ratio* means 'The method of writing the Latin letters, which are called italic and cursive'. There is no reference to the chancery origin of the script. The significance lies in the adjective 'Latin'. This manual is written entirely in Latin and deals only with one script. In a short preface, Mercator asserts (as Erasmus did before him[2]) that works in Latin should not be written in Greek or German characters, but in the appropriate script, 'elegant, easy to write and far more legible than any other' — in other words the *cancellaresca corsiva* or italic hand. There were clearly sharp differences of opinion about this in Louvain. Critics, we learn, had attacked italic as frivolous, unnecessary and merely decorative. The only specimens of formal italic that most of them probably had seen were in the work which Mercator had been doing for the last five years on his globes and maps. It was not then apparent to them how this young man's new-fangled lettering was to change the face of cartography in the Netherlands.

Mercator, however, had realised that italic offered the means of designing maps which would be clearer and easy to read and (whether they liked it or not!) more decorative. Moreover, he appreciated that maps would be of greater use if they contained information about the countries portrayed. Such information might be quite copious and would be usually presented in panels on the maps. It would necessarily be couched in the international language of science, Latin, rather than Dutch. The panels would therefore need to be written in the correct script, which, as we have already seen, he considered to be italic. These panels of fine italic lettering are in fact one of the most handsome features of Mercator's maps.

The manual is both an act of affirmation and a *technical* guide for map, globe and instrument-makers, rather than for secretaries. In this respect it is unique. One can now understand something that has confused antiquarians, which is that Mercator regularly employed two styles of handwriting: for his letters to fellow scholars on scientific matters, he wrote a beautiful italic; for ordinary letters and commentary in the vernacular he used the conventional mercantile or 'secretary' hand. In some of his letters the text is written in the latter, but the address on the outside is in italic.

Mercator's is the most concise and precise of the manuals on the italic hand. He recognised that the student required something fairly short so as not to distract him from other studies. Even when allowance is made for his writing in Latin, a particularly compact language, Mercator expresses in a few lucid sentences material which other writers describe with difficulty at two or three times the length. Vicentino has some of this brevity but at the price of either omitting information (e.g. about pen-hold) or of imprecision (e.g. about the slope of letters). With

[2] See p. 29 above.

Mercator, we see the gleam of the dissecting knife. The same environment and training produced Vesalius, the father of modern anatomy, a contemporary and fellow student at Louvain University.

The *Literarum Latinarum* is printed from wood-blocks, with the occasional insertion of a line or so of type. As said above, Mercator cut these blocks himself. The quality of the work is good, though lacking in the final polish and subtlety of Ugo da Carpi and Eustachio Celebrino. The graduations of contrast between the thicks and thins of the pen are not entirely rendered, and the diagonal joins tend to be overemphasised. Some strokes are downright ugly. The pages are, however, well laid out and diversified with flourishes and contraction marks. These are deliberately introduced not for ostentation or idle display but as models for the map-designer. Large maps tended to have large areas of white space which Mercator liked to mitigate with well chosen arabesques.

The book consists of six crisp chapters, illustrated with nine sketches in the text. The first chapter opens briskly: 'The tools which you require for writing are compasses, straight-edge and a pen.' Then we quickly learn how to rule paper with lines and to select and cut the quill. A full-page drawing makes clear the business of quill-cutting, of which so many other masters made heavy weather. The second chapter contains a succinct description of the way in which the pen should be held. It is taken between the forefinger and thumb and rests on the middle finger; the other two fingers are tucked under, and the third finger (not the little finger as later became the custom) alone touches the paper, supporting the hand and regulating its course. Mercator obviously, and rightly, thought that correct pen-hold was important, because he devotes two pages of his little book to sketches showing first the correct position of hand and arms, and then a faulty position. These two drawings were copied without acknowledgement in more than one book in the sixteenth century and after.[3] Next the angle of pen-hold—45 degrees— is discussed and illustrated.

The third chapter brings us rapidly to the proportion and slope of the letters. A simple mathematical diagram of the letter *y* enables us first to calculate the slope of the italic letter. It is, in fact, that of the long side of an inverted right-angled triangle, whose shorter sides are in the proportion one to twelve; this is approximately 5 degrees. No other writing-master of the sixteenth century attempts such a calculation; they refer vaguely to a 'slight slope' or 'not too straight and not too sloping'. The diagram, however, brings up another significant point that was not to be aired fully until Francisco Lucas took it up in 1570. In the same year that Mercator published his book, Palatino in Rome was laying down a ratio of two to one for the chancery letter; that is to say, typical letters such as *a*, *n*, *o* etc., would fall within a slightly sloping box, of which the height is twice that of the width. When skilfully manipulated, this proportion can give a svelte letter with a swan-like grace. It does not however, leave much room for the diagonal joins or for turning such

[3] e.g. by Urban Wyss, *Libellus valde doctus*, Zürich, 1549.

letters as *a* and *n*. There is a considerable risk that the letters will be too sharp and angular, producing a zig-zag or saw-edge effect. The ascenders and descenders are also longer so that, although they will be of rare elegance when written by a skilled penman, they are just that much more difficult for an average man wanting to write quickly. We have already seen that at the time when Palatino was stating his rule, there was a feeling in Italy that the chancery hand was in need of change.[4] Mercator anticipated this feeling and devised his own remedy. It was, as his diagram shows, to alter the original two-to-one proportion to three to two. The result is a more rounded letter, which is somewhat easier to write and is still compressed enough not to flop or disintegrate when written at speed. This slightly elongated script harmonised well with the maps that Mercator and his followers were to engrave, especially in some of the cartouches or decorated oblong frames which, as already mentioned, could be filled with long pieces of descriptive matter. It is ironic that, whereas many of the Italian masters prided themselves on their 'geometrical' construction of letters, Mercator, a highly trained mathematician, never mentions the subject.

Mercator rounds off this part of his exposition with an analysis of the elementary strokes of handwriting. Palatino had identified three of these. Mercator postulates no less than six: a horizontal, a vertical, a curved vertical, a broad diagonal, a narrow diagonal and a narrow curved diagonal; and he indicates the faults to be avoided with each. Among his general rules, he gives one for the distance between individual letters, which is more refined than that of the Italians, who for the most part simply said that this distance should be the width of the white space between the legs of letter *n*. He recommends that the distance should be that which separates the arms of *y* (which comes to the same thing), except that it should be reduced by half after letters which have an open space on their right side, e.g. *c*, *e*, *f*, *s*, *r*, *t*. Curiously enough, he says nothing about word-spacing.

The fourth chapter is occupied by a demonstration, letter by letter, of how the minuscule letters are formed out of the six basic elements. The fifth deals with joins, ligatured letters (Mercator was much attracted by these) and the ampersand. The sixth is concerned with capital letters and swash characters. Brief instructions are set in type. It is possible that Mercator, who was working under pressure throughout this period, did not have the time to complete all the blocks.

Such in brief was Mercator's treatment of the italic hand. We may conclude with the last words of his preface: 'Should you ever want to leave my teaching for another's, I shall be perfectly content, provided only that you can demonstrate its superior elegance and legibility; for these qualities are the hallmark of good writing.'

[4] See p. 83 above.

HOW TO WRITE LATIN LETTERS WHICH THEY CALL ITALIC OR CURSIVE

I

The tools which you will require for writing are compasses, a straight-edge, and a pen. Mark off with your compasses equidistant points corresponding to the number of lines to be written: then adjust the compasses to the size of your writing. Now, placing your straight-edge so that it connects the appropriate pair of points, lightly score [*with compass points*] two blind lines, within which all the letter-bodies are to be accommodated. More advanced pupils ought gradually to dispense with them; they are admitted simply to train the hand. The following is an example:

For the sake of brevity, we shall from now on refer to these pairs of lines as the 'parallels'.

Choose a transparent, medium-hard quill. I say 'transparent' because, if it is clouded with white marks, it will be less easy to make the correct slit in it. It must be of medium hardness because, if it is too soft, it will supply too much ink, and, if it is too hard, it will usually supply too little; and it will cause other difficulties as well.

When you are preparing your pen, first make very sure that the slit follows a diameter of the quill; you can do this most easily in the middle of the back of the quill.

Then see that the point is moderately thin, so that sufficient ink to make individual letters flows gently down. If it is stubby and wide, it will release too much ink for your letters; if it is too long and narrow, then it will release too little. Next cut the extreme tip back a little from the edge which faces away from you as you write, but in such a way that the whole of the edge so cut is in contact with the paper when the pen is being used. See too that the slit you made before is in the centre of this writing edge, thus:

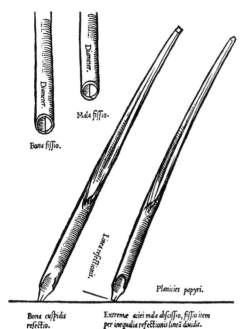

Bona fissio: good (vertical) cut.
Mala fissio: bad (vertical) cut.
Linea resectionis: the line of the trim.
Planicies papyri: the surface of the paper.
Bona cuspidis resectio: the tip well trimmed.

Extremae aciei mala abscissio, fissio item per inequalia resectionis lineam dividit: a bad trimming of the extreme point, and the vertical cut divides the line of the trim into unequal parts.

II

When you have prepared your quill, hold it in two fingers—the index and the thumb—gently supported by the middle finger so that it is enclosed by them in a sort of triangle. Only the two former have the function of holding the pen; that of the middle finger is simply to stop its slipping away from the other two when they have to be pulled back in the act of writing. You will also find it a help if the two former fingers are stretched out straight in order that they can be drawn back a greater distance, since this will often be necessary, as you will see later.

The remaining fingers should lie in the same line as the middle and index fingers, but in such a way that half the middle finger rests on the fourth, and half the fourth on the little finger so that the whole hand is supported only on the little finger, with the least possible pressure, thereby enabling the hand to move readily in any direction. But the fourth finger should touch the surface of the paper.

See also that the whole of the upper arm is free to the forearm, around which the hand itself can revolve like a pivot. Do not allow the elbow to press with undue weight on the table; it should move smoothly, resting partly on the table by its own weight and partly supported from the shoulder.

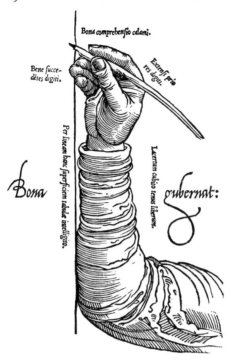

Bona comprehensio calami: good pen-hold.

Extensi priores digiti: first (two) fingers extended forwards.
Bene succedentes digiti: the fingers arranged well.

Per lineam hanc superficiem tabulae intelligito: by this line you are to understand (that we mean) the surface of the table.
Lacertum cubito tenus liberum: forearm free to the elbow.
Bona gubernatio: good management (of the pen).

Inepta calami comprehensio: a poor pen-hold.
Contracti priores digiti: first (two) fingers drawn back.

Male succedentes digiti: the fingers lying together badly.

Superficies tabulae: surface of the table.
Procumbens lacertum: forearm lying down flat.

Mala gubernatio: bad management (of the pen).

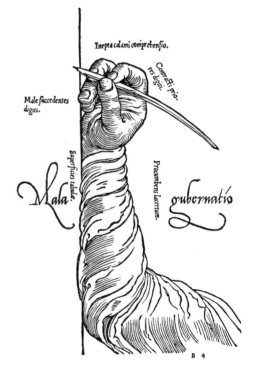

So much for the position of the hand. But the pen should be held invariably in such a position that its broadest stroke would join the opposite angles of a square [*i.e. at an angle of 45 degrees*].

The broadest stroke of the pen is that which occupies the whole width of its tip and is made according to the breadth of the pen. Opposed to this is the hairline, which runs at right angles to the thickest stroke, as shown below:

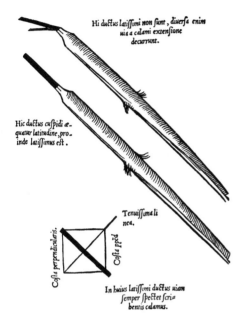

Hi ductus latissimi non sunt, diversa enim via a calami extensione decurrunt: these are not the thickest strokes, for they run in a different direction from that in which the pen is pointed.

Hic ductus cuspidi aequatur latitudine, proinde latissimus est: here the stroke equals the width of the pen, so it is the thickest stroke.

Tenuissima linea: the thinnest line.

Costa perpendicularis: perpendicular side.

In huius latissimi ductus viam semper spectet scribentis calamus: let the pen of the writer always point towards the path of this thickest stroke.

Finally, the pen must not be tightly gripped by the fingers nor pressed too firmly on the paper, since the former tires the fingers and the latter makes it impossible to preserve a uniform width of pen-stroke.

III

It will not be necessary to consider proportions here in minute detail, but I should discuss those which occur in the most frequently used components of letters: this I shall do at length with the two-branched letter, *y*.

So let us take a square *abcd*, the two perpendicular sides of which are *ac* and *bd* respectively, and let the other two sides be divided into twelve equal parts. Take away a quarter of the whole square, *ef* being the dividing line. The remaining quadrilateral will contain the letter *y*. Then let a line be drawn from angle *c* to the first division of the line *ab* and, parallel to this, another from the second division of

the line *ab* to the first division of the line *cd*. These lines form the boundaries of the first downstroke of the above-mentioned letter.

Similarly, let a line be drawn from the ninth division of the line *ab* to the eighth of *cd*: this will eventually be prolonged below in the same direction, but just how far I will explain in the following chapter. Let another parallel line be added from the eighth division of line *ab* to the seventh of *cd*, and these two will be the boundaries of the second downstroke of letter *y*.

Now let a line, connecting the two outlines already made, be drawn from angle *c* to *b*.[5] This we shall call the narrow diagonal, not that it is the thinnest stroke that can be made but because, of all the strokes used to make the letters, it approximates most nearly to this. It is, in fact, to the line which connects the angles *cb* that this term properly belongs.

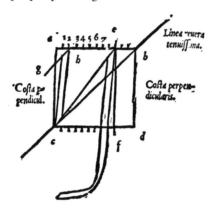

Linea revera tenuissima:
the really thinnest stroke.

Costa perpendicularis:
perpendicular side.

The measurements of the remaining letters of the alphabet should be derived from the proportions of this letter. I shall be able to explain how with greater brevity and clarity, if I first divide the basic elements into categories as follows:

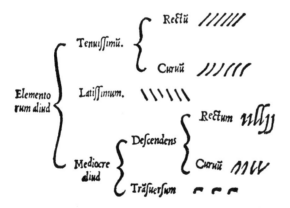

Elementorum aliud: elements.
Tenuissimum: narrow diagonal.
Latissimum: broad diagonal.
Mediocre aliud: medium strokes.
Rectum: straight.
Curvum: curved.
Descendens: down-stroke.
Transversum: horizontal or
 cross-stroke.

[5] This is surely an error for *c* to *e*.

The narrow diagonal is the thinnest line that this style of handwriting admits. It always follows the same slope from the perpendicular to the right as the line *ce*, which joins the verticals of the letter *y*. The broad diagonal is in fact that which I defined in the second chapter, except that it slopes only so much to the left of the perpendicular as the narrow diagonal from the right. For example:

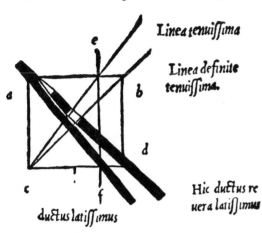

Linea tenuiſſima

Linea definite tenuiſſima.

Hic duƈtus re uera latiſſimus

ductus latiſſimus

Linea tenuissima: the thinnest line (in writing).

Linear definite tenuissima: the line which is absolutely the thinnest.

Ductus latissimus: the broadest stroke (in writing).

Hic ductus re vera latissimus: this line is actually the thickest.

The medium stroke is the line which is approximately halfway between the broad and narrow diagonals, as for example the cross-stroke – – – or the two sides of letter *y*. I imagine that the descriptions of the other lines will be clear from the examples included in my categories. I will, however, indicate their nature in a moment.

Some of the basic elements that I have mentioned are made by drawing in the fingers, i.e. by pulling them downwards—such as the medium down-strokes and the broad diagonals; others by extending the fingers, i.e. pushing them forward—as with the narrow diagonal. Others are made with the hand held stiff, e.g. the medium horizontals and the various other strokes used in capitals.

Now let me give you some general rules.

Rule 1
All narrow diagonals have the same slope from the perpendicular, thus:

///////))))) (((((

Those which are curved have the same slope, whether their shape is convex or concave, e.g.

///(())))

Hairlines [*i.e. serifs*], which are attached to the head or foot of unjoined letters are a third of the length of the others such as I illustrated by line *ch* of the letter *y*.[6]

[6] It should be *gh*.

The following offend against this rule:

////// ///// ////////

Rule 2

All medium down-strokes slope equally to the right and are equal in length, being bounded by the two parallels. Of the remainder, those with ascenders rising above the parallels and those with descenders are twice as long: while those that have both ascenders and descenders are three times as long, on the principle that the parts which go above the parallels are equal in length to those which hang below, as follows:

These offend against this rule:

Lines with curved contours similarly incline to the right with either a convex or concave bend, as follows:

Make half the stroke perpendicular so as to keep the bend moderate in size, at the top with these *ꞏꞏꞏ*, and at the bottom with these *ꞏꞏꞏ*.

The following are incorrect in various ways:

ꞏꞏꞏ Too much slope

ꞏꞏꞏ No slope

ꞏꞏꞏ Bend too great and half the line not perpendicular.

Rule 3

All letters that fall within the parallels must have the same width as that of letter *y*, with the exception of *m*, in which the first prong is this distance from the second and the second the same distance from the third. Also *f*, *i*, *l*, and long *ſ*; *i*, *l*, and long *ſ* because they are single lines, and *f* because the horizontal bar, which crosses the medium down-stroke, does not attain this width unless it precedes *i*, *l*, or the element *ɩ*, in which case it has almost the same width.

Rule 4

The distance between the individual letters should be the same as that between the two down-strokes of *y*. But the distance between *c*, *e*, *ſ*, *g*, *r*, *t*, and *v* and the succeeding letter should be half of this. However, the distance between the medium down-stroke of *f* and *i*, *l*, or the element *ɩ* is the same. For the cross-bar of the letter *f* extends to the left-hand side of the following letter.

You now have the rules governing the proportions of the principal elements; if you want further detailed information, this can be found in the following chapter.

IV

Practically every letter is the result of a combination of these basic elements: *cſjiıυ*, the character of which I have in part already described: now hear the remainder. *c* and *ſ* begin with a medium horizontal made in reverse motion; in *c*, it runs along the top parallel, in *l*, it runs back along a line, which is higher by the width of the interval between the two parallels. Be careful to draw it straight across (like this: - - -), not drooping at one end (like this: -‿ ‿‿), and continue with a very short curve as follows: ‿‿‿⌐⌐⌐ not a long one like this: ⌐ . Now add a medium down-stroke, as straight as possible, thus: *rrr ⌐ſſ* Let a thin, straight stroke flick up from the foot in this way: *ccc ſſſ*.

j is made the opposite way, like a lengthened *i*: but the former has a longer cross-stroke at the foot, whereas the latter remains within the limits of the parallels and turns back at the bottom with a narrow diagonal. I have already demonstrated how the other two are made, apart from the fact that a hairline begins one and finishes the other.

All these four elements: *ciıυ* are completely contained in the parallels; of the remainder, *ſ* breaks out above them and *j* below, the latter moving from the upper parallel, the former from the lower.

The angles made by the medium down-stroke and the narrow diagonal should be acute, but beginners who are practising this operation must take care that they are not made too sharp.

This will happen unless the lines which meet at the point of junction move quickly away. It is, therefore, desirable that the straight lines should be as straight as possible at the tip.

Now here are specimens of bad joins: *ɹ ɹ ɹɹ ɹ ɹ ʌʌ ʌ ʌʌ*

But the top of the element *j* is narrowed in the letter *p*, and it likes to project a little over the upper parallel thus: ═ɟɟɟ═

And now let me give you a few general rules.[7]

a is constructed from *c* and *ı* in this order: *crυa*.

b from *ſ* and *ı*, thus: *ſſſ* or from *ſı* and *ı* thus: *ſſſſ* but the former method is more reliable.[8]

c was explained at the beginning of this chapter.

d is formed from a closed *c* thus: *υ* and *ſ* in this order: *υυſd*, but the pen is moved diagonally from *υ* to the top of the next element, as follows: *υdd* so that the down-stroke to the beak of *υ* may be made with greater certainty.

e is formed from *υ* but with a slight change. For the hair-line should not spring

[7] This is a printer's error for 'Now let me tell you how to form each letter'.
[8] Vicentino prefers the second method: no pen-lift is needed for this.

straight from the down-stroke, but from a short thick line of the following shape ⌣ which is added like a foot to the medium curved down-stroke in this fashion: ｜ι. Then the pen is brought slightly round to the original start of the line, and a very short curve is made along the upper parallel thus: ｜υ. Then, in the same direction, shape the head of the letter as in ｃ but dropping down a little, like this: ｃｏ. Finally, close it with a fine line to the left, which must, however, not fall to the centre of your first line, thus: ｃ ｃｃｃ.

f. is made from *ſ* and *ｊ* joined together in this order: *ſſ.f.* When this letter begins a word, the cross-bar should follow the upper parallel for a short distance before passing through the spine of the letter.

It should begin very fine, but be a little thicker at the end thus: - -. It is written from left to right.

g is formed from *ｇ* with the addition of a curved line, which finishes in a narrow diagonal at the lower point of the bowl thus: *ｇ ｇ* though be careful not to produce any unevenness like this: *ｇ ｇｇ*.

ğ is a combination of *ｏ* and *ｓ* but the tail is brought round to a narrow diagonal in the same way as in *ｇ* as follows: *ιｃｏｇ ğ*. Finally [*lit. 'thirdly'*], on the level of the upper parallel, a short line *ｒｒｒ* similar to the nose of the letter *ｒ*, projects from the back of the head like this: *ğ*.

h is made from *ſｒ* and *ｚ* in this sequence: *ſ ſ ſ h h*.

ｎ was described when I dealt with the basic elements.

k is composed of *ſｒ* and with a broad diagonal as follows: *ſ f f k*.

l is already known from what I said about the proportions of the elements.

m is made of *ｉｒｉｒｎ* thus: *ｉ ｒ ｎ ｎ ｍ*.

n from *ｉｒｖ* in the same way.

ｏ is constructed from *ｉ*, the first stroke of *ｅ* as prescribed above and from the same line turned upside-down thus *ｚ*. It is drawn in exactly the same way as the former, but the order is reversed. Consequently the letter is made like this:[9] *ｉｃｏ ｉｚ ｏｏｏ*.

Moreover if, when it is completed, you have preserved the correct position of its components, its shape will be such that its highest point and the lowest part of the body will have the same slope as a medium down-stroke thus: *｜ ｄ ｄ ｄ*.

p is formed from *ｊ* and *ｃ* reversed *ｚ* in this way: *ｊ ｊ ｊ ｐ*

ｚ and *ｊ* are written in the same way, except that the latter goes outside the parallels, but the former does not.

ĝ is made from *ｒ* and *ｊ* thus: *ｒ ｒ ｒ ｇ*.

x is a combination of *ｉｒ* thus: *ｉｒ*. But the tip of the hair-line bends from left to right into a very short bar of medium thickness like this: - - -. See that the letter does not exceed the width of *ｙ* thus: *ｒｒｒ*.

ſ. (long) is the same as *f* without the cross-bar.

[9] Vicentino makes the letter *o* in one stroke without lifting the pen.

ʒ (final), known as the snake, consists of these two semi-circles: ˤᴐ. The former begins on the hair-line and finishes on the broad diagonal, while the latter, starting on the broad diagonal, is carried round back to the broad diagonal. The former is smaller, and its two ends should follow the slope of a medium down-stroke as follows: ꝗ ꝗ ꜿ. The latter observes the same slope with its tip and the spine of its partner thus: ẞ ẞ ʃ. Furthermore, the line which connects these two circles must show no trace of irregularity, e.g. ʃ ʃ ʃ but should wind down the path of the broad diagonal, and its shape should consist of two arcs curving in opposite directions in this way: ʃ ʃ, so that not even the tiniest part of the letter is straight, as in these examples: ʃ ʃ ʃ. The letter stays between the two parallels.

ꞏt is a mixture of ⁄ and ⱀ with a medium, straight down-stroke, in this order: ⁄ⱀⱨ. Then add a bar - moving the pen to the right so that the line is thicker at its termination than at its beginning: ⁄ⱀꞇꞇ. But the elements ⁄ⱀ and - must converge at a single point on the upper parallel. Here are examples of ugly separation: ꞇꞇꞇꞇ.

ɣ, which is used only at the beginning of words, starts from a hair-line and curves round and down in a broad line. Then when it drops down in a wider arc and reaches a point midway between the two parallels, it follows the perpendicular to the lower parallel. Thereafter, it rises straight and thin—though with a lesser slope than the narrow diagonal—from the third section of the line *cd* in the diagram and ascends to the ninth section of the line *ab*, except that, near the upper parallel, it is carried back to the eighth section, where it is quickly finished off with a slightly broader stroke.

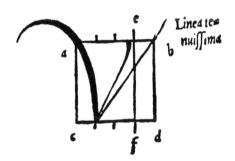

ɯ is formed from ⁄ⱀ, as follows. ⱳⱳⱳ. This kind is used only in the middle of words.

x is composed of ⱱ (not made with the broadest diagonal but more upright than it to the same degree as the hair-line in the letter *v* diverges from the narrowest diagonal) and an ⁄, of which the foot rises from the end of a horizontal stroke and the head is brought round into a very short horizontal, in this order: ɣⱱx x .

Take care that the hair-line cuts the broad diagonal in the centre—not like this: x x x x. and also that a line connecting the points furthest left and another

connecting the points furthest right have the same slope as a medium down-stroke as follows: 𝄞 𝄞 x x. The height of the letter should be equal to the distance between the two parallels.

ÿ̈ Its first part ↱ after the hair-line, is similar to the first stroke in ν coming down from the upper parallel but reaching the lower parallel with a moderate width. Add to this, at a short distance from the top, a hair-line to the upper parallel; from this point, a line almost straight runs down in a wide sweep, touching the lower end of the first line.[10] To begin with, it is medium thick, then it is a narrow diagonal, and, at its termination, it gradually curves more and becomes a horizontal of medium thickness thus: ↱r y yy.

ƶ is constructed from two cross-lines ~~ connected by a narrow diagonal ∕, which is made by drawing back the fingers. The cross-lines consist of two equal curves, the one turning down and the other turning up in this order: ⌐~ ꙮz z z z. Its slope should be similar to that which we have assigned to x; its height, too, is the same.

The points which I have placed against individual letters show how many strokes are needed to make them. When their construction can be completed in one stroke, I have simply put one dot against each.

In general, all letters should project evenly forward. But these b d h k ſ p y may be changed into these b d h k̲ p̲ y̲ —but it is wrong to mix the two kinds. Moreover, these g k v x y & z can be written in a variety of ways, as you can see by looking through this manual and as I shall explain when we come to capitals.

A medium stroke can be narrowed unnaturally, when it is required as in ƒ and t, by letting the pen touch the paper lightly; but when the pen is committed to the paper with great vigour, it restores the naturalness of the stroke.

[10] Vicentino's letter y is made in one stroke without pen-lift.

V

Joined letters (apart from their decorative value) increase writing speed and, more than anything else, enable the writer to avoid useless movements of the pen. Yet, even if they involved some loss of time, the demands imposed by the contours and sequences of letters would frequently call for them.

Some combinations are pure, as when one letter is joined organically to another like a living creature. Others are impure, either when a large part of a letter is hidden or distorted from its natural shape or when something is added to the outlines of consonants e.g. ⁀vʈ ɛ̄ ʈ̄ .

Now learn which rule governs the former.

All letters that end in a serif rising from the lower parallel should be joined, by prolonging the serif, to those which follow them, with the exception of *c*; for example: *an na uc ſo*. So *e*, *c*, and *t*, although they finish with a hair-line at the foot, cannot be joined to the following letter.

So long as a horizontal ⁓⁓ does not follow, letters are connected with a single stroke of the pen as in *immunis, numu e*. But when a horizontal follows, the pen must stop and move across, so that the continuous production of strokes is interrupted — for the narrow diagonal of a preceding letter must not be joined to the beginning of a horizontal.

Therefore, when a horizontal follows, the diagonal is prolonged from the previous letter to a point a little beyond the centre of the parallels; then transfer the pen to the upper parallel, at a distance from the end of the diagonal equivalent to the width of the letter *y* thus *ʌ ʌ⁓ ʌc ʌc ʌc*. But when *ſſ* follows, the narrow diagonal is as before, but the lift of the pen is the same as I demonstrated in letter *d*.

ſʈ ſʈ cſʈ ſʈ ſʈ ſʃ ſʃ ß and *œ œ œ* are linked in a different way: most of them readily combine as a consequence of their letter-shape.

Now we must consider the ligature in *ſʈ ſʈ ſʃ*. This is carried smoothly left to right from the tip of *c* or *s* round to a straight horizontal line, which, at its right extremity, drops firmly down, either at right angles or with a backward curve, on the first element of *p* or *t*. If you want to make a more elaborate join of this, let the horizontal be prolonged and then let it turn round sharply, wheeling back to the upper parallel and terminating at the start of the medium down-stroke in this fashion: ⟞⟍⟋ ⟍⟋ ⟍⟋ ⟍⟋⟋

Finally, there is the *ampersand*, and this is formed as follows. On the upper parallel, draw the top of an *e* but in the reverse direction; and the curved line which follows it must preserve an unvarying circular movement until it is brought round to a narrow diagonal, or to the thinner arm of the letter *v*, thus: ᴗ ᴗ. Allow it to continue along its course as far as you wish and then let the ligature which joins *c* and *t* *ɛʈ* rest evenly balanced on its tip. Finally, the head of the character should be closed with a thin diagonal like this ᴄ⟋ ᴄ⟋ ᴄ⟋, brought down as follows ɛ⟋ ɛ⟋.

But the ampersand &, is most frequently used instead with beautiful effect; it is written with the following sequence of movements: ‹ ‹ ρ ℮/ ℮/ &/ or ‹℮/℮/ ℮/ & or ⁄℮/℮/ ℮/ ℮/ & or ⁄α &.

You must, above all, try to make the part ℮/ as rounded as possible, until it turns into the narrow diagonal. Then the part ↘ with ℮/ forms almost a circle, when it has turned back to the broad diagonal.

The belly of the letter—namely this α—must keep its round shape throughout, except where the broad and narrow diagonals intersect. Likewise, let the top be rounded and rest on the belly in such a way that a line drawn through the centre of each will be found to be perpendicular. But the ampersand likes to appear in many guises, as is clear in numerous places throughout this manual.

VI

For the writer who knows how to give the capitals and minuscules their correct proportions, capital letters correspond in dimension with the respective minuscules; they have the same slope to the right, but they can be perpendicular if preferred. Capital *M*, however, is not as wide as its namesake *m*; but though smaller than its square, spreads out a little more than the remainder.

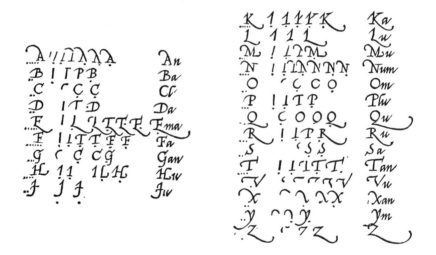

Those letters that riot with greater exuberance than their fellows outside the body of the text frequently assume a variety of shapes in the same way as we have shown with some of the minuscules; sufficient examples will be found throughout this manual and in the alphabets that follow.

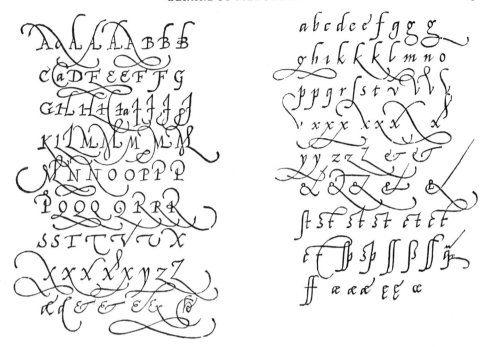

In making flourishes upwards and downwards, take care that they leave the square containing the letter in a straight line for a little and then curve round in a narrowing circle; they must not seem to wind languidly and cautiously around as though they were broken down, like this:

Gerardus Mercator, *Literarum Latinarum . . . scribendi ratio.*

THEATRVM
ARTIS SCRIBENDI,
VARIA SVMMORVM NOSTRI
feculi, Artificum exemplaria
complectens, novem diverfis linguis exarata.
Iudoco Hondio cælatore.

PALAMEDES

CADMVS

ANAXAGORAS

MERCVRIVS

15. Title-page from Jodocus Hondius, *Theatrum artis scribendi*, Amsterdam, 1594 (reduced).

CHAPTER FIFTEEN

A Man of many Parts:
Jodocus Hondius

The names of Mercator and Hondius are inseparably linked in the history of cartography. For after the former's death, Hondius bought the plates of Mercator's famous Atlas and, after adding some maps of his own, published the whole—the 'Mercator-Hondius Atlas' as it is usually known—in 1606. The pattern of his early life also resembles that of Mercator in some ways.

He was born in Flanders in 1563 of Protestant parents, who shortly afterwards settled in Ghent where, for a few years at least, it was possible to enjoy religious toleration. The young Josse de Hondt, to give him his un-Latinised name, was a gifted craftsman; he taught himself to cut punches for type (a highly skilled trade) and to engrave on ivory and metal. Even at school, he was noted for his handwriting. Manual dexterity was accompanied by a lively intelligence. His father, therefore, had him taught Latin, Greek, and mathematics. When the Duke of Parma captured Ghent, the Protestants were ordered either to become Catholics or get out. Even in these conditions, Hondius' work attracted attention, and some of his engravings were presented to the Duke. In 1584–5, however, he joined the mass exodus of the Protestants of Ghent to London. Here he completed his scientific education. He established contacts with such people as Hakluyt, who introduced him to Mercator's work, Drake, Frobisher, Raleigh, Edward Wright and probably John Dee, and perhaps the leading writing-masters: J. de Beauchesne, F. Clement and P. Bales. Hondius was always a tremendously active man; he engraved many maps, portraits and illustrations for books, and he continued to cut punches. He was the engraver of the celebrated pair of Molyneux globes, the first of their kind to be made in England. During his stay in England he married and started a family; he must have relished the defeat of the Spanish Armada in 1588.

He was still only thirty years of age when he left London for Amsterdam, where he spent the remainder of his life. In 1594, the year of Mercator's death, he published his writing-book *Theatrum Artis Scribendi*. When he was thirty-nine he enrolled in Leiden University for a course in mathematics. In 1605 he was able to buy a house in the Kalverstraat in Amsterdam, from which he published the first Greek book to be printed in that city—an edition of Ptolemy's *Geography*. A year later, as we have seen, came the Mercator-Hondius Atlas, in which thirty-six new plates were added to the original hundred and seven. Hondius died suddenly in 1611.

Even if he were not the author of a writing-book, Hondius would still be of some interest to the student of italic handwriting. He is an authentic disciple of Mercator. His maps are designed after his master's style, and the lettering on them is a neat, well shaped version of the formal chancery hand. Moreover, the name of his writing-book is intended to recall that of the first atlas—the *Theatrum Orbis Terrarum*—which was published in 1570 by Mercator's dear friend Abraham Ortelius. When the book appeared, Mercator immediately acquired, or was presented with, a copy. The old man, with only a few more months to live, must have been pleased to discover in its preface a sentence which had been lifted almost word for word from the introduction to his own writing-manual of fifty-four years before.

The *Theatrum Artis Scribendi* is an excellent specimen of the copperplate engraver's art; the clean lines of the handwriting models are a testimony to Hondius' skill with the burin. It is, however, worth pausing briefly at the title-page. Around the middle of the sixteenth century, especially in Italy, elaborate title-pages, often embodying images of allegorical significance, are found in many writing-books. Those of the writing-master Ludovico Curione (which were known to Hondius) are splendid examples of the genre, which deserves a monograph in its own right. Hondius' design exhibits some typical themes. In the top left hand corner, we see the Greek philosopher Anaxagoras, who was born about 500 B.C. and influenced a whole generation of Athenians, including Pericles and Socrates. In this title-page, he symbolises the intelligence which brings order into chaos; indeed, his contemporaries, as Plutarch tells us,[1] nicknamed him 'Nous'. In the corresponding position at the top right-hand corner sits Palamedes, the mythological sage who cleverly exposed wily Odysseus' attempt at draft-dodging just before the Trojan war, and was credited with having added four letters to the Greek alphabet of Cadmus—as well as having invented lighthouses, weights and measures and dice! The frame of the design is flanked on each side with an oval panel. The one on the left portrays Mercury, who (among other attributes) is the god of writing: to judge from a pyramid and crocodile there with him, the scene is set in Egypt. The other panel is occupied by Cadmus himself, who is said to have imported the alphabet from Egypt to Greece. A small panel, centred in the upper border of the frame, displays a hand beckoning to some writing on a tombstone, while its counterpart at the bottom has another hand pointing to the Writing on the Wall in the biblical story. The message comes over loud and clear: 'Learn to write—it is later than you think'.

The book is primarily an anthology of pages from other writing-masters, copied out, set in decorative borders, and engraved by Hondius. These masters comprise van den Velde, Henrix and van Sambix of the Netherlands; the Italian Curione (mentioned above); the Englishmen Peter Bales and M. Martin; and John de

[1] *Life of Pericles*, IV, 4. For modern fantasies about the mythological origin of the Western alphabet (Palamedes, Cadmus, etc.), see Robert Graves, *The White Goddess*, Faber & Faber, Chapter 13, 'Palamedes and the Cranes'.

Beauchesne of France.[2] Two models are from the hand of his sister Jacomina. There is a piquant touch about the inclusion of the three Netherlands masters. On Christmas Eve 1589, a famous handwriting competition for the 'Prix de la Plume Couronnée' was held in Rotterdam. The result was: first, Felix van Sambix; second, Salomon Henrix; third, Jan van den Velde. Hondius was evidently not unaware of the commercial advantage of having in his book samples of the work of the three prizewinners in this contest. Incidentally, the five plates shown in the *Theatrum* are the earliest published work of van den Velde.[3]

Of the forty-two plates, the first thirty (with one exception) are each furnished with a different border, whereas the same one does duty for the last twelve. This seems to indicate that Hondius may not have had as much time as he needed to complete the series. The borders are ornate and must have required a lot of work. They clearly owe a debt to Clément Perret.[4] The models of handwriting are texts in nine languages, one being Greek and another Hebrew. This again may betray Perret's influence.

Well over a third of the plates (sixteen out of forty-two) were written by Hondius himself, and over half of these are models of the italic hand in various forms. Thus we can see where his main interest lay. In his preface, he describes the qualities for which he looked in handwriting; they are, not unexpectedly, those prized by Mercator—elegance, rapidity, and ease of learning. Looking back to his boyhood, he relates how, although in school he was reckoned to be a bit of an expert at handwriting, he was unable, with the script which he had been taught at that time, to keep up with the teacher when he dictated to his class. It is clear that Hondius disapproved of the direction which the writing-masters of his day were taking. He criticises the lack of discipline in contemporary handwriting. He also deprecates the complicated, flourished, letters that take four or five strokes to make. Such letters had always formed part of the Gothic styles: at this period a taste for them was becoming prevalent in the Low Countries and reached its climax in the early seventeenth century with the magnificent specimen books of Van de Velde, Maria Strick, Boissens and Roelands. Hondius's purpose, therefore, was to offer to young students a portable compendium of practical modern hands.

Hondius's preface, which is printed from type, also contains some sensible, though not very detailed or complete, rules about writing the italic and other styles. It comes as no surprise that, with his training in the Mercator tradition, he draws them up in Latin. One or two references to printing reflect his experience as a punch-cutter as well.

He starts by defining two elements: the basic stroke (*lineamentum*), a vertical down-stroke, which serves to define the distance between the pair of writing-lines,

[2] See Chapter 17 below.

[3] See A.R.A. Croiset van Uchelen, 'Dutch writing-masters and the "Prix de la Plume Couronnée"', *Quaerendo* VI, 4 (1977). [4] See pp. 218–20 below.

and the letter-body (*corpus*), which is the letter or part of letter that is bounded by the writing-lines. The height of the basic stroke will vary according to the style of script. For the roman, italic and *rotunda* scripts, it is ten pen-widths. Since the proportion for the classic chancery hand is five pen-widths, we can see how narrow the pen had become over the years. Basic strokes should be of uniform length and width; and in the italic style they, and any rounded letters, should be given a slight slope.

Hondius then states that every letter should be connected to another where possible—for cursive writing all should be joined except *f* and *t*. This rule goes far beyond anything found in earlier books, which allowed natural breaks. Hondius emphasised his point by providing two plates showing systematically how any letter of the alphabet can be connected to practically every other. This 'alphabet directory', as it is called, has over 600 entries. The space inside letters e.g. *o* and *d*, should be the same. The normal space between letters should be equivalent to that between the legs of an *n* but closer spacing is recommended where the side of the letter is rounded. This recommendation is borrowed from Mercator.

Ascenders and descenders should be equal in length to the basic stroke and the distance between lines of script should be slightly more in order to prevent an ascender touching the descender above it. Like Yciar, Hondius points out that printing types have shorter ascenders and descenders and therefore the lines can be closer together.

In a note following his preface, Hondius announced his intention of producing a further collection of fine scripts; the project, however, apparently came to nothing.

HONDIUS
ON HANDWRITING

Greetings to the reader!

You have before you, my dear reader, the true forms of written characters according to the rules and proportion suitable to each language, culled at any rate from the best authors; you have, I claim, the best method of writing. When you have mastered it, you will be able to write with both elegance and great rapidity; and in my opinion those are the two qualities above all to look for in this craft. What is the use of those tortuous flourishes now favoured by so many writers? For this is the name I give to that sort of writing in which each letter has to be written with at least three, four, or even five strokes. What ever is the point, I say, of that kind of script, which is neither useful for the writer nor easy for anyone to copy—unless its purpose be to meet the needs of the painter rather than the writer?

On the other hand, I think it a laudable object to prescribe for young people handwriting models that are both elegant and simple to copy, and can be of use to a writer who is pressed for time; that is to say, models in which the letters are constructed with an even, correct size and proportion, and are connected together in such a way that they are legible and, as far as is possible, run on in a smooth sequence of strokes.

Whether that tortuous kind of writing has any value, I leave to the judgement of those who have had to take down dictation from someone without warning. I myself recall how I found that, while I was at school, I was not able to keep up with the teacher when he was dictating something to us, although I was reckoned by some to be proficient in handwriting. I believe, then, that pupils should be thoroughly trained by their instructors with practical models until they reach the point of being able to write by themselves with grace and speed. It is only when the hand of the pupils has become expert in this way that they should be permitted (and simply for practice) to copy that slow, tortuous style of writing—and this they will be able to do readily and effortlessly. And so, with the greatest of ease, they will acquire the whole art of handwriting.

But if other people think differently, I am so far from resisting them that I would, in fact, welcome their view with open arms, but on one condition, that they can show that their style is superior in elegance, more legible, and more practical to use.[5] In case I appear to be too arrogant in saying this, or I seem to be claiming another man's credit for my own as if the models of handwriting in my book were all my invention, I have included in every example the name of the writing-master whose work I have engraved; in this way, everyone will receive the honour due to him.

[5] A quotation from Mercator.

I have not undertaken this task in order to cheapen the work of my predecessors by my book, but to give as much help as possible to young students at least, who will be able to carry with them wherever they wish, and to have always ready to hand, an ample store of material from various books digested in this vademecum of mine; as I stated before, I have chosen all the best things from the best books: and this at little cost. I felt I ought to make these remarks for the benefit of my young students.

It will not, however, be inconsistent with my purpose if I set down for my students a few brief general rules that are valid for every style of writing. With the help of these rules, they should be able to write all their letters better and more surely. First of all, then, I must define what is the basic stroke [*lineamentum*] and what is the body [*corpus*] of the letters.

Rule 1: I call the *basic stroke* the vertical line or base on which the body of the letter is built, and I call the *body* of the letter all that part which is contained in the line of writing, neither going up above it nor going down below it. In order to make the matter clear, we say that the letter *n* has two basic strokes and the letter *m* has three.[6]

Rule 2: *length and thickness of basic strokes*. The length of the basic stroke varies according to the kind of script. For with the Attic letters, which we commonly call 'Latin', with the cursive (often known as 'italic'), and with the *rotunda* or, as it is commonly called, the 'roman', we think of its length as consisting of ten units, each unit being equal to the width of the stroke.

With the Flemish, French and English letters, the basic stroke—not unreasonably—consists of seven units of thickness: and with the *quadrata* which we also refer to as the text-letter [*textualis*] the length of the stroke consists similarly of five units of breadth.

Rule 3: *uniformity of the basic strokes*. Basic strokes should be of uniform length and breadth and, in the Attic, *rotunda*, *quadrata*, Flemish, French, and English styles, should be written perpendicularly; but, in the case of the cursive letters, they must slope uniformly off the perpendicular. Here, too, curved letters such as *o* also slope at the same angle as the basic strokes.

Rule 4: *continuity of strokes*. Let every letter be made with a continuous line of basic strokes as far as is possible; in the cursive style this means all except those with a cross-bar, e.g. *f* and *t*.

Rule 5: *space between strokes*. An equal space should be left between the basic strokes of a letter, even if they are round on one side, as, for example, with *b* and *d* and so on, or round on both sides, as with *o*.

Rule 6: *distance to be left between the letters*. All the letters should be divided by a space equal to that between the legs of a single *n* or *m*. (The space, however, between *c*, *e*, *f*, *g*, *r*, *t* and the next letter should be half of this distance; or else—as with *f* and *t*—

6 In its simplest form, this basic stroke is an *i* without serifs, i.e. a sloping vertical down-stroke between the lines of writing. But Hondius later extends the meaning to include curved strokes, e.g. those of the letter *o*.

the cross-bar should be joined to the letter that follows). But letters that are curved on their left or right sides are exceptions to the rule. These are written with closer spacing: *c*, *d*, *e*, *g*, *o* and *q* are letters with a curve on the left side, and *b*, *h*, *o* and *p* are letters with a curve on the right.

Rule 7: *length of ascenders and descenders*. There is a rule about ascenders and descenders; but because, on account of the undisciplined ways of writing which prevail now, it is frequently neglected, it will seem pointless to some. Since, however, it was always observed by the earlier writing-masters and even now is highly regarded by some scribes, I will state it just as it has been laid down by other writers. Ascenders and descenders follow the length of basic strokes. This means that the length of the ascenders and descenders is the same as that of the basic stroke: so the letters with ascenders, such as *b*, *d*, *h*, *k*, and *l*, and those with descenders, such as *g*, *p* and *q*, are twice as long as the basic stroke, and letters with both ascenders and descenders, such as *f* and long *f*, are three times as long. In printing types the letters are usually a bit shorter.

Rule 8: *distance between lines*. It is clear from what I have said already that the distance between the lines should be such that, whatever the length of the ascenders and the descenders, one should not touch another. Therefore the distance between lines will be a little more than twice the length of the basic stroke. *This is the normal rule*. But just as I remarked about the ascenders and descenders, this rule is ignored today by writing-masters who allow a greater distance in the interests of elegance, or so they claim. In printing, the usual practice is to use a smaller distance. The object of this is to save space and expense. These, then, are my general rules.

Attention should, however, be devoted to some further qualities in each letter, that is to say, good shape, elegance, clarity and certain other things, depending on the style of the letters. But partly because I have made all this plain throughout my models and partly because these considerations are related more directly to printing than to handwriting, I have deliberately left them aside, so as not to seem too critical. What I have already said should meet the requirements of the young student. If anyone wants more, he can find out the rest by his own efforts.

From Jodocus Hondius, *Theatrum Artis Scribendi*: Introduction.

16. Mirror-writing. From Clément Perret, *Exercitatio alphabetica nova et utilissima*, Antwerp, 1569 (reduced).

CHAPTER SIXTEEN

The French Connection: Christopher Plantin, Pierre Hamon, Jacques de La Rue and Clément Perret

When we turn over the pages of the writing-books of the sixteenth century, admiring the assured authority of their elegant scripts, we are apt to overlook the conditions of dreadful insecurity in which many were produced. This was the age not only of the High Renaissance in art, but equally of the wars of religion, Reformation and Counter-Reformation, and bitter division between Catholic and Protestant. Disseminators of ideas—printers, authors, publishers—were often men of strong convictions and were therefore particularly vulnerable to persecution. We have already observed how Mercator narrowly escaped judicial death and thought it prudent to move to Germany. In France, things were no better. In 1546, Étienne Dolet was burned at the stake in Lyon together with the heretical books that he had printed; and, in the next decade, the publisher Thomas Vautrollier and the writing-master Jean de Beauchesne, who will appear again in these pages, abandoned France for England to escape religious intolerance.

The case of Christopher Plantin is instructive. Here was a man of flexible disposition, prepared to work with the authorities, if only he could practise his craft; nevertheless, he was caught up in the turmoil of his times. He was born in France, leaving Touraine in 1545 to enter the book trade in Paris. The doctrinaire atmosphere of the capital proved uncongenial, so that he set up business in Antwerp, where he was to become the leading printer of his generation. While on a visit to Paris in 1562, he was charged with heresy and his entire stock sold up. He was, however, able to go back to Antwerp in the following year and re-establish a flourishing press. Then, in 1576, came the Spanish Fury. Antwerp was sacked by mercenaries. Plantin's losses, according to his friend Ortelius, amounted to not less than ten thousand guilders. Recovery was slow in Antwerp, and he went to Leiden as printer to the university. Homesick, he returned after two years to Antwerp where he remained for the rest of his life. Despite these vicissitudes, he brought out about two thousand books, many of them substantial with excellent press-work. His output includes at least three which are relevant to handwriting.

The little *A.B.C.* of 1585 belongs to Plantin's Leiden period. It is designed to help children to learn to write without difficulty. The material to be copied is a collection of rhymed precepts arranged alphabetically, each sheet bearing an elaborate decorated initial. The texts are in Flemish. Once again we note the confluence of the roles of writing-master and printer. For the whole work is reproduced in printed type, the bulk of it in *'civilité'* (a script type-face, based on the secretary hand and pioneered by Robert Granjon in France in 1557): alphabets of roman, italic, Greek and Hebrew, and numerals are also included. The child was expected to learn to write by copying the printed pieces, but the book contains no guidance as to how to set about it. This was consistent with Plantin's view, expressed in an earlier book, that *civilité* type would serve as a good model for young clerks.[1]

For his daughter Martine, who displayed some aptitude for the pen, Plantin arranged a less casual scheme of improvement. He took her to Paris to study with 'a fine scribe who was teaching the King to write'.[2] This can only be Pierre Hamon, who was regarded in France and the Netherlands as one of the most able writers of his day. Yet, apart from his surviving works, little is known about him, and even that little is of dubious authenticity. He was born in Blois (no great distance from Plantin's Touraine) perhaps in the 1530s. In 1556, he wrote out an account of the Ottoman court under Soluman II in five volumes. About this time he acquired the title of Master of the Golden Quill.[3] He published the first edition of his writing-manual *Alphabet de l'invention des lettres en diverses écritures* in 1561. He also made some maps—a description of Gaul in twelve sheets, presented to Charles, Cardinal of Lorraine, and a map of France, dedicated to Charles IX in 1568.[4] Since 1564 Hamon had been appointed to be the King's amanuensis and secretary to his chancery. He was deeply interested in the historical origins of writing and, with royal authority, scoured the monasteries around Paris for specimens of old scripts. His collection is in the Bibliothèque Nationale: one item purports to be a portion of the

[1] *Le Livre de l'Ecclésiastique*, 1564. The term *'civilité'* was in fact derived from its use in a school-book, *La Civilité Puérile*, by Jean Louveau, Antwerp, 1559.

[2] Colin Clair, *Christopher Plantin*, Cassell, London, 1960, pp. 250–1. Other notable penwomen of the time were Hondius' sister Jacquemine (see p. 207) above); Esther Inglis of Edinburgh, daughter of a Huguenot refugee; and Maria Strick, author of writing-books, e.g. *Tooneel Der loflijke Schrijfpen*, Delft, 1607.

[3] From the middle of the sixteenth century, we hear of contests between writing-masters for the award of prizes, such as a golden quill. There is the famous contest between Daniel Johnson and Peter Bales in England in 1595: cf. Ambrose Heal, *The English writing-masters and their copy-books 1570–1800*, Cambridge University Press, 1931, pp. xv and xvi, and, in lighter vein, Isaac D'Israeli, 'The History of Writing-Masters' in his *Curiosities of Literature*. For Dutch competitions, see A.R.A. Croiset van Uchelen 'Dutch writing-masters and the "Prix de la Plume Couronnée"', *Quaerendo*, VI, 4 (1977), p. 319 et seq. Hamon seems to have won some such contest.

[4] Dr. Wolpe has also attributed B.M. Harleian MS 3996 to Hamon (see *Renaissance Handwriting*, pp. 76–7 and Plate 45).

will of Julius Caesar. Certain references in his comments prove that he was familiar with the manual of Palatino.

In 1569, he was, it is said,[5] suddenly arrested either for his religious beliefs, or for forgery, or because he wrote some scurrilous verses against the King. He was tried, condemned (the King being absent from Paris at the time) and two days later, on 7 March, hanged in the Place de Grève. This very circumstantial version, however, runs counter to the statement in the title-page of the fourth edition of the writing-book (Lyon, 1580) that the work had been revised and enlarged by the author himself. Moreover, there is documentary evidence[6] that the scribe Pierre Hamon apprenticed his son Jean, then aged sixteen years, to Nicholas Bonfons; this in itself has a certain plausibility in that Bonfons published a writing-book of his own some years later.[7]

Hamon's *Alphabet de l'invention* is a copy-book rather than a writing-manual. He gives no rules for handwriting nor indicates any preference for style. Several varieties of the secretary hand, the script most commonly employed then in France and England, are shown. Well over half the book is devoted to the italic hand, some kinds being intended for practical use and others for entertainment. Hamon seems to have been particularly influenced by Tagliente, and indeed one of his italic pages is called 'The Venetian'. Not only are the letters in his models flourished with the vigorous strokes reminiscent of the Venetian master, but Hamon includes a block illustrating, as Tagliente did, an italic hand that slopes so far back as to be grotesque. There is also a curious specimen of mirror-image writing. One page is printed with white letters thrown up on a dark background.

Another possible source—and one that should be mentioned in any account of the italic hand in France—is the German schoolmaster, Caspar Neff of Cologne. He published his manual *Ein Köstliche Schatzkamer* in 1549. It has an alternative title-page in Latin *Thesaurarium artis scriptoriae*, in which the author lovingly refers to his 'golden book' as a 'treasury of the art of writing' and 'a precious jewel of the scribes'. The book is unusual in that each page contains *two* complete exemplars, giving a large upright format. Naturally most of the models are of German script, but nine of them deal with chancery hands. For the Italian versions of the latter, Neff went back a quarter of a century to Vicentino and Tagliente, two of his alphabets being direct copies.[8] As many as four variants in the French style are shown, and these have a distinct affinity with the work of Hamon and de la Rue, who is discussed later in this chapter.

[5] This tradition originates in a Protestant martyrology, *Histoire des martyrs persecutez et mis à mort pour la verité de l'Évangile*, Geneva, 1616, and has been transmitted from one authority to another.
[6] Reference given in Colin Clair, *Christopher Plantin*, pp. 250–1.
[7] *Exemplaire pour bien et proprement escrire*, Paris, exact date not known.
[8] The alphabet in 'La littera cancellaresca' is copied from Tagliente's block 'Ben ch'io', and that in 'Hi characteres in Roma' from Vicentino *La Operina*, f.D1r.

Hamon's antiquarian interests are reflected in the texts of his models, which aim to tell a continuous story about the invention, development, and value of the alphabet. It must be admitted that the quality of the writing in the models as printed is not of the highest, though this may well be a measure of the competence of the unknown engraver rather than that of the author.

The book went into four editions. Its influence can be plainly detected in the work of Beauchesne who, as Dr. Wolpe reasonably conjectures in the following chapter, may well have been a pupil of Hamon. It is also conceivable that the two men met in Lyon in 1580, since each had a book published there in that year.

Apart from the lessons given to the printer's daughter, Hamon had other links with Plantin. He designed a *civilité* type-face for him, and it seems as though he collaborated with him as an author. In 1567, Plantin published a bi-lingual book *La Première et la seconde partie des dialogues françois pour les jeunes enfants*, which was made up of dialogues in French and Flemish, the latter being translated from the former, although this is not absolutely clear from the text. The last two dialogues are about handwriting and printing. Some scholars believe that one was written by Hamon and the other by Plantin. There are three characters, designated G, H and E respectively. It is almost certain that they are Jacques Grevin, French physician and poet; Pierre Hamon; and Robert Estienne, who printed the 1567 edition of Hamon's manual. Even if Hamon is not the author, the conversation undoubtedly reported his views. It is, therefore, an important document for sixteenth-century handwriting and is accordingly reproduced here.

17. From Jacques de la Rue, *Alphabet, de dissemblables sortes de lettres*, Paris, *c.* 1565.

This is a convenient place to introduce the other leading French writing-master of the period, Jacques de la Rue, who devoted an entire copy-book to the italic hand. A strong stylistic affinity exists between his work and that of Hamon. Since Hamon was regarded by his contemporaries as an incomparable pen-man, the probability must be that he influenced de la Rue rather than vice versa. Information about Jacques de la Rue is scant. According to the privilege printed in his first book, he was a professional scribe attached to the University of Paris. His unusual interest in the Greek majuscule alphabet may have arisen from this connection. The content of his models, two of which are elementary mathematical puzzles, suggests that he may have been a schoolmaster. It is also possible that he practised as an engraver.

His *Alphabet, de dissemblables sortes de lettres: En Vers Alexandrins* was published in Paris, apparently in 1565; the work is not dated but the privilege referred to above was issued on 27 June of that year. A distinctive chord is sounded by two small panels of elegant lettering, one a Greek majuscule alphabet and the other a Roman, engraved so that the characters show white on a black background.[9] De la Rue's other books were brought out by a different publisher, Claude Micard. An enlarged, somewhat muddled version of the *Alphabet* appeared in 1569 under the title *Exemplaires de plusieurs sortes de lettres en vers Heroiques.* It is enhanced by a notable addition, an alphabet of bold Greek capitals, the finest in any sixteenth-century writing-book. The problem of faithfully reproducing handwritten words by engraving crops up again. Dedicating his book to the Duc d'Anjou, the author describes his verses as 'made and written with my pens of wood' (very likely an allusion to his own engraving) and apologises because the wood-block is unable to 'represent to the life the effects of the hand and pen'. The scripts in these books lack the variety of those in Hamon's, being limited to a few secretary and italic styles in roughly equal proportions.

It is, however, clear that, at least in University circles, the italic hand was popular. De la Rue responded to public demand by taking the italic examples which he had already published and adding further material to form a new collection which he called *Exemplaires Italiques de I. de la Rue.* It is undated. Variations are played on the italic theme by alterations in letter-size, roundness, slope, pen-width and the relative lengths of ascenders and descenders. One example, used twice previously, is in mirror-writing. Although not of conspicuous beauty, the *Exemplaires Italiques* are an important indication of the current state of the chancery hand in France.

De la Rue's procedure is the same in all three books. The text to be copied is invariably a moralising quatrain or couplet suitable for young people. The appropriate alphabet is generally shown, above or beneath. Each verse opens with a different letter so that the full set makes a complete alphabet, a device borrowed from Hamon. No instruction about handwriting is given.

[9] The two small white alphabets appear again in the *Newe Booke of Copies,* which Thomas Vautrollier published in London in 1574. See next chapter.

To return to Plantin and his circle. Abraham Ortelius, map-publisher and colleague of Mercator, used to keep an *Album Amicorum*, an elaborate autograph book, in which his friends were invited to write or draw something. This book is preserved in the University Library at Cambridge.[10] It shows us a cross-section of the intellectual and artistic talent of the Low Countries in the second half of the sixteenth century. Here we find great scholars such as Lipsius; artists and outstanding engravers such as Braun, Hogenberg and Galle; the distinguished botanist Charles de l'Écluse; the English savant John Dee; and, of course, Plantin and Mercator (see illustration on p. 184 above).

The album is worth attention simply as an anthology of examples of contemporary handwriting. Since many of the entries are in Latin, the language of scholarship and science, the authors write their contributions in the appropriate humanistic or italic hands. Naturally, they differ in quality. One of particular elegance is that of Alexander Grapheus, a professional scribe closely associated with Plantin, and, like his father before him, town clerk of Antwerp. The thirty-third page contains another striking entry — striking because the first two lines are written in reverse so that one needs a mirror to read them. This was a well-known trick of the writing-master. We have already noted examples in Palatino, Yciar, Hamon and de la Rue. In this case, the writing-master is Clément Perret, a man of French extraction living in Brussels.

No reliable details of his life are recorded. He flashes before us, leaving few traces beyond two writing books, one of 1569 and another of 1571, and the entry in Ortelius' album, which is dated 1577. The remarkable thing is that Perret was still in his eighteenth year when he made his début as an author. It might have been expected that a calligrapher and designer of such brilliance would surely have published more work, had he lived an average span of years. It is tempting therefore to conjecture that he died young, perhaps being killed in the troubled period that followed the Spanish Fury. Yet there is a tantalising shred of evidence that, possibly as a refugee, he may have been employed in England by Queen Elizabeth's 'secretary' (presumably the Chancellor) and taught Her Majesty the italic hand, in return for which he was granted an annual pension of about £100;[11] and an indication from another source that he was alive until at least 1590. Clearly further research in the Royal archives could prove rewarding.

Perret's first book *Exercitatio alphabetica nova et utilissima* captures the eye

[10] There is a facsimile: *Album Amicorum Abraham Ortelius*, van Gendt, Amsterdam, 1969.

[11] Jan van den Velde, *Lettre Defensive, pour l'Art de bien escrire*, Rotterdam, 1599, fol. C1r. It is uncertain what value should be attached to this evidence, circumstantial though it is; for Elizabeth I, while still a girl, learned italic handwriting from Roger Ascham. On the other hand, Dr. Wolpe has pointed out that the binding of the copy of Perret's *Exercitatio Alphabetica* preserved in the Victoria and Albert Museum is stamped with Elizabeth's Royal Arms. I suggest that the book's presentation to the Queen may be the origin of van den Velde's garbled account. This passage was drawn to my attention by Mr. A. R. A. Croiset van Uchelen, who has generously allowed me to embody his discoveries here, even though my book may be published before his forthcoming essay on Perret.

immediately with its handsome, large, oblong format and the wealth, ingenuity and variety of the borders. As the title-page boasts, the book is adorned with 'rare ornaments, shadings and perspectives taken from painting and architecture'. In essence the borders (which occupy far more of the copper plates than the writing models) are designed on a framework of architectural motifs shaded and drawn in perspective—scrolls, cornices, architraves, pillars, etc.—on which are draped or hung a mass of fantastic objects. On the title-page itself, for example, we see masks, goats' heads, sphinxes, bunches of fruit, birds, snails and, in one tiny panel, a scene which almost certainly portrays Susanna and the Elders. On other borders, cherubs hold quills, blow trumpets, or swing on trapezes; banners wave; frogs watch naked gentlemen wielding tridents; bats hang from ropes; candles blaze; lions meditate and snakes writhe. A curious, though doubtless deliberate, feature is that although each design is symmetrical, most have a small variation; for example, the counterpart to a male figure may be female. It seems clear that Perret designed the borders. They are most skilfully engraved, but the engraver has never been positively identified.

The title-page describes the author as a man of Brussels 'still in his eighteenth year'. The name of the printer is not shown. At the end of the book, however, there appears a privilege (on a plate designed by Perret), which is dated 13 February 1569 and forbids the book to be copied without Christopher Plantin's permission. An entry in Plantin's books for 10 April 1570 states that he had 200 copies of this privilege printed by Wilhelmina Mynken. It has been argued from this that Perret would have had to wait until he had actually obtained the privilege before completing the last plate, and Plantin may have found it convenient to have put the final page out to contract for printing. At any rate, the entry is not without interest as it reveals the typical size of an edition of a writing-book.

Perret's models are scriptural texts in different contemporary languages—French, Flemish, English, Italian, Spanish, German and Latin.

The idea is not entirely novel. Palatino had included in his manual a page each of French, German and Spanish. But he did not make a feature of it. Caspar Neff, however, in his manual of 1549 (*Ein Köstliche Schatzkamer*) proclaimed on his title-page that he was showing Latin, Italian, French, German, Flemish and English models; in fact, texts in all these languages, with the unfortunate exception of English, which would have been of particular interest, are provided in the book.

The styles used are gothic, mercantile, chancery italic, and roman. Each main style is repeated so as to form a suite of models progressively declining in size. As we have seen, the Spanish masters in particular regarded it as important that the writing-master should give his pupils at least three sizes of model, and perhaps Perret's idea came from this source: of the various italic models in the book, the most elegant happens to be a Spanish text. Another plate has a text with the italic written in reverse. In yet another, the text is treated like a ribbon and fashioned into a maze-like design, a device which was not original. Wolfgang Fugger had used it with a

German text in his manual of 1551. But Perret's is the first italic example. The lettering in the *Exercitatio* was engraved by Cornelis de Hooge, a fine craftsman who had spent many years in England and was shortly to be executed in 1575 at Delft for high treason. He was accused of inciting the Northern Provinces to disaffection by circulating pamphlets, which he had caused to be printed in Leiden and in which he claimed to be the son of the Emperor Charles V. Perhaps it was an association with de Hooge that led to Perret's early death?

In his first book, Perret was eager to display his virtuosity. His second is the *Eximiae Peritiae Alphabetum* of 1571. It is possible that the title is a punning one (*Peritiae* (skill, knowledge) = *Perret*). The book is described as 'useful and necessary to all persons of liberal mind and to young people alike, who take delight in fine lettering. By studying and copying it both beginners and those with some experience will succeed in this art'. In this book, only the title-page has a border. Once more, we find no indication of the printer. The writing models occupy only a small part of the plate, so that it is most likely that borders were intended to be added. If so, it looks as though Perret had to abandon his work, and it may not in fact have been printed in 1571. Or possibly he still was able to use the services of de Hooge to engrave the lettering, but could no longer command those of the man who had been responsible for the borders. The writing models are again in seven languages and are graduated in size, though rather less systematically. Neither in this book nor in the previous one are any directions given about how to write. Nevertheless Perret's manuals exercised a strong influence on the teaching of handwriting in the Southern Netherlands.[12]

Plantin, as we have seen, was at the centre of a network of connections that reached out well beyond Antwerp. In 1567, for example, he entered into a contract for the supply of books to England through Jan Desserans and Thomas Vautrollier, who were partners in London. Within a couple of years, however, Vautrollier withdrew from the partnership, setting up as a printer on his own. Dr. Wolpe takes up the story in the following chapter.

[12]Mr A. R. A. Croiset van Uchelen will explore this theme in his essay on Perret.

Lettre carrée commune

Noé homme docte, sainct, et sage les sauua en l'Arche, Combien qu'en la confusion des langues la pluspart du monde perdit connoissance d'icelles, laquelle seulement demoura en Eber, duquel depuis sont descenduz les Ebreux, qui ne perdirent leur premiere langue, ains a esté en eulx continuee

a . b . c . d . e . f . g . ʃ . g . h . i . k . L . m . n . o . p . q . r . ʃ . s . t . v . u . x . y . z . Z .

18. From Pierre Hamon, *Alphabet de l'invention des lettres*, Paris, 1561.

HANDWRITING:
ITS TOOLS AND TEACHING

GREVIN: . . . *While I was reflecting on these matters to myself in the course of a walk outside the town, I had the good fortune to come across two of my close friends. One is the finest writer of our time, and the other the most careful printer that has so far been known. Both have been appointed to serve their King because of the exceptional quality of their work. They asked me about my reflections and thereby opened up this vast field of discussion. The penman opened by saying:*

HAMON: I am quite sure that the use of the alphabet goes so far back into antiquity that one could hardly find out who discovered it, although Pliny set himself the task of naming the inventor.

ESTIENNE: Is it not the case that the Phoenicians invented and, for this reason, acquired much renown among the ancients? However, I would like to hear what you think.

GREVIN: It is my opinion that the letters were invented as soon as men were forced to think about them—not in one hour, or one at a time, or by one individual, but piecemeal; for it is always easy to add to something that has already been discovered. But it is not this that exercises me, because I know that you [Hamon] have written about it in you most admirable manual,[13] having carefully extracted the facts from the ancient authorities. I shall be satisfied to learn from you the terms which you commonly employ in your art of handwriting and (*turning to Estienne*) from you those which you use in printing.

HAMON: Indeed, I shall be more than pleased to tell you; for I know how careful you are to search out the correct use of our French tongue, and I have long had it in mind to let you know about the elements.

GREVIN: Tell me then what are the things which are most essential in handwriting?

HAMON: Pen, paper and ink.

GREVIN: What is required of the pen?

HAMON: First, that the quill shall be properly selected, and second, that it shall be properly cut.

GREVIN: How do you choose it?

HAMON: It should have a barrel that is long, clean, dry, and not too greasy.

GREVIN: How do you cut it?

HAMON: Quills are not all cut in the same way. Those with a soft, tender barrel should be given only a short slit, and should have an extremely short nib. Hard quills should have a longer slit with the nib smoothed well back so that its length will make the pen less resistant to shaping the letters correctly.

[13] As already mentioned, the texts in Hamon's book deal with the origins of the alphabet.

GREVIN: Is it a general rule that all quills must be slit?

HAMON: Not at all, seeing that it is not always necessary to write with delicacy. Thus we are sometimes compelled to draw with our pens rather than write—for example, when we make the initial letters of the gothic scripts, the *lettre de forme* and the *gros bâtard*.

GREVIN: Then the penknife is one of your most important tools. To express it more neatly, it acts like a schoolmaster to your quills and so often makes them talk.[14]

HAMON: It is not, with respect, the most important; for you may prefer to regard as most important the straight-edge, the lead ruler, and the compasses, with which we rule our lines and regulate our writing.

GREVIN: I will mention another very important thing, though I realise that, when it is compared with the first three, it is not absolutely essential—I mean the pen: it is not so essential because they did without it in ancient times, writing instead with a stylus.

HAMON: They did this because paper had not yet been invented and they were compelled to use tree-bark.

GREVIN: This is still done in our time by people who have much to do and have business to transact in several places. In order not to forget anything, they carry tablets on which they write with a needle.[15]

HAMON: This kind of writing ought not to be subjected to comparison with any other.

GREVIN: But it is all right because it meets a need. For no sort of writing is good or profitable, except in so far as it enables us to conduct the affairs of everyday life more effectively. But let us pass on. What about the choice of paper?

HAMON: The qualities which paper needs most are that it should not be absorbent and should be smooth. Paper lacking in these qualities is usually manufactured for some purpose other than writing, such as for printers' tympans, for book-boards, and for wrapping up merchandise.

GREVIN: But you do use blotting paper?

HAMON: Yes, we use it instead of sand.

GREVIN: Well, is that all we look for in paper?

HAMON: Yes, though sometimes when it has not been properly sized and we are afraid that the writing will show through on the other side, we rub it with pounce. We find this especially necessary when we are writing large letters.

GREVIN: Has the paper any effect on showing the writing to better advantage?

HAMON: It all depends on the whim of the penman. One man likes to write on shiny paper, the next on grey paper, the third on blue[16] and the fourth on parchment or vellum.

[14] There is a play on words here which cannot be reproduced in English: the word *bec* means both 'nib' and 'mouth'. [15] The Flemish text says 'with a slate pencil', which seems more likely.

[16] This is the only reference to coloured writing-paper that I have noticed in the manuals of the period.

GREVIN: What about ink?

HAMON: It should flow well. For this purpose, it must not be too thick as a result of being laced with too much gum. It must also be very black. These are the points about which we should be careful.

GREVIN: What do you do to teach a child well?

HAMON: The principal method is by practice; it is also necessary that the schoolmaster should be painstaking and industrious. One is no use without the other.

GREVIN: What is practice? What does it achieve?

HAMON: That the child adapts himself and strengthens his hand, another thing most necessary for correct handwriting. You can see that otherwise a sluggish, shaky hand cannot succeed in anything, even if it belonged to the best writer in the world!

GREVIN: Is it possible that practice alone can train the hand so that nothing else is necessary?

HAMON: I am referring to practice organised by a master, who is careful and takes the trouble to guide the child's hand and to make him write, sometimes on his knee, sometimes on a table, so that he gets used to it and becomes confident of writing properly in any circumstances.

GREVIN: So a writing-master must exercise the greatest care?

HAMON: Yes, because otherwise he is not worthy to carry his writing-case and ink-pot.

GREVIN: Then I'm surprised that there are so many scrawlers about, who are only fit to cross out or scratch out what they have written. But what about models for handwriting?

HAMON: A good teacher, when handing out copies to his pupils, should ensure that they serve as examples not only of good handwriting, but also of learning to live a decent life.

GREVIN: What must he do after carefully watching this point?

HAMON: He should proceed from small things to great. He teaches the pupils the simple things before coming to the more complicated parts. He starts with the letters of the alphabet and shows how to make the correct shapes for each of them.

GREVIN: Are all alphabets the same?

HAMON: Not at all.

GREVIN: Which should he begin with?

HAMON: Those in commonest use.

GREVIN: What is the style which is most used?

HAMON: The cursive secretary hand that we employ for everyday purposes.

GREVIN: And after that?

HAMON: If parents want their children to learn more, they can be taught the *lettre carrée*, the *lettre ancienne*, the *lettre d'état*, the *lettre ronde*, the *lettre de comptes*, the *lettre de finances*, the *lettre italique commune* or *ronde* or *d'exercice*, the *lettre*

venecienne ronde or *carrée*, the *lettre pattée et droicte*, the chancery letter, and a host of others, which are simply for amusement, such as the forward-sloping, the left-handed,[17] the bisected,[18] the backward-sloping, the dog-toothed and others that you can invent at will and name as you please.[19]

GREVIN: After teaching the individual letters, what do you do?

HAMON: We teach the pupil first to make words from them, and then a whole line, and then two, three, four lines and more, according to the child's ability.

GREVIN: How do you teach him to decorate and draw his letters well?

HAMON: By the same means; that is to say, by copying the model which is given to them. They can in fact teach themselves to make vigorous flourishes after they have mastered everything else and have acquired a light touch.

GREVIN: So those who have been born with a heavy hand are not suited to writing well.

HAMON: No, but practice can rectify this defect.

From Plantin: *La première et la seconde partie des dialogues françois pour les jeunes enfants*, Part II, Dialogue 9.

[17] Mirror writing. [18] Cut horizontally by a white line running through the middle.

[19] All these models can be found in Hamon's book.

Italiq Letter

uarell not with a mighty man, lest thou Ɛ̃amme,
to fall into his handes, and make not variaunce
with a riche man, lest be happen to bring vp
an hard quarell against t.

A. B. C. D. E. F. G. H. I. K. L. M.
N. O. P. Q. R. S. T. V. W. X. Y.

19. From John de Beauchesne, *A Booke containing divers sortes of handes*, London, 1570.

CHAPTER SEVENTEEN

John de Beauchesne
and the first English Writing-books

'To him from Paris, move thine antique station,
BEAUCHENE, the perfectst Pen-man of thy Nation'[1]

Since the beginning of the sixteenth century the use of italic, also known in England at that time as the Roman hand, was favoured by scholars, some poets and courtiers, and became the accepted style for diplomatic correspondence. Petrus Carmelianus, Latin secretary to Henry VII and to Henry VIII, wrote a beautiful italic hand; so did Henry, Duke of Richmond, natural son of Henry VIII. Edward VI, Katherine Parr, Lady Jane Grey and Elizabeth I, were all proficient in this hand. Other exponents of it were Leland, Udall, Cheke and Ascham, to mention only a few names of literary fame.

Among the writing-masters of the sixteenth century John de Beauchesne occupies a special position in that, although he was a Frenchman, he gave the Elizabethans of England their first native printed writing-book. Before him, the only writing-manuals available in this country were those imported from the Continent.

Beauchesne was born in Paris at the end of the fourth decade of the sixteenth century. Little is known of his origins. Inquiries as to possible parish records have not so far led to any information, but an examination of the lists of printers and booksellers at Paris has revealed a number of persons bearing his family name: e.g. Abraham de Beauchesne, a bookseller active in 1532; Julien de Beauchesne, a printer in 1545; while Jeanne de Beauchesne, wife of a bookseller, died in 1572, a victim of the massacre of St Bartholomew.

John de Beauchesne may have been apprenticed to one of the Paris writing-masters of the day; possibly to Jacques de la Rue or, what is more likely, to Pierre Hamon. Both these masters of the pen produced copy-books in the 1560s. These years saw great unrest in France. Catherine de Medici, the Queen Mother, and the boy King Charles IX tried to suppress with fire and sword the growing movement of the reformers. As a Huguenot, the young Beauchesne preferred the more tolerant climate of England to the religious strife of France, which he left in 1565 to settle in

[1] Nicholas Deeble in John Davies, *Microcosmos*, Oxford, 1603.

London. An 'Account of Strangers in the Several Parts of London etc. at Easter 1567', mentions as living in 'The Warde of Farringdon Without' one 'John de Beaue Chesne, servaunt, 2 (yeares)'. We do not know with certainty whose servant Beauchesne was. At any rate he undertook work for William Bowyer, the keeper of the Royal Archives at the Tower of London. He wrote a manuscript for him in 1567. This book of a hundred and forty leaves of vellum is written in fourteen different styles of script, including the italic hand, and is dedicated to the Earl of Leicester.[2]

In 1569 the French printer-publisher Thomas Vautroullier, who had come to London a few years before Beauchesne and settled in Blackfriars, entered in the Stationers' Company register 'a book of copies, English, French and Italian'. He paid tenpence for his license and next year registered another book 'containing an alphabet of copies for the secretary hand'. The fee was sixpence in this case. These licences were designed to protect the work, which came out in 1570, entitled: *A Booke containing divers sortes of hands, as well the English as French secretarie with the Italian, Roman, Chancelrie & court hands. Also the true & just proportion of the capitall Rom(an)ae set forth by Iohn de Beau Chesne. P[arisien]. and M. Iohn Baildon. Imprinted at London by Thomas Vautrouillier, dwelling in the blackefrieres.* This was the first English writing-book and Vautrollier's first publishing venture in his adopted country.

It is very difficult to sort out the meaning of the two separate licences. It is possible that Master John Baildon, who was a curate of St. Mildred in the Poultry, supplied the models of a small book 'containing an alphabet of copies for the secretary hand' which was then added to John de Beauchesne's book. An indication of the combining of two books might be seen in the title lettering, which is cut on wood and has the addition—like an afterthought—of: 'and M. Iohn Baildon' set in small-size type.[3] In later editions the dedication to Henry Fitzallan, twelfth Earl of Arundel is followed by a poem of 'Rules made by E.B. for his Children to learne to write bye'. They give instructions for the making of inks, preparation of paper, selection and cutting of pens, pen-hold, etc. The Rules are composed in twelve stanzas and in their doggerel rhymes show a lot of sense and practical experience of teaching.

The book is a small oblong quarto containing forty-two specimen alphabets and texts, which are mainly cut on wood. These range from formal black letters to their derivatives such as Secretary, Bastard Secretary, Set Hand in the Common Pleas and Set Chancery hand, to roman capitals and lower-case, with the italic hand and variants

[2] 'Heroica Eulogia Guiliel(mi) Boweri Reg(iae) Maiest(atis) archivor(uni) infra Turrem Londinens(em) Custodis' now in the Huntingdon Library; it is unsigned but I ascribe it to Beauchesne from a careful comparison with a signed manuscript in my possession. This is a small oblong volume of fifteen leaves, each showing a different style of handwriting (see Plate 88a in Fairbank and Wolpe, *Renaissance Handwriting*, Faber & Faber, London, 1960).

[3] The suggestion that Baildon was the wood engraver or the translator of the texts of an earlier Paris book should be dismissed as without any foundation of fact. The Beauchesne book of 1550, which is mentioned by many serious writers, never existed.

called *frizée, piacevolle, renversée, couppée* and *pattée*. These latter clearly demonstrate the influence of Pierre Hamon.

This is an altogether colourful variety of styles representing the whole scale of contemporary penmanship. Happily this diversity of hands is held together by a sequence of large decorated and historiated initials, forming an alphabet in themselves, in twenty-three pages in the beginning of the book.[4] The book obviously stimulated interest in handwriting, and the year 1574 saw the publication of *A Newe Booke of Copies Containing Divers Sortes of Sundry Hands, as the English and French Secretarie, and Bastard Secretarie, Italian, Roman, Chancery and Court hands. Set forth by the most Excellent Wryters of the sayd hands for the instruction of the unskillful.*[5] The *Newe Booke of Copies* has thirty-two specimens of lettering. The names of the 'most Excellent Wryters' are not given, but some of the specimens almost certainly came from the manuscript models used for Beauchesne and Baildon's 1570 book.

In both books the same woodcut of 'How you ought to hold your penne'[6] is shown and the poems of 'Rules . . . for Children to write by' is printed. Again a certain continuity has been achieved by the use of a complete alphabet of somewhat smaller decorative initials gracing twenty-four pages with various styles of hand.

In the book first described, ten pages are of the italic style and only eight in the second, smaller book. This indicates that in the Elizabethan period and actually well into the seventeenth century the secretary hand, an easy flowing derivative of gothic or black letter, remained the everyday form of handwriting. The new 'Italique' however was well on the way to superseding it. Two pages from the *Newe Booke of Copies, 1574,* one of secretary and one of italic, each with additional alphabets of capital letters, appear again in F. Clement's *The Petie Schole with an English Orthographie,*[7] also printed and published by T. Vautrollier, London, 1587. There are further links which connect *The Petie Schole* with the two books already mentioned. A pen-flourish from the *Newe Booke of Copies* was used for the tail-piece, and a part of the wood-block, illustrating the way to hold the pen, was reproduced in the text. Furthermore, some of the eleven text-pages accompanying the plates are merely prose renderings of verses from the *Rules . . . for Children to write by.* This is not surprising, as all three books were produced by the same publisher.

A broadsheet written by Beauchesne as a calligraphic specimen is in Mr. Philip Hofer's collection at the Houghton Library, Harvard. It shows seven styles of

[4] *A New Booke containing all sortes of hands . . ., Imprinted in London by William Kearney, 1590* has several plates from the 1570 Beauchesne-Baildon writing manual.

[5] This slender little book was unknown till 1953. A facsimile of this book, which I edited for the Lion and Unicorn Press of the Royal College of Art, was published in 1962 by the Oxford University Press.

[6] This illustration is copied from Urban Wyss, *Libellus valde doctus,* Zürich, 1549. Wyss in his turn was influenced by Mercator's design in *Literarum Latinarum* of 1540.

[7] Complete text reproduced in Robert D. Pepper, *Four Tudor Books on Education,* Gainesville, Florida, 1966.

writing and was penned on a blank leaf of a copy of Hartman Schedel's *Nuremberg Chronicle* and is subscribed in mirror writing: 'Johannes de Beau Chesne Anno 1575' and the date is the seventh December.

In the late 1570s Beauchesne travelled in Italy, but came back to France not later than 1579. He stayed at Lyon for about three years in the house of Guillaume Ouldry. From there in the rue Mercière at the Sign of the Trinity he issued in 1580: *Le Tresor d' Escriture, auquel est contenu tout ce qui est requis et necessaire a tous amateurs dudict art. Par Jehan de Beauchesne Parisien, Avec privilege du Roi.* This work has been praised by Stanley Morison as 'one of the finest books of the period, superior to any book produced this side of the Alps'. It contains, on sixty-two wood-engraved plates, specimens of italic, and French secretary; alphabets of decorative initials, of black letters, and of roman small letters and capitals. The *Tresor d' Escriture* is in a way more methodically arranged than the Beauchesne-Baildon book, which is perhaps not surprising as Beauchesne in this case was not only the author and designer but also his own publisher. The book is dedicated to François Mandelot, who was governor of that district of France. *Le Tresor d' Escriture* opens with two sonnets in praise of Beauchesne. It received the grant of a royal privilege protecting its copyright for six years. Before this time was up, however, the author returned to England. There is documentary evidence of this in one of the Cecil manuscripts: 'names of strangers, Farringdon Within, John de Beauchesne Frenche—Schoolmaster 1583'.

His next publication was *La Clef de l'Escriture*. The unique copy is at the Newberry Library, Chicago. This undated writing-book (about 1595) is dedicated to the Ladies Mary, Elizabeth and Althea Talbot, daughters of Gilbert, Earl of Shrewsbury and granddaughters of Bess of Hardwick.

It is very likely that Beauchesne made the acquaintance of the Dutch map-engraver Jodocus Hondius, who had worked in London for some years. The latter published in 1594 in Amsterdam his *Theatrum Artis Scribendi*, an anthology of handwriting. It contains six plates engraved after models from the hand of Beauchesne.[8]

We find further reference to Beauchesne in the tax records of the period: the lay subsidies of 1 October 1599 mention him as living in the parish of St. Anne's in the Black Friars. A few years after this, his talent was recognised by his appointment as writing-master to Princess Elizabeth and to Prince Charles, the children of King James I of England. To his pupil Princess Elizabeth, he dedicated a small oblong calligraphic manuscript in French and Italian. It is signed 'Jehan de Beauchesne. Aeta. Suae 72½' and is in the collection of the Newberry Library, Chicago.

In 1613 he was granted a yearly pension of fifty pounds for the rest of his life for teaching Prince Charles, who was to become King Charles I, 'the art of writing'.

[8] Another anthology, that of the engraver Giacomo Franco, *Modo di Scrivere*, Venice, 1600, reproduces a plate of abbreviated addresses from the pen of Beauchesne.

Beauchesne spent the rest of his days at Blackfriars. The parish register contains this entry: 20 May 1620, 'buried John de Bushan'.

In 1582 Vautrollier had published another book which is of some interest to students of English handwriting. This is *The First Part of the Elementarie which entreateth chefelie of the right writing of our English tung* by the educationalist Richard Mulcaster. The book is mainly concerned with the use of English, but the following passage throws light on the contemporary attitude to handwriting, particularly the reduction in the number of styles to be taught—a trend which we have already seen taking place in other countries:

'Writing shall not need to trouble itself any further in the elementary time of learning, than with those two tongues, the English and the Latin. If other trades do require more hands, as for the use of some court, and such other like, the writing-master may help himself, with the particular form of hand that is sought for . . . though I make choice of two only, but here me think I find honest men's diligence very sore mismatched, with an intricate way and most wearysome to themselves. For they spend their whole time about setting of copies, whereas fewer copies, and more looking to his hand would help the child more, as the number of copies occupying the whole time is mere enemy to amendment, and direction of the hand. I will therefore, because I like that best, set down two tables [*plates*] of the English and the Latin tongue with the letters, joinings, and what so else shall be necessary for one perpetual copy.'

This seems to indicate that the author wanted to have samplers of italic and secretary hands bound in with his book, as in the case of *The Petie Schole*.

To round off our survey of early manuals in England, we now discuss Peter Bales. He was born in the City of London at Burchin Lane, Cornhill in 1547 and was therefore about ten years younger than Beauchesne. By 1575 he had made his name as a leading penman, specialising in miniature writing and shorthand. Holinshed reports that in 1575 he presented Queen Elizabeth at Hampton Court with a specimen of his work, mounted in glass, and set in a ring. The Queen was pleased to show it to the Lords of the Council and to the ambassadors, who all admired the microscopic writing. Bales practised with success as a writing-master and teacher near the Old Bailey. He had many pupils and in 1590 published his work *The Writing Schoolemaster*. The work contains three books in one. The first, *Brachygraphie*, deals with a method of shorthand; the second, *Orthographie*, with spelling; and the third, *Calygraphie*, with 'faire writing'. The latter, which has no plates,[9] consists of eight chapters in prose, each followed by a rhymed version, and covers more or less the same ground as the *Rules . . . for Children to write by* in the Beauchesne-Baildon book. It is curious that, in both books, the text of the verses occupies a hundred and two lines.

[9] However Hondius shows in his *Theatrum Artis Scribendi* a plate of *Anglicana* which is signed Petrus Bale Ang.

The famous trial of skill between Bales and a rival penman, Daniel Johnson, took place in 1595 between seven and eight in the morning at 'the Black Fryers, within the Conduit Yard next to the Pipe Office' before five referees and a crowd of about a hundred onlookers. It is very likely that Beauchesne, who was living at Blackfriars at that time, was present. The prize of a golden pen to the value of twenty pounds was awarded to Bales, who, from then on, adopted the Hand and Golden Pen as his sign. In 1597, his *Arte of Brachygraphie* was published in a new edition, and again in 1600, under the title a *New-Years Gift for England: the Art of new Brachygraphie*, the printer this time being Richard Field, the successor of Vautrollier.

It appears that the skill of Bales was used by Sir Francis Walsingham and Sir Christopher Hatton for certain State activities, such as deciphering and copying secret correspondence. By intercepting letters and making changes or additions in forged handwriting, it was possible to compromise and set traps for their authors. I wonder whether Shakespeare knew of these activities. For in *Hamlet*, Act V, Scene II, the Prince does something similar by intercepting his death-warrant and replacing it with one for Rosencrantz and Guildenstern:

> 'Devised a new commission, wrote it fair.
> I once did hold it, as our statists do,
> A baseness to write fair, and labour'd much
> How to forget that learning, but, sir, now
> It did me yeoman service: wilt thou know
> The effect of what I wrote? . . .
> 'I had my father's signet in my purse,
> Which was the model of that Danish seal:
> Folded the writ up in the form of the other,
> Subscrib'd it, gave't the impression, plac'd it safely,
> The changeling never known . . .'

RULES MADE BY E.B.
FOR HIS CHILDREN
TO LEARNE TO WRITE BYE

To make common yncke
To make common yncke of vvyne take a quarte,
Tvvo ounces of gomme, let that be a parte,
Fyue ounces of Galles of copres take three,
Longe standing dooth make it better to be:
Yf wynè ye do want, rayne water is best,
An asmuch stuff as aboue at the least:
Yf yncke be to thicke, put vinegre in:
For water dooth make the colour more dymme.

To make yncke in hast
In hast, for a shift when ye haue great nede,
Take woll, or wollen to stand you in steede,
Whiche burnt in the fire the powder bette smale,
With vinegre, or water make yncke with all:

To keepe yncke longe
Yf yncke ye desire to keepe long in store,
Put bay salte therein, and it will not hoare.

To make special black yncke
Yf that common yncke be not to your minde,
Some lampblacke thereto with gome water grinde:
Eche paynter can tell, howe yt shoulde be done,
The cleaner out of your penne it will roone:
The same to be put in horne or in leade,
No cotton at all, when longe yt hath stayde,
The bottom will thicke, put more common yncke.
And yt will be good well sturred, as I thinke.

To make stanche graines

Make stanche graine of allome beaten full smalle,
And twise as muche rosen beatten with all.
With that in a faire cloute knit verye thinne.
Rubb paper or parchment, or ye begyn.

To chuse your quil

Take quill of a goose, that is some what rownde,
The third or fourth in wynge to be fownde:
And if at sometyme of those ye do wante,
Take pynyon as next, when Rauens quille is skante,
And ryue it iust in the backe, as maie bee.
For ragged your slitt ells shall ye see,
A middle the slype that ronnes vpp the quill:
Weare it of gander ye doo yt not spill,
The feather shaue of the quille do not pare,
The stronger your penne in hande ye maye bere.

To make your penne

Make clyfte without teeth your penne good, and hard:
Thinner, and shorter on right hand regarde:
The clyfte somewhat long, the nebb not to shorte,
Then take it in hand in most comlye sorte.

To houlde your penne

Your thoumbe on your penne as hiest bestowe,
The fore finger next, the middle belowe:
And holding it thus in most comely wyse,
Your Body vpright, stoupe not wyth your Heade:
Your Breast from the borde if that you be wyse,
Least that ye take hurte, when ye haue well fed.

To make a good penneknife

Your Peneknife as staye in leaft hand lett rest,
The mettell to softe nor to hard is best:
To sharpe it maye be and so cut to faste,
If yt be to dull, a shrewde turne for hast:
For whetstone harde touch that is verie good,
Slate or shoo sowle is not ill but good.

How to set writinge

Your Bodye vpright stoupe not with youre heade,
Your Brest from the bourde when you haue well fed :
Yncke alwayes good stoore on right hand to stand,
Browne Paper for great hast, elles box with sand :
Dypp Penne, and shake penne, and tooche Pennes for heare,
Wax quilles and penneknyfe see alwayes ye beare :
Who that his Paper dooth blurre or elles blott,
Yealdes me a slouen it falles hym by lotte :
In learning full slowe write at begynninge,
For greate is your losse, and small your wynninge,
If at the first tyme an ill touch, ye catche,
Use onely is cause of speedye dyspatche.

Howe to write faire

To write verie faire your Penne lett be newe,
Dish dash long tale flye false writing escewe :
Neately, and clenlie your hand for to frame,
Stronge stawked penne use best of a rauen.
And commelye to write, and gyue a good grace,
Leaue betwene eche woorde smale a letters space,
That faire and seemelye your hand maye be redd.
Keepe euen your letters at foote, and at heade :
Wyth distaunce a lyke betweene letter and letter :
One out of others showes muche the better.
Scholer to learne it maye doo you pleasure,
To rule hym two lynes iust of a measure :
Those two lynes betweene to write verie iust,
Not aboue or belowe write that he must :
The same to be don is best with blacke leade,
Whiche written betwene is clensed with breade.
Your penne from your booke but seldom remoue.
To folowe strang hand with drie penne first proue.
Manie one writeth the example lyeth bye,
Who so one the same dooth neuer set eye :
But he that will learne with speede for to write,
To marke his example must haue delight,
Letter and tittle to make as the same,
So shall the scholler be voide of all blame.

Slowe not thy lustes, but torne it & from thine
Owne will, for yf thou giue thy soule her desire it
shall make thine enemyes to laugh the to scorne in thy misery

A a b c d e f g h i k l m n o p q r ſ s ſſ ſt u x y z

20. From *A newe booke of copies*, London, 1574.

Necessarie thinges belongyng to writing

And one thing well marke your self well to ease,
That none but best handes maye alwaies best please:
Both farre of, and neare for faire handes do seeke,
And them safe as gold, see that thou well keepe:
And neuer let rest thy hand for to frame,
Untill that thou write as faire as the same.
To writing belonges good thinges two or three,
As drawing, Painting, and eke geometree:
The whiche, I would wish eche, wight should obteyne:
But surely to some it weare to greate payne.
So fare you now well with out booke well learne,
These fewe rules I gyue, which are as the sterne,
To Rule a good scholler, whiche doth hym bend,
To folowe good counsell so I make an end.

From John de Beauchesne, *A Booke containing divers sortes of hands.*

GLOSSARY

This list of words used in the RULES includes only those which are difficult to understand and not those whose meaning is clear when read aloud.

allome = alum (an astringent).
bay salte = sea salt.
cloute = cloth.
copres = copperas = copper salt
 or green vitriol.
eke = each
fayer = fayre = fair.
galles = galls (or oak-apples;
 produced by the action of
 insects on oak leaves).
heare = hair.
hoare = grow mouldy.
horne = inkwell made of horn.
leade = inkwell made of lead.
mettell = metal.

nearely = misprint for neately.
pinion = the outmost wing
 feather.
rosen = rosin.
ryue = tear.
shoo sowle = shoe sole.
slitte = slit.
slype = the hollow.
stanche graine = pounce
 (composition to prepare
 writing surface).
sterne = star.
strang = strange.
to lynes = two lines.
wight = youth.

CALYGRAPHIE

For the choyce of your penknife
Provide a good knife; right Sheffeild is best.
A razor is next, excelling the rest,
A whetstone likewise of hoane that is white,
Will make your knife cut your penne well to write.

For the choyce of your quills, and the making of your pen
Make choyce of quills, the best that may be found,
Of seconds or thirds, both hard, good and round.
Then clense your quill well, and slit your pen cleane,
To better your writing, it will be the meane.
And with that olde verse let your pen agree,
That the right side more light and short may be.
But in the nicking of your pen take heed,
That the right side be not too short indeed.
And if your pen be too weake or too stiffe,
Help it you may in the neb and the cliffe.
If it be hard, make neb and cliffe longer:
If it be soft, then shorter and stronger.
Thus by this rule, (if well you understand)
Soone may you make a pen fitt for your hand.

For the holding of your pen and the placing of your arme
Betweene your thumb and your two fingers place
Your pen to write with comelines and grace.
Your thumb first aloft, as highest bestowe,
Your fore finger next, your middle belowe.
Hold softly your pen, leane lightlie thereon,
Write softlie therewith, and pause thereupon;
For swiftness will come of it selfe anon.
Ill tricks are soone caught, but not so soone gon.
Hold not your pen upright in your hand,
Nor too much aslope; twixt both let it stand.
Set not your elbowe too close to your side:
Nor which is as ill, to place it too wide.
Alwaies in all things, observe well the meane:
To right side or left, too much leave to leane.

Thus in short time, beginning each thing well,
Have you no doubt, your writing will excell.

For the setling of your selfe to write
Write on a deske, least that you hurt your eyes
By stooping much; which hinders health likewise.
In comelie sort, and with a seemlie grace,
For your best ease, your selfe right forward place.
And tourne not your head too much at one side.
Nor bow it too low, least griefe you betide.
The softer you sit, the longer you may.
Each thing for ease provide by the way.
Then shall you better endure so to doo.
When urgent occasion compells you thertoo.

For the good choyce of paper and parchment
Choose not your paper too hard nor too soft,
For being too hard, it marres the pen oft:
And being too soft, then slippeth your letter;
But yet of them both, the softer is better:
For helpe it you may by rubbing the same
With stanch graine, to make it, the better to frame.
As for your parchment, chuse it not chaulkie.
Nor let it be greasie, for that is more faultie.
If chaulkie, then write not till it be gone;
First with a knife, and last with pumice stone:
If greazie it be, then let it alone:
For other remedie sure know I none.

For the making of your letters
First have an eye unto your coppie set:
And marke it well, how everie stroake is fet (*sic*);
Then as before, goe softly with your hand,
When in your minde the shape thereof is scand.
This rule is sure, by proofe right well I know,
Minde, hand, and eye, must all together goe.
But when a letter seemes too hard to make,
Then it is best a drie pen for to take,
And never cease, untill your hand can frame,
With your wet pen at last to make the same.
And then proceed in order to the rest,

For order sure, in everie thing is best.
A, B, and M, if rightly you them make,
Three quarters of the Alphabet doo take:
Then of the rest, but sixe in all remaines,
This have I showen, to ease you of some paines.

For joyning your letters together
Make ruled lines, the way more plaine to showe:
For children first must creepe before they goe.
Although some simple sort absurdly say,
That writing first by rule is no good way:
Nay this I finde as triall due assignes,
Tis good at first, to write between two lines.
For writing straight, dooth grace the hand better,
Than oftentimes the goodnes of the letter.
To set your letters even, above and belowe,
Maketh your writing the better to showe.
Between each letter keepe equall distance,
That one with another have no resistance.
Your whites and your blacks observe with good heede,
Which maketh your writing, more seemly to reede.
Between word and word keep one letters space.
Leave nothing undone, that giveth a grace.
Keepe uniformitie from first to the last,
And alwaies beware, you write not too fast:
For writing fast, before you write the better,
Will cause at last, you make not one good letter.
With scantling alike, let each word be plaste:
By keeping these Rules your writing is graste.

A most speciall and necessarie Rule for perfection in writing
For perfectnes, no better rule is found
Than Exercise of everie Art the ground:
Without the which no cunning comes to man:
No Rule can helpe but this, doo what we can.
Whereto belongs both labour and delight,
With diligent heede of minde, hand, and sight:
Still viewing your Coppie, observing each grace;
So shall you write faire in verie short space.

From Peter Bales, *The Writing Schoolemaster*.

21. From Marcello Scalzini, *Il Secretario*, Venice, 1581.

CHAPTER EIGHTEEN

Epilogue:
the Cresci-Scalzini Debate

Giovan Francesco Cresci delivered a mortal blow to the classic chancery italic with the publication of his *Essemplare* in 1560. The models of cursive handwriting which he offered in substitution were, however, carefully constructed and consciously preserved the standards of honest workmanship which he applied to his roman capitals and traditional book-hands. He believed that if handwriting is no longer subject to rules, it is performed casually, and 'casual things do not contain in themselves, nor can they induce in others, high standards of achievement.' But, as we see around us today, when the bacillus of mindless hustle is released, it multiplies and takes charge and overwhelms; moral insensibility sets in, and standards are debased. Within a generation, Cresci—the conservative revolutionary—was himself under attack by young men who were ready to make any sacrifice in the interest of rapid writing. Education to them was just vocational training. Although the system sponsored by Cresci and developed by his followers was accepted in Italy and elsewhere as the norm, the classic chancery hand lingered on; publishers still thought it worthwhile to bring out the occasional edition of Tagliente, Vicentino, Palatino and da Carpi. The cause was lost, however, as the two texts translated below make plain: they are fundamental to the study of handwriting and its teaching in the later sixteenth century.

The first comes from the writing-book of Marcello Scalzini, *Il Secretario*, published in 1581, but, if the privilege granted by Pope Gregory XIII is to be believed, composed over the previous fourteen years.[1] Scalzini, a native of Camerino in Northern Italy, who was educated in Rome, was able to perform the spectacular feat of writing a Paternoster on one side of a lentil and the Credo on the other.[2] He was a rather brash, superficial fellow, whose aim was to teach the greatest number of people to write some sort of hand in the shortest possible time. He explained his philosophy in the rules and detailed recommendations which follow his engraved models. He not only repeated the previous criticisms of the chancery italic but, with the recklessness of youth, also dared to attack Cresci's favourite book-hands. Cresci

[1] Among the preliminaries, however, we find an excellent portrait of the author 'in the 25th year of his age'.

[2] Peter Bales was said to have written 'within the compass of a silver penny' the Creed, the Lord's Prayer, the Ten Commandments, a prayer for the Queen, and the day of the month and year.

was never one to refuse a fight. He not only wrote a long, angry reply but, by a curious quirk of publishing, got his blow in first. *His* counter-recommendations came out—surprisingly in Venice, not Rome—some two years before his opponent's appeared. Scalzini's manual was probably held up while his handwriting examples were being engraved.[3] He succeeded in obtaining the services of one of the best copper-engravers of the day, Giacomo Franco, to whom he pays a special tribute. It is perhaps significant that a panel on one of the plates is incomplete and that at least two of the other plates have corrections or afterthoughts.

 Scalzini begins with some practical matters: posture, the choice of quills, ruling the paper. The master should teach his pupil no more than four letters a day, writing them himself in order to show their construction and the movement of the pen. When difficulties arise, he should either write or score the letters so that the pupil can trace over them many times until he picks up the correct movement. Scalzini then goes over the ground with more detailed rules for the benefit of those who do not have access to a writing-master. It is typical of his system that he plays down the importance of pen-hold: adults should be able to learn to write well despite the manner in which they have been accustomed to hold the pen; similarly, he says that writing hastily does no harm—it actually encourages the lightness of touch required for the new chancery cursive. He suggests—and this is a good idea—that a piece of writing should be hung up in a part of the room that catches the eye; thus a mental image of the model will be built up, almost unconsciously.

 Scalzini then discusses a practice about which sharply divergent views were held. Copperplate engravers were echoing the taste of the times, revelling in complicated curls and twists. Writing-masters like Scalzini, using the thinner pen held with the raised hand, saw in these arabesques a means of improving the agility of the wrist with a view to speed. It is a further instructive example of how handwriting was influenced by the technique of another graphic art. They therefore advocated the practice of 'flourishing' or, as it was later called in England, 'command of hand'.

 Now Scalzini starts walking over the mine-field. People who wish to learn to write quickly have spent months and months with 'vainglorious and unintelligent teachers' in learning slow, laborious hands, which are of no use for normal purposes and are damaging to speed. He mentions many of the exotic and decorative alphabets found in the manuals of Tagliente, Vicentino, Palatino and Amphiareo, and then deliberately criticises the roman capitals, and the roman and italic book-hands, in which Cresci specialised, as being 'particularly suitable for old men with weak sight'.

[3] It is worth noting that, during the years 1575–7, Venice was attacked by plague so savagely that perhaps 30 per cent of the entire population died (see Brian Pullen, *Rich and Poor in Renaissance Venice*, Oxford, 1971, p. 324). This had long-lasting effects on the city's life. Scalzini's rules are called *Regole, et Avvertimenti Particolari*, a title which his rival mockingly echoed, designating his polemic (with a slight change of spelling) *Avertimenti di Gio. Francesco Cresci*. For Scalzini, the word 'Avvertimento' means 'recommendation' or 'suggestion', whereas Cresci probably intends a sharper nuance, for example, 'cautionary advice' or even 'warning'.

He turns one of Cresci's pet arguments against him, asserting that it is unnecessary and confusing for a secretary to have more than *one* script. This script is, of course, Scalzini's undistinguished chancery cursive, of which he can write over twenty-five varieties. The Cresci version, on the other hand, is bogus and slow, requiring pressure on the point of the pen to write it. There is much more in the same vein.

Eventually we come to a most revealing passage. Scalzini describes how 'Tagliente, Vicentino and others' popularised a 'very slow script constructed from pointed elements, in which the letters were unjoined . . . it was written with a square-edged pen, and the aid of pounce and ruled lines.' The next generation consisted of Palatino, Amphiareo and others, who brought into use 'new styles of letter that were round in the body and sharp at the ends of the ascenders and descenders'. So the process of innovation went on, but none of them possessed a genuine, swift chancery hand 'because of their deeply-ingrained habit of practising many sorts of script that involve a heavy touch'. Scalzini then resumes the attack on Cresci, carefully omitting to name him but dropping obscure hints about the complete scribe (a reference to Cresci's *Il Perfetto Scrittore*[4]). A final criticism of Cresci is that his models show too much contrast between thick and thin strokes. Even Cresci's narrower pen was not pointed enough to satisfy Scalzini's craving for speed.

In his reply, Cresci returns the compliment of not mentioning Scalzini by name. Although the subject matter would be sufficiently revealing in itself, he deliberately plants a clue to establish his adversary's identity, when he states that his critics despise the traditional scripts 'which . . . in point of beauty, soundness, skill and dignity can be compared to their cursive as a Venetian ducat to a penny (*marcello*), a rich noble to a poor, infirm, bare-footed (*scalzo*) knave, and a well furnished salon with a miserable attic (*camerino*)'. Marcello Scalzini of Camerino; Q.E.D.!

Most of the arguments deployed by Cresci are, as one might expect, head-on refutations of claims put forward by Scalzini. For example, handwriting cannot be mastered in a few months; the pupil's hand may be compared to a newly made earthen pot which, however good it looks, can easily be ruined by premature use before it has been well dried in the sun and baked in the oven. Assiduous practice is essential. Cresci repeats the metaphor which Vives had borrowed from Quintilian — 'when we want to fill a vessel with a narrow mouth, we cannot pour the liquid in all at once.'[5] Scalzini's statement that a man who wants to take up writing as a profession can do so without a master, if pressed, is vigorously opposed; so, too, are his claims about the value of 'flourishing', which is just a confidence trick foisted on a credulous public. Flourishes should be used with tasteful discretion, e.g. for capital letters and abbreviations.

The next proposition to be answered is that a man who knows several styles of

[4] The position is made unmistakably clear in one of the plates of *Il Secretario*, which is dedicated to one 'M. Gio. Francesco diminuito' ('cut down to size') and contains a rather clumsy pun on the name Cresci. [5] See p. 39 above.

writing cannot be a master of one. Here Cresci, in one of those analogies from painting of which he was so fond, says that, if the proposition were true, we would have to admit that a man who can paint an eagle or swan could not paint a monkey or a parrot. Mastery of the more formal hands means that the secretary will bring more craft and skill to his chancery cursive, giving it greater firmness, finish and elegance. People who cobble up a so-called slow chancery script without any grounding in the traditional alphabets are like the monkey who, when he saw the cook put some salt on the food to flavour it, wanted to copy him and, taking a handful of ashes, threw them in.

A man who lacks knowledge of the primary scripts cannot rationally discuss the art of penmanship. Cresci further claims (probably with reference to himself) that a writing-master who is not by nature a fast writer, can nonetheless teach his pupils to write rapidly if they keep to the correct rules: the important thing is that they should not be encouraged to run before they can walk. Later on, Cresci enters into the technical argument of whether the use of pounce, in order to make the paper smoother and less absorbent, slows up one's writing. He defends the practice on the grounds that, by controlling the flow of the ink, it sharpens the outlines of the letters and makes the writing more distinct and legible. Men who dispense with pounce, unless they are very clever, produce ragged letters that look as though they have been written with a stick. Cresci does not, however, insist on the universal use of pounce. He is merely making the case for it against those who condemn its use in any circumstances, although the truth is that it is of great value to beginners.

In conclusion, Cresci takes some actual examples of Scalzini's models,[6] pouring scorn on their ugly strokes, made with so much ink that it would be impossible to write on the other side of the paper, the monstrous descenders of the *p*'s, the *g*'s with exaggerated tails that 'look like Venetian gondolas'. How can their narrow-pointed pens stand up to such work? Such an untidy mess!

Cresci wrote his *Avertimenti* at the same time as he composed his third writing-book, *Il Perfetto Cancellaresco Corsivo*. It is noteworthy that the book consists only of one style, the chancery cursive—as Scalzini had advocated—and that some of the models are appreciably looser and less legible than before. In other words, was Cresci making a limited concession to Scalzini's practice just as Palatino, in earlier years, had given ground to Cresci?

The texts which follow are valuable in illustrating the social conditions and mental climate in which the classic chancery italic went out of fashion, and was either completely transformed under the influence of new techniques and attitudes or, as in Spain, modified less radically (though just as permanently). They also depict in lively colours the perennial conflict between the preservation of standards of craftsmanship and surrender to the market-place. That may be their lesson for us to-day.

[6] They are the models which appear as plates 21-4 of *Il Secretario*.

RULES
AND PARTICULAR RECOMMENDATIONS

of Marcello, known as Il Camerino,
inventor of the new Roman chancery cursive script,
as now commonly used,
and introduced by him in Rome and other cities

The rules and precepts that govern an art are of no benefit whatever unless they are applied to practical uses. I therefore felt I ought to deal with some matters that are relevant to it for the benefit of those who want to learn by themselves and of masters who wish to teach the chancery cursive script, the queen of all scripts. Teachers should first make the pupil write two or three words in their presence so that they can see the natural disposition of his hand and as necessary instruct him how to hold his pen with his fingers extended gracefully, to sit with his waist a little away from the table, his head held high and erect, his arms resting in a line, and with the paper or the dividing line of the sheet at right angles to the axis of the body. Then he must teach him to distinguish good quills from bad, to trim them according to their quality, to pick up carefully a generous portion of ink, within the part of the quill that has been cut, and finally to shape and link the letters together with a light touch, in accordance with the clear directions given above in my copper-engraved models and rules.

After this, he should take either a two-line fork with smooth points that will mark the paper without tearing it, or a false rule. He will, of course, appreciate that while a pupil is learning he needs the guidance and help of these devices to train his wrist; they are not, however, necessary for those who already are endowed with a good innate disposition of hand, but only for children and other beginners for the first few days of their tuition and for those whose hand is by nature rather ill coordinated and unsuited to writing. He should then rule up a sheet of paper with the ruling-fork and should begin, in the middle of the first line, to form the letters. He should first make his pupil thoroughly familiar with the basic elements of which letters are composed and then teach him to shape quickly, by joining together the separate elements, the characters *a* and *l*, one by one as shown in my models. He should now start the pupil on writing the long ascenders and descenders. These make the hand more supple and exercise the wrist; they can be readily reduced to suit a smaller letter, whereas short ascenders and descenders, once learnt, are difficult to reduce or enlarge gracefully by a writer whose wrist is not well controlled.

The master should teach four letters—not more—each day, even if the pupil has a good natural hand and is himself capable of learning many letters; this is so that he may acquire a solid foundation and a fixed habit of forming the characters correctly. The master should write the letters, which are to be set for practice, one or more times in the presence of the pupil, showing him the action of the pen and the proper formation and joining of the characters. If this is not enough, he should write out the letters which are giving trouble to the pupil and make him trace over them several times with his own pen until he picks up the movement and the way to write them confidently himself according to rule. The master can also draw the letters with a stylus of lead or iron or some other tapering instrument with a smooth point that will give an impression without piercing the paper. Then he will make the pupil go over them with his pen as before until he thoroughly understands how to write firmly and well all the characters and the appropriate joins.

These instructions are for those fortunate enough to have a master. Yet I do not wish to say that, if one has my exemplars, it is impossible to learn to write without a master. This would be absolutely wrong, for countless people can be seen to have copied and learned successfully by this method. But the pupil will learn better and much more quickly if his models also embody simple, easily-followed rules.

On the properties of quills

Quills should match the paper that is to be used for writing. Thus the coarse paper employed by merchants for double-entry book-keeping (called 'royal', 'imperial', '*mezana*' and so on) demands a rather solid, transparent and dry quill. When it is cut, the point should not be thinned, and thus it will readily stand up to continuous writing. The thin paper, which we call 'chancery paper', requires a rather thin, clear, dry, transparent quill from an Italian or Dutch goose: it should be taken from the left wing so that its end will curve away to the right. This fits the hand best and facilitates writing. Young children whose wrists are feeble and weak should be given a quill with a rather weak barrel.

A fresh quill, however well cut, often breaks. In rapid writing, its excessive hardness inevitably makes it difficult for the hand to move quickly, while the lines of writing and individual words frequently come out twisted and uneven; and the letter-forms lack life. Yet there is something which retards the hand much more than a hard quill and should be avoided by anyone who writes or is learning the chancery style; this is pounce. Some employ it when writing leisurely, studied styles— *bollatica, ecclesiastica*, gothic, *rotunda* and so on—in order to stop the ink from running too fast. While it adds finish and weight to those styles, yet, being of its nature very tenacious, it holds back the hand and renders it sluggish and heavy.

Now it remains for me to instruct you about holding the pen. I have, in my models above, given you a firm rule for holding it correctly and easily; I will nevertheless not

conceal from you that even though men differ in the natural disposition of their wrists and may likewise have acquired different habits of writing and holding the pen, it is still possible, especially for those who are of mature years, to learn to write well, despite the manner in which they have become accustomed to hold the pen. It is true that, with children of tender age who are not used to a pen and cannot grip it firmly but hold it first one way then another, it is well to give them the best and most agreeable rule for holding the pen so that they establish a firm habit of it.

You should also know that if your quill does not work properly, even though it has been well cut and you are using good ink and paper, then it must be for one or other of the following reasons. Either the quill contains too much fat so that, because of this fattiness, the point wears out after a little writing, or it is too sinewy and too robust and hard in composition: such a quill never, or only rarely, turns out well because the letters it makes are large, solid and ungraceful.

Others may contradict me: but experience, the mistress of all things, is the best guide to truth. Do you not see Frenchmen, Poles, Spaniards, Flemings, Germans and other foreigners, both within and outside Italy, who, by usage and nature, hold their pens in a different fashion from that which is normally followed by an infinite number of people at Rome and elsewhere? Even so the characters they make are sound, handsome and fluent; they write rapidly and elegantly without the aid of a line. They clearly succeed in doing this, whether the body of their characters is long or whether it is rounded and short.

Rule for writing quickly and moving in a straight line

Arrange your posture, the paper, and the quill, which will be cut in compliance with the rules that I have engraved above. Pick up a good supply of ink in the tubular cavity where you have cut the quill, and take the pen into your hand according to your habit. Shape the letters as laid down in my models, joining one to the other rapidly with a light touch. Above all direct your eye with particular attention so that the succeeding syllable follows evenly on the syllable which you have already begun. And so continually join the syllables and words as they come, always keeping your eye on the final letter of these syllables and words and matching them as you begin the ones that follow. Quite apart from the fact that the chancery script by its nature impels the hand to fast writing, you will also get a lot of pleasure out of joining and putting words together, and in writing a long passage.

The distance between one line and another is left to the judgement and needs of the individual writer. I merely say that when the lines are rather wide, ascenders and descenders that are a little longer than normal look better and it is well to use them. Provided they do not touch the line above or interfere with the line below, they are acceptable.

I should also tell you that, although writing exercises and other matter with

headlong haste is of no help to those who are learning, or can write, the chancery cursive, you should nevertheless appreciate that, contrary to what some men believe, it does no particular harm. If, when you write like this and pay no regard to any of the rules, you move your hand lightly, you will not upset the good habits you have acquired, for the chancery style is written with a light touch: indeed, when people write with extreme rapidity, it often happens that their letters turn out to have a kind of regular rhythm of their own. The opposite happens to those who are learning, or already know, scripts that are laboured. These demand a robust touch inconsistent with speed and, when they are written in haste, they are ruined and lose their character, as many who have learned this to their cost realise only too well. These two opposites are incompatible, i.e. the lightness of touch demanded by the chancery cursive and the strength required for the heavy formal hand.

The pupil who wishes to learn the chancery script quickly will find it of great benefit to keep, in a part of his room that frequently catches his eye, a specimen of this style written in the size that he likes and needs. In this way he will pick up a mental picture of the image and shape of the letters by continually looking at them and will have them firmly imprinted in his mind.

It will also be as well to avoid, as far as possible, playing games which are very tiring to the hand, such as ball-games of different kinds. They spoil the wrist and throw it off balance, rendering it unfit for writing.

When the pupil has learned his script, it will be of the utmost value to him to practise command of hand, imitating the various flourishes which are included for (*sic*) their benefit in the present work. By this means the hand will become more agile, supple and confident. Thus you will appreciate more clearly that, just as the ability to make perfect flourishes is the plainest evidence of the velocity, boldness, and control of the hand and is the finest achievement and proof that a perfect writer of the chancery script can display, so it is the most agreeable and superb accomplishment which anyone can possess and make use of at one's pleasure. The critics, therefore, who condemn flourishing for a useless or frivolous thing either do not know what they are talking about or say so because their own hands are incapable of flourishing, having perhaps lost the necessary disposition for speed by continually practising the laborious styles that they write. In the same way that a good musician who has a complete mastery of counterpoint regards it as a very easy thing to sing a simple ground melody [*cantus firmus*] and thinks nothing of it, because the most difficult and important part expected of a real singer is the counterpoint, so, as I have already said, the man who can flourish with elegance will show his skill and complete control in writing the chancery or secretary's hand and will write fast and well with the greatest of ease, without a false rule or similar aids. This will be so whether he is standing or sitting, with his head high or low, whether he is holding the paper or keeping his posture according to the rules or not, or even standing in an uncomfortable position for writing. It is well known that there are many secretaries, chancery officials and

gentlemen in Rome and other Italian cities, who are averse to laboured styles of writing and know how to flourish: and if they stand in an uncomfortable posture, they write well, straight and fast without a line just the same. I single out especially from the scribes now working here in Venice the Very Reverend Nicola Bruni of San Severino in the District of Ancona and his brother M. Antonio, both (in my opinion and that of others) splendid writers of the new Roman chancery cursive.

I do not mean by this that it is impossible to write or learn to write a handsome, firm chancery cursive without being able to flourish. There are many who, with the aid of natural ability and easily understood, complete rules, can write rapidly and well without flourishing. But I assert that flourishing loosens up the writer's hand and assists its speed and control.

When the student has thoroughly grasped all these points, he can proceed to copy the following three plates in my manual: the one which begins *con lentezza etc.*', the one showing the chancery majuscules and the pair that show abbreviations. All the letters, all the initials, joins, flourishes and words which anyone who wishes to learn to write to perfection occur in these plates. When he has formed a tolerably firm habit in copying these plates, he will be able to go on to copy and write all the remaining words and ligatures belonging to this same style of chancery hand. It may happen that, through forgetfulness or some other reason, when writing his exercise he has made letters more or less at variance with the rules. In that event a good teacher, when he corrects them, should mark them all in his own hand, writing them at the head of a sheet of paper, and give them to the pupil for practice. He should first carefully explain to him how they should be shaped and where he has gone astray. As it is so essential, the master should correct the pupil's work daily according to the needs of the student. For really there is no easier or more effective road than this to learning to write swiftly and well in a few weeks.

Detailed, practical, essential advice

Hitherto I have been describing what is required to enable anyone to learn to write perfectly the new Roman chancery cursive for secretaries as it is used today. Now I shall indicate what to avoid and what prevents the writing of a perfect chancery cursive—for example, studied, laborious scripts or scripts involving a touch inconsistent with speed. I shall also expose to the world at large all those worthless views and arguments which some vainglorious, unintelligent writing-masters have put forward in the past and taught to simple, credulous persons. This has caused immense harm. Many people have been seduced by the ill-founded promises and hopes aroused by these writing-masters, as I shall demonstrate in the section that follows. They have wasted month after month, and even years, in imitating them. Eventually when they have at last written, copied, and practised these scripts, they have found themselves with a hand so torpid and heavy that, when they wrote

quickly, they could not put together a couple of good straight lines of writing. These scripts are by nature slow and laborious. They slow up those who have a fast hand and they make even more sluggish and slow those whose wrists are naturally sluggish. This is because when you write them, you must press hard on the point of the pen and thus your hand becomes heavy.

But the simplicity of these dupes is not surprising in view of the cunning of those masters who are eager to gain the reputation of being famous scribes. In order to beguile and attract into their schools people who want to write well, they are in the habit of showing them exemplars which they design themselves and write many kinds of letters in various scripts on goatskin or parchment (on which, as is well known, even one who is not very good at writing will make characters that will have some degree of beauty, for this is the property of these materials) decorated with pictures and illuminations of gold, silver, and all sorts of colours. These letters consist for the most part of varieties which are not needed very often or are of little value for normal purposes and very damaging to speed, e.g. the ecclesiastical round hand; old-fashioned styles from choir-books; large and small inscriptional capitals from tombstones and epitaphs; bastard mercantile, Florentine, Bergamesque hands which are employed in several versions under different names (full of bold ascenders and descenders); complicated abbreviations, with so much decoration that they can hardly be understood or recognised by an expert; ciphers of letters; models of saw-edged, flowered, reversed, bisected letters; Hebrew, German, Chaldean, Turkish, Flemish, Gothic alphabets large and small which are only good enough for the signs on apothecary's boxes; letters of scroll-work, capitals composed of tree-trunks and masks, with intricate knots made up of a thousand lines, arabesques, cupids, *lavoretti*, *putti*, and foliage which serve to illuminate choir- and other books—in short, scripts suitable for monks to hang on the doors of their cells, to delight children and make them run to copy them and, as the proverb goes, to get the horse a-galloping;[7] antique roman letters, unjoined italic letters and '*antichette tonde*', the three types[8] which serve for privileges and prayer-books and are particularly suitable for old men who have weak sight or cannot see without spectacles and for those men and women who cannot read very well and always hanker after the kind of characters which most resemble the printed pages from which they learned to read; and the majuscules depicted on maps, chronicles and so on.

All this is the business of the painter and miniaturist, not of the scribe. In order to confuse scholars by the diversity of the above-mentioned scripts which they have imitated in their painting, these masters say: 'Choose what you like best: here you see letters which are finer than printed ones, and all the effects which the pen of an exceptional and consummate scribe can achieve and display'. They believe that, with the blandishment of these things, they can influence one's judgement, which,

[7] The scripts mentioned so far appear variously in the writing-books of Tagliente, Vicentino, Palatino and Amphiareo. [8] These were the specialities of Cresci.

however, in well balanced, perceptive men, does not follow the deceits of the senses but the soundness of the reasoning. It is manifestly quite unreasonable to judge the perfection of fine handwriting according to effects appropriate to painters, miniaturists and the like. Such effects, as I have said, are a hindrance to the faultless chancery cursive, which should be the student's sole aim.

These writing-masters deserve the reproach that, as Plato relates in his *Theages*,[9] Socrates said was merited by those craftsmen who want to embrace several trades at once, i.e. that they are not only useless but actually a menace to the State; on the other hand, those do great service who devote themselves to a single skill, become complete experts in it and also make their pupils succeed in becoming experts.

I do not say that one master can attain complete command of one style, and another of some other style. But I do say that one man cannot master them all. For copying different scripts involves contradictions in touch, in the kind of quills employed and in the way in which the quills are cut. Complete mastery will find no place amid these contradictions. This can easily be proved. Let those who practise those scripts and the contrary touch demanded by them, and have accustomed their hand to them, write quickly before witnesses. It will generally be found that the letters they make, so far from being perfect, are not good or even mediocre; moreover, thousands of copyists and other persons can be found who are far better than these at writing continuously with speed.

A man may call himself a complete master of the ancient Roman letter, of the ecclesiastical letter, of the *bollatica*, of the *cancellaresca* and so on with the others. But he simply cannot call himself a complete master of all the scripts. One person can be an eloquent doctor, or a fluent jurist, or a persuasive mathematician, and another man an eloquent orator. The eloquence of the latter consists in the strength of public, political oratory, that of the former in their familiarity with the terminology peculiar to those disciplines. The excellence of all the branches of knowledge that have been devised solely for the practical benefit of men, consists in the way in which they are commonly used, not in the particular objects to which they can be applied. It is obvious to everyone that in handwriting the commonest and most frequent practice is that of the chancery cursive.

Furthermore, many people deceive themselves by not distinguishing the scribe who is a complete master of his letters from the scribe who is a mere imitator of them. There is nothing special in imitating different sorts of script and mimicking printed books and the like. Countless people, above all those who have studied illumination and drawing, do it. Imitation is merely counterfeiting the published work of other men. A real achievement is discovering handsome, useful letters which have been gratefully received and given the widest currency. Many people go around copying so many different types of script; they are like painters, sculptors, draughtsmen and illuminators, who imitate all varieties of letter without becoming expert in any. The

[9] A dialogue doubtfully attributed to Plato.

man in the street is easily taken in because, as you might expect, he is lost in wonder at so many different kinds, and his wit does not penetrate to the truth of the matter. He therefore often says 'Oh, such a fellow can write perfectly a hundred, two hundred kinds of script, and among them there is one decorated with the most beautiful little figures that you can imagine as though they had been printed. They are a hundred times better than printed letters.'

I do not contend that it is impossible to master different sorts of script if they involve the same touch and belong to one category. Otherwise I should be speaking against the truth and myself. I write not in one style of letter (as some critics claim, either because they are ignorant or because they wish to slander me) but with over twenty-five different kinds of speed, arrangement and size (as can be seen in my foregoing models and even more so in my manuscripts), all in the chancery cursive genre. You can clearly appreciate their beauty and utility not only from the evidence of their being in common use throughout Italy but also from the fact that, at first when my chancery script was accepted and welcomed into common use in Rome and Italy, many of those who were reputed to be leading scribes tried, by words and deeds, to prevent the world from adopting my invention: they found it strange that their original styles were being generally discarded by many who had learned them and were avoided by those who wanted to write well. They acted as they did because it was a source of great damage to them. But when they realised that, the more they opposed me in word and deed, the more my script was commended and highly valued, while theirs was rejected by nearly everybody because it was very slow and inherently sluggish, they decided to learn mine as best they could from my models and pupils. This they did. They not only taught, and still teach it, having as we all know stopped teaching and writing their original laboured script in their schools, but also hurried to have my models engraved and printed, and attributed my invention to their own account. Because this is well known to the world I do not need to tell you that the verdict of men of sound judgement condemns them and justly castigates them for their arrogance.

Nevertheless some of them strive for fame and reputation with the spurious, worthless simulacrum of a script which they practise and teach as a chancery or secretary hand. This might after a fashion be termed chancery writing. But one could, and should, well describe it as an affected and bogus chancery cursive. It is the job of a chancery official or a secretary to write quickly and well. Their script, which is by nature very resistant, constrains the wrist, slows up the hand, and can never be written at speed. If it is to be written well, it especially demands all sorts of aids like false rules to keep it straight, pounce to prevent the ink from flowing too fast and to ensure cleanness of outline, and plenty of time. This style is essentially one of thick strokes, and pressure has to be applied to the point of the pen in order to write it, this being the reason for its slowness. How then can men who write this hand, succeed in the chancery style if it requires an agile, light, supple wrist, with which, as I have

already said several times, their constricted script is completely incompatible in regard to the physical qualities required, its intrinsic character, the kind of quill employed and the manner of cutting the quill?

I have known so many people who have applied themselves to this constricted style without making any useful progress at the cost of an immense expense of effort. When they have had to write a few lines quickly without any of the aids mentioned above, they have written letters so uneven and so uncouth that they themselves have been ashamed to let them be seen or to let themselves be seen writing, mostly doing so with such a lack of speed and standing with their chests so near the table and their paper that, quite apart from the vast effort and time which they were observed to put into it, it was an ugly sight to watch them writing in this way. This is why most of them lose their health and good complexions.

When they have been forced to demonstrate their cursive script, they have always made excuses or said 'I did not study it or apply myself at all to writing it' or 'I wrote it in a hurry or at night'. When they have taken three or four days to write something, they claim to have written it in three hours, protecting themselves as best they can with such subterfuges. Another trick is to display texts carefully written on goat-skin, then to give these specimens to their pupils, shunning the test of allowing themselves to be seen in the act of writing. Similarly, when they are obliged or forced to write fifteen or twenty lines rapidly in the presence of a Prince or Lord, they find themselves embarrassed and confused because decency forbids their preparing the paper with pounce, employing their false rules, and taking an hour to write eight or ten lines, as they are accustomed, and are indeed compelled, to do. They try to cloud the issue with the most involved artifices that you can imagine. They start trotting out excuses like these: 'I'm not in very good form today, Sir', 'My head is not very clear', 'This ink doesn't run properly', 'My hand is shaky', 'This paper is covered with hairs; it is of poor quality; it is too thick to write on; it is too thin; it is like blotting-paper', 'I'm standing with the light in my eyes', 'This is the wrong sort of quill; it is too thick and hard; it is too thin and weak; it is not properly cut', 'This penknife isn't sharp', 'This table wobbles'. They try to get out of writing by this sort of talk. If they do write, they will produce no more than four or five words and a flourish that reveals the ability to draw rather than to write a controlled hand. Then they throw down the pen, saying 'We will write and talk some other time'.

Many inexperienced writers will be able to write four or five words acceptably. But they could have succeeded very well in learning the fine, genuine chancery cursive much more quickly and with greater profit to themselves. If a man is intelligent and naturally endowed with the right physical qualities, all he needs to learn to write well is three months' sustained effort. For those who are less gifted mentally and physically, five or six months will suffice to acquire a reasonable hand. But, even for people who possess a good natural bent, two or three years' hard work will be scarcely enough to attain a firm hand and confident mastery of that other

laborious, slow script. Even when learnt, it is useless except to write at a snail's pace with much effort.

Credulous and light-headed men should not allow themselves to be taken in by the specious claim that the truly complete scribe[10] aims to master every branch of the art and that his superior perfection and excellence is revealed in his knowledge, and command of, many different types of script: at the same time stringent criticism is levelled against those who do not pursue this versatility which is so detrimental to the chancery hand. The claim might be true except that it is disproved by the test of experience and the fact that one style needs a natural aptitude incompatible with that of the other. These persons are also in the habit of claiming that a good cursive will eventually emerge from their laboured styles. They assert that it is not essential for their teacher to know and be able to write quickly and well; even then, with practice the pupil will write rapidly the script which they themselves have neither the knowledge nor the capacity to write speedily. A further claim is that a person ignorant of mathematics and without a perfect comprehension of Euclid cannot learn to write with understanding.

The short answer to them is that, even if some pupils may write faster than their masters, which most people will take to be a normal consequence of a greater natural ability, they will not make or write exactly the same letter-forms as taught by their masters, but something considerably different, since the movements of the pen inherent in the laboured style are diametrically opposed to speed. If we classify writing habits according to the diversity of their objects, how can speed result from the writer's hand and not from the nature of the script according to whether it demands either speed or the opposite? It is impossible to copy faithfully at speed a style that is naturally sluggish and slow. Nor can a master, whose hand has a fixed habit of writing a laboured style, teach others or learn for himself how to write quickly and well long passages of the genuine chancery cursive. But an intelligent pupil who has a virgin hand, i.e. who has not learned any kind of script and whose wrist is unencumbered, will be able to do so. Even naturally slow writers will, provided that their slowness does not arise from their being inured to a laboured style, nevertheless succeed in making their hand ready and quick by copying a naturally rapid style. How can a pupil in ten or eleven months or even a couple of years write quickly and well what his master has not been able to write in twenty-five or thirty years? Who is so innocent and lacking in judgement as not to realise that the absence of speed is a function of the script? And how can such masters talk of specially aiming at the common good? For they are perfectly aware of the almost incurable mistakes that they are repeatedly making. As to the mathematical proportions with which they puzzle their brains, they expose the poverty of their judgement and intellect by looking for them in the construction of the chancery

[10] An allusion to Cresci's *Il Perfetto Scrittore*.

cursive letters, and they become the laughing-stock of men of good sense. Even a child knows nowadays that any mathematics applied to these letters are the rules devised and laid down for them by their inventors and authors. It would indeed be ridiculous to assert and foolishly naïve to believe that these letters were based on mathematics and geometry. They never had, nor could they have, their origin or proportions in any kind of geometry.

Just as a language is based simply on the authority of those who speak it and is modified and changed by the passage of time during which the idioms formerly used later become obsolete, so the beauty of a script depends upon the practice, custom and accepted choice of those who write it. In this art there are no fixed unchanging rules handed down by men like Bartoli[11] and Euclid. This is plain and clear as daylight.

Before our time the only normal styles of letters used for writing were those which today are represented in printed types and particularly those in general use for choir-books, missals and hymn-books. Examples of this script can be seen written in countless books in many places in and out of Italy. Then Tagliente, Vicentino and others appeared who, as is well known, popularised letters beginning with pointed strokes, unjoined and very slow to write. They were heavy and extremely full, not only in respect of letters that fall within the line of writing but of practically every character. Each individually required four or five movements or finishing strokes to make it. The script was written with a square-edged pen, and the aid of pounce and lines. They also used other scripts such as the *bollatica*, the mercantile, the *ecclesiastica*, the flourished bastard, decorated majuscules, letters in ciphers, scrolls and so on. After them came Palatino of Rome, Friar Vespasiano Amphiareo of Ferrara, Thomaso Castelleti of Fabriano, the Frenchman L'Etien, the Portuguese Crespino Morengo and other excellent writers. They brought into use other, new styles of letter that were round in the body and sharp at the ends of the ascenders and descenders. These suited the taste of the times and were prized. They too were written with pounce and a square-edged nib. Then others emerged such as Friar Sisto da Siena, the Spaniard Don Diego and others who popularised other styles, which they regularly taught and used to call 'chancery hands'. About half the letters were joined: they were written slowly with a line and pounce. They also taught a decorated mercantile hand full of thick flourishes. So gradually others came to introduce newly invented scripts different from their predecessors and the early ones were superseded.

All these men were renowned and famous and praiseworthy writers of the scripts which they taught and were widely used at that time. But really none of them possessed the genuine, fast chancery hand, because of their deeply ingrained habit of practising many sorts of script that involve a heavy touch. This can be appreciated

[11] Cosimo Bartoli, whose book on mensuration *Del modo di misurare* was published in 1564.

and clearly observed in their surviving manuscripts and models, which can be found in nearly all the principal cities of Italy, and from the testimony of several old men still alive who frequently saw some of them at work.

Nor should people who are inexperienced in appraising the true chancery cursive let themselves be led astray by those scripts which, because they are connected and linked together and are written with a false rule and pounce, display an excessive neatness in their lineation. Characters which are neatly connected up are not always reliable evidence of speed. It is possible to write deliberately and to connect up letters which, by reason of pounce, are constructed with slow strokes and show the excessive heavy finish that the true cursive, with its rounded pen-point and its naturally rapid strokes, cannot exhibit.

Some masters often make letters like this and say 'Look, here is my script. It shows its speed by being joined up'. These letters should be called, and referred to as, spurious chancery cursives: drawing a letter is quite different from writing quickly and well. A writer's speed and firmness cannot be judged, as I have already stated, from four or five words but from an extended passage of ten or fifteen lines of fast writing which should convey an impression of boldness, ease and a certain elegance that attracts and catches the eye of everyone who looks at it. The eye desires and is entitled to have its own satisfaction in all this. The judgement and touchstone of this chancery script lie in two qualities, namely speed and beauty.

Thus it would be officious and contrary to natural justice to reach a decision about which of two writers is better at the chancery hand in the way that some people do. Inspired by passion and envy, uninvited and of their own accord, and completely disregarding all the considerations needed to arrive at a true and correct judgement, they take the chancery cursive script of an experienced and intelligent secretary and the slow laborious script of a writing-master or copier of letters, which are totally opposed in the touch required to write them and are of completely different types. Then, indifferent to any praise or blame that they may incur, they judge them and decide that the affected chancery script is better and more beautiful than that of the secretary. They fail to apply the acid test which, since it defines and determines all the points of difference and doubt, should be that both write at the same time and place without lines, and after the speed and confidence of each has been noted, the grace and beauty of their letters should be judged. Secretaries and honest gentlemen who write a fine, fast chancery or secretary hand, as is right and proper for them, should be called upon to give judgement, not those writers or teachers of a laborious script who have never been able to write well when writing rapidly. How could they give a sound, authoritative judgement on the chancery hand and support it with reasons if they themselves write and profess every other style of letter except this, the most essential and useful of all?

For those who have to use it, the false rule is like the hobbles and shackles of the horses and donkeys in Spain or the bridles on ponies. They are put on them to induce

the correct carriage until a fixed habit is firmly established. I well remember seeing in Milan[12] a large, old chestnut donkey who had been shackled to make him acquire the gait of a mule, and after a time this succeeded. But will they be kind enough to state whether, if they were in the service of some Prince or Lord, for whom they were obliged (as frequently happens) to write forty or fifty long letters in four or five hours and were summoned to his chamber, they would write in a leisurely fashion with their lines and pounce and how long they would take to complete the assignment? What credit would it be for them to put the false rule under the paper each time, to dust the paper with pounce, to settle down in a comfortable posture, and to spend a full hour in writing ten lines? Would they not be embarrassed and full of apprehension at their own ignorance? And yet they boast of being complete scribes, when they wrongly take their affected script for the pure chancery cursive, calling affectation by the name of perfection.

In order that everyone can understand more clearly, I declare that the script, whether joined or unjoined, which displays in each letter a peculiar heaviness or thickness that is the result of the pressure of a pen-point making deliberate strokes (a movement in other words completely inconsistent with speed) is, and should be so termed, a defective or, in short, a beggarly script. Those characters which have thin strokes for the beginnings and endings of letters and thick strokes between are an example. This effect can be seen in all those letters with a rounded body, such as *a*, *b*, *c*, *d*, *e*, *g*, *o*, *p*, *q* and so on. And similarly with the middle of those strokes that go outside the line of writing, both ascenders and descenders. This laboured style, for the reasons I have given, cannot be written quickly and well nor can it be so taught. Nor should it be called a true chancery cursive but a false, spurious cursive.

In order that everybody who wants to write well and learn my new Roman letters may know how to overcome completely by rational argument the audacity of certain individuals who, from motives of envy at another's success, go around continually with specious arguments planting in the minds of ordinary men words and deeds which are entirely opposed to the truth (as, for example, when they state that the point of the quill if cut for chancery cursive writing is too weak and has to be re-cut with every word; and also that this chancery hand is no good because it cannot, when the quill is cut in that way, exhibit the thick strokes, excessive finish and meticulously exact measurement in all its details, which is the usual mark of their leisurely, painstaking style; they claim that they have proved this for themselves) I tell you, then, that what they say about the quill can only result from three things—the heaviness of their hands, now habitual because of the beggarly letters which they have written and practised for so long, immediately ruins the quills cut for the chancery cursive (which demands a free, light touch); or the choice of quills that are too fresh and fatty, whose tips are easily worn down even though they have been cut according to the rules for the chancery cursive; or finally their own inability to cut a

[12] Cresci, of course, came from Milan!

quill or copy the genuine chancery letter. If they used the correct pen for the true, cursive letter and if their hands were not encumbered and burdened by writing letters involving a different touch, they would undoubtedly learn to write the natural cursive style better, more continuously, and at greater length with the cursive quill. This they cannot do with their thick, hard, sharp-tipped pen which they use to write their sluggish, beggarly script. The pen, as is well known, is easily worn down by the continuous pressure they employ when writing: the thickness of the lines thus varies as the work proceeds. It therefore becomes obvious to all that the heavy finish and exact dimensions associated with the slow script are due in the former case to the use of a sharp, square pen-point and, in the latter, to the finicky care and pains that they take or to the lines of the false rule within which they write or to the use of pounce. The swift strokes of the chancery style, which needs a pen that has a slanting or rounded tip, cannot show this kind of finish at all. They also like to assert that this finish makes the letters more elegant and lively than that produced by the slanted or round pen. That is an absolute lie. To prove it, you should take a truly cursive letter which displays the natural, light finish appropriate to its rapid stroke —so different from the heavy finish resulting from slow strokes; then take another letter made deliberately with pen, pounce and false rule. Now place the two together and compare them. You will find the cursive letter far more delicate and more lively to look at than the laboured one, even though the cursive may here and there show letters or the uprights of letters that tend to vary a trifle, being higher or lower, wider or narrower than their neighbours. This is the mark of the cursive stroke, which is not subjected or subordinated to the heavy, thick finish and minute equality of dimension in every detail to which the very slow script is subjected.

From Marcello Scalzini, *Il Secretario.*

CAUTIONARY ADVICE
OF CRESCI

*against those who promise to teach
a pupil to write perfectly
in two or three months in most cases*

I

It was never difficult to make the simple layman believe things that have a semblance of truth, especially when they are linked to the prospect of material gain. For the human mind readily persuades itself that what is useful, or has an appearance of utility, is good and true. Indeed there are many who, wishing to attain some object with the help of another person, attract his interest with the bait of utility. Just as today we see that it is the practice of some writing-masters, who are more concerned with their personal welfare rather than that of the public, to cause simple people to believe that they can teach them to write perfectly in two or three months, enticing them by the prospect of not needing to spend much time or money.

Whether this is true or not, we shall soon see by means of powerful argument. I say nothing of the evidence of those who have tried it at their own expense; nor how the arguments used by the masters themselves who undertake to teach perfectly in three months do not hold water; nor, on the other hand, how those who take pupils by contract, ask for eight or ten scudi, thereby showing that their first offer was untrue, since no one is such a fool to do for ten scudi what he can do for fifteen giuli;[13] nor how it is plain from the price they demand that, at the rate of five giuli a month, it would take more than a year, not three months.

I will rather argue in a more straightforward fashion. Who does not realise that such promises belong not to a man but rather to some miracle-worker? For it is not within the power of man to do in a single day what nature and art will not allow to be done except in a long period of time. It is obvious that human actions cannot attain their end without the appropriate means that are needed. Therefore, the pupil who wishes to write with complete correctness and regularity must first understand the position of the hand, how to hold the pen, how to make strokes, ascenders, curved parts, oblique lines, turns, tails, joins and flourishes, and then to learn to dispose all these elements in their correct place and order in forming the letter, which, when completed, would be useless, if it were not in proportion and lacked the elegance appropriate to it. Even this is insufficient if, when one letter is connected to another, they do not exhibit harmony, an even slope and a just, well-proportioned system of joins.

[13] A scudo is a crown; a giulio is a considerably smaller silver coin.

Because you could not easily find a pupil naturally endowed with such excellent intelligence, such good judgement, and so apt a natural disposition that he could immediately comprehend and have a practical mastery of the above-mentioned components, nor a master so amazing that, by a process of infusion, he could make the pupil understand them, it is impossible for a learner to understand this art fully in two or three months. And even if some reach a mediocre standard of writing that gives them a lot of satisfaction, nonetheless one notices that they must continually practise with the aid of sound examples written by their teacher, lest by getting too attached to that mediocre standard and neglecting the study required to obtain the facility and confidence that will enable them to take full advantage of it, they fall back into a worse style of writing than they began with. Just as a newly made earthen pot, however fine and good it looks, is easily ruined by being used, unless it is first well dried in the sun and baked in the oven, so the hand of the pupil, coming new to the discipline of writing, even though it seems to be good—unless it is then, so to speak, dried well in the sun of lengthy practice and baked in the oven of the passage of time—will, because it has only a fragile and weak grasp of the rules, easily drop back into its former bad habits and into far worse ones.

Assiduous practice is essential. This cannot be brief, because it requires time to train the hand so that one's writing is uniform and fluent. It is not possible to assert that anyone can complete his course so quickly or in a few days. Even if human intelligence or understanding were quick to master the complete theory of writing, yet it is impossible to acquire, with the same rapidity, the correct arrangement and movement of the hand in the act of writing, since it is necessary first to eliminate the natural stiffness of the hand and to instil correct habits in its stead. Because this has to be done in many different particulars, each of which demands its due ration of time, I do not know how we can honestly claim that the entire business can be learned except in a great number of days and many months.

Perhaps my opponents might answer that the skill and industry of the writing-master, combined with the will, intelligence and application of the pupil, is sufficient to overcome all these difficulties, because this result has evidently been achieved, simply by means of a great desire to learn, in branches of knowledge that are more important and involve more effort than this. I reply that these qualities are rarely, if ever, present together and, even supposing that they could generally be so present, they might reduce the time a little, but not to the extent of completing in three months something which can only be mastered in years. Although, together with the other means which the master uses with the pupil, a systematic and intense scheme of teaching may break down more quickly the stiffness and resistance of the pupil's hand, it will not thereby give to that hand, without prolonged practice, the same security and firmness that it ought to have.

It happens that we see many who, whatever their age, have, by their determination to master some science or art, made wonderful progress in it and have overcome the

impediments of nature by their persistence. For all that, it is undeniable that much practice, aided by determination and the expenditure of time, has played a large part. As I said, the master has not the power completely to eradicate from the scholar the defects of his natural endowment, such as rigidity either of hand or intelligence or any bad habit, without long practice; such practice is essential in any art or science.

This can be seen with children; because they do not possess sufficient judgement to understand the technique required for writing neatly, their masters, however keen they are, do not train their hands to write good, correctly shaped letters but contrive that the quality of their letters improves with the increase in their years, and that, as they grow older, they attain to a genuine and faultless manner of writing. With young men and those of more solid judgement who place themselves in the hands of a master, either to strengthen a hand that is already subject to good discipline or because of their need to restore it in every respect, it is obviously almost impossible in most cases to inculcate rapid, correct writing in so short a time simply by diligence and instruction.

Thus it happens that those who have been given sound rules have not been endowed also with a disposition capable of observing them and vice versa: and so with the rest, in varying degrees according to their natural aptitude of the hand and their enthusiasm. And if you say to me that those masters undertake to teach in a short time those pupils in whom all these advantages are combined, leaving aside all the other answers that could be made, I simply say that they ought to have given qualified undertakings, viz. that they can teach a perfect chancery style in three months only to those possessing natural ability, excellent judgement and a lot of enthusiasm, and not to all and sundry. Those who lack nothing for writing well except to practise and copy a good cursive style will need more than twenty or thirty days before they acquire neatness and fluency and a firm mastery of it; and here the master can do no more than to see that they practise diligently and assiduously. As for the others who need to retrain themselves to write in accordance with the correct rule, it is ridiculous to expect them to write well in so short a time. It is necessary to rid them of two obstacles, i.e. the natural stiffness of the hand, and bad habits, which are most difficult to eradicate. And from this anyone can perceive how much truth is contained in those lying promises which you can read in the samples of the pupils' work publicly displayed by some writing-masters, when they say, to entice the layman, that this is the writing of a pupil of fifteen or twenty days.

Concerning this, I say that such examples are either good or bad. If bad, it is a waste of time to display them to others, since anyone can learn to write badly in ten or twenty days. If good, then they have either learned from these masters or they have not. They cannot claim to have learned from them, since (as I shall prove later on) the latter have not done it themselves. Therefore it follows that they have learned from others. If this is so, they have rather stupidly imitated the crab which, to show that it could run as fast as the fox, clung to the latter's tail and thereby travelled at the

same speed, but only by using the other's legs. Let us conclude then that it is frivolous to wish to believe that, as laymen persuade themselves, writing-masters can teach any pupil whatever to write a complete chancery hand with the perfection that one expects to find in it.

When we want to fill a vessel with a narrow mouth, we cannot pour in at once all the liquid that is going into it. In the same way it is impossible to teach this art at a stroke without long and careful practice. Let serious students dismiss these vulgar misapprehensions and content themselves with acquiring, under the guidance of a competent teacher and on fair terms, the genuine, decorative style of writing with an expenditure of time appropriate to the pace of learning, depending on their natural ability, intelligence, physical endowment and energy. Thus they will come to appreciate the kind of knowledge, teaching, intentions and motives of those who dress up their lies in various colours to pass as truth. When they understand the elements that comprise perfection in this profession, they will recognise for themselves the defective script of these masters, the deceit of outward appearance which they present, the results attained by their pupils and many other matters.

Thus they can ascertain how far I go in avoiding pretexts to blame those masters and how I merely follow my duty as a Christian and an amiable teacher of this art, who only wishes to reveal to his young pupils things which can be harmful to them in learning to write well in every particular. And so in this, as in many other things, I want to remove from the minds of ordinary people the harmful misapprehensions caused by the lack of experience and lust for gain of others, especially when, in addition to all this, they state that anybody who does not wish to make a profession of writing need not learn from a qualified master. Since this statement can be a source of harm to young men, we shall now expose the falsity of the argument.

II

The malice of some people has gone so far that, in order to attract pupils into their schools, they say publicly that, unless a man wishes to take up writing as a profession, it is not essential for him to take lessons from a qualified master; a claim so obviously deserving of censure that it would be completely superfluous to refute it, except out of consideration for the unfortunate layman who, as the proverb has it, 'drinks in through the ears'; he does not examine more deeply the reason why such things are said and readily believes what he hears and what appears to be credible. But I, whose sole object is to be of assistance and not to fail to remove this false impression from the minds of the inexperienced, reply that, if it were true, there would be more masters than pupils.

I do not think you could find anyone with such poor judgement as to deny that, for the purpose of making a pupil's hand reasonably capable—I do not say absolutely perfect—at writing, a good master is better equipped than one with a feeble

command of the art. Because the physical qualities and aptitudes of pupils differ, a good, experienced teacher will know how to find the appropriate method of dealing with such differences and defects of disposition so as to put his pupils on the right road and make them learn well and with greater readiness. But how can the master, who is not very capable or experienced in this art, find a remedy for the faults of his pupils' hands, if he does not know how to remedy his own weaknesses and defects?

They also claim that, in teaching handwriting, it is enough to write an exemplar daily in the presence of the pupil, their argument being that the best way to learn writing is to see it being done. This is a downright lie, which only a fool would believe. Everyone knows the enormous difference between the hand and the eye, and between seeing and doing. If their view were correct, it would follow that, if one person stood by carefully watching someone forming a letter for a whole day and then picked up the other's pen, he would know how to make the letter himself. Everyone can test for himself just how far it is true. This notion then is neither true nor credible. If a man were to say that the eye helps a great deal, another might reply that, of course, we all know that we cannot see light without our eyes.

But I say that the capacity for holding the pen in one fashion or another and for shaping the letter according to this or that style is a matter of practice. It occasionally happens that a man thinks that he knows how to do a thing, but, when he actually comes to do it, he finds it very different from what he imagined, and especially in the sort of thing in which success depends on familiarity. Furthermore, if it were true, many of those inefficient masters who do not know their business, after having seen the excellent writing of those that do, would have completely mastered the art, since those whom they watched writing were perfect at it. We therefore say that everyone who wishes to learn this art, even for his private use, will attain his object better and in a shorter space of time from genuine masters of the rules than from those who do not know them; and that merely seeing is not sufficient, but practical application is demanded as well.

They completely deceive themselves who give ear to the tales of those masters, about whom two things are perfectly plain; first, that they are neither outstanding nor even moderately good in their profession, and second, that they do not have a methodical system of teaching others. That they are not qualified or competent is proved by themselves, for, if they were, they would strive, in contradiction to their own views, to keep pupils away from their schools by saying that there is no need to learn from competent masters. It is absolutely clear that they do not know how to teach; they not only state that seeing someone write is all the training that is needed, but make it apparent that they say this because they do not know any other way of teaching their pupils nor how to set out the particular rules for making letters one by one with the correct joins and necessary flourishes. In order to make themselves more understood, they add that the perfection and firmness of hand of a good writer is recognised by the variety and skill of his flourishes.

III

People who have no knowledge of writing are utterly amazed when they see a penman making flourishes. Some who profess to be experts at flourishing take advantage of this to claim that the strength of a good writing hand consists in the quality of its flourishing and that its firmness and stability can be judged from it. They support this dubious thesis by making many flourishes in public, and by decorating the tops, bottoms and sides of their exemplars with them. With such words and actions, they not only praise themselves by claiming to be called good writers, but it also seems that they want to create the impression that other writers, who do not waste effort on such frivolity and do not practise flourishes except to meet some rational need, should be regarded as worthless and that their hands lack confidence and any firmness. This is no more than a kind of trick to win the goodwill of the public, who are struck by admiration arising from their ignorance. The firmness of one's hand does not consist in the ability to make the elaborately decorated flourishes that they use, flourishes which are neither useful nor necessary to fine writing; such things are done for a joke even by people who do not know how to write. It can, however, be recognised when the writing flows with regularity, proceeds uniformly and shows clear outlines, the joins and bodies of the letters being well formed, to which are added those necessary flourishes without which the writing would lack elegance, as well as the other characteristics and effects that a good, well disciplined pen should display (as I shall explain more fully below). These characteristics are missing in *their* writing, and to cover their faults they assert that a firmness of hand consists in flourishes. They are readily believed by boys and young children, who like such things and grant them the worthless praise that such efforts deserve. They go around showing every Tom, Dick and Harry marvels of this sort. Now I do not deny that flourishes, made in a rational manner as necessary, are graceful and beautiful. I have, in fact, made an infinite number of them both for decoration and to relax the minds of my pupils who take pleasure in seeing them. But I exhort my pupils to learn the essentials of good writing and to amuse themselves only with the flourishes required for the capital letters and abbreviations, which display restraint, order and elegance and embellish the letter by the skill and confidence with which they are executed, but always in an appropriate fashion and proportion, when it is necessary to introduce them into the writing. These are the true flourishes, essential and useful to fine writing, which those masters lack and prove that their hands are not firm or experienced and that their decorated flourishes are quite useless, since in their own hands they do not produce an effect that is beneficial to fine and secure writing. One can say that they resemble those delicate flowers that come out in the first days of spring; just as these produce no fruit but collapse at the slightest breath of wind, so their flourishes, having no sound foundation, do not produce the fruit of a firm hand but are useless and feeble—as

feeble as their opinion when they say that he who can make several varieties of letters, cannot make one good one.

IV

There is no need to spend too much effort in eliminating this false conclusion from the mind of men; with a single argument they will be able to see on what foundations it rests. I say then that, if it were true that a man who uses several styles of letters cannot be a thorough master of one, the inevitable consequence would be that those who limit themselves to one would be perfect. In this way, according to them, all the carpenters and other people who do not know more than one style of letter would be excellent masters, while those who have mastered all the scripts would be bad pupils: pursuing this topsy-turvy argument, we should come to the conclusion that a good painter who knew how to paint the human body, could not draw an eye or an ear, those being parts much different from the neck, limbs, and arms. We should also have to say that a man who paints an eagle or a swan could not paint a monkey or a parrot, and that a man who knew all the parts of speech would not know what a noun or verb is. By their reasoning, they would overthrow all the arts and sciences, because they deny the possibility of anyone being capable of learning all their constituent parts, although one sees that many people not only execute perfectly, or at least as far as human nature permits, all the elements of a particular art or science, but of several arts and sciences at once. This can be said of any woman, not to mention men of judgement.

It seems to me just malicious ignorance on their part to condemn in others what they cannot do themselves. How can what they say in their own defence make sense, when they boast of teaching people to write perfectly the true cursive letter used by secretaries, without that instrument which is the basis of perfection, i.e. the chancery *formatella* style[14] in which all the real elements of writing are to be found? If, after studying the cursive hand for so many years, they are afraid that, by learning a more sophisticated script, which can give perfection to the cursive, they will no longer be able to write the former properly, it follows that their hand has not been properly trained in that cursive. If after so many years they have not trained their hand sufficiently, what training can they give to those pupils whom they contract to instruct perfectly in three months? They admit without a doubt that, in such a space of time, their cursive script has not reached any degree of firmness or excellence in their hands, since they are thrown off course merely by learning another script, such as the *formata* and *formatella cancellaresca*. If, as I said, they mastered these, they could invest their ordinary cursive with a greater perfection of firm lines, a better finish and sounder technique.

Those who do not know or understand these scripts do not enjoy such advantages. So it is in vain that they persuade young men that they can learn to perfection in

[14] Cresci's version of the formal italic hand.

three months the true cursive style from those who possess neither perfection nor any firmness of hand. Just because they do not know, they should not condemn those who know more than they do, behaving like the fox in the fable who, because he did not have a tail, blamed all the others for having one. They should bear in mind that a task, which they, because of their lack of skill in the art and their untrained hands, find slow and difficult, will be more easy for one who has greater experience of it, a deeper knowledge of the art, and a better endowed hand: we can say that he who has mastered the elements of writing, which are most difficult and are its heart and soul, can learn the cursive with that much greater facility.

So we see that an expert penman, who is skilled in that kind of script which is superior to the chancery cursive, produces a chancery cursive which has a greater finish and firmness in its outlines and the curves of its letters and a better effect of grace and elegance than was apparent before he became experienced in the superior style. But those who make this claim do the opposite to certain others, who boast that they know how to write many kinds of script and exhibit them in public. All of this is said and done with little sense, because these styles are not written according to any rules and lack any basis of art, as we shall see.

V

Just as it is a great mistake on the part of those writing-masters whom I have already discussed to find fault with those who can write more than one style of script perfectly, so, on the other hand, other masters commit just as serious an error when, without a correct grounding in proper principles, they wish to show off their wonderful cleverness in making many varieties of scripts, which, for reasons that I will explain in a moment, are not to be recommended: yet because of their good intentions, they are more worthy of pardon, since they want to enrich the art that they profess—quite the opposite of those who are so hostile to the art and to themselves that they want either to destroy completely the profession of which they claim to be masters, or to dismember it to such an extent that no vestige of its original shape is left. For they want no one to learn more than one branch of it, arguing that anybody who wishes to study all its branches cannot completely understand one of them.

I should in truth, as I said, praise those who are so desirous of enriching this profession, if they were assisted by some rational system of good writing, and if the styles of letter that they write were based on sound technique. But because they are entirely ignorant of the structure of those scripts which are the most important, require more study, and are fundamental to the art, such as the ancient roman capitals, the *lettera antica tonda*, the *formata cancelleresca antica*, the *formatella*, and the cursive, it is obvious that, if they do not know these styles, from which the others are derived, they cannot succeed. If, then, they do not know or understand these

scripts and their technique, which are (so to speak) the mother from which all the other styles are born, it is clear that, if they bring to birth another script prematurely from an unnatural mother, it will be the ugliest monster ever seen. Therefore the man who thoroughly acquires the above-mentioned scripts and is an experienced master of those which comprise the perfection of the art, the management of the pen and the ability to recognise the errors of those who cannot manage the pen, will be able not only to copy every variety of script, perfect or imperfect though it be, but also to discover, with great credit to himself, many other fine styles.

My own is a case in point. The world knows that I have done this in my great book[15] (the last that I published though, with God's help, I will publish others) with such ingenious invention as God has been pleased to reveal to me for the benefit of students of this art. The others have tried to imitate me, but they do not know how to, so it is no wonder that, in order not to be seen to be defeated by anyone, they have imitated the crab (as the saying goes), moving without the essential rules. We can say that their plight is like that in which a monkey found himself when he saw the cook put some salt on the dishes to flavour the food and, wishing to copy him, took a handful of ashes and threw them in; for which he was beaten.

To accompany this new invention of letters, there comes also the 'mastery' of those who boast that they can cut a quill with four strokes. Let each answer as he thinks fit. I will merely say that, if things are to be properly done, one must prepare one's tools carefully and not with such miracles of brevity and ease. I do not wish to be so indiscreet as to deny that it is a convenient thing for every man to turn to his own profit his stock of knowledge, great or small; but I condemn the judgement of those who, for the sake of gain, strive to implant foolish opinions in the minds of the ignorant, making them believe that the moon is made of green cheese, by praising things which should be blamed and blaming those that deserve praise, and slandering good, well made things—as they do when they say that writing the above-mentioned scripts (the ancient roman capitals, the *antica tonda*, etc.), which are naturally written with deliberation, is a hindrance to writing the cursive—a verdict no less malicious in its detraction of the reputation of others than cunning in its concealment of their own shortcomings.

VI

Some say that styles of letters, which, by reason of their difficulty, have to be written deliberately and meticulously, prevent the hand from retaining the speed required for the chancery cursive as used by secretaries and, consequently, that writers of these styles cannot have a cursive hand. In reply, I say that it may appear to children and persons of little judgement, who do not understand such styles, that their argument is reasonable; but to anyone who understands the art and is not

[15] *Il Perfetto Scrittore.*

entirely devoid of understanding, this opinion of theirs will seem much more foolish and senseless than the others they have advanced. If they understood the skill that goes to the making of scripts like the *antica tonda*, *cancellaresca formata* and *formatella*, etc., they would not speak so loosely, passing judgement on something they know nothing about. For they would realise that it is like a competent and experienced musician playing the lute, organ or other instrument. When he plays some fine composition or musical work, although he plays with his hand some passages that demand a slow tempo, according to the notes of which they are composed, such as semibreves and minims, he is not prevented by this from playing with the same hand other passages composed in the faster tempo of quavers and semi-quavers which require the greatest velocity. In the same way, if a competent penman happens to write those kinds of script that call for deliberation, this does not mean that he cannot write rapidly other styles that demand speed and are naturally fast, such as the cursive; he will cut his quill and adjust the consistency of the ink to the requirement of the scripts, according to whether they need to be written slowly or quickly.

I cannot understand why those who maintain this point of view are so lacking in judgement as not to recognise the truth in all that I say; if they claim the opposite, it is only to denigrate the honour which is due to others and has been earned by some merit. In this, they act like tyrants who always try to suppress the good works of others. Hence the philosopher Antisthenes used to prefer, for honesty, the public executioner to the tyrant. When asked why he did so, he would reply that the executioner kills bad men, while tyrants kill the good. This is exactly the behaviour of those who seek to banish excellence from the world by the limits imposed by their lack of experience. They criticise penmen who use those scripts which are the true foundation of the art and from which, as I have said several times, firmness of hand is acquired, although, by reason of their excellence, they demand deliberation and skill in their execution. Through them one obtains an understanding of how every kind of script is written. A man who lacks this knowledge cannot rationally discuss the art of penmanship; nor can he know how to make his pupils avoid the defects resulting from the various faulty positions of their hand—an essential part of correct instruction. And since one error gives birth to another, they claim not only that writing these scripts is an obstacle to writing the cursive style but that anyone who naturally is a slow writer cannot teach pupils to write quickly. This is the subject of my next cautionary advice.

VII

It frequently happens that, the more truth is attacked by dishonest arguments, the greater the splendour and clarity with which it stands out, in spite of the enemy who seeks to bury it. A cold flint when repeatedly struck by a hard iron sends out sparks of

living fire. Similarly, truth by being trampled on by cold lies and hard opinions steps forth clearly, naked and unadorned, and untouched by calumny. The same thing happens with those who notice that some good penmen are praised for writing incomparably better than they (the nature of these penmen being perhaps not to write with the hurried speed that is more suitable for the casual writer rather than one who makes a profession of fine writing). They assert that these writers do not know how to do the chancery cursive style, because they take their time with their formal chancery hand, and that pupils cannot learn to write quickly from such masters. So we see that, even if the public possesses any natural defences of its own against their fallacious claims, they still find devices to oppose them strenuously.

Men of discernment, to whom I am addressing myself, will consider that it would follow from their opinion that a master of Latin or any other tongue, because by nature *his* speech is hesitant and stammering, would find this an obstacle to his pupil's speaking quickly and fluently —a truly foolish and ignorant argument, as if it were in the power of a master to teach speed or slowness to his pupil, or as if the pupil picked up fast writing from watching his teacher write quickly, and not by practising for the length of time demanded by the nature of his hand. If this were the case, well, I have certainly taught many who have seen me writing quickly. But it is not, as they claim, true that the speed or slowness of the master's writing determines that of the pupil's hand. The truth is that it is the method of teaching which helps the hand, with its natural qualities, to write with more or less speed. The teacher, however, does not have to write quickly, but with deliberate care, in order that the pupil can learn the way to write fast with less difficulty. Those who do otherwise are complete amateurs.

Good masters in any profession teach the first elements of their art without haste. Good riders, when they are training colts to race, teach them first to trot and then to run. In the same way, a writing-master, when he sees his pupil racing ahead in confusion at the early stages, should rein him in, making him progress through the elements at an easy pace. This is the natural order in everything. It would be bad for babies if those who take the opposite view were to become nurses; for by wanting to teach them first to run, then to walk, within a short time they would have broken their necks. But talk like this from the mouths of some men is intended not only to bring other people into disrepute, but to provide an excuse for their always writing in a mad rush (persuading themselves that fast writing will cover up the defects in their script) and also for their not knowing how to write slowly. It occurs to me that they may be in the same plight as that related of a soldier who, being badly lamed and thinking that he might be detected at the pay table, ran with all his power and caused great disorder in the ranks, thinking thus to hide his defect. But the colonel noticed him and had him brought before him. Being thus forced to walk slowly, he was not only shown to be lame but everybody could see why he ran.

In just the same way, these brave masters fail to appreciate that the racing that

they practise and boast of in their writing undoubtedly proceeds from their lameness in this art and, when they are mustered with other sound and healthy penmen and have to write slowly, they disclose one of two defects: they either have a shaky hand or they do not know how to form any letter with the skill required of a good penman. So they force themselves to write quickly, like the soldier who ran, and wish to cover up their shortcomings. They should reflect that, if the perfection of writing lay in speed, many notaries and writers of processes would be better masters than they.

To return to our purpose; let them tell me this. If a teacher of the chancery cursive style displays well made ligatures and joins, with the rules that normally apply in the true art, and his letters are clearly finished with the correct slope and fullness, and a firm hand is revealed in the letter-shapes and the flow of the writing, then why cannot such a man teach that chancery cursive, even if he is naturally a rather slow writer? Here we are faced not with a failure in the rules, which are those which teach handwriting and facilitate speed, but with a defect of nature, that plays no part in the master's capacity to teach; nor can it play such a part. For the natural slowness of a master does not prevent his instructing the pupil with the correct rules which will enable him to write quickly.

In addition to the rules, the pupil must have a natural aptitude for fast writing, since the natural ability of the hand with its agility in writing, differs between individuals. The same situation occurs with players of the lute or other instruments. If the teacher is a real master in the art, even though he does not possess the wonderful speed of hand that another man might have, nevertheless it does not follow that he will not be proficient in teaching his pupil to play fast; those who learn from him can attain a fast hand in varying degrees according to their natural endowment, aided in varying degrees by practice. It is not the rapidity or slowness of the master's hand that gives the pupil speed, but the natural ability of that pupil and, in part, the application of sound rules, which give rise to these differences. Therefore, if a penman can display his skill and art in the necessary detail, as mentioned above, I shall consider him a good master, fit to teach the cursive style. It is a vain thing in such a case to teach pupils to pride themselves on the speed of their writing and to say that a man who is naturally a slow writer cannot teach cursive writing, because the basic principles need to be taught without haste so as not to cause confusion. We must assert that correct rules, the physical nature of the hand and practice contribute to speed, and not the instructor, who can do no more than teach sound letter-forms with lively, essential flourishes, and how to achieve the harmony and fluency demanded by fine writing. If this is lacking in the instructors of this art, they will continually betray that they have in them more of the pupil than the teacher, and more of malice than simplicity. They will demonstrate the nicety of their judgement in this profession, not only in the matters I have mentioned, but also in their describing as 'defective' that script which is written with skill and judgement.

VIII

Some say that the *antica tonda*, *formata* and *formatella* are useless, harmful styles because they are sluggish and defective and make the hand lazy. They call unhurried writing 'sluggish' and finished writing done with care and skill 'defective'. I have come to the conclusion that it would be of considerable benefit and pleasure to students of this art to discuss this question, treating of the ways in which letters that *I* call 'defective' are made. And in opening this particular discussion, I say that, among those experienced in writing, that script or letter is called 'defective' which is written by hands that have various physical defects and consequently commit various faults. A letter is called 'defective' when it comes from a hand that does not know the correct rules for holding the pen; as a result, the letters are shaped in a topsy-turvy fashion, i.e. where they should be thick, they are thin, and where they should be thin, they are thick without any neatness, and everything is the opposite of what it should be. This fault can occur either in a hand which is physically well endowed or one which is not. If it occurs in a well endowed hand, it is easy to correct. If it is in a hand that is badly endowed, because of the physical quality of the fingers, it is more difficult; when such a fault appears in a child, it can be corrected in time, and he will be able to write well, but only with difficulty will he attain to speed in writing.

A second type of defective script is that which, although written by a strong, well endowed hand, which shows a good lineation in the script, lacks skill in shaping the individual letters, especially those with curves, and elegance in linking and joining them. This kind of fault can be easily avoided if its possessor is willing to place himself in the care of a capable teacher and learn how to shun the impropriety of such a defect, always provided that his judgement is not too weak.

A third type of defective script is that written by a feeble, trembling hand, i.e. with a weak wrist and fingers which are unable to hold the pen in a way natural to the art of writing and cannot control it for the length of a line to enable the point of the pen to make clean, neat shapes. This defect is incurable: the man who is afflicted with it cannot reach the necessary standard of good writing and, even with the greatest effort, will only make a poor shot at it.

A fourth type of defective script is one which does not occur from a natural defect or lack of skill, but is written by a hand that has been out of practice for some time. Those who run into this fault do so not because they lack sufficient knowledge in the art or do not recognise their failings; their situation is that of a skilful painter who, after ceasing to practise painting for a while, finds that he does not have his former skill of hand, but, after some practice, quickly gets back to the same pitch of excellence. Similarly, penmen who understand how to write many kinds of difficult scripts and the differences between one and another, temporarily drop one because they cannot practise them all simultaneously; and then, having to write some book or important document in this style, find that their hand has become stiff, and set to

practising the letters of the alphabet of the script in which they have to write; after strengthening and training the hand which was somewhat adrift from want of practice, they start on the book, or whatever it is that they have to copy, and they continue to write well, firmly and without any defect.

To conclude my discussion of the meaning of a defective script, I say in a few words that it means a script made by a hand that, although it is eager and does its best to write well, is unable to succeed by reason of some physical defect or lack of practice, and simply displays great defects in copying a fine, well contrived script; it thereby reveals more of the *defects* than the *effects* of a good writer: this is what can be called a defective script. These are the real faults that should be branded as 'sluggish' and 'defective', not those that arise from the exigencies of art such as writing deliberately, neatly and fluently, and showing confidence, complete mastery of the art, and wide experience in every movement. Such is the case when we write the *cancellaresca formata, formatella, antica tonda*, etc., which necessarily require skill and time to write them correctly. It must not be said, as my opponents do, that neat, finished chancery cursives, written by competent penmen, cannot be fast, because they are finished and neat, and are therefore defective because they are carefully written. This is untrue, and so is everything that they say to persuade the public that slowness, deliberately employed in scripts where it is appropriate, arises from a defective hand. They hope by this means to hide the incurable shortcomings of their own so-called cursive script, which contains all those faults needed for a thoroughly defective script.

They combine the defects of the pen with those of judgement, and argue always to their own disadvantage. For if it were true that anything written slowly is naturally defective, then it would follow that the degree of its defectiveness would depend on the degree of its slowness. Thus all the styles would be defective in one respect or another. They themselves cannot escape the awkward fact that there are countless writers who, bad though they are, could be reckoned better writers than they. They cannot be excused for claiming that their script is more beautiful, because the same reply can be made to them that they apply to others, namely that their script is defective because it is written too slowly. For, according to them, the skill and beauty of penmanship consists of speed. In truth, this is an extremely ridiculous claim, and there is no need to prolong this discussion with further argument to refute such ill-informed opinions, by which they attempt to conceal things that are obvious to any average writer. This is all the more so, since they despise those scripts which, as I have repeatedly stated, in point of beauty, soundness, skill and dignity can be compared to their cursive as a Venetian ducat to a penny (*marcello*), a rich noble to a poor, infirm, bare-footed (*scalzo*) knave, and a well furnished salon with a miserable attic (*camerino*).[16]

[16] A pun on the name Marcello Scalzini il Camerino; see p. 245 above.

IX

Some people assert with little, or rather no, semblance of reason that the use of pounce is not beneficial, but a source of great harm to a writer, because it retards the speed of the hand and makes it slow and sluggish. My answer to this is that it is well known that the use of pounce was introduced by leading masters of the art of writing because all papers, to a greater or lesser degree, are imperfect and are an obstacle to perfect writing if they are used without pounce. Therefore anyone who wants to write privileges, briefs, books and the like, where clarity and excellence of the script are particularly essential, whatever the kind of script or variety of paper used, can (I say) do so without spreading pounce on the writing sheet, but in general not so well as if he employed pounce in the correct way. With the aid of pounce, the integrity of the penman's art is fully demonstrated, as it shows up the lines, the finishing-strokes and all the flourishes clearly and vividly. By holding back the ink according to the shape and capacity of the pen, it prevents it from flowing too fast and spoiling the elegance and grace of the turns in the joins, the up-strokes and ligatures, and leaves them delicate and neat as they should be; finally, it exhibits perfectly all the effects produced by the nib of a well trimmed pen and the hand's mastery in shaping the curved parts of the letters and in joining up words. Without the use of pounce, all these effects which the hand, guiding the point of the pen, can display, would be impossible.

Pounce gives these good results if the writer is a good penman. The opposite can be observed in one who does not know how to write. Just as the skill of a good penman is shown up in writing, so in one who does not know how to write, the defects and shortcomings of his writing are exposed. The reason why some people criticise pounce is because they do not know how to use it, nor how to cut their quills. Hence all those effects produced by the hand of a good penman in making lines, finishing-strokes and the curved parts of letters, which I mentioned above, become, in the hands of those who would banish pounce from the world, ragged, trembling, uncouth and infirm—as though they were writing with a stick. The undisguised shortcomings and inexperience of their hand stand out all the more clearly.

These are the gentlemen who have told their pupils that the cursive script is simply a graceful and elegant series of lines combined with an even uniformity of flourishes and joins, and that great liveliness should be shown in making them. Then, in self-contradiction, they have persuaded people, with the exemplars that they write as models, to abandon all finished and uniform scripts. One learns from their considered opinions that the firmness needed for a trained writer of the cursive script can be learned in three months by attending their schools; and then they go on to condemn finished and harmoniously disposed letters. If these are omitted, writing is no longer subject to rules and, as a result, is performed casually; and casual things do not contain in themselves, nor can they induce in others, high standards of achievement.

Accordingly, one must pity simple men in the street, who without carefully weighing the words and deeds of these masters, allow themselves to believe that a crab is a whale. It is not surprising that, for the reasons which I have given, the latter criticise writing with pounce because, if they betray innumerable faults in their penmanship without it, they will reveal all the more with it. Like men who wish to pass off brass for gold and shun the test by which the worthlessness of brass is distinguished from the worth of gold, they condemn pounce, the touchstone of good and bad writing.

They also want to pass off brass for gold, when they say that they do not wish to get accustomed to writing with pounce, that it is impossible to write the cursive style with it, and that anybody who uses it cannot write quickly. They aim in this way to make up for the defects in their technique by frivolous arguments. A man who has acquired a mastery of the art does not do this. He seeks for the sake of his own good name, the satisfaction of his pupils, and the benefit of the world at large, to demonstrate the worth and value of pounce—all the more when there is clear proof of the opposite to what they say; for among the scribes in the Apostolic Chancery there are those who always write the *lettera da Bolle* with pounce and can write so fast that it is amazing to see them. Even more wonderful is to see their speed in the *lettera bollatica*, which involves two or three pen-lifts to make a single letter. How much faster would they write the chancery cursive, in which a complete word cannot often be made without lifting the pen!

I do not insist that every writer should use pounce. For a man who writes to suit himself need not bother with these matters. I am arguing against those who, in professing to teach fine writing, utterly condemn the use of pounce; and I seek, in their own interest, to make them realise the benefit they would derive from using it, especially in the case of beginners who, if they are to learn anything properly, must have the means that will open the way to their objective.

Pounce is a most suitable means of making a beginner learn well and recognise his shortcomings. It is, therefore, a good thing to make them write with it, because most beginners do not of their own accord know how to hold the pen, have a heavy hand, and do not understand flourishes and good strokes, or how they should be neatly made. By writing with pounce, which shows up their defects and ragged, ill-made flourishes, they see without prompting and try to avoid their mistakes, and so they come to learn more quickly how to shape the letters according to the correct rules; and by understanding matters for themselves, they can then write a good, neat cursive style rapidly with or without pounce, as many of my pupils have done with complete success. This result is not easily attained by any other means.

Errors committed in writing are hard to recognise, as many inexperienced writers find, who, by virtue of having had little practice in it and for other reasons, instead of making a perfect script produce one that contains every possible fault. The effects are quite contrary to those desired by the writer. You can see it in the models which

those people have just had printed in Venice,[17] whereby serious students of the art can now realise how out of touch these masters are with good judgement and the practice of fine writing; and being recognised for what they are, they can no longer deceive the world, and everyone will now be valued at his true worth, whether he is good or mediocre in his profession. This will, I hope, be a source of some benefit to the public in general. I shall have discharged my task by having done my duty in clearing men's minds of false impressions that they have created and by rendering all honour and glory to God, the true original and cause of every good.

X

I have already attacked the false opinions of those who have attempted to introduce into this profession of writing a useless script, full of the gravest errors. I also wished to give a description of their method of writing the chancery cursive, so that, in addition to their slanders, you can see what their handwriting is really like. You can prove how rigorously it should be avoided by anyone who wants to write properly, comparing their models not only with those of notable penmen such as, at Rome, M. Cesare Moreggio, M. Gio. Luigi Mercato, scribe in the Papal Library and Chapel, M. Giovanbattista Landino, scribe in the chancery of the Illustrious Cardinal Albano, M. Cristoforo Livizzano of Modena, M. Giovanni Pomodoro, M. Gio Battista Tronchi, M. Mario Massari and M. Luca Orfei da Fano and others; in Milan, Signor Baron Sfondrato and M. Benedetto Costa; in Venice, M. Gio Francesco Bellinato; in Siena, Signor Camillo Spannocchi and M. Ventura Fondi; in Bologna, Father Cherubino Gherardacci, and M. Antonio Zanetti; in Bergamo, M. Leonardo Maffei—but also with many others, who although they are not writing-masters, nonetheless have good judgement and views on this matter. Let everyone be warned how useless is this script, which I now describe.[18]

To begin with the alphabet with its abbreviations and all its other elements, I say that for the most part this model is all shaky and ragged, and the natural movement of the pen cannot be recognised in any letter. It is clear that the quill that makes such letters is cut to such a narrow, weak point that it cannot shape any letter according to rule: the finishing-strokes are as broad as the diagonals, and everything is thin and monotonous: these faults would not occur with a properly cut quill. The ascenders of the letters are written with such a discharge of ink and are so badly shaped that they make an ugly model.

Moreover, I should like someone to tell me, please, how one can write intelligibly on the other side of the sheet. The paper is so thin and the ink so diluted for fast

[17] This indicates that, although Scalzini had not yet published his book, some of his models had been engraved, printed and apparently circulated.

[18] The text implies that at this point Cresci may have printed examples of Scalzini's models for comment, but they are not reproduced in the *Avertimenti*.

writing that the strokes, which are made with a lot of ink, penetrate from one side of the sheet through to the other. I do not know how a script which contains such blemishes can be acceptable to Princes or anyone else; for since it is necessary to write on both sides of the paper, the script is hard to read.

Furthermore, it is obvious that this script, being executed with a weak pen laden with ink, must make the writer very apprehensive and unhappy. By filling the pen so greedily and so frequently to show off those useless ascenders and the finishing-strokes of *p* and *q* and other letters, the writer will always be afraid of spattering his work with huge blots of ink. A secretary who followed this style of writing would spoil many sheets before completing a fair copy of a letter. This often happens when these masters write exemplars for their pupils to use as models. Apart from the fact that many leaves are spoiled by these faults, you can also see in their exemplars several square holes indicating where many blots fell on to the sheet as they wrote; these they afterwards cut out of the paper, because they were ashamed that these mistakes should be noticed.

As for their capitals and the abbreviations which you can see in their second model, the flourishes they have invented and the joins of the abbreviations and capitals have been done much better by any number of notaries and merchants as they write without giving any particular thought to it. Who can possibly like those capitals so pregnant with ink, and those flourishes which we see here in their abbreviations for 'Illustrissimo', 'Governatore', 'Magnifico', 'Fratello', 'Monsignore', etc., and those *p*'s made with such long descenders and such an expense of ink in the tails that they seem to be made with anything but a pen? Who would look with any pleasure at those *g*'s with their full curves that make them look like Venetian gondolas, those *f*'s and *p*'s with the end of their down-stroke turned back with thick strokes quite out of keeping with the nature of the pen and contrary to all good order? Who will relish a script in which every part is composed of such monstrous strokes? I admit that a liberal use of ink suits certain strokes in the capital letters and other cursive letters, provided it is done with discretion, but not so lavishly and extravagantly as they do. The abbreviations for 'Eccellenza', completely drowned in ink like all the others, really exhibit such deformity that they do not appear to have been made by the hands of writing-masters but by those of mediocre pupils. *This* is the script with which they want to please princes and great lords and which they wish to pass off as some rare thing.

They claim that this untidy mess displays liveliness (it does, because anyone who looks at it has to laugh) and gives delight to the eye and is the cursive for secretaries. Yet I, and they, and everyone else, know that no secretaries in the Court of Rome and of so many illustrious lords are introducing it into their own offices, let alone in the chancery in the presence of their masters, but they avoid it as something harmful. As to its being 'cursive', how can a miserable pen, cut thus to so weak a point, such as they use, stand up to work in an account-book, which is made of thick, rough paper?

You can imagine that, as they perpetrate that confusion of ink in their ascenders and press the pen point down to produce those variegated and badly-proportioned flourishes on any sort of paper, they must re-cut the pen with every line. So they will spend more time doing this than in writing the remainder of the letters. Together with this mistake, they pretend that they want the flow of ink to achieve an effect in their letters, an effect which they never intended. Such copious flows of ink cannot possibly suit the wishes of a penman who is writing in haste: the lines come sometimes too thick and sometimes too thin, by accident and according to no rule, but just as good luck guides them. The rest of their letter is so thin and written entirely without art that they cannot plead that it is not done without rules or reason. In the same way the sample which they usually give to their new pupils to copy, which you can see on the first model, lacks a sound foundation.

These are the errors which the tribe of inexperienced masters, with their faulty judgements and their pens, inflict on the profession of handwriting. I have exposed them for the benefit of the public and out of respect for the art, and for no other purpose. I pray God that this work of mine shall have the good effect on them that I intend. In which event, the glory will be due to God, in Whom the beginnings of all good deeds have their origin. If by chance they do not want to submit themselves to the truth of my observations, I shall play the part of a good doctor. When, while treating a delirious patient whose life is despaired of, he sees that the medicine, diet, and such like are of no further help to him, he lets him have what he likes. In the same way, when I see that my work is of no benefit to them, I will let them behave as they please and will leave them to look after themselves in their own way without imposing any restrictions on them. In order to serve them, I shall not only not oppose them in any way, but will help them to any extent that they wish. I shall see that real opportunities are made for them. I shall not only formally designate them as experienced writers and true innovators in this art of cursive writing, but I shall also allow them all the fancy titles that they especially like, so that to anyone who doubts them they can show their credentials in writing: this will perhaps be the best way of producing in them the effect which my critical observations will have failed to have on them. As they go around boasting in this fashion, they will hear the mockery, which persons with an understanding of the profession will direct at them. They will become a subject for popular fable, as well known as that of the animal who appeared among many other beasts wearing a lion's skin: he was being honoured by everyone but, at the lion's first roar, was recognised for what he was.

From Giovan Francesco Cresci, *Avertimenti*.

SELECTED BIBLIOGRAPHY

Allen, P. S. and H. M., and Garrod, H. W., *Opus Epistolarum Des. Erasmi*, Oxford, 1906–58.

Alonso García, Daniel, *Joannes de Yciar, calígrafo dirangués del siglo XVI*, Bilbao, 1953.

Anderson, D. M., *The Art of Written Forms: The Theory and Practice of Calligraphy*, Holt, Rinehart & Winston, New York, 1969.

Augustino da Siena, The 1568 edition of his writing-book in facsimile, ed. Alfred Fairbank, Merrion Press, London, 1975.

Bank, Arnold, 'Calligraphy and its influence in the time of Plantin', *Gedenkboek der Plantin-Dagen*, 1555–1955, Inter-Nationaal Congres voor Boekdrukkunst en Humanisme, 4–10 September 1955, Antwerp, 1956.

Benson, John Howard, *The First Writing Book: An English Translation and Facsimile text of Arrighi's* Operina, *the first manual of the Chancery hand*, Yale University Press, New Haven, 1954.

Bonacini, Claudio, *Bibliografia delle arti scrittorie e della calligrafia*, Sansoni Antiquariato, Florence, 1953.

Calligraphy and Palaeography: Essays presented to Alfred Fairbank on his 70th Birthday, ed. A. S. Osley, Faber & Faber, London, 1965.

Casamassima, E., *Trattati di Scrittura del Cinquecento Italiano*, Edizioni di Polifilo, Milan, 1967.

Clair, Colin, *Christopher Plantin*, Cassells, London, 1960.

Cotarelo y Mori, Emilio, *Diccionario de calígrafos españoles*, Madrid, 1916.

Cresci, Giovanni Francesco, *Il Perfetto Scrittore*, Miland Publishers, Nieuwkoop, 1972 (a facsimile of the 1570 edition).

Echegaray, Carmelo de, *Calígrafos Vascos—Juan de Iciar*, Bilbao, 1914.

Fairbank, Alfred, 'More about Arrighi', *Bulletin of the Society for Italic Handwriting*, No. 26, Spring 1961.

———, 'The Arrighi Style of Book Hand', *Journal of the Society for Italic Handwriting*, No. 35, Summer 1963.

———, 'Giovanbattista Palatino', *Journal of the Society for Italic Handwriting*, No. 48, Autumn 1966.

———, 'Arrighi and Papal Briefs', *The Book Collector*, Autumn, 1970.

———, *The Story of Handwriting*, Faber & Faber, London, 1970.

———, *A Handwriting Manual* (rev. ed.), Faber & Faber, London, 1975.

———, *A Book of Scripts* (rev. ed.), Faber & Faber, London, 1977.

Fairbank, Alfred and Wolpe, Berthold, *Renaissance Handwriting*, London, 1960.

Heal, Ambrose, *The English Writing Masters and their Copy Books* 1570–1800, Cambridge University Press, 1931.

Hofer, Philip, 'Variant Issues of the First Edition of Ludovico Arrighi Vicentino's *Operina*', *Calligraphy and Palaeography*, London, 1965.

Jammes, André, 'Un chef d'oeuvre méconnu d'Arrighi Vicentino,' *Studia bibliographica in honorem Herman de la Fontaine-Verwey*, Amsterdam, 1970.

Jessen, Peter, *Meister der Schreibkunst aus Drei Jahrhunderten*, Stuttgart, 1923.

Johnson, A. F., 'A Catalogue of Italian Writing-Books of the Sixteenth Century', *Signature*, New Series, No. 10, London, 1950. Reprinted in *Selected Essays on Books and Printing*, ed. Percy H. Muir, Amsterdam, 1970.

Johnston, Edward, *Writing & Illuminating, & Lettering*, London, 1906.

Kataloge der Ornamentstichsammlung der Staatliche Kunstbibliothek, Berlin, 1939.

La Fontaine-Verwey, H. de, 'Het handschrift van Ludovico Arrighi en de Amsterdamse Universiteits Bibliotheek', *Amsterdam en de drukkunst*, Amsterdam, 1951.

Lindberg, Sten C. (and others), *Ludovico Vicentino*, Tidens Vörlag, Stockholm, 1958 (contains a facsimile of *La Operina* and *Il Modo*).

Lowe, E. A., 'Handwriting', *The Legacy of the Middle Ages*, Oxford University Press, 1926.

Marzoli, Carla, *Calligraphy 1535–1885*, Milan, 1962 (a catalogue).

Mercator, Gerardus, *Literarum Latinarum quas italicas cursoriasque vocant, scribendarum ratio*, Miland Publishers, Nieuwkoop, 1970 (a facsimile of the 1540 Louvain edition).

Morison, Stanley, *The Calligraphic Models of Ludovico degli Arrighi surnamed Vicentino*, Paris, 1926 (a facsimile).

———, *Eustachio Celebrino da Udene, calligrapher, engraver and writer for the Venetian printing-press*, Paris, 1929.

Morison, Stanley, and Potter, Esther, *Splendour of Ornament: Specimens selected from the* Essempio di recammi ... *by Giovanni Antonio Tagliente*, Lion and Unicorn Press, London, 1968.

Mosley, James, 'Trajan Revived', *Alphabet No. 1*, London, 1964.

Nash, Ray, *An Account of Calligraphy and Printing in the Sixteenth century from dialogues attributed to C. Plantin*, Harvard University, Cambridge, Mass., 1940.

Ogg, Oscar, *Three Classics of Italian Calligraphy*, Dover Books, New York, 1953 (facsimiles of the writing-books of Ludovico Vicentino degli Arrighi, Giovannantonio Tagliente and Giovambattista Palatino).

Omont, H. A., *Le receuil d'anciennes écritures de Pierre Hamon*, Paris, 1901.

Osley, A. S., 'The Origins of Italic Type', *Calligraphy and Palaeography*, Faber & Faber, London, 1965.

———, *Cresci: Essemplare di piu sorti lettere, 1578*, Nattali & Maurice, London, 1968 (a facsimile).

————, *Mercator*, Faber & Faber, London, 1969 (contains a facsimile and translation of Mercator's writing-book).

————, *Luminario: an introduction to the Italian writing-books of the sixteenth and seventeenth centuries*, Miland Publishers, Nieuwkoop, 1972.

————, 'The Variant Issues of Ugo da Carpi's *Thesauro de Scrittori*', *Quaerendo*, Vol. III, 3 July 1973, p. 170 etc.

Potter, Esther, *Ugo da Carpi: Thesauro de Scrittori*, Nattali & Maurice, London, 1968 (a facsimile).

Pratesi, A., 'Arrighi, Ludovico', *Dizionario biografico degli italiani*, Vol. 4, Rome, 1962.

————, 'Amphiareo, Vespasiano', *ibid.*, Vol. 3.

Rohde, Bent, and Ejnar, Philip, *La Operina: Faksimile-udgave af Ludovico Vicentino's laerebog i at skrive*, Copenhagen, 1959 (contains a facsimile of *La Operina*).

Servidori, Domingo, *Reflexiones sobra la verdadera arte de Escribir*, Madrid, 1789.

Servolini, Luigi, 'Il Maestro della xilografia a chiaroscuro: Ugo da Carpi', *Gutenberg-Jahrbuch*, 1934.

————, 'Ugo da Carpi, illustratore del libro', *ibid.*, 1950.

————, 'Le Xilografie di Ugo da Carpi', *ibid.*, 1953.

————, 'Eustachio Celebrino da Udine, intagliatore, calligrafo, poligrafo ed editore del secolo XVI', *ibid.*, 1944–9.

Standard, Paul, *Calligraphy's Flowering, Decay, and Restauration*, The Sylvan Press, The Society of Typographic Arts, Chicago, 1947.

Spelta, Antonio Maria, *Saggia Pazzia. Dilettevole Pazzia*, Padua, 1607.

Tagliente, Giovannantonio, *La Vera Arte delo Excellente Scrivere*, Miland Publishers, Nieuwkoop, 1971 (a facsimile of the shorter 1524 edition).

Thomas, Henry, 'Juan de Vingles (Jean de Vingle) a Sixteenth-Century Book-Illustrator', *The Library*, 4th series, 18, No. 2, 1937.

Thomas, Henry, and Morison, Stanley, *Andres Brun: Calligrapher of Saragossa*, Pegasus Press, Paris, 1929.

Thomson, Frank Allan, 'Arrighis Ställning i Bokstavskonstens Historia', *Biblis*, 1959/60.

————, 'Arrighi's Writing-Books', *Journal of the Society for Italic Handwriting*, No. 52, Autumn 1967, and No. 53, Winter 1967.

Torío de la Riva, Torquato, *Arte de Escribir*, Madrid, 1798.

Tschichold, Jan, *Schatzkammer der Schreibkunst*, Basel, 1945.

————, (ed.), *Das Schreibbuch des Vespasiano Amphiareo*, Dr. Cantz'sche Druckerei, Stuttgart—Bad Canstatt, 1975 (a facsimile of Amphiareo's *Opera di Frate*, Venice, 1554).

Ullman, B. L., *The Origin and Development of Humanistic Script*, Edizioni di Storia e Letteratura, Rome, 1960.

Vanegas de Busto, Alejo, *Tractado de Orthographia*, Toledo, 1531.

Wardrop, James, 'Arrighi Revived', *Signature* No. 12, 1939.

———, 'The Vatican Scriptors, Documents for Ruano and Cresci', *Signature*, New Series, No. 5, 1948.

———, 'A note on Giovannantonio Tagliente', *Signature*, New Series, No. 8, 1949.

———, 'Civis Romanus Sum. Giovanbattista Palatino and his circle', *Signature*, New Series, No. 14, 1952.

———, *The Script of Humanism*, Oxford University Press, 1963.

Watson, Foster, *Tudor Schoolboy Life: the Dialogues of Vives*, Dent, London, 1908.

Watson, Foster, *Vives and the Renaissance Education of Women*, New York, 1912.

Wells, James M., *Opera di Giovanniantonio Tagliente*, Newberry Library, Chicago, 1952 (a facsimile of Tagliente's 1524 abridged, half-size version of his writing-book).

Wolpe, Berthold, *A Newe Booke of Copies 1574*, Oxford University Press, 1962.

Yciar, Juan de, *A facsimile of the 1550 edition of Arte Subtilissima*, with translation by Evelyn Shuckburgh, Oxford University Press, 1960.

INDEX

*Scripts are listed according to the designation used by the individual writing-master. Different names may therefore be found for the same script, e.g. antica = lettre ancienne.